DIGITAL PAINTING
techniques
VOLUME 8

DIGITAL PAINTING
techniques
VOLUME 8

3DTOTAL PUBLISHING

Correspondence: publishing@3dtotal.com
Website: www.3dtotal.com

Every effort has been made to ensure the credits and contact
information listed are present and correct. In the case of
any errors that have occurred, the publisher respectfully
directs readers to the **www.3dtotalpublishing.com**
website for any updated information and/or corrections.

First published in the United Kingdom, 2016,
by 3dtotal Publishing.
3dtotal.com Ltd, 29 Foregate Street,
Worcester, WR1 1DS, United Kingdom.

Soft cover ISBN: 978-1-909414-37-2
Printing and binding: Everbest Printing (China)
www.everbest.com

Visit **www.3dtotalpublishing.com** for a
complete list of available book titles.

Editor: Annie Moss
Proofreader: Melanie Smith
Lead designer: Imogen Williams
Designer: Matthew Lewis
Cover designer: Matthew Lewis
Managing editor: Simon Morse

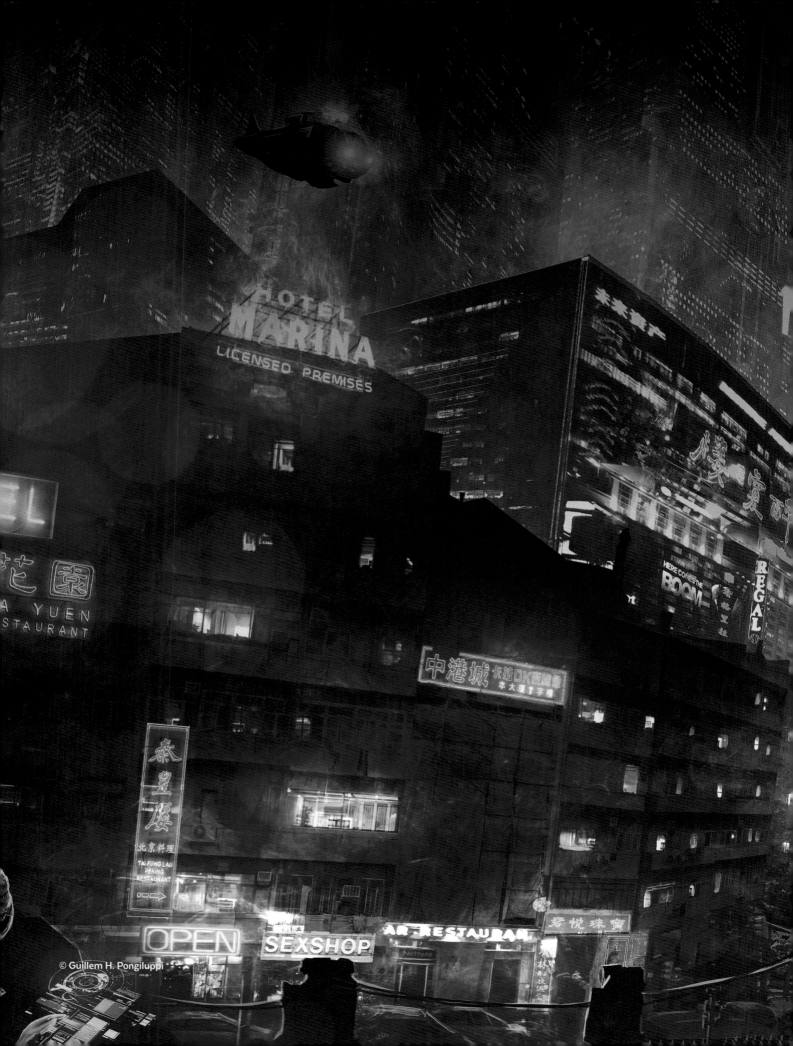

© Guillem H. Pongiluppi

Contents

Foreword 08

Introduction 10

Narrative Art 12
Monster: villain 14
Monster: heroes 22
The Dead Dude: villain 30
The Dead Dude: hero 38

Matte Painting 46
Futuristic shipwreck 48
Fish market 60
Spacecraft wreckage 70

Custom Brushes 80
Fantasy 82
Sci-fi 90
Otherworldly structures 100
Cityscapes 106
Weather effects 112
Creatures 120

Costume Design 128
Female assassin 130
Masquerade ball 138

1920s dress 148
Aged jester 154
Thirteenth-century knight 162
Space pirate 170

Imaginative Landscapes 178
Alien badlands 180
Cyberpunk city 188
Organic alien city 196
Glass city 204

Functional Transport 212
Movement enhancer 214
Bicycle power generator 222
Sci-fi delivery truck 232
Prison vehicle 242
Sci-fi cloud scooper 252

Gallery 260

Featured Artists 282

Index 284

Foreword

For a young artist, or even for an experienced one, picking digital tools as your weapon of choice might seem the best possible option these days. Indeed we live in a world vastly occupied by digital gadgets and computers; we see digital images everywhere around us: in games, movies, TV, on the internet, in advertising, graphic design, and illustration. All over the world digital tools are rapidly becoming a standard, even for traditional industries such as children's book publishing and editorial illustration. Digital tools are fast, reliable, flexible, and they all have that magic Undo option which we lack so desperately in all aspects of our lives.

That being said, it is important to keep in mind that there is no universal digital technique or tool that can be applied to every industry. In fact, different industries have different requirements and sometimes demand different approaches and sets of skills. For example the game industry, and especially concept art, requires speed painting skills and knowledge of different brushes and combinations of tools. Illustration requires more thorough and careful work, often with a more handmade look; there is therefore no need for speed painting when it comes to illustration.

Advertising illustration in most cases is all about vivid realistic paintings, while visual development for animation needs a much more exaggerated artistic style and simplified color schemes. Even illustration for magazines may need an approach slightly different from illustration for newspapers, due to the different paper qualities used in each case and their paint absorption properties. So the bottom line is that each tool you choose, and each skill you develop, should specifically fit the industry you are intending to work in.

However, while some basic artistic skills like draftsmanship, color, composition, anatomy, and perspective never change, digital tools are constantly evolving along with the technology they are based on. Therefore in order to keep up with industry standards it is crucial to keep on learning new tools and techniques.

The book you are holding right now provides you with an excellent basis for such learning. With tips, tricks, and in-depth tutorials from industry experts, covering a very vast range of issues, you have all that might spare you an enormous amount of time. After all, there is no substitute to professional experience, and that is what this book about. It is about pros sharing their experience with you. Good luck!

Denis Zilber
Illustrator & Character Designer
www.deniszilber.com

Introduction

Digital painting is an ever-expanding art form which uses the immense power of modern software and the constant advances in technology to create outstanding works of art. Used widely across numerous industries, there are always new and interesting tricks and techniques to learn. By exploring the ways other artists work you can quickly refresh your processes and discover unexpected uses for familiar tools.

In *Digital Painting Techniques: Volume 8* we have gathered together a wide selection of detailed, practical tutorials from highly skilled artists. Here those artists share their knowledge and experience from years of working as concept artists, freelance illustrators, matte painters, graphic designers, art directors, and visual developers. From exploring different methods to make and use custom brushes,

to manipulating photos and textures, you will find ways to expedite your creative process. You can also discover ingenious ways to maintain a narrative when painting scenes from different points of view, observe how top character designers research and stylize costumes appropriate for their characters, and see how vehicle designs are assimilated with functionality.

As an artist it can sometimes be easy to fall into the practice of using the same tools and techniques time and time again, so grab your tools and prepare to shake up your workflow! *Digital Painting Techniques: Volume 8* will help you on your way to reinvigorating your work and creating impressive pieces of art.

Annie Moss
Junior Editor
3dtotal Publishing

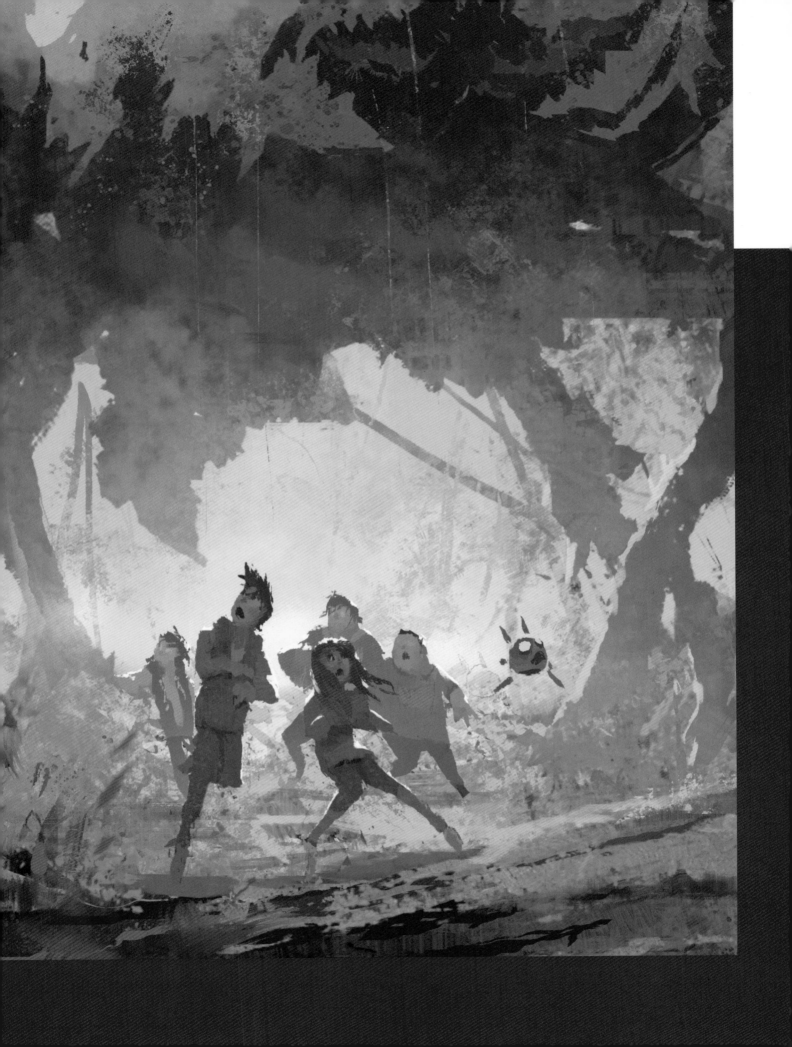

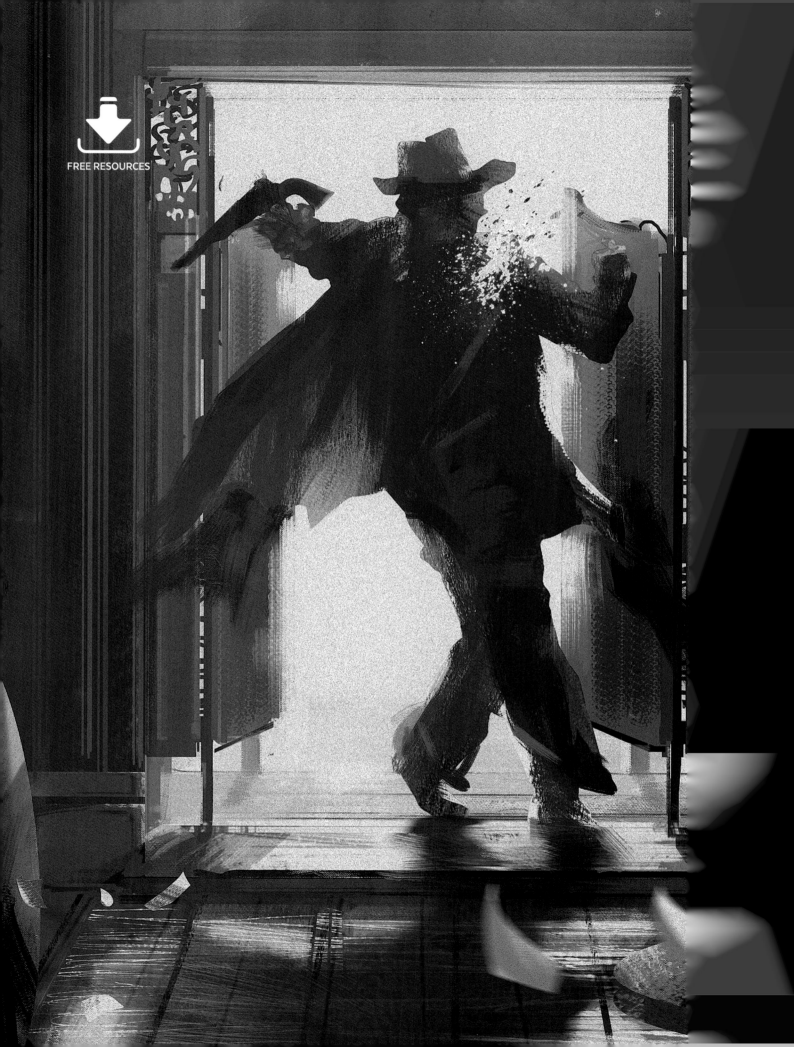

Narrative Art

When creating illustrative art for books, games, or films it is often beneficial to be able to consistently replicate scenes from different angles or points of view to enhance the narrative being visualized. As you will see in this chapter, being able to consistently maintain key elements such as colors, lighting, and mood across multiple images enables you to quickly and convincingly present an illustrative scene from different perspectives.

In this chapter two renowned artists from the entertainment industry, Zac Retz and Markus Lovadina, show how they tackle painting a narrative action scene from the points of view of both the villain and the hero. Learn from their tips and tricks to speed up your own narrative art!

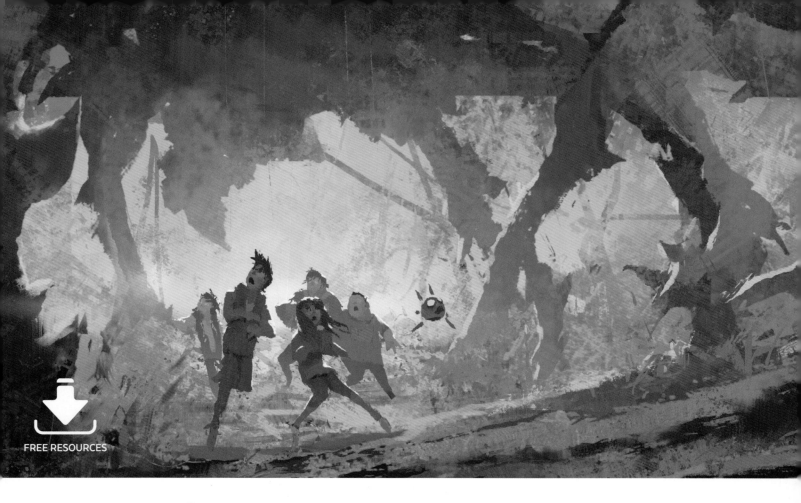

Narrative Art | *Monster*: villain

Zac Retz
Visual Developer
Software used: Adobe Photoshop

In this tutorial I will take you through the steps I use to create a narrative illustration. I will start with really loose and messy brainstorming sketches and move all the way through to color exploration and finishing details. I will be producing two separate illustrations based on a story about a gigantic monster attacking my characters. The first scene, which I will tackle in this tutorial, will be from the villain's point of view and the second scene, covered in the next tutorial, will be from the heroes' view.

In this first tutorial I will talk a lot about how I use Photoshop and the digital painting techniques that I use in my professional and personal work; in the next tutorial I will cover some techniques but will focus on other elements such as lighting and color. Between both tutorials I hope to give you a wide variety of information and talk about the important narrative devices I use to push the mood and feeling of a painting. I primarily work in film as a color key artist and environment designer so as I work I am always focusing on capturing the mood of the scene. I want the viewer to feel something when they see the image. This is important in any kind of illustration. If your artwork can evoke a feeling then you have captured your audience. In order to do this you need good color, composition, and design knowledge. I will share tips along the way on how to improve these principles in your own work. In the end you should have fun, be expressive, stay loose, and create your own original artwork that tell your own stories.

> "I think of the scene as a frame from a film where you can see more of what's going on. I start to ask myself, if this shot is in favor of the villain, what would the composition look like?"

01: Value sketching

This first stage is a lot of fun but also very frustrating at times. This step is also the

↑ I use grayscale sketches to develop an engaging scene that tells a story with value and shapes

longest step in the process, even though it may not look like it. For this painting I will focus on the villain view of the story.

My initial thought is to literally be looking out of the eyes of the monster, and pretend that I am the monster attacking the people. However, this seems a little too typical to me so I want to steer away from that approach. I think of the scene as a frame from a film where you can see more of what's going on. I start to ask myself, if this shot is in favor of the villain, what would the composition look like? How would the monster be framed in the shot? How would the people look compared to a threatening villain? I keep these questions in mind as I start scribbling ideas.

I say scribbling because that is literally what I am doing. I stay really messy and loose so that I am able to work almost as fast as my brain is spitting out ideas. I also shrink my canvas so it is really small on my screen and work on multiple sketches at a time. You may look at these sketches and not fully understand what is going on, and that is okay. At this point all I am trying to do is create interesting shapes and an engaging composition. It is important to have fun, stay loose, and explore lots of different compositions.

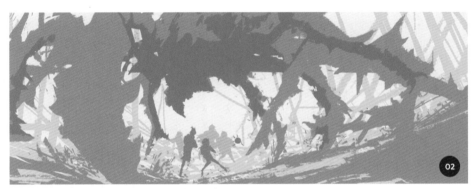

↑ I keep the energy of the original sketch but refine the focal point

> "It is important to use a hard brush or a brush with no opacity here. I personally like to use a hard brush that has a bit of texture in the edges just to keep that sketchy feel"

02: Finalizing the sketch

I pick my favorite sketch and blow it up so that it is the size and resolution of the final painting. Then I refine it. It is so important to avoid refining every bit of the sketch as I do not want every form to be perfect, every edge to be hard, or every spare pixel cleaned up. If you do this your image will become lifeless and static and you will not enjoy your new sketch as much as your initial messy one. You need to maintain the same energy as in the initial sketching phase.

To keep the life in my sketch I take a step back from the painting and look at what reads well. If an area reads well then I leave it. For example in this image I leave much of the background foliage and the legs of the monster. The important part for me is to figure out the poses of the people below the monster.

The silhouettes of the figures are very important in order for the action to be communicated successfully. I look up images of people running and playing sports for inspiration. It is important to use a hard brush or a brush with no opacity here. I personally like to use a hard brush that has a bit of texture in the edges just to keep that sketchy feel. Try to limit your values to two or three; you will find out the reasons for these preferences later in this tutorial.

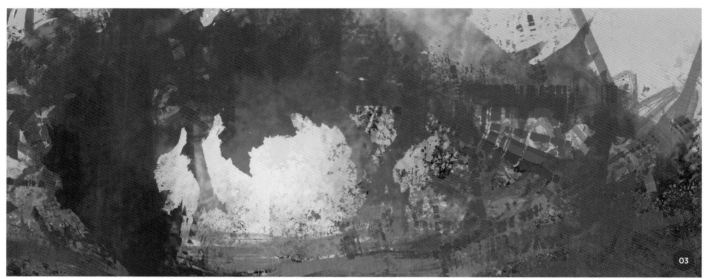

↑ I create a color palette where the colors relate to each other and work together as a whole

"As I put down colors, I let them mix and interact with each other. This is when interesting results occur... I am a big fan of happy accidents and letting the colors mix"

03: Texture and color

I keep stressing the importance of staying loose and in this step nothing has changed. I make a new layer and just fill it with the Paint Bucket tool. I think about the feeling I want to create in this image and just start throwing colors down.

I shrink my canvas so that it is very small on my screen and make my brush about the size of the canvas. I then just slap color down and experiment. Sometimes when I am doing this I will look up some of the old master landscape painters or I might keep an image search window open. This helps to expand my color knowledge and to come up with new colors that I may not have thought about.

As I put down colors, I let them mix and interact with each other. This is when interesting results occur. I make a brush (which is included in the downloadable resources for this tutorial) with a Hue Jitter setting that helps to give even more

⚡ PRO TIP

Texture

Use texture in your paintings to paint broken color and let the viewer's eyes mix the colors. This will produce a richer painting. Balance the texture with areas of big brushwork and little color or value variation. This balance between texture and no texture will create resting places for the viewer's eyes and other areas of interest.

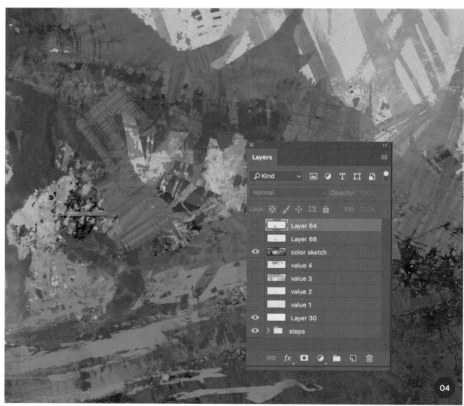

↑ Set up layers for an efficient workflow by placing different values on separate layers

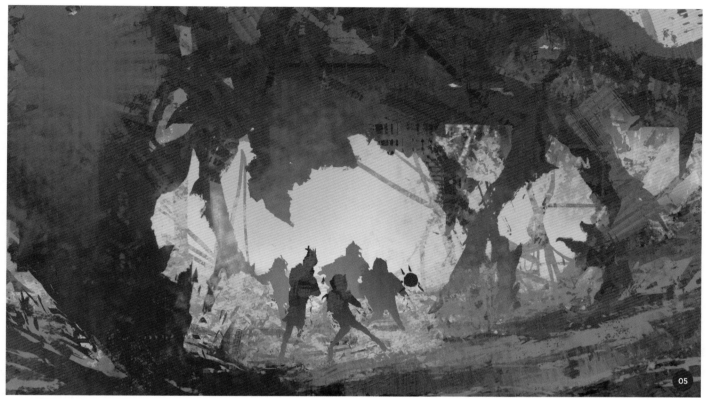

05

↑ I start to refine the focal point and keep the values grouped

variation. I am a big fan of happy accidents and letting the colors mix, and then color picking those "in-between" colors.

04: Setting up layers

Until this point I have not talked much about layers or any of the more technical parts of painting in Photoshop. I generally do not like to use many tools while I am painting. I have found that just sticking to the brush and some minimal effects or adjustments is best as it helps to maintain that more traditional painted look.

At this point I click off the color sketch layer and go back to my refined grayscale sketch. I then use the Magic Wand tool to select a value. Earlier I mentioned that you should sketch using a brush with no opacity. I do this so that when I go to select a value I select that whole shape. After I have made a selection I go to Select > Similar. This will select all of that value throughout the painting. I then make a new layer and fill that selection. I now have a layer with just that value on it.

> "When I block in the figures I think about the general values of them and keep them consistent and grouped. For example the foreground figures are a mid-to-dark value"

I go through and repeat this with each value I have. In image 04 you will see my layers labeled, "value 1," "value 2," and so on. These are all my values and above that is my color sketch layer. This may seem a bit confusing and strange but there is a reason I do it this way, as described below.

Now as I go back to working on my color sketch I can Ctrl+click on the thumbnail of the layers with the values on them to select the contents of that layer. As I hold down Ctrl over the layer thumbnail a little dotted box should show up. When I see this I click to make a selection. I make sure I am still on the color sketch layer as I make these selections. Now as I paint I can go through and select these shapes and bring some hard edges into my painting.

05: Focal point

Now I have a good sense of atmosphere, color, and value I can start to put some details into the focal point. I like to establish the background before I work on the characters. This way I know what the lighting will be like and how the colors will affect the figures.

When I block in the figures I think about the general values of them and keep them consistent and grouped. For example the foreground figures are a mid-to-dark value. When I start to add color, I will keep that value consistent; I will not put an extremely dark or a very bright light within that shape. I apply this rule to the rest of the value selections in the painting as well, at least to start with.

Keeping big shapes of value is very important in a painting. It allows areas for the eye to rest. So I block in the local colors of the foreground characters and leave the background ones lighter and pushed back with atmosphere.

06: Painting the full image

I continue to paint the environment at this point. I like to jump around as I paint so that I don't get caught up in too much detail in any particular spot and so the whole painting will grow as one.

I start to refine the monster, painting his shaded underside. I choose a warm red/purple to play off the warm ground. Then my color shifts to more of a yellow hue as I paint the light forms on the monster.

The fill light is yellow so I can sprinkle yellows into everything that the atmosphere will touch. I make the darker shadows warmer, and as they go back into space I increase the purple hues. You can see this happening in the legs of the monster in image 06. I do this to help push the depth of the image.

07: Foreground and depth

I start to add saturated color into the foreground. These saturated colors will bring areas forward, adding more depth to the image. As you look back into space in my painting you will see things becoming more similar to the color of the atmosphere. I do this to create depth. In the foreground I have red earthy dark areas so I push the red color more in the foreground to bring it towards the front of the image. These little tricks can instantly add more depth to your painting.

Focusing your detail is essential as well. Each illustration will be different so for each painting you do you need to make a rule for yourself. Where do you want the most detail to be? In this case I want the most detail to be in the foreground and further back in the image I will have bigger brushstrokes and a closer value range.

08: Fresh eyes

It is so easy to get in the zone and keep playing around with your painting until it is finished, but you need breaks. Every hour or two stand up and walk around the studio, take a step outside, or see what your friends are doing next to you. Your eyes need to take a break and look at other things for a while.

I like to take five- or ten-minute breaks. When I come back my mistakes jump out at me straight away and the positive parts of the painting are more evident. These ten-minute breaks will save you hours of messing time.

At this stage of the painting I come back the next day and instantly see that I need to add a brighter light behind the characters. This pushes the contrast a bit and makes for a stronger image. I also enlarge the figures and add in some rim lights on the monster. These are just a few small changes that instantly make the painting much stronger. So take breaks; set a timer if you want!

> "After finishing a part of your painting you can use this area as a reference point for the rest of the piece. You can then judge where you need to add details and where you need to lose details"

09: Characters

The painting is almost finished so at this point I need to make sure I define the area with the most detail and focus to bring it to completion. In this image that is the characters below the monster. I paint in the

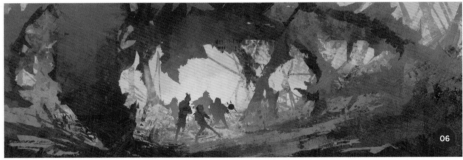

↑ I paint the image as a whole, jumping around and building everything up at once

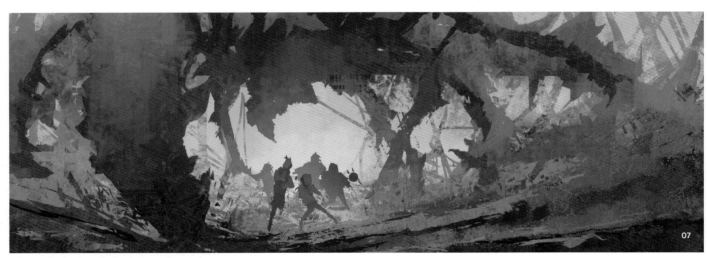

↑ I create depth using color, brush size, and atmosphere

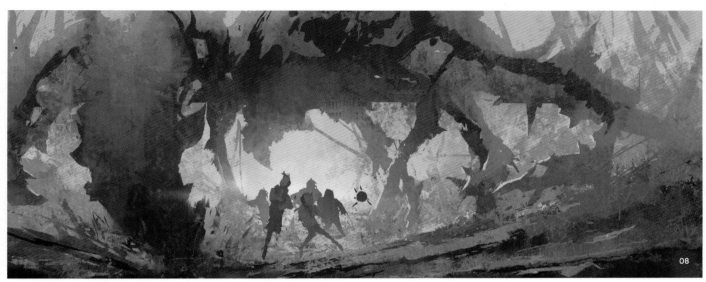

↑ Taking breaks throughout your painting allows you to come back with fresh eyes and easily spot what is working and what is not

characters in the background and finish detailing the foreground characters.

After finishing a part of your painting you can use this area as a reference point for the rest of the piece. You can then judge where you need to add details and where you need to lose details. After detailing the figures a bit I realize I want to paint into some of the foreground and blend some edges, and just break up some of the hard shapes.

10: Final touches

As I am finishing up, this is once again a good time for a fresh pair of eyes, so I take a break. Another thing I like to do is put Photoshop in Full Screen mode by hitting F on the keyboard, and then stand on the other side of the room. I feel this has a different impact than just shrinking down the painting within Photoshop. Flip your canvas horizontally and vertically too (Image > Image Rotation). I recommend flipping the canvas every ten to twenty minutes as you are painting. This falls into the same category as getting up and walking around. It just gives you a fresh perspective and you can correct your mistakes.

At this stage, I add a bit of atmosphere and lighting to the monster to bring it to a finish. The next tutorial will focus on the heroes in the story.

✎ PRO TIP
Character gesture
When you are drawing characters think about their overall shape, especially when they are in motion. The silhouette is so important. You should be able to tell what the character is doing from the silhouette alone.

Usually when I am drawing characters in a painting, I don't draw at all; I just block in the shape with a large brush. This way I get an instant read on the character pose.

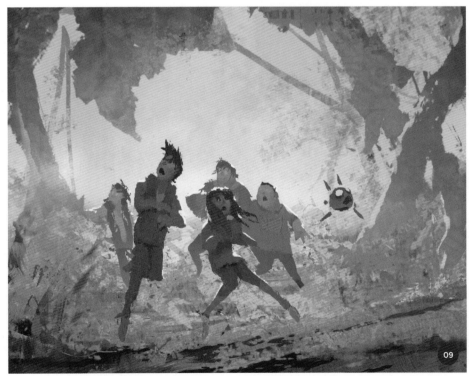

↑ When the image is nearly complete, finish the focal point to allow you to gauge the level of detail in the rest of the image

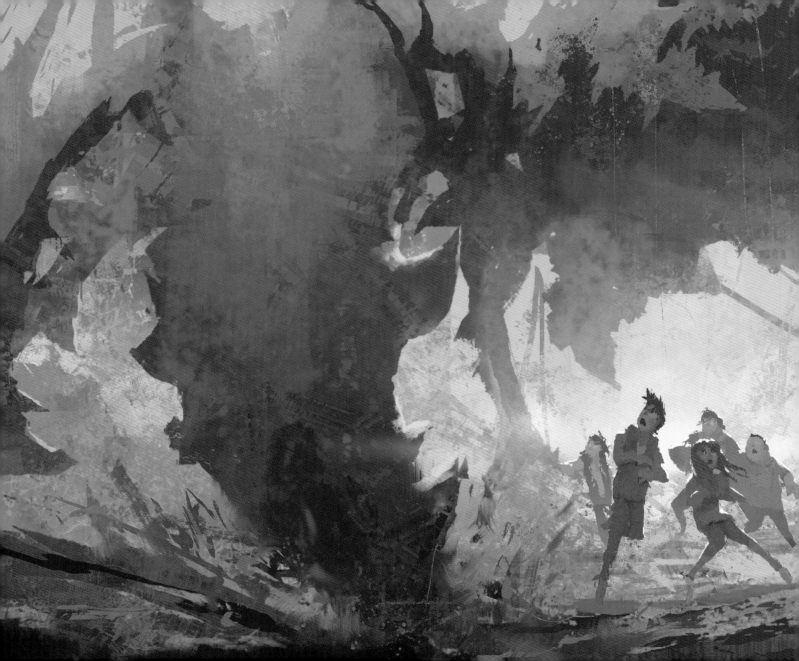

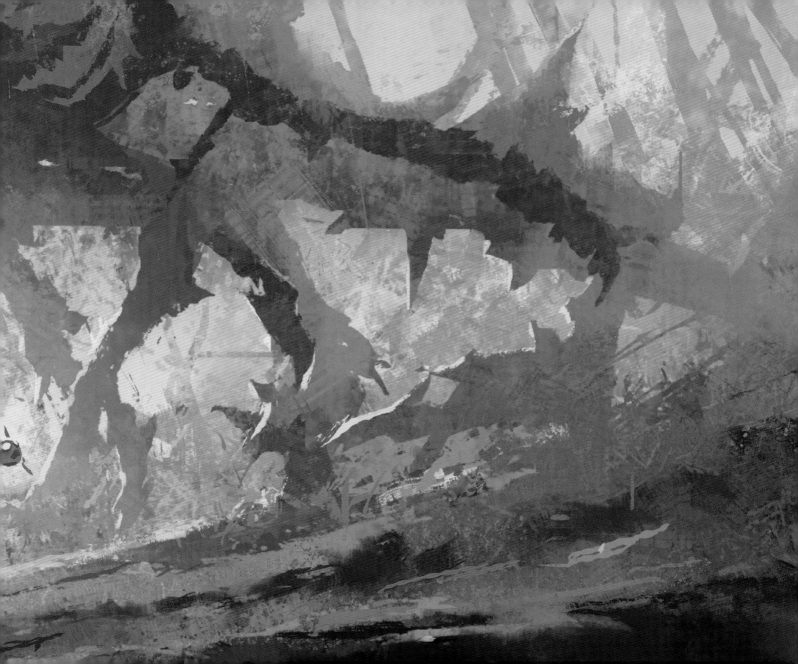

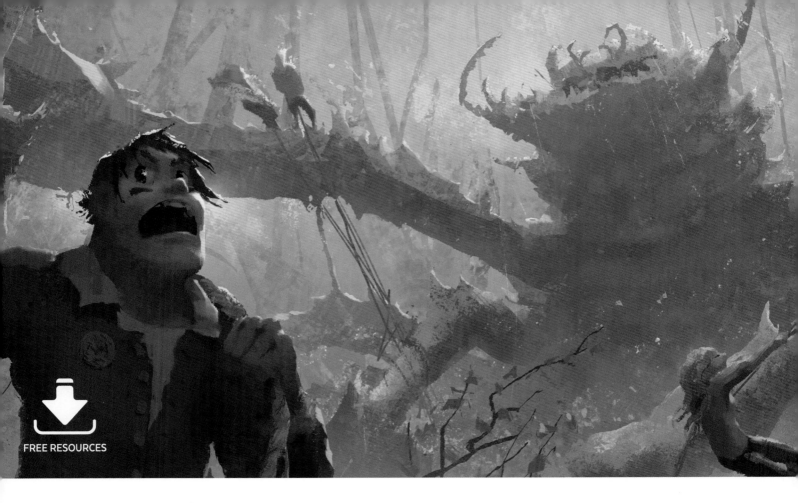

FREE RESOURCES

Narrative Art | *Monster*: heroes

Zac Retz
Visual Developer
Software used: Adobe Photoshop

In this tutorial I will take you through my painting process for a narrative scene from the point of view of the heroes in the story I began in the previous tutorial. You will see that this image is geared around the characters as they take down the monster. I will walk you through my thought process for sketching out dynamic compositions, adding color, atmosphere, and values. I will go into detail on how you can use colors in your paintings to help to push the story and evoke a mood. I will also talk about how to set up your lighting to push the readability of your concept further and go over how to set up a value structure that gives your image depth and makes a strong statement even at a quick glance.

In my previous tutorial I focused more on technique, whereas here I will go into more detail on why I make certain decisions relating to values, color, and light. I recommend you read both tutorials together to gain the full range of information.

01: Sketch

It is important when you are sketching to always try new techniques; never get stuck in ruts and always experiment. To overcome the trap of making the same kind of compositions, I switch up my approach to sketching ideas. Sometimes I start with just blocking in shapes with values, other times I will use more lines. In this case I start with some messy lines to create the gesture of the characters and overall environment. I then paint in some simple values underneath the lines. I find that I come up with different shapes than I would if I were to use purely values and shapes. This is a great way to loosen up and scribble out lots of ideas.

> "I will use this character to connect with the audience so I give him a scared yet determined expression because his friends are in trouble, something that I think most people can relate to"

22

↑ Constantly try different sketching techniques to avoid getting into creative ruts

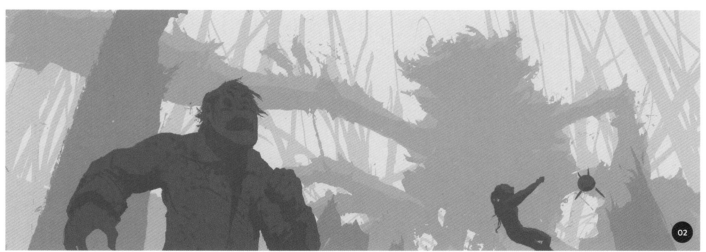

↑ I put the camera close to eye level so the viewer feels like they are a character just off screen

Another trick is to close your eyes and imagine the scene you want to paint, and while your eyes are closed start to sketch. By doing this you will create new shapes as your eyes will not be able to interfere with the direct translation of thought-to-hand movements. Try this and you might surprise yourself with the interesting shapes you come up with!

02: Refining the sketch

Since this painting is the heroic view, I want to favor the human characters more. From my initial sketches I pick the composition with the big foreground character. I will use this character to connect with the audience so I give him a scared yet determined expression

because his friends are in trouble, something that I think most people can relate to.

I also place him in the foreground and at a large scale to help push the depth. I put the camera close to eye level so the viewer feels like they are a character just off screen. By positioning the camera a bit lower than eye level I can also show the scale of the monster.

I set all the characters at different levels in the foreground, middle ground, and background. By doing this I am able to show movement and depth in the image. I do this with the trees as well so that I have a big foreground tree, middle ground stumps,

and distant background trees. It is all about the illusion of space, which creates depth.

⚡ PRO TIP
Film stills
Next time you are watching a movie, take screenshots of the scenes that interest you. Look for interesting lighting, colors, and composition. Then study these screen stills by breaking them down into three values similar to grayscale sketches. This will help you to see the big shapes that make these shots successful.

03: Perspective

Perspective is very important when creating an image and there are many ways to produce it. I use a very quick and simple method to create a perspective grid here. On the Tool bar I click and hold the Shape tool down, then select the Polygon tool. In the shape options I select 100 pixel width and height, 99 sides, check the Star option, and indent the sides by 99%. With this I will be able to create radiating lines which I can blow up and use to guide my perspective.

In this case I use one-point perspective so the vanishing point is far off the top of the screen. I like to keep this grid on a separate layer throughout the painting process so I can click it on and off whenever I want to refer back to it and double check anything.

04: Color

Now on to color. When I lay down colors I like the local colors to have a warm base or I paint a warmer version of the local color. This is because when I paint in the cooler atmosphere it affects the local color and replicates what happens in real life.

The purist color is when it is not affected by any other light source. As you mix in other lights an object's colors will become impure and have bits of atmosphere, or

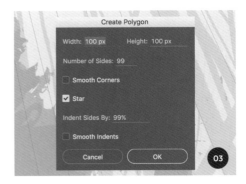

↑ A custom polygon is a simple way to set up one-point perspective guides

reflected light, in them. This is a little tricky to understand at first but if you keep this in mind as you observe the world around

↑ I use a warm base for the first colors to create a realistic effect later on

↑ I mix cool sky colors into areas that would be most affected by the atmosphere

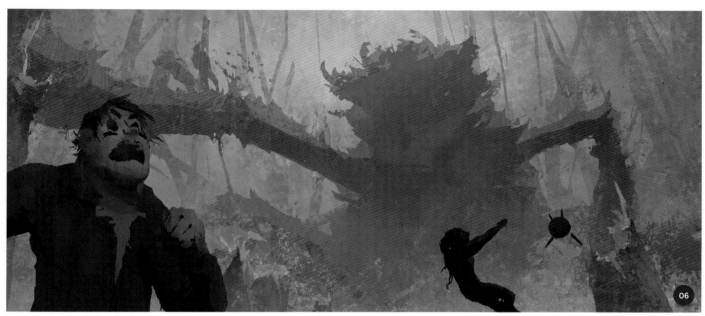

↑ I incorporate little bits of broken color that interact with each other to create a new color

you, it will start to make sense. I recommend that you do a lot of painting from life; go outside with your traditional paints or use your tablet at a coffee shop. The more you observe the more you will evolve your eye and understand how light and color should look.

> "My personal favorite is a brush that within one stroke has some variation of color and hue to it. This gives the effect of a traditional paintbrush with only partially mixed paint"

05: Color and atmosphere

It is important to create a sense of the color and atmosphere in your scene as quickly as possible. To do this well you need to keep in mind your values and color temperatures. I figured out the values of this scene in step 02 so I refer back to that image often. I find it helpful to take a screenshot of the value sketch and keep it open as I paint along with any references I have so that I can constantly glance down at them.

As for color temperatures, most of the time the sky or atmosphere will be cool, so when you paint in the sky you can start to see where else you need cool colors. I look around my painting and pick out the planes that are most affected by the atmosphere and

> ## ⚡ PRO TIP
> **Master and plein air studies**
> A great way to study art theory is to look up landscape paintings and portraits by the old masters and do quick copies of them. Look for the big groups of values first, and then block in the color. Keep these studies to fifteen or thirty minutes and do them every day.
>
> Painting outside is also an amazing way to study color and great training for your eye. I recommend that you paint on small-sized paper (3.5 × 4 inches) with a large brush. I like to use a 1-inch flat brush so that I can quickly block in a painting.

mix some of the sky color into them. This is when the magic starts to happen for me. The relationship between warm and cool colors really makes a painting come alive.

06: Texture and broken color

I like to get textural and traditional elements into my artwork. This is partly because it appeals to my personal taste, and partly because it is how I see and build up my colors. Most of my color knowledge comes from studying the landscapes of the old masters and portrait artists (see the pro tip above). I look at how they applied the paint, built layers, and how their colors interacted with each other.

I have produced hundreds and hundreds of master studies, learning what I can, and I trained myself to see color in different

ways. Sometimes it is a solid mass with little variation in it (such as the sky in my painting) whereas sometimes it has a lot of little broken fragments of color that interact with each other and as a whole they create a new color. This is where the texture element comes in.

I use brushes that allow me to lay down multiple brushstrokes while still seeing some of the color underneath. For example I use a brush that lays down a lot of speckles which gives the effect of broken color. My personal favorite is a brush that within one stroke has some variation of color and hue to it. This gives the effect of a traditional paintbrush with only partially mixed paint. It is a brush that I made and I have included it in the downloadable resources for this book, so please try it out if you are interested.

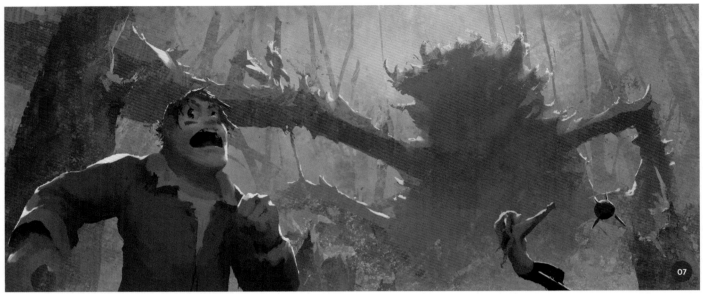

↑ I look for areas to add rim light as this will help to lead the viewer's eye around the painting

7: Light

Much of this scene is backlit so I place rim lights on the objects where the light bends around the surfaces. Looking for areas to add rim light to your paintings is a great way to help lead the eye around the image and also separate out some of the forms.

The brightest rim lights in my image are on the main character as he is the focal point. I want the viewer's eye to go to him first. I also paint the other characters in the middle and background at this point.

I feel happy with the colors and lighting in the painting so I know I am painting in the correct lighting on the figures.

> "Color can play a lot of tricks on the viewer so use it to your advantage. Red is an interesting color that can be shifted slightly in hue to create different feelings"

As I paint the characters I try to keep the values grouped. I want the main character in the foreground to have a large dark shape for composition purposes. You can always mess with the levels as you are painting to help keep your values close together, and I do this a lot. As I add in color variation and details, I sometimes get a little carried away and have too many value changes. I use the Levels tool to fix these values.

08: Mood

Creating mood in your painting is essential to successfully telling a narrative. I decide to create a fairly atmospheric environment so that

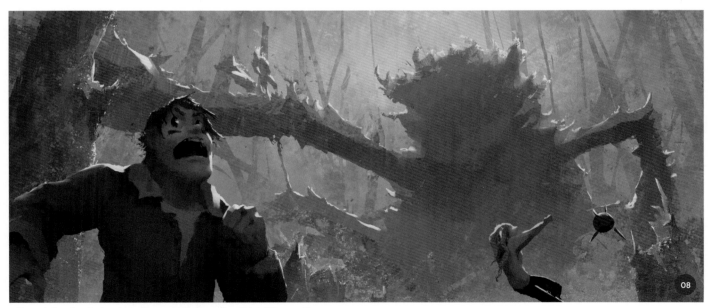

↑ Use variations in color to enhance the mood of your work and hint at the narrative

there is a subtle creepy feeling. This is because I want the image to focus on how the characters are about to win the battle against the monster. Adding too much fog or atmosphere would make the painting too creepy.

Color can play a lot of tricks on the viewer so use it to your advantage. Red is an interesting color that can be shifted slightly in hue to create different feelings. For example blood red suggests fear, while purple-red suggests passion, and orange-red suggests action.

Of course, how you use colors in relation to other colors can change the effect they have as well. It is important to look at your piece and check if you feel the correct reaction, and also ask your friends to look at it too. In this piece I want a combination of fear and passion so I use blood red and purplish hues. This way the mood is not too overbearing but there is a hint of both emotions to help tell the story.

09: Double checking
I mentioned earlier that I like to keep my value sketch handy. Looking back at my sketch now I realize that I should push the main character forward and the background further back. This will add more depth and

create a cinematic feel. It also pushes the monster back further into space, which makes him seem even larger.

> "Little fragments of light through the trees and particles in the air help to make the environment more believable"

When I am painting I like to think of the painting as a 3D space and consider how the space has layers to it. I think about repeating shapes that I can have throughout the painting. In this case I have both characters and trees that repeat from foreground to background. This helps to trick the viewer's eye into seeing this 2D image as a scene that could be walked into.

10: The finishing touches
As mentioned in the previous tutorial, when you near the end of your work make sure you take a break and walk around for a while. Then come back to your painting with a fresh perspective.

When I come back to this work I add some elements into the environment such as more branches and plants. I also add in the

crab monster's claws in the middle ground so that they are pointing towards the main character. This will help lead the eye to the focal point of the scene and create more movement in the piece. Little fragments of light through the trees and particles in the air help to make the environment more believable. I also add more detail to the monster's face, giving the painting a good second focal point. This completes the image.

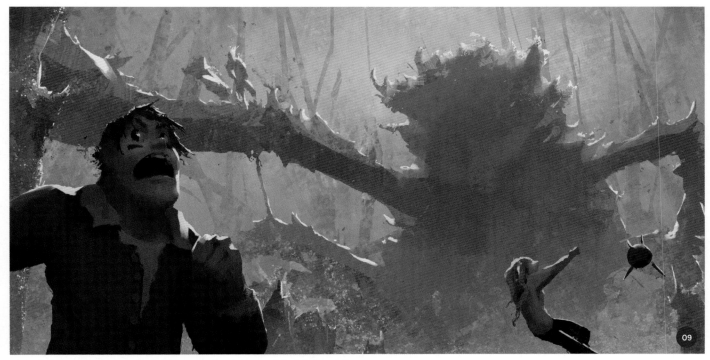

↑ I check the image against the value sketch to ensure there is a sense of depth in the painting

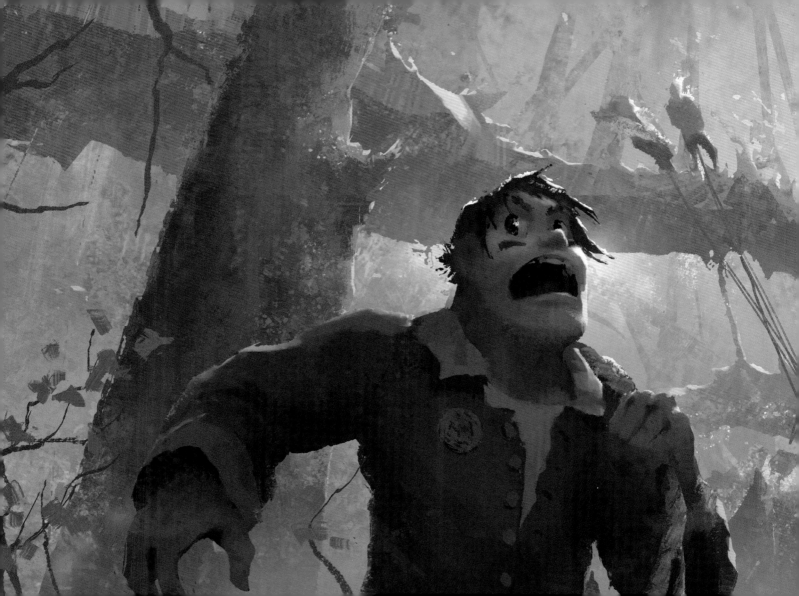

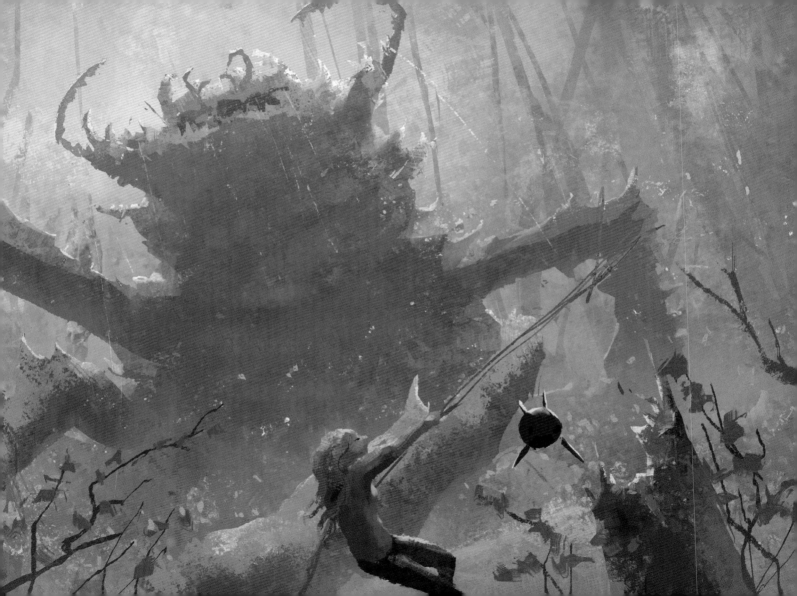

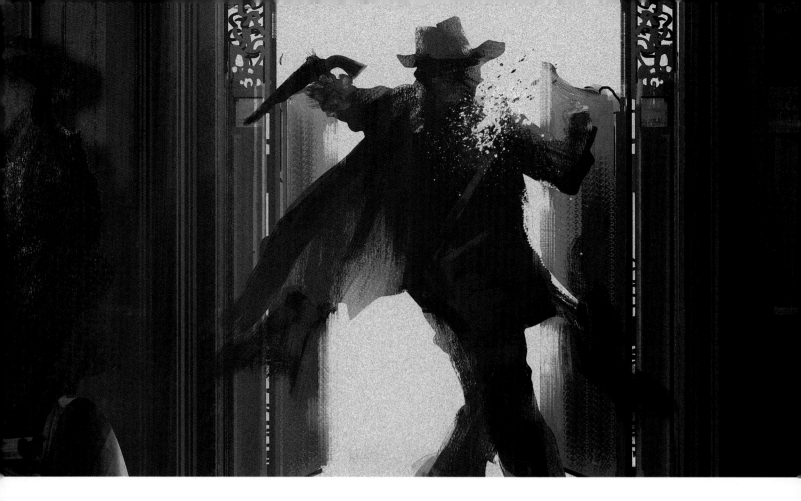

Narrative Art | *The Dead Dude*: villain

This project is about telling a story in two concept images, one from the point of view of a hero and the other from the point of view of a villain. The focus of this and the following tutorial is therefore about the process of creating an image which tells a narrative, rather than creating a highly polished and super detailed illustration. In my opinion, storytelling is one of the most important parts of an image.

The two tutorials will each show a different workflow. In this part I will show a more common way of creating a concept, starting with thumbnails and line drawing, then moving on to a value sketch. After that I will bring colors in and add mood and effects to the image as a final touch. I will capture the basic principles of each tool and how to use them in an efficient way. There are many ways to use tools in Photoshop and none is ever exclusively correct or incorrect, so it is really up to you how you use them, how you combine them, and especially the way you choose to create with them. My process steps will offer you interesting ways to use Photoshop's tools and show you how you can speed up your process too. Most of all I hope to inspire you to play around more with the tools that Photoshop provides.

01: Creating the thumbnails

When I received the brief for creating tutorials showing both a hero's and a villain's view of an illustration, the first thing that came to my mind was the old Wild West and a kind of high-noon scenario. But we have all seen those scenes quite a few times before so I asked myself whether there are any different ways to show such a scene. With this in mind I start to create thumbnails.

The thumbnails are hand-drawn with a brush pen on a simple sheet of white paper. You do not really need good-quality paper for this, since these small

Markus Lovadina
Senior Concept Artist
Software used: Adobe Photoshop

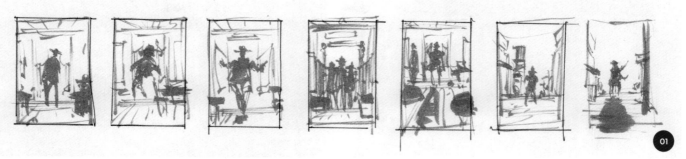

↑ From time to time it is really helpful to create a rough thumbnail drawing, either digitally or with pen on paper

sketches are just meant to help you get the first ideas out of your head. While I am drawing loosely, the idea of a saloon shooting scene comes into my mind. Such a setup has opportunities for lots of interesting details and has great potential for an interesting lighting scenario, too.

> "This step is just to help me introduce a bit more detail into the image. I am still focused on the setup of the scene at this point and not on the detailing"

02: Loose line drawing

My next step is to scan the thumbnails in a high resolution before producing a line drawing on top. The resolution of the scan does not really matter in this case, but I like to have a bit more detail on the thumbnails. If you use a low resolution scan and have to scale it up to fit your actual image size, you will get jagged, pixelated edges that are not easy to work with.

Now I create a new Photoshop file of about 3,000 × 4,000 pixels. I copy and paste the chosen thumbnail into the newly created canvas. The thumbnail is on a new layer and I reduce the Opacity setting to about 20%. Now I am able to focus on creating a more detailed drawing and use the thumbnail just as a guideline. For the line sketch I use the standard Round brush, set to Clear mode. This step is just to help me introduce a bit more detail into the image. I am still focused on the setup of the scene at this point and not on the detailing.

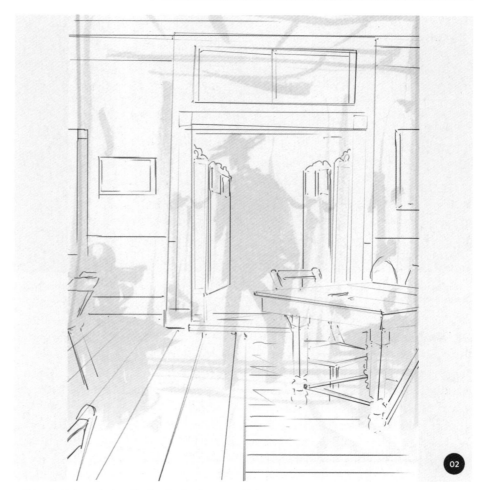

↑ Although this image begins with a line drawing there are multiple ways to start a painting, such as value sketches or jumping straight into blocking in colors

✎ PRO TIP

Thumbnails

Thumbnails are a really great way to get your first ideas down as well as to explain an idea to an art director or client. The size of the thumbnail does not really matter as long as it shows the idea and the composition. The medium is totally up to you; sometimes it is more fun to play around with pen and paper, and sometimes it is much faster to just work digitally.

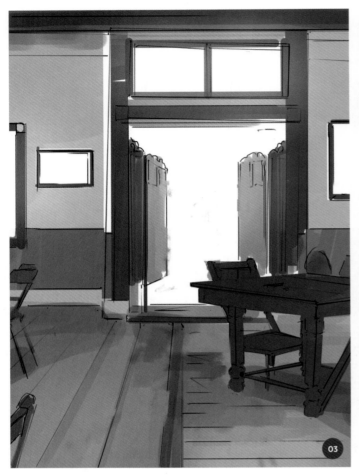

↑ Values are necessary to make sure your composition is correct. Here the elements closer to the camera are much darker than elements in the background

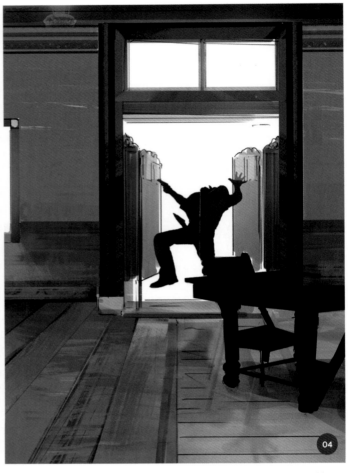

↑ I keep the colors simple within the first sketch, allowing me to work on the composition and lighting

03: Simple values

I will now add in the basic values for the image. I create a new layer (Ctrl+Alt+Shift+N) and move it below the line drawing. The layer of the line drawing is set to Multiply which gives me the option to paint my values without losing the line drawing. The values are painted with the same standard Round brush but I change the size regularly to match the area that I am painting in.

These values are still not meant to provide any details; instead they give me an idea of the lighting setup. For example, the door is pure white and this will therefore be my main light source. Depending on the light source of a scene, the values become darker the further away from the light they are. This effect can be seen in the final image on the table on the right-hand side. As the value tones are an indication of light or the absence of it, you can also use

this as an early opportunity to demonstrate the materials that items are made of.

> "Instead of just filling it with colors, I try to give a feel of direction and texture with each stroke"

04: First colors and texture

With the values finished, it is now time to bring in the first colors and work on the overall palette for the image. Since the story happens in the Wild West and the scene I have set up is in a saloon, I decide to use a brown-ish, green-ish palette, although I expect this to change slightly later as I work on the mood and lighting.

The way in which I add brushstrokes is most important here; it is more a way of modeling the structures instead of simply laying down

colors. A good example of this is for one of the boards in the foreground. Instead of just filling it with colors, I try to give a feel of direction and texture with each stroke. Those modeling strokes guide the eye and give a feeling of perspective early on.

All color is painted on top of the values and line drawing and, of course, on a completely new layer. The brush I use to apply the colors is a simple flat textured brush. I then create a new layer and draw a rough shape of a person with the Lasso tool. This will not be the final version, but it will work well as a reference for now.

05: Textures and light

Now it is time to merge all of the visible layers and work on light and texture. I like to use as many shortcuts as possible in order to save time. The shortcut for merging all visible layers

↑ Using a textured brush allows you to easily create structures and textures in your painting

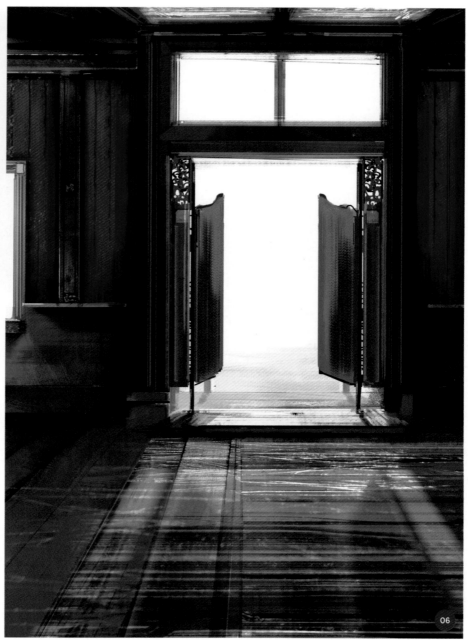

↑ Adding just a hint of detail to distant elements lets the viewer fill in the gaps

is Ctrl+Alt+Shift+E. After that, I create a new layer on top of the merged layer and start to focus on the texture and light. As you can see in image 05, I remove the shape of the person. This makes it easier for me to paint in the light sources, and to focus on the overall mood.

I duplicate the merged layer and use the Dodge tool to bring in a glow to the left-hand window. The Dodge tool is set to Midtones and at around 30% Exposure. The brush I use for this is a soft round brush. The next step is to create a new layer and paint in some thin brushstrokes to produce highlights on the floorboards. I use the same flat textured brush that I mentioned in the previous step to achieve these highlights.

Now I draw in the negative shape of the doorway with the Lasso tool. With the selection made, I choose the Levels adjustment from the adjustment layers menu on the Layers palette (the half-filled circle icon on the bottom of the palette). Adjustment layers are great as you can always go back and change the setting you have made if you are not happy with the result. Now I select the mask on the adjustment layer and add a Gaussian Blur effect (with a radius of about 3.0). This is just to make the edges softer. I repeat this step until the textures and light look correct.

06: More texture and details

The lighting looks correct so this is a good time for more details. Details can be kept loose so the viewer is able to fill out the blanks with their imagination. For example, the wooden wall planks just consist of darker vertical lines, but they effectively communicate the idea of wall-mounted wooden planks, which is all that is needed for this narrative-based image.

The same idea applies to the wooden pillar to the left of the door. I add a new layer, make a rectangular selection, and fill it with a darker value than the wall. Next I add vertical strokes to give the idea of carvings in the wood. If you take a closer look at image 06 you will see that the light source is close to the pillar, so I need a highlight there. With the same flat textured brush and on a new layer, I paint in a simple stroke. Next I use the same brush as an eraser and remove some of the brushstrokes. This gives the impression of an uneven wooden structure.

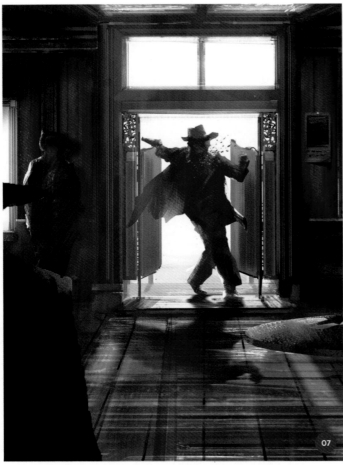

↑ I bring in the villain and people surrounding the area to create depth and mood

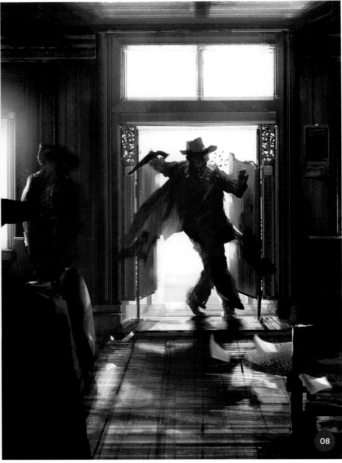

↑ Take a break more than once and return to your work with a fresh eye

07: Filling the room

The colors, light, and mood are all heading in the direction I want them to so it is time to bring in the story's villain. As mentioned earlier, this painting is all about storytelling and it is much easier if you have the story you would like to tell in mind.

In my case it is a simple shoot-out between the local sheriff and a villain. The villain enters the saloon and believes he could surprise the sheriff. The sheriff is prepared and expecting the villain so there is a quick shot and the "problem" is quickly resolved. With this story in mind, I know that the focus of the image lies in the doorway, so the main character in this image (the villain) should be placed there.

On a new layer I start to simply block in the shape of the villain entering the door. The pose I choose is dynamic as this underlines the narrative, so I give him a flapping jacket

and position his hands raised in the air. With just a black solid shape for the villain, I create another layer and a selection of the shape by clicking on the layer icon while holding down Ctrl. With a textured brush I paint in loose details and highlights.

Keeping in mind that this is image about storytelling and not adding in as many details as possible, I use the same method to paint a figure in the foreground and one on the left side of the doorway. All are painted on separate layers, which gives me the option to move them around and see where they are best placed.

With all visible layers merged I highlight the idea that this is a saloon by creating a table top using a round selection. I paint the table using the same brushstroke technique as I used for the figures, focusing on loose details and highlights.

08: Changing the angle

The room is becoming more crowded, and I have the villain in and at focus, so it is now time for a break. Taking a break from an image can really help you to see any issues that may have been created. After coming back to the image, I realize that the perspective is not quite correct so I merge all the visible layers again and duplicate the layer. By pressing Ctrl+T I transform the duplicate layer vertically and move it downwards. I keep the layer below visible to use as a reference as I paint in the roof. Basically, I use it to extend the light and shadow cast from the door and window, which helps the perspective issue.

I also adjust the gun in the villain's hand as I realize that a half-dropped gun would make more sense as the villain is being shot. Again, this is important to the storytelling element. Continuing to add details to the room, I create a new layer to paint in a chair on the right-

hand side. The chair is painted with the same flat textured brush as before. This does not need to be a fully fleshed out chair, it just needs to possess the elements that communicate "chair." By pressing Ctrl I make a selection of the freshly painted chair and, on the same layer, I paint in small value changes and highlights using small strokes.

After that and on a new layer again, I make a selection with the Lasso tool in the shape of flying cards, just simple bent rectangles. Keeping the light in mind I change the values between white and beige. I deselect the cards and add a Motion Blur effect to them. I have to play around with the settings and angle of the motion blur to get the effect I want. This adds to the sense of movement in the scene.

09: Color mood

I suggested earlier that my color palette changes slightly during my process; this is not in a general sense, but in a more subtle way in certain areas (image 09a). To change the colors and mood I use different tools: Photo Filter, Color Balance, and Selective Color adjustment layers.

Photo Filter is an effect you can imagine as a layer of colored foil that is on top of the image. The whole image is tinted, depending on the values. Color

↑ Changing the color on either a dramatic or subtle level can absolutely change the mood of your image

Balance is a filter effect which allows you to change the color values for highlights, midtones, and shadows.

For this image I will use the Selective Color adjustment layer, which offers plenty of color options to play around with by allowing you to change the values of each color separately. Depending on the color setting that you pick when you start a painting (CMYK or RGB), Selective Color allows you to change every color value for RGB or CMYK. If you take a closer look at the screenshots in images 09b–09d, you will see how the color values can

be manipulated with the sliders. As an example, the shadows of my painting are now more blue-ish in image 09a compared to the previous version in step 08. This is due to removing the yellow values for the black colors in the image.

The best thing to do here is to play around with the sliders to see how they work for your piece. It requires a bit of trial and error and an understanding of how colors work, but as soon as you become used to using the Selective Color effect it can be of great help in terms of manipulating the mood in your works.

↑ You can play around with the different colors separately using the Selective Color adjustment layer

↑ Reducing the Yellow and Magenta sliders for blacks and increasing the Cyan means the shadows gain a blue tinge

↑ To contrast with the blue tones of the shadows, black and yellow are increased in the red colors

> "The important part is the floor since it is there we have the biggest play between light and shadow. It also shows the light direction, which comes from the outside and flows inside"

10: Increasing the lights

The colors and mood have changed and you now understand how valuable the Selective Color tool can be. With everything in place, it is now time for me to adjust the lighting. As lighting is an essential part of this image, it absolutely makes sense to spend time making sure it is right. I merge all the visible layers and group all other layers. I like to keep all my layers in case I have to go back and change certain elements or in case I am not happy with something after a while.

Next I duplicate the layer and use the Dodge tool again, mostly on areas around the window, door, and floor. With 30% Exposure, I am able to slightly change the intensity of the brightness. Brushstroke after brushstroke, the light becomes more gleaming. The important part is the floor since it is there we have the biggest play between light and shadow. It also shows the light direction, which comes from the outside and flows inside.

To add a bit more glow to the window and door, I create a new layer and add round gradients around those areas. I then play around with the transparency and layer effects such as Soft Light and Overlay. I settle on Soft Light and 100% Opacity for this image.

11: Final touches

With the image almost complete I make sure that I am able to check-off all the things I was hoping to achieve at the beginning: storytelling, character, mood, and good lighting. I am happy with all of these elements.

My next step is to flatten the whole image and create a new layer on top. This layer is just filled with a solid white color. I then go to the top menu and select Filter > Noise > Add Noise. Adding noise is a bit time consuming as you have to make sure it is right. Too

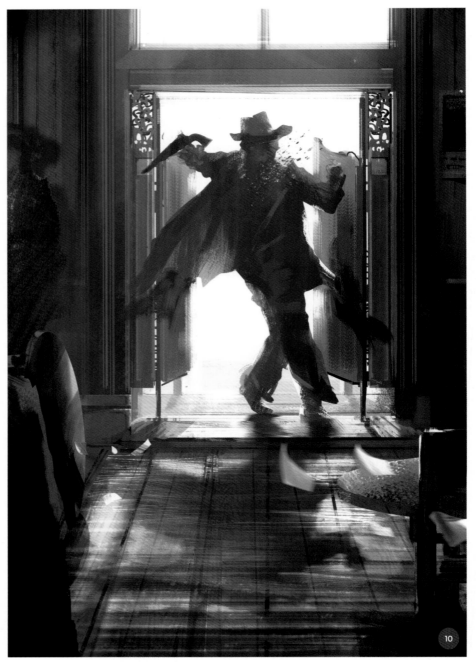

↑ I spend extra time perfecting the lighting

much noise and the image could look a bit strange, but too little and the noise will do nothing at all. Most of the time I use Uniform and about 15–20% for Intensity. Viewing the image at 100% gives you a good impression as to whether the noise is too much or needs adjusting. Once done the layer is set to Multiply and all layers are flattened again.

One of the final effects I add to almost every image of mine is the Sharpen filter (Filter > Sharpen). If needed you could repeat the effect by pressing Ctrl+F, making sure that it is not used too much as this will create extremely crispy edges.

In the next tutorial I will show you how I create the second part of this scene and will offer a different take on how to create a narrative-driven image by using the villain painting as a base for the color, lighting, and mood.

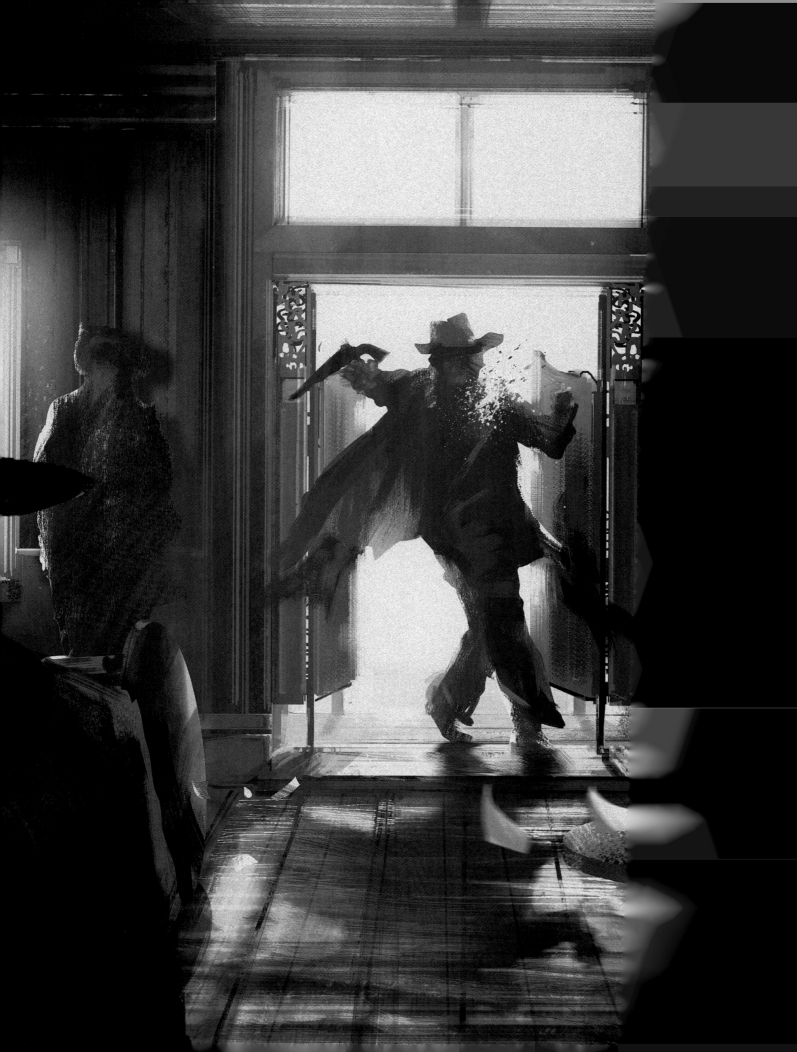

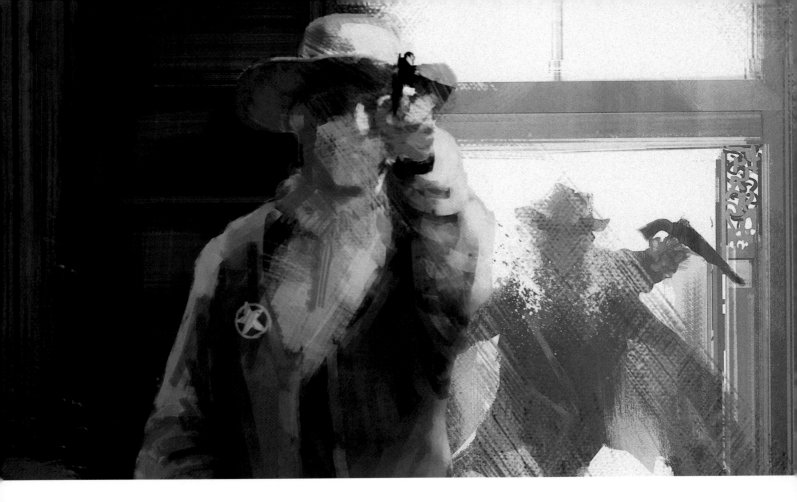

Narrative Art | *The Dead Dude*: hero

In this tutorial I will explain how to create storytelling artwork by reusing a past scene (in this case the image of the villain from the previous tutorial) and modifying it to fit a different aspect of the narrative: the hero. The method I will use is very simple because once again this tutorial is more about the story aspect of the images rather than creating a highly detailed illustration.

You will find that some of the steps are the same as in the previous tutorial, and some are different. While the previous tutorial focused on a more "classic" way of creating an image, this tutorial will focus on how to use an existing image. The benefit of reusing an existing image is that it gives you the ability to create a new painting while keeping the most important information from the original: mood, story, colors, and lighting. Since both images are tied together, it makes sense to have huge similarity in these aspects. Nothing would confuse the viewer more than a different

color mood or a totally different setup. Both images should be recognizable as part of one world or, better said, one story. Both paintings have to work on facing pages, depending on the story, and therefore they have to speak the same visual language.

01: Thumbnails

If you return to image 01 in the previous tutorial you will see that when I started the thumbnails for the villain image, I also drafted out some initial thumbnails for the hero on the right-hand side. This is a good way to compare two images early on to see if there is anything that might need changing in the first thumbnail to make it work for the second image. It can be especially useful to do this if you are creating sequential art.

The most important part of this step is the way you tell the story. What will one character see and how will the view of a second character be affected by the event that happens in the previous image? As

Markus Lovadina
Senior Concept Artist
Software used: Adobe Photoshop

with the first batch of thumbnails I use a brush pen and redraw the scene from the villain's point of view, based on the initial thoughts I had on page 31.

02: Motion blur

Consistency is the main thing I have to remember for this second image. Since the villain is being shot inside a saloon, the hero should not be on the street or on a horse; he has to be in the same place.

As I have already established the look and feel of the interior it makes sense to reuse the villain image. I copy the final image from page 37 and create a new file in Photoshop (Ctrl+N). I use the same high resolution and the same aspect ratio of 3,000 × 4,000 pixels. I then paste in the painting and duplicate the layer by pressing Ctrl+J. I keep one version as it is, as I know that I will reuse certain areas of the painting.

Next I apply the Motion Blur filter to the duplicated layer. The filter is set to Angle 90 degrees and a distance of about 250–300 pixels. This is blurry enough to start afresh, but still has all the necessary information essential to the feel of the new image.

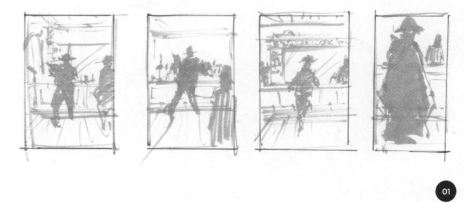

01

↑ I sketch thumbnails for the new image using thumbnails from the first image as reference

02

↑ Using the Motion Blur filter on the previous image maintains the mood and colors, but also gives a fresh start

⚡ PRO TIP

Keeping sketches and paintings
It is always a good idea to keep your paintings and sketches on your hard drive. They may be rough, unfinished, and far from good, but some of those sketches will have useful textures and shapes. These could become quite handy for any other painting you do.

Copy and paste the sketches into your painting and play around with layer effects such as Soft Light, Color Dodge, Darken, or Luminosity. These effects, combined with your sketch and the actual painting, can bring your work to a totally new level. If it doesn't work, just use another or keep painting.

↑ Reusing parts of the original scene speeds up the process and keeps important information consistent

↑ I use the Rectangular Marquee tool and a textured brush to create a mirror, reflecting the original scene

03: Reusing parts

As I mentioned in the previous step, I will reuse certain areas of the non-modified image. In this case it is the floor. I select the lower part of the floor on the original painting and duplicate it. Ctrl+J copies the selected area on a new layer and in the exact same location. With the floor in the same location I do not have to worry that my camera angle is wrong or that the perspective will not match. It is like turning a camera around 180 degrees.

04: Knowing your scene

When you create a scene, especially an interior scene, you have to make sure that the setup is correct. As this is a saloon scene, I need to decide how to make it believable. After spending some time researching the web for good references I know that there are a few common features required:

a huge mirror in the back, a bar counter with a wooden pattern, and of course lots of bottles. With these features in mind, I create a new layer and start to roughly paint in the back part of the counter.

The mirror and wooden frame structures are made using the Rectangular Marquee tool. The selection is then filled with a flat textured brush. You can see the texturing on the left-hand side of image 04. The brush I use is part of Jama Jurabaev's brush set and has exactly the right texturing to keep the painting loose and textured at the same time.

As for the mirror, I just paint in a simple rectangle on a new layer and duplicate the original image once more. Then I scale the image down to make it fit into the mirror. Clicking on the mirror rectangle layer while

pressing Ctrl gives me a selection of the mirror. With the selection active, I switch to the newly duplicated original image and create a layer mask. To make a mask, simply click on the rectangle icon with a cut-out circle at the bottom of the Layers panel.

05: The counter

The next step is to paint in the counter, which is a main piece in the scene. I now create a new layer and again use the Rectangular Marquee tool to draw a selection.

When working on a counter you have to make sure you know how the material works for different parts; the upper area is quite polished while the lower part is more rough and structural. This knowledge gives me enough information on how the light bounces off or is absorbed by the material to detail the counter appropriately. Since the upper part

↑ Always start with rough blocky shapes and work your way to details later on

↑ Creating depth is an essential part of the process, especially if you are working on a centered composition

↑ Just give hints of information and let the viewer fill in the blanks to encourage exploration of your artwork

of the counter is polished, the light will be highly reflective and needs a harsh highlight. The lower part of the counter is more light-absorbent so it only requires subtle highlights. A good way to start painting large elements like this is to start quite blocky and work your way to fine details. If you start with the details you might lose focus.

06: A few details

The next step is to create depth in the composition. Adding people, or the shape of people, to the background could easily create depth in the painting. Another good way of adding more depth is to paint in building structures. As you can see on the left-hand side of image 06 there is an arch. This could be an entrance to another room or just a sitting area. A loose shape of a person creates a sense of depth through the arch. The arch is painted using the Elliptical Marquee tool. This time I do not need a new layer as I just have to paint in darker areas, using the same brush as before, to give a sense of shadow.

Now I create a new layer and form the shape of a person on the far right side with the Lasso tool. I paint in dark values and work my way to brighter values to give volume.

I keep all the elements simple, as the focus will be on the hero character later on.

I merge all visible layers, and then on the same layer I make a selection with the Rectangular Marquee tool around the left side of the mirror, where there will be a shelf. With the textured brush I paint simple strokes from left to right to give hints of wooden planks.

Using the Color Picker I choose a brighter color for the edges of the shelving. Don't forget to add shadow to create depth!

07: More details

Since the counter is just a flat surface, it is time to bring in some more details. As I mentioned in step 04, research can help you create a believable location with appropriate

props. After a few more minutes of research online, I find that almost every counter has a few decorative details. Some are just made from different types of wood and some are enriched with ornamental embellishments.

I create a new layer and use the same textured brush as before in a small size of about 10 pixels. With the Shift key held down I can get straight lines which are exactly what I need. I start painting from left to right and top to bottom to create a rectangular embellishment. With a darker color I repeat the same strokes and add shadow. Then I duplicate the layer and move it towards the left.

On a new layer I create a vertical rectangular selection and paint in the banks between the embellishments. The strokes are made from top to bottom to communicate the impression of wood and, after that, from left to right to add more decoration onto the banks. On a new layer I make a brushstroke from left to right, again with a small brush size. Below that stroke, I add another in a darker color. Holding the Ctrl key, I click on the same layer and make a selection of the layer content. With a much smaller brush size and the color white I add highlights on the metal bar. This step is about adding hints of details to sell the narrative without being too elaborate and meticulous.

08: The hero

It is time to add the main element of storytelling in this scene: the sheriff. On a new layer and with a simple round brush I start to paint in the silhouette of the sheriff. In this very first step it is just the shape that counts; if you can read the action in the shape, you have done a great job so far. If you take a look at the silhouette in image 08a you can already see that the figure is pointing a handgun in the direction of the villain.

Based on this shape I start to paint in rough details with the textured brush I mentioned in step 04. Again, it is not about creating a highly polished version, it is about the storytelling. With this in mind, I add more loose information by modeling the structure of the character instead of adding fine details. All these loose elements are painted on a separate layer so I can easily adjust anything that I am not satisfied with (image 08b).

As mentioned in the previous tutorial, I like to keep all my layers and create separate layers for all elements. I think this is a habit that I have kept from matte painting where you really have to keep everything on separate layers. Besides that it always allows me to go back and forth without being forced to paint over my entire image.

09: Adjusting brightness

With the shape and some details in place, I find that the level of brightness is not correct, especially considering the sheriff is facing a light-flooded doorway. I group all the layers of the sheriff and merge them into one layer. I set this layer to Color Dodge.

The Color Dodge effect works simply by increasing the brightness of the layer below based on the existing values. If you have to adjust the brightness and would like to keep the original version, press Ctrl+L. This will bring up the Levels correction tab and you can now modify the brightness, midtones, and shadows. Adjusting the brightness works fine in this case.

On a separate layer again I create a simple leather vest for the sheriff. Since I have already established the light and shadow direction it is easy to paint in the darker areas for the shadows on the vest.

10: More light

Considering the light-flooded doorway setup of the previous image and the fact that the image in this tutorial is part of the same setup, I need to make a brighter floor and match the lighting scenario of the two paintings more. With the Rectangular Marquee tool I select the

↑ I paint a character silhouette with a simple round brush, focusing only on the shape

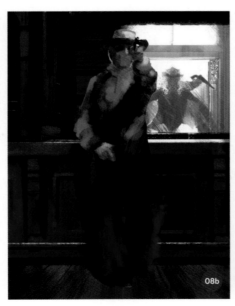

↑ Painting on different layers gives you the opportunity to go back and forth until you are happy with the shape

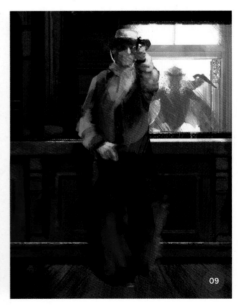

↑ You can brighten up areas of your image with a Color Dodge layer effect

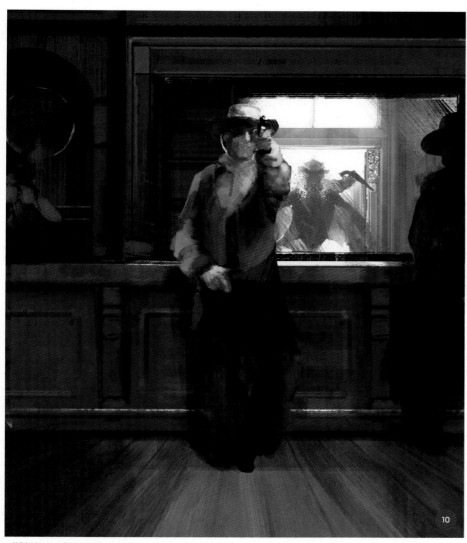

↑ With the Levels correction tab you can easily adjust the brightness or darkness of certain areas or the whole image

↑ Flipping the canvas allows you to get a fresh view on your image and spot any issues

⚡ PRO TIP
Colors

Colors are such an important part of a painting. There are many ways to play around with colors and the way colors change the mood of a painting. Here I only describe a small number of ways but there are many, many more.

One thing is for sure: you have to have a really good understanding of light and color to push your work. So go out and study all and everything with a keen eye for detail. Everything you need to know is out there!

shape of the door based on the first painting, then click on the half-filled circle at the bottom of the Layers panel and select Levels. In the Levels window I can easily change the values for light, shadow, and midtones.

In this case adjusting the lights will do the trick. Since this effect creates a new layer with a mask, I am still able to make finer adjustments. Either way, by painting in the mask or changing the values again, you can change the light situation really flexibly. Here I paint over the mask with the textured brush and pure black.

11: Flipping the canvas

From time to time it is necessary to flip the canvas. First off it refreshes your eye and second it allows you to see any flaws that might have sneaked in. In my case I find that the floor is too high so I move the entire image down (press V for the Move tool) and transform it slightly in height. Using Ctrl+T and holding down the Alt key, I am able to transform the layer in both top and bottom directions equally. I then have to paint in the ceiling as there is a gap. Duplicating a part of the floor functions as the ceiling as it is flipped vertically.

Using the same Levels correction method as I used for the light in step 10, I bring in the shadow of the villain on the floor.

If you would like to have the same consistent shape for the shadow, open the previous PSD file and copy and paste the shadow in – another good argument for keeping layers separate!

12: Filters and effects

The next step is to add a green photo filter. This effect changes the overall appearance of the image and is much more in the direction I think is appropriate. I flip the canvas back to the way it was before. Again, I double check if I have made any mistakes but the changed composition feels better so I continue to add more details. Most of the details are on the back of the counter (close to the framed mirror).

The next step (and a step I like to make quite often) is to duplicate the initial Motion Blur background and use Motion Blur on it again. I set the layer to Lighten and reduce the Opacity setting to about 10–15%. Again, this is something you have to play around with to make it work for your taste.

I also need to make the sheriff a keeper of law as he is the hero facing a villain, so I add a simple sheriff's star to his chest to indicate this.

13: Final touches

With the painting almost complete, I decide to add more color variation to the entire image. This time I use the Color Balance tool to do this. There are two ways to use the Color Balance effect. One is to use the effect straight on the final painting by pressing Ctrl+B, and the other is to use it as a layer effect. I prefer to use the layer effect most of the time as it is slightly more flexible and allows me to alternate my colors quickly.

With a layer effect on top, I increase the number for green and blue to get a more green-washed look. On a new layer I use the Gradient tool to darken the edges of the painting, adding to the shadowy feel of the inside of the saloon. As the gradients

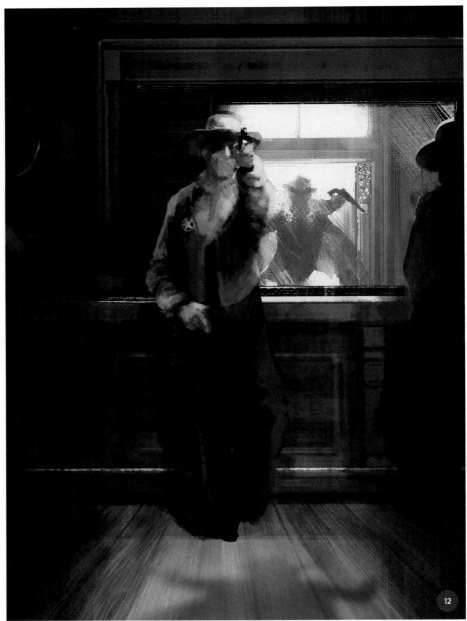

↑ I create structure with the same blurred image and different layer effects

are on a separate layer, I reduce the opacity to about 60–65%. This value is dark enough, but maintains the small details.

For the final adjustments I create a new layer with a solid white fill. I go to Filter > Noise > Add Noise and select Uniform with an intensity of 15–20%. Happy with the look, I merge all layers to one background layer and add a final Sharpen filter. A good alternative for the Sharpen filter is the Unsharp Mask filter. Of course, you have to play around with the settings to discover

a result to your liking, but I find that the following setup works well: Amount 50%, Radius 1.0, and Threshold 0.

You can see the final image on the next page. Hopefully over this and the last tutorial you have found some insights and settings which will be useful for your own painting process. Again, this is all about storytelling, but if you use some of the techniques described here, I am certain there will be plenty of lovely details in your panting.

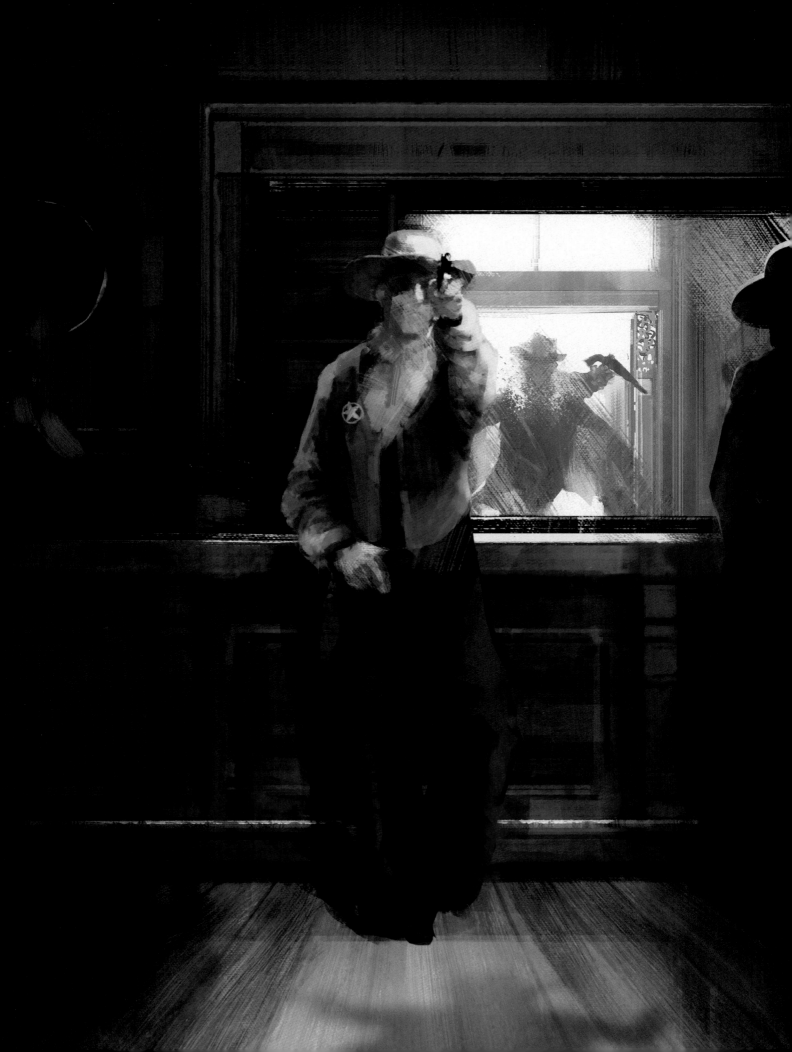

Matte Painting

Predominately used in the film industry, matte painting is the art of developing a realistic-looking environment. Often matte paintings are constructed from carefully manipulated photographic references and textures with digital painting techniques used to clean up or paint over any areas which need correcting. In this chapter three experienced professional matte painters demonstrate in detail their different approaches to producing atmospheric scenes, covering the subjects of a futuristic shipwreck, a bustling urban fish market, and a sci-fi wreckage. Over the course of these projects you will learn how to manipulate, adjust, and paint photo references to create imaginary environments which appear real.

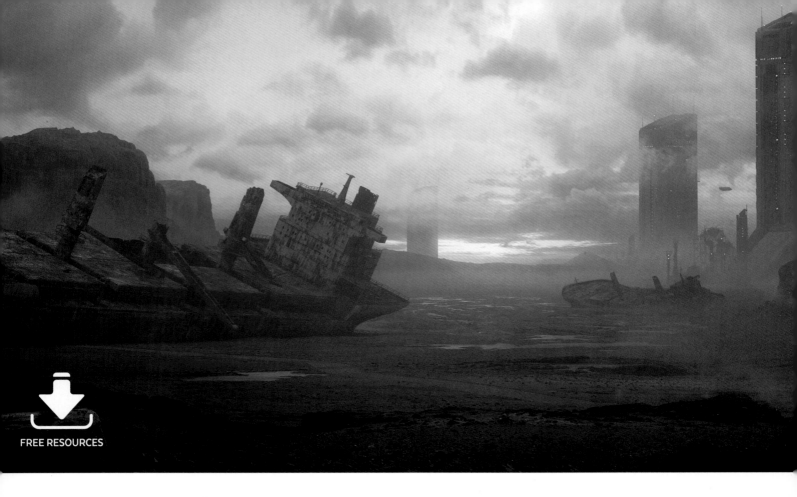

FREE RESOURCES

Matte Painting | Futuristic shipwreck

Have you ever wondered how those amazing landscapes, futuristic cities, and fantastic worlds come to life on the big screen? It's called movie magic! Matte painting is what I would call movie magic at its best, and that's why I love it. With today's technology, a matte painter has the possibility of creating an entire shot all by themselves and see their work directly in the final film.

Matte painting combines different skills and techniques, but in my opinion matte painters are first of all filmmakers. Their process is linked to filmmaking as their goal is to create a perfect illusion of an environment and to integrate it seamlessly into a sequence. You can use matte painting techniques to create a standalone image, but if you work in films it is important to pay attention to the fundamentals. These fundamentals include cinematic aspect ratio, realistic lighting, composition, moving elements, camera exposure and lens, and many more factors besides.

Matte painting can have various types of applications but here I will focus on a case in which the camera is stationary and I am given a frame which I can paint over in Photoshop. I will show you how to transform a plate (a base photo in this case) into an epic matte painting using a variety of 2D and 3D techniques that are used in today's industry, so that you too can create your little piece of film at home.

01: The plate

The art director has provided me with a frame of the film and the brief, and it is now up to me to transform this plate into a matte painting. The first thing I want to do is adjust the size and aspect ratio. I will work at twice the film resolution and in 300 dpi, which will give me plenty of details. I create a new 4,096 x 1,716 pixel document and paste my plate into it (this one is from www.textures.com). I also decide to flip the canvas. Then I adjust the position of the plate and this results in image 01.

Steven Cormann
Matte Painter
Software used: Adobe Photoshop, Autodesk Maya, Chaos Group's V-Ray

↑ The base photo that will be transformed into a matte painting. Photo source: www.textures.com

02: The brief

I am aiming for a futuristic scene and have chosen to go for a very dark, post-apocalyptic, deserted mood, something between *Alien*, *The Matrix*, and *Mad Max*. The face of the Earth has been changed by a disaster caused by human activity and the remaining humans live in tall dark buildings while a few outcasts are forced to live in the wasteland, inside shipwrecks and other ruins.

The shot will show a huge cargo shipwreck with the buildings in the background. I gather as many references and stock images as possible. I recommend you go outside with your camera, watch films, and look at books and anything you can! As this is commercial work I make sure my images are all copyright-free references sourced from **www.textures.com** and Wikimedia Commons (**https://commons.wikimedia.org**).

03: The concept

Once I have my references, as well as an idea of the mood and kind of scene I am going for, I find my composition. I feel it is better to stay rough and not set things in stone, but that is also up to you.

I prefer to keep things extremely simple; there is no point in doing a detailed sketch

↑ Some of the references and stock photos that will be used as a guide throughout the process. Sources: Boats (Wikimedia Commons); industrial building (www.textures.com); cloud (www.textures.com); landscapes (www.textures.com)

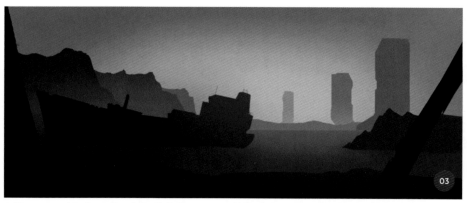

↑ A loose concept for the matte painting that will serve as a guideline, but can always be subject to change

because everything is going to be replaced by photo elements, 3D, and painting. My only goal here is to find a composition. I know it is not a particularly attractive drawing but I don't want to lose time focusing on something else at this stage.

04: Starting the matte painting

First I am going to clean the plate and correct the color of it. The cleaning part is easy; I just need to get rid of some of the human-made

⚡ PRO TIP

Watch films

As I said in the introduction of this tutorial, matte painting is a part of creating movie magic, so being in love with cinema and having a solid knowledge of it is quite useful in my opinion. If you want to master the cinematic look, it is important to study a little cinematography and photography. If you master subjects such as ISO (this indicates a film's sensitivity to light), aperture, and focal length, you will have a strong advantage in this industry.

↑ The plate has been cleaned and color corrected to fit the mood of the brief

↑ The sky is masked out using a selection from a duplicate of the blue channel with a pushed contrast

↑ A quick, rough under-painting of the new sky which will be used as a base

↑ The sky photos are roughly placed in the painting and color corrected

elements except for the road. I use the Clone Stamp tool to do this. Then I color correct the plate by using the Curves and Color Balance adjustments. I desaturate it, darken it, and then push some blue and cyan in the shadows and midtones. I keep adjusting until I get something similar to my concept. I make sure I look at my references and constantly have them on my second screen while I work.

05: Masking the sky

Masking the sky is one of the most common tasks of a matte painter. First, I get rid of the original sky. There are many ways to do this. Here I duplicate the blue channel

in the Channels panel, push the contrast by using Curves, and paint over a little bit in black and white until I get that perfect contrast between the sky and ground. Then I Ctrl+click on the duplicated channel to select the white area, invert the selection, and create a mask on the plate layer.

06: Replacing the sky

Now I need to create a brand new sky for the scene. First I create an under-painting on another layer with a large soft brush, just to get the basic colors. This will serve as a base on which I can blend my photos. There is no need to spend a lot of time here

as I can always change it according to the photos I am going to use if I feel like it.

07: Adding photos

I now bring my sky photos on top of the under-painting. I try to not use too many photos as the more photos that are used, the more complicated it will be to join everything seamlessly.

I mainly use two photos here. I place them where I want them to be and color correct them as in step 04 to make them match together and also match the under-painting. Once again, I try to keep it simple.

08: Blending the photos together

I mask out the parts of the photos I don't want, which exposes some of the underpainting, and join everything together with painting. I use a large soft brush or cloud custom brushes to do this. I also decide to add a sun as it will make the image more interesting.

Since the clouds are going to be low, I paint some on top of my plate to cover the mountains a little bit. I also start to add some haze on top of everything, again, simply by painting.

09: Adding rocks

Now I bring in some of the rocky hills according to the earlier sketch. It is important to choose photos that have a high resolution (300 dpi) but that also have neutral lighting. I do not want any details lost in harsh highlights or strong shadows, especially for the kind of mood I am going for here. I want to light these photos to fit my needs rather than be restricted by the photos. This is basically where a knowledge of the fundamentals and your eye will be important.

10: Adjusting the rocks

Once the rocks are in place I reshape them a little bit, color correct them, and then add a Color Overlay effect to adjust

⚡ PRO TIP
Learn multiple skills

Try to learn some compositing skills. For example, if you are able to composite your own shot, your colleagues and art director will definitely appreciate it. It is also very rewarding to be able to bring an entire shot to life all by yourself.

The same goes for 3D; it will definitely benefit you greatly if you know some 3D. Maya and NUKE are used in a lot of VFX companies but not everywhere, and the preference is constantly changing. Remember that no matter what software you use, it is the artist that will always make the difference.

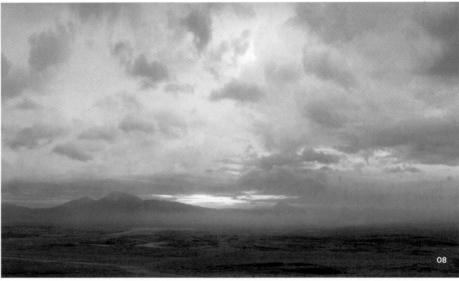

↑ The sky photos are blended together and some atmosphere is added in order to define the mood a little more

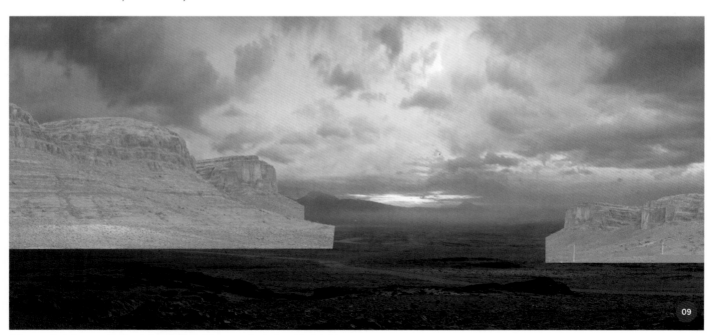

↑ Some rock photos are cut out and placed in the painting according to the original sketch

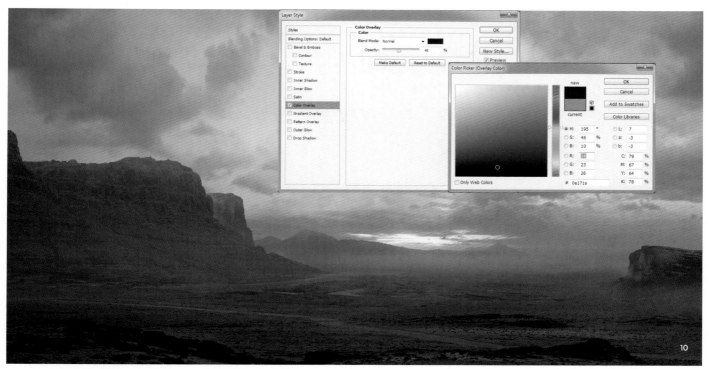

↑ The hills are integrated into the painting and more haze and fog is added

↑ The 3D scene is set up on a simple plane. The Physical Camera and Perspective Match are used to adjust the painting and Dome Light creates an overcast sky

the values. Now I am going to create one or two highlight and shadow passes.

For the highlights, I duplicate the layer, put it in Screen mode, and adjust it until I have the right color. I add a mask, fill it in black, and finally paint in white where I want those highlights. I also start to add haze layers to maintain a good separation of values and atmospheric perspective. Those layers are usually put in Lighten mode.

11: Setting up a 3D scene

I will leave the painting for now and jump into Maya. I choose to make the ship and buildings in 3D because it will be fast and will look better. It is also very common to have 3D assets in a production environment.

My first step in 3D is to set up my scene and camera. I am using V-Ray to render so I use the V-Ray Physical Camera, which gives me real-life parameters. I import my painting as a background and create a simple plane for the ground. Then I use Perspective Match in the Utilities panel to correct the perspective. For the lighting I am going to use the Dome Light plug-in with an HDRI of an overcast sky.

53

12: Modeling and texturing

I model my ship and building using simple Polygonal modeling in V-Ray. I go to Mesh Tools > Create Polygon Tool, which creates a model mesh, as I don't need to be perfect here. I add a fair amount of detail to the models but only with very basic geometry. The same applies to the textures; there is no precise UV mapping or complicated work here. I use a few V-Ray materials with textures that I adjust on the mesh. It doesn't need to be perfect as I can correct details in Photoshop. Maya is a heavy piece of software but just basic 3D knowledge can help you get the job done here.

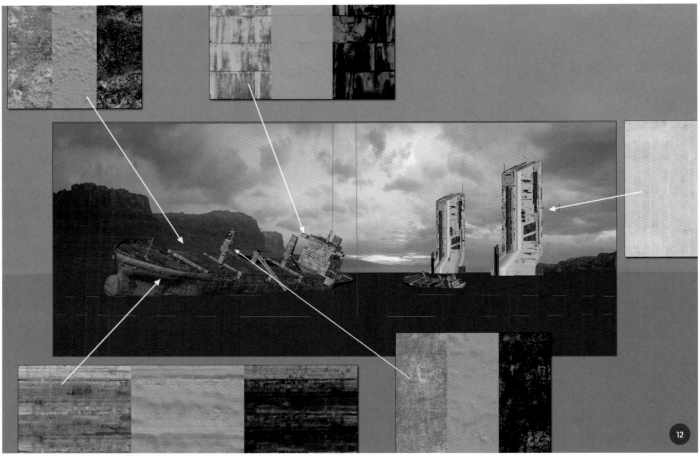

↑ 3D assets are modeled in V-Ray with polygon meshes before basic textures are added

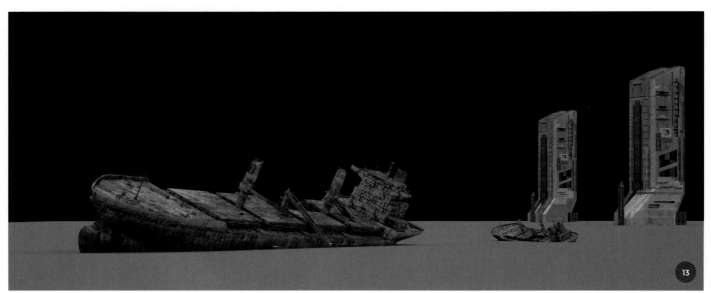

↑ The 3D elements are rendered in V-Ray to see how they look. They can be adjusted in Photoshop later if necessary

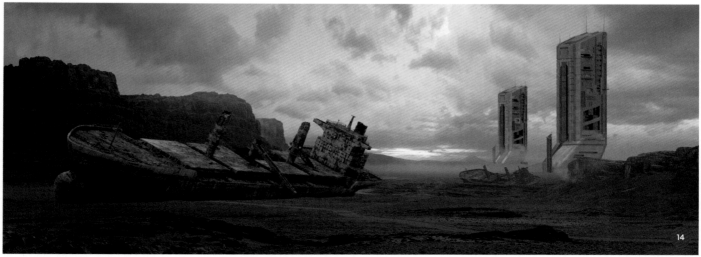

↑ The 3D assets are imported into the painting and color corrected to make them fit with the scene

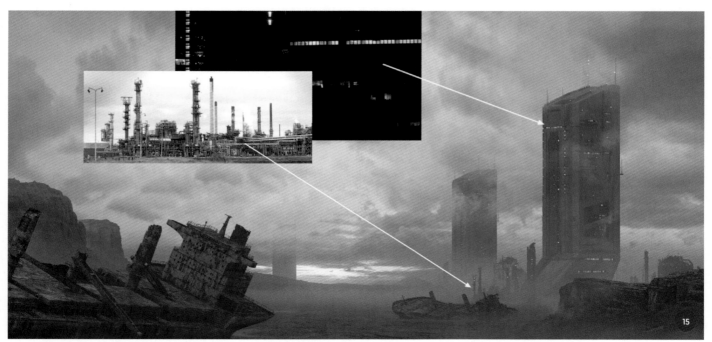

↑ As the painting progresses, haze is added, as well as industrial details to bring the 3D assets to life. Photo source: www.textures.com

13: Rendering

Now that I have my lighting, models, and materials ready, it is time to render and see how everything looks. I could render several different passes here but I feel it is not useful. Some basic Photoshop adjustments in later steps will be more than enough. A graphic of the render settings I use here are included in the downloadable resources for this tutorial.

14: Maya to Photoshop

I import my render into the painting in Photoshop and then correct the colors a little by using the same tools as I used before in step 04. You can see this immediately takes me one big step forward in the matte painting.

At this point, the adjustments are fairly straightforward and it is just a matter of taking the time to fix problems and add details. I cut my render into layers for each element, which I place in logical groups.

15: Bringing life to the painting

This is a fun but tricky part. I add a lot of haze layers to bring life to the buildings. The key is not to overdo the effect. For the haze and smoke, I either paint in Lighten or Normal mode, or bring in some smoke photos that I put in Screen mode.

For the lights on the buildings, I take chunks of photos from cityscapes, put them in Screen mode, and then adjust them into the correct perspective. Finally I add extra details by bringing in some reference photos of industrial buildings that I adjust, using the same methods as before.

16: Adding the foreground

Now I am really moving forward quickly. I keep repeating the same methods to add details and life to the painting. I make pools of water by duplicating and mirroring the sky layer and then cutting some shapes into it with the Lasso tool.

For the foreground, I bring in more photo elements and create shadow and light passes to make them fit perfectly in the painting. I add more details to them by pasting in some photo textures in Soft Light mode. You could also blur out some of the elements close to the camera to add more depth to your image.

17: Post-production

I have now added details, haze layers, and fixed problems to the point where I am happy with the result. I now want to carry out some final adjustments and manipulations.

I merge everything into one layer and duplicate it. Note that I still save a copy of all the layers in a group just in case I need to go back to fix something. I want to add a slight gloom effect so I add a simple Gaussian Blur filter to the duplicate layer on top and lower the Opacity setting to 24%.

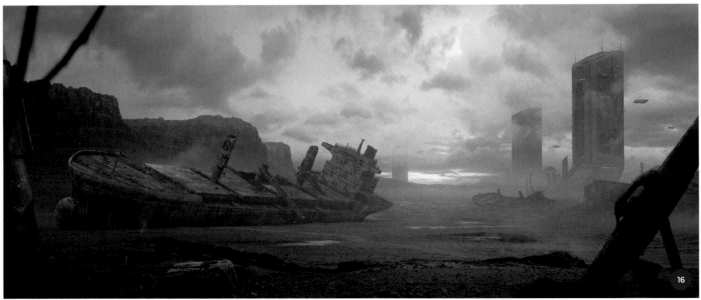

↑ The foreground is added with photo elements in Soft Light mode

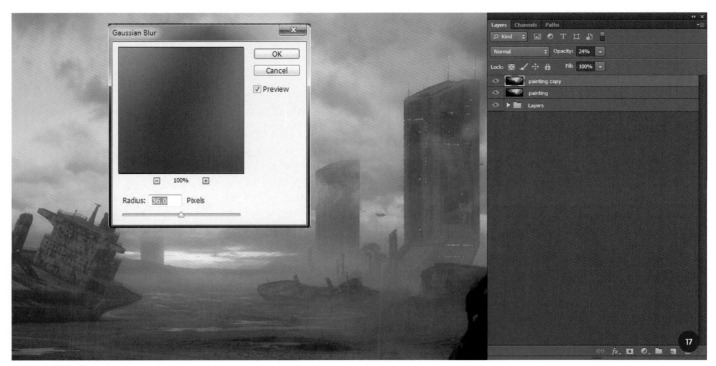

↑ The painting is almost complete, so the layers are merged and a Gaussian Blur filter is added on top to create a gloomy effect

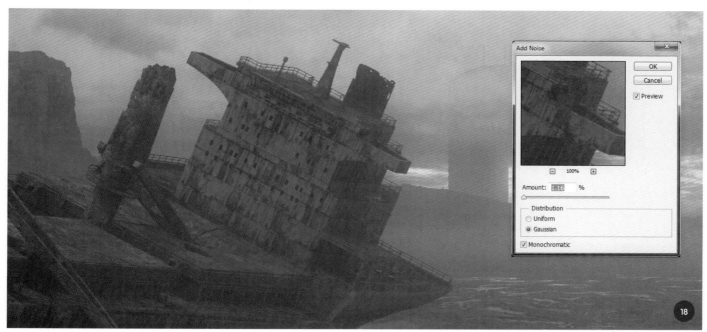

↑ A slight noise filter is added to the image to hide any small imperfections

18: Adding noise

A little post-production trick I use a lot is to add some noise to the whole image. This will help to make everything look more cinematic and will hide a lot of the little imperfections in the image. To do this I merge my two layers and duplicate the painting again so that I still have a safe copy under the layer to which I am going to add the noise. Then I add a noise filter from the Filter

↑ Add a color gradient to increase the cinematic feel and push the contrast and colors further

menu, select the Gaussian distribution, and check the Monochromatic option.

19: Increasing the cinematic look

The last tasks are to add a color gradient and some minor color corrections. For the color gradient, I use a Gradient Map adjustment layer in Overlay mode and lower the Opacity setting to about 25%. Be careful with the Gradient Map opacity as it will increase the contrast and give

a slight tint to the image but you don't want to lose details in the shadows and the highlights. In this case I put some blue in the shadows and some yellow in the highlights.

20: Final image

And there you have it, the completed image. Matte painting is a discipline that takes time and patience, and is a never-ending learning process. I am always learning and experimenting with new techniques and software. Just remember to have fun.

⚡ PRO TIP

Make your own references

Don't stay in front of your computer – go outside to see the world and take a good camera with you everywhere you go! It will help you build a solid visual library and sharpen your eye. If you only use and look at the material available on the internet, you will end up using what's already out there again and again.

Some fresh air is always good to free your mind too. Matte painting can be a lengthy process; sometimes you will spend weeks on a single shot so it is important to balance things.

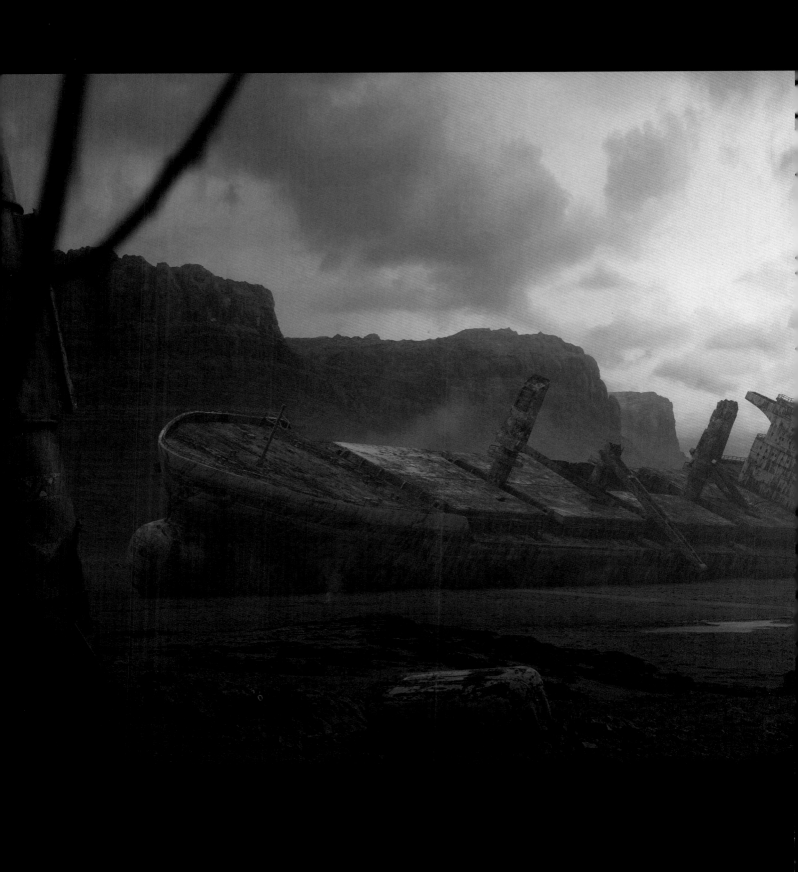

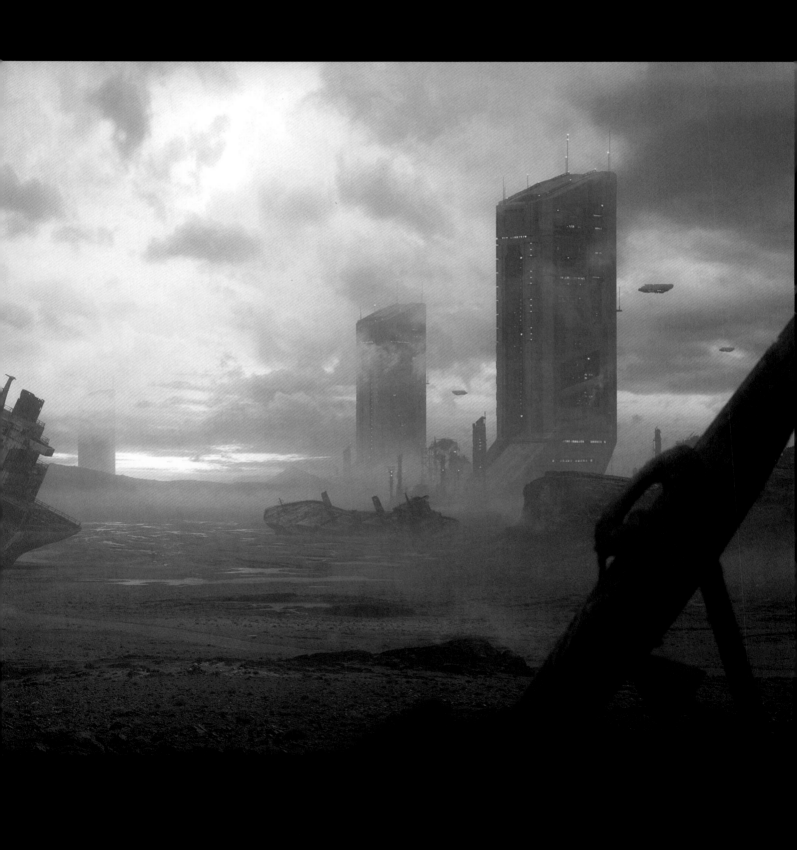

Matte Painting | Fish market

In this tutorial I will show you how to execute a complex production image with matte painting techniques. The theme of this image will be an urban fish market scene. The following steps will cover the initial concept and how to approach such a painting. I will look at images by romantic painters and images online to get inspiration for light and composition and to understand the world I am going to create.

I start to think about a fish market that I want to visit, set in a fictional Eastern city at sunset. What kind of market would it be and what kind of shops would I see there? The main aim is to get a strong atmosphere and composition, because in this context this is much more important than textures or painted detail. The painting will be backlit by the sun and the perspective will only have one focal point, which will make things much easier.

As this is a matte painting tutorial, I am **going to show you how to make the final**

image as photorealistic as possible. I will focus on the landscape and architectural elements, but also integrate elements such as birds and smoke to make the final image more understandable and complete for this demonstration, which usually would not happen in a real production matte painting as these would be added in compositing.

I will also cover the color grading (enhancing an image's color for film) and complex layer techniques I use for creating a uniform and coherent image with sources that have different noise and sharpness levels. At the end I will work on optical elements like look-creation, chromatic aberration, sharpening, and glow to make the final image feel more cinematic.

01: The concept

This stage of the production, creating the concept, is both the most creative and challenging at the same time. I look at paintings by romantic painters such as

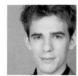

Falk Boje
Matte Painter
Software used: Adobe Photoshop CS6

Caspar David Friedrich and travel journals and talk to friends to get inspiration for an urban fish market. I decide to set it in an Eastern, almost ancient setting. In particular I look at the floating markets of Thailand, which inspire a few designs.

I put eight rough and quick designs together to gain an understanding of perspective and also of what is realistically achievable in the given time frame. At this point I do not focus on specific images or elements, and do not worry about technical aspects such as black levels (the level of black in the darkest area of an image) or working resolution. A matte painting should feel realistic and it is vital that the world that is created is believable. I constantly ask myself questions while I am painting: Is it a market on land? Is there water close to the market? What time of day is it? Is it a rich city? Where in the world is it set? Finding answers to these questions helps me to try new things and decide on a concept. The photos I use in this tutorial are from my personal library which contains images I have taken myself as well as ones from family and friends.

02: Getting started

Now I have a number of concept ideas I can start to create the actual image. To start off, I paint at a resolution of 8,000 pixels wide, as I am intending to deliver an image of 6,000 pixels. This will add an extra amount of pixels to blend the painting together later when I reduce the size.

I like to create a layer filled with black and set the blending mode to Color, and then add a Hue/Saturation adjustment layer (set at 65% Saturation). This allows me to check my color and black values the entire time I am working, which is a great help for any kind of color grading.

Furthermore, I start looking at images, in particular a sky, and begin prepping them. I try to remove chromatic aberration (find out more about this on page 67) and noise. The best way to do this is to use the Adobe Camera Raw plug-in or the Remove Noise filter in Photoshop.

03: The sky

I always construct my matte paintings from background to foreground, which makes them easier to understand. The sky is very important and will almost set the entire color palette and light direction for the scene. I look for a sky with a sun very close to the horizon and a lot of atmospheric haze. I only take a section of a photo and paint on top of the entire sky to achieve the desired mood. I like to paint skies with no clouds using Photoshop's standard Round brush with a low opacity, sampling colors from the image. It is important to check the value range in the sky to make sure that there is no clipping in the white tones. Clipping is where part of an image is lost during color correction, but it can be checked with Levels.

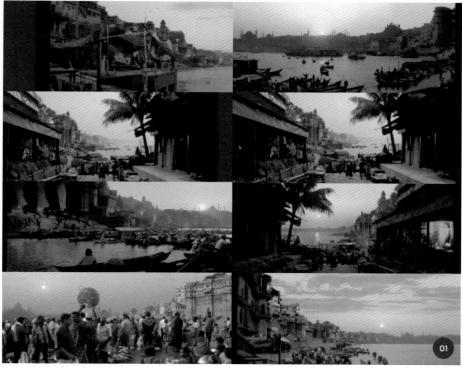

↑ A quickly constructed contact sheet of eight potential fish market concepts

↑ I set the image size as shown here

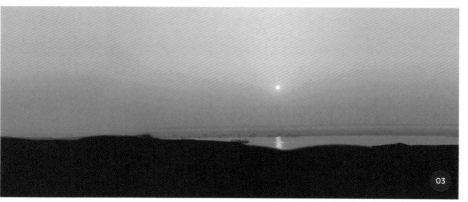

↑ I start to paint the sky, sampling colors from a base photo to establish a color palette and light direction

04: Establishing the landscape

This step is a significant one for establishing the landscape in the painting. I focus on images with Eastern architecture and elements that could help place the painting in a different time period. I like the idea of old towers and temples as silhouettes on the horizon, which will be very easy to create with the backlit lighting.

I combine two images to continue the urban landscape across the entire image, which involves a bit of grading to match the different haze levels and unifying the scale of the images. I start looking at my image under my black-and-white value check layer and try to unify the blacks and whites in the image. After that I switch to the saturation layer and try to match the colors with the Curves, Color Balance, and Hue/Saturation adjustment tools. After that the images should match perfectly.

05: Bringing elements together

I paint a lot of elements on top of the architecture such as little towers and walls. I also do a bit of clean-up work to remove lights and wires that I do not want. I like to use the Clone Stamp tool for most of this work, although I always rely on the standard Chalk brush at size 17 for painting architecture from scratch. This brush is perfect for painting

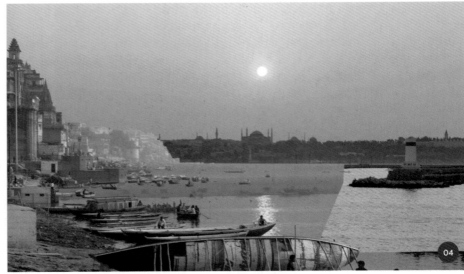

↑ I combine sections of different images to create the landscape composition

transitions by sampling the color with the Color Picker tool, and I use it to paint extensions.

Every time I need to bring in a new element like the structure with the two towers in the foreground (see image 05), I look for an image with a similar light direction and perspective to the one in my painting. Little adjustments can be made to new elements with Distort or Perspective transformations. The light direction can be slightly fixed with a painted layer mask in a Curves adjustment layer, which will sadly only work to a certain point.

06: Blending the water

Another major element of this landscape is the water. Obviously, I need a picture of water that will work with the sunset sky and that will also have the correct scale waves to fit with the boats. It is very interesting how trained our human eye is in identifying the scale of something as abstract as waves.

A lot of Lasso tool selection and hand-painting is needed to isolate the boats and fit them on the new water surface. The reflection on the water is especially tricky so I hand-

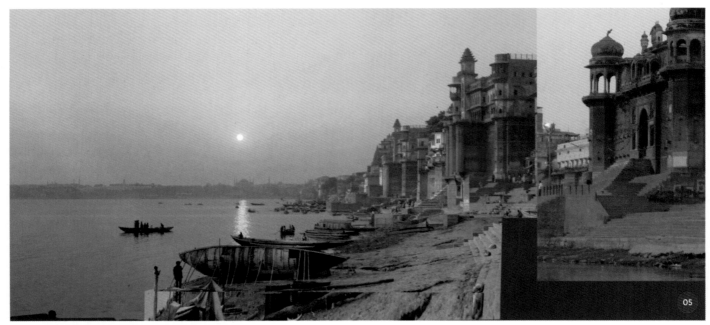

↑ I blend the architecture with the Clone Stamp and Transform tools

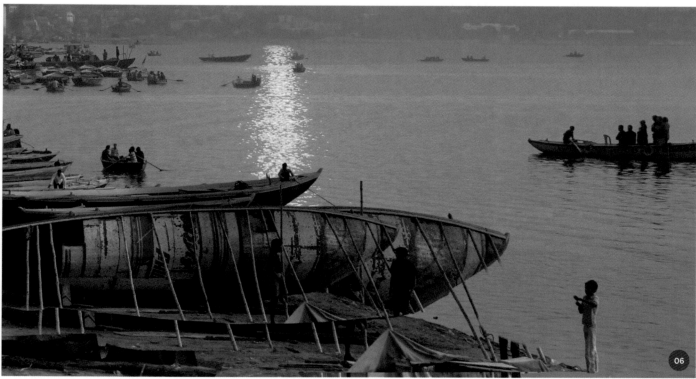

↑ Blending the water together with the boats requires plenty of hand-painting and use of the Lasso tool

paint it for most of the foreground boats. I also find that painting a light orange color on top of the boats on a Soft Light layer, with no more than 5% Opacity, helps to blend the images. I continue to add a slight orange color spill on the underside of the boats to show the color reflecting off the water.

I also need to extend the water to the right in order to fill my canvas. I use the Lasso tool to grab a selection for the missing area and with a Content-Aware fill (Shift+F5) I now have quite a good image as a starting point, which I refine with the Clone Stamp tool.

07: Blocking in the market

With almost all other big compositional elements of the landscape in place it is time to start on the market. I look for an image of a busy market with a lot of people in order to create a feeling of chaos, and also to draw the attention of the viewer to this area.

I want to keep the sandy ground I already have, which means I have to cut out every person and market stall to integrate them into the new ground. To do this I make a Curves adjustment layer underneath my market layer and reveal darker parts of ground underneath the feet and other elements on the ground by painting in the layer mask.

I layer two market elements behind each other to achieve the right depth and more complexity. I also keep the little lights on the market stalls because I feel they add a lot of atmosphere. These lights are exposed even more with a bright yellow color painted over them with a low opacity and the layer set to Overlay.

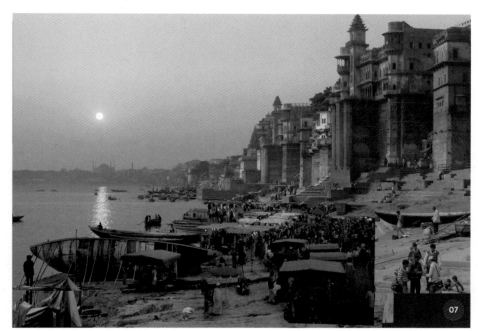

↑ To preserve the sandy ground of the market, every person and stall is cut out with a layer mask on a Curves layer

08: Adding details to the market

One small but very important step in terms of the color palette is to change the color of a few market stall canopies to red. In my opinion the best way of doing recoloring like this, without introducing artefacts, is to create a new layer. I mask it with my selection of the canopies and paint with the desired color, in this case red, on top. After this, I blend the layer in by setting its blend mode to Color and adjust the brightness and saturation.

There are a lot of modern elements in the market such as motorcycles and bicycles, which I do not like, so I clean these up to prevent the painting from being associated with a specific time period. The best way of doing this is to again use the Clone Stamp tool and sample from clean areas to remove unwanted elements. But for extensive cleaning a lot of hand-painting is inescapable. The best method for this is to sample a color from the image and use the Chalk brush to paint on top of elements.

Now that I have the market in place I also need to adjust the size of a few boats to cheat a bit with the perspective. I make sure that they have the right scale compared to the people around the market place. This kind of rescaling

↑ The canopies are refined by altering their color and modern elements are removed to make the image timeless

of elements should be kept to a minimum, because eventually, if it is done in too many places, it will ruin the image; on a subconscious level the viewer will notice that something is wrong if some elements have a different scale and do not fit with others, for example if the people in the market are bigger than the people on the boats right next to them.

09: Perspective in the foreground

I now want to add a foreground to bring the image together. It will establish the perspective of the scene and will also form the transition into the market area. The viewer will be on a higher viewpoint than the center of the market

which allows me to show more of the scene, instead of having people blocking the view.

I start to color correct and think about what other elements I want to add to the foreground. I add an old ornate wall element on the right side to tie the architecture of the foreground and background together. I always try to repeat elements in my image to give scale and help the viewer to understand the landscape.

10: Adding some nature

Another element that I repeat in the image is the little fishing nets that hang

↑ A foreground is introduced to guide the perspective towards the market

off the boats. Two of them are in the mid-ground and one is further in the distance to support the perspective.

Looking at the picture with the foreground in place, I realize that I want to have another, more natural element in the picture. I decide to add a palm tree as this will support the Eastern look of the scene and stand out clearly as a silhouette against the sky. Again, using an image with backlit lighting is helpful here because it means I do not have to adjust the light direction. This way my light source is in frame and it helps to add depth to my image. The best way to cut out the tree

↑ A palm tree adds an element of nature to the picture and breaks up the foreground

is to duplicate the layer, make it black and white, and with the Curves adjustment tool grade the image until the sky is white and the tree is black. After that I use this image as a layer mask for my original tree layer. Any unwanted white outlines around the small leaf detail can be removed by going to Layer > Matting > Defringe. To grade the tree into the image, I try to get the black and white values correct and focus on the colors afterwards.

11: The foreground market

To bring more fish market elements into the painting I want to add a big fish store into the foreground. I look for an image with a similar perspective and make only minor adjustments with the Distort tool to warp it into place.

I first focus on the values to see if the image will work, not considering any integration of color. After this I start making selections to position the shop behind the pillars of the foreground building and join it with the structure. The image has a lot of clipped highlights on the fish caused by their reflectivity and my heavy grading.

Next, I take some fish textures and transform them to the correct perspective. I then place them on top of the fish in the image with a Soft Light layer to give the illusion of detail, which works quite well. I also add a brick wall on the right side to direct the viewer's gaze to the center of the frame and toward the market.

↑ A fish market image is integrated into the foreground and adjusted with extra fish textures

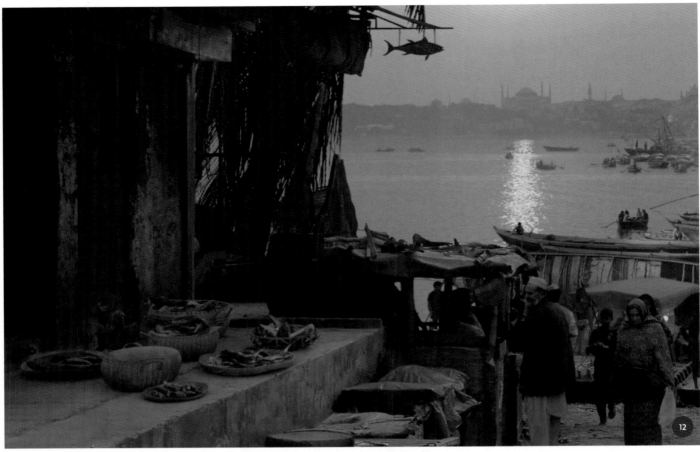

↑ Adding small details will make the scene come to life, but they must match the perspective, values, and color of the scene

12: Detailing

Detailing is probably one of the steps I enjoy the most in matte painting. Here I add details from barrels to little baskets with fish inside, signs, birds, and smoke. This is the time I can explore my painting and try to add as much detail as possible.

However, even with the smallest details I always need to check that the perspective, values, and color are correct for the scene. It is very easy to break an image by adding more and more images from different sources, as there is a higher potential for small errors such as incorrect highlights or shadow color to make the image fall apart.

Making sure the shadows are correct can be a challenge in particular. I usually use a soft round brush with low opacity to paint with a very dark color over the connection line between the object and the ground in order to bring them together.

↑ For the final color grading, Photoshop provides useful LUT presets in the Adjustments panel

13: Look-creation

During this process, almost all of the color grading has been done to match the colors of the sky, which is always the brightest element in the scene. Now I have an image that is ready for the final overall grading.

> "Before blending all the layers together, I add some Gaussian blur to elements that are too sharp. The Blur tool can also help to blend edges between layers and remove the impression of something not sitting in the scene"

I have discovered that Photoshop provides some very useful Color Lookup presets in the Adjustments panel. A Lookup Table (LUT) is basically a matrix that stores grading information about values and color. In this case I use the LateSunset preset which is, like all the presets, too strong for this scene.

I like to lower the opacity and switch the blend mode to Soft Light to resolve this. I try to develop stronger blues in the shadows on every element that is further away from the camera in order to help with the atmospheric perspective.

14: Adjusting the overall sharpness

The main task in this final step is to make sure that the image has an overall consistent level of sharpness. Before blending all the layers together, I add some Gaussian blur to elements that are too sharp. The Blur tool can also help to blend edges between layers and remove the impression of something not sitting in the scene. After this, I duplicate the image and apply a Highpass filter with Radius set to 2 on an Overlay layer in order to sharpen the image. This step needs to be carried out quite carefully because I do not want to end up with an over-sharpened painting.

15: Finalizing

The final elements I add are a bit of chromatic aberration and grain. Chromatic aberration is an effect which appears in photography, where the image is slightly blurred due to the camera lens not focusing on the different colors in light correctly. You can add chromatic aberration by going to Filter > Lens Correction and playing around with the RGB channels. Grain is reminiscent of the old-fashioned film grain you would see in traditional analog photography and is also found under the Filter tab. Both of these effects help to make the image feel more cinematic, and would usually be adjusted to the amount that is already in the given plate or to match it to the camera that the movie is shot with, which is a common process in VFX.

Again, I do not want to destroy the image so this should be done very lightly. After this I reduce the size of the image to 6,000 pixels to help the brushstrokes blend together. At last the image is complete.

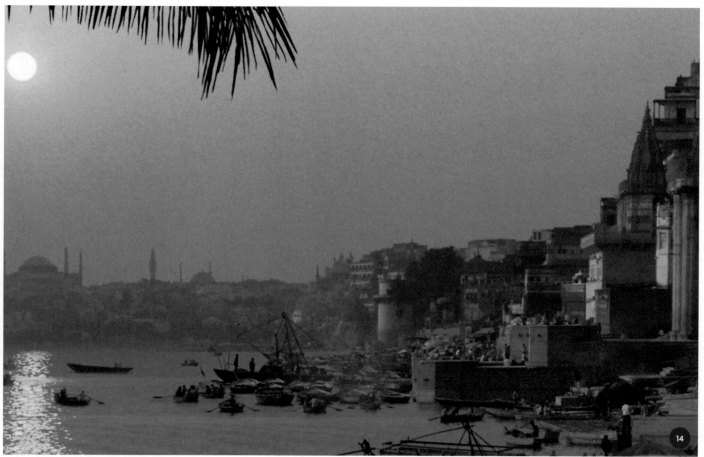

↑ I add blur effects to help bring the image together

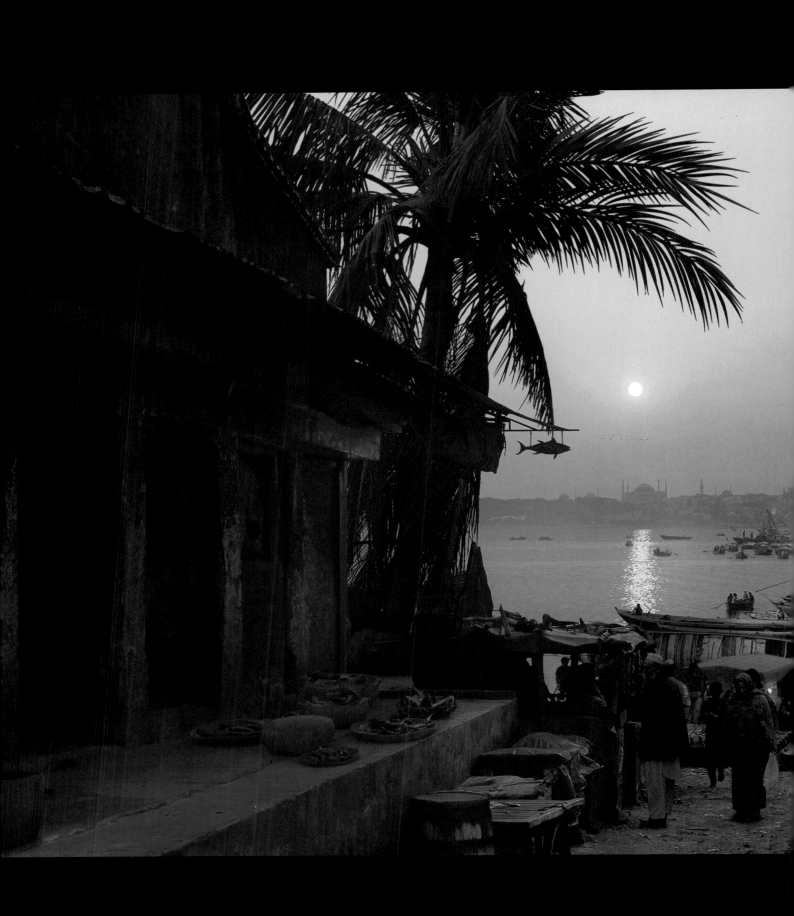

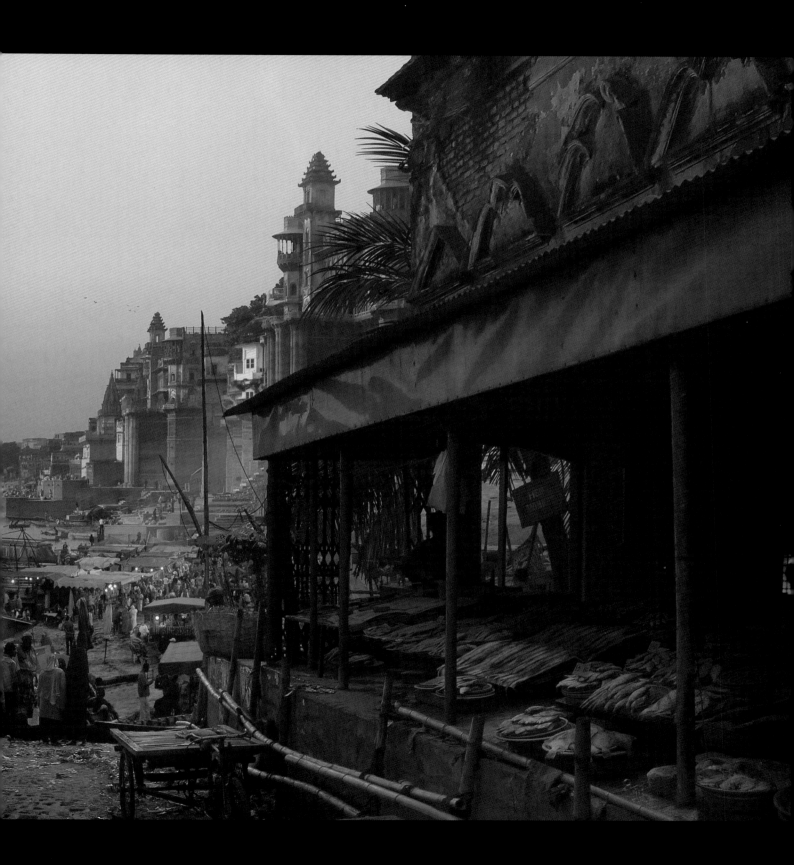

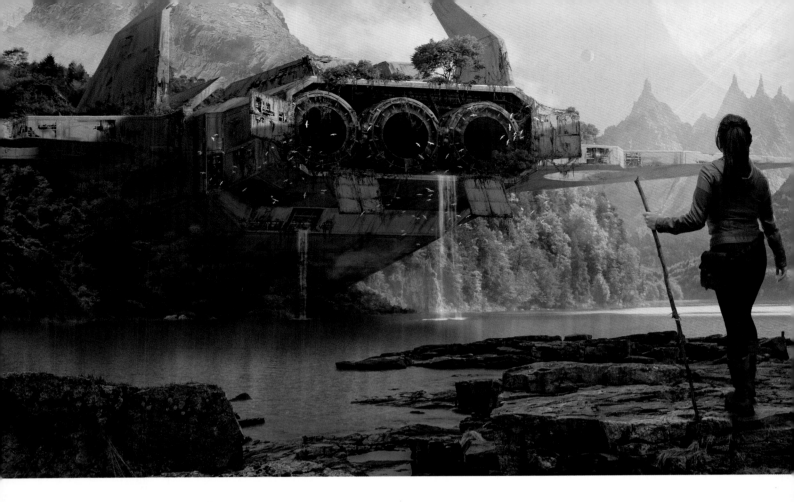

Matte Painting | Spacecraft wreckage

A futuristic shipwreck will be the theme of this matte painting project. The possibilities are endless; the range covers all varieties of futuristic vehicles, and from there, all kinds of exotic landscapes. The wreck could be set in the future or be a wreck of a futuristic ship in the present day, on this planet or an alien planet. I have to make a choice. I find the idea of an old wreck of a futuristic ship on an alien planet appealing due to the possibility of painting textures, rust, and debris. All of this could be surrounded by nature which has invaded the ship, making it part of the environment.

The contrast between nature and human-made constructions is an interesting aspect, especially as through time nature erodes machines and buildings, making them a memory of the past. I will use this concept as a guide to help me recreate the environment.

The digital matte painting processes of today include an array of tools and techniques, so the finished pieces are as realistic and believable

as possible. In this project I will only use 2D techniques that include photo manipulation and digital painting in Photoshop.

The tools we count on give us lots of possibilities to develop our work, but we should not fall in love with technology. We should consider it a tool that will help us portray our artistic vision. The key to a good matte painting is not a computer program, beautiful photographs, or a fantastic 3D model, but a strong composition and precise execution.

01: Concept development
For the first step I need an idea. With this theme, I can imagine lots of scenes that would be interesting to paint, but not all of them will work. To explore different ideas I paint a series of very basic sketches in color, without focusing on the details or the design of the objects that we will see in the final piece. I dedicate only a few minutes to these sketches (the faster they go from my head to

Pablo Palomeque
Matte Painter & Concept Artist
Software used: Adobe Photoshop

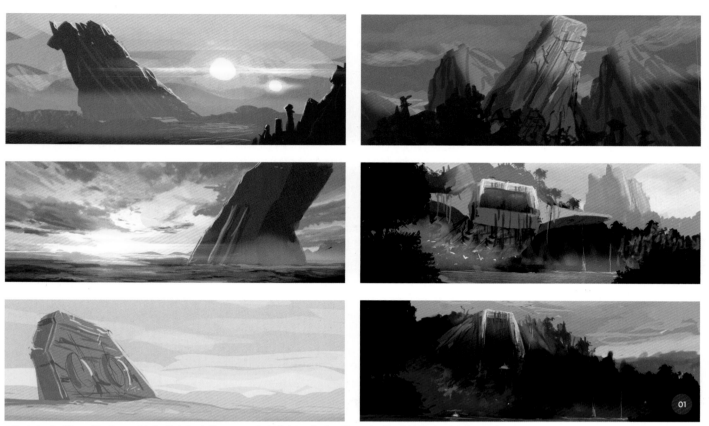

↑ Exploring the ideas of the theme; it is the first step in the process that will determine how the work will unfold. The key is to be creative

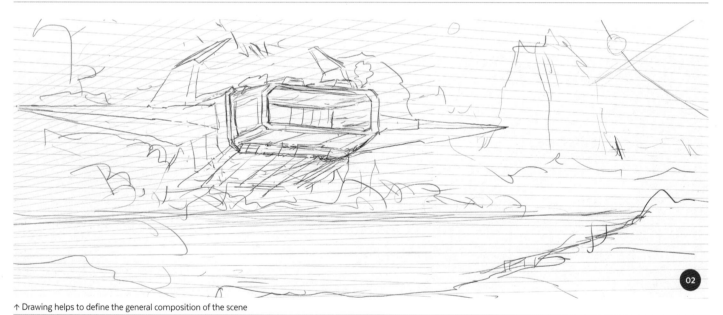

↑ Drawing helps to define the general composition of the scene

the canvas, the better). I just want to establish the general composition, light, and color. I use one or two brushes and a few layers.

In this case, I try a variety of compositions, landscapes, and lighting. I have to make a lot of these sketches because with quantity

appears quality. The sketches I don't use now could be useful on another occasion.

02: Line drawing
Now that I have developed an idea for the matte painting, I start to create something more definite. In this line drawing, I establish

the general shape of the object and the location of every element in the scene.

I do not go into drawing details yet, but nevertheless it is important to develop the shape of the abandoned ship, how the landscape will appear, the scale of the

objects, and the visual composition. The lines of perspective you can see in image 02 help me to draw the ship and integrate it into the scene. For the rest of the process there will most likely be some changes and adjustments if the scene requires it, but this is my starting point.

03: Color sketch

Before I begin to work on the matte painting, I need to have a very clear idea of what I am going to do: a preview of how the work will look in the end, not only the shapes but also the light and the general atmosphere. This is why I need a color sketch.

In this step I establish a scene: an abandoned ship, worn by time and covered in vegetation. In the sky there will be a giant planet with rings. In the background there will be exotic mountains, and in the front, over some rocks, the character will watch the scene.

I start painting over the drawing, trying to give it depth. The elements that are farther away will have less contrast,

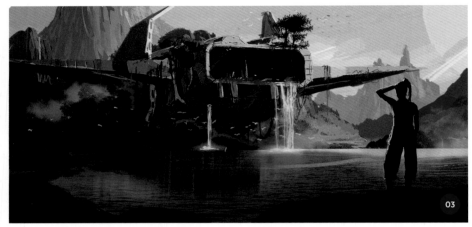

↑ In the color sketch, the shapes, light, and atmosphere are developed and enhanced

and I give them a range of colors similar to the colors of the sky, so they look distant. I paint closer elements in a more defined way and with more contrast.

04: Photographic resources

Generally one of the characteristics of matte painting is photorealism, which is why there is nothing better than using photos. The photos have to be high resolution and of good quality so we can manipulate and adapt them to what we need. The images are chosen once

the idea is developed, as the photos should be resources that cater to our creations and not the other way around. If not, we run the risk of them conditioning our work.

For the landscape in this scene, I use pictures of a sky, different mountains, vegetation, a lake, and finally some rocks for the foreground. The photography of the rocks in particular has to be high resolution because they are closer, and this area is also where I will position the character later.

Photographs from www.pixabay.com

↑ The pictures need to be very high quality

05: Photobash development

By now, I have developed the concept art and finalized some of the aesthetic details, so now it is time to begin adding the elements that will build the matte painting up to professional quality. The project will have a width of 6,000 pixels and a height of 2,550 pixels. (The bigger the project, the more room there is for details.)

I use the various photos settled on to create the landscape, cutting off the mountains, adding vegetation, and placing the rocks where I established them on the concept and the color sketch. To make selections within the photos and separate the elements, I usually use the Magic Wand tool, but for the finer details I prefer to use the Eraser tool. I leave a black area for the abandoned ship.

06: Mountains and planets

Taking elements from photos is fun, but nothing is better than painting by hand. For the planet, I paint a white circle within the clouds on a separate layer. The rings should be thin lines, and it is important to remember the shadow the rings project over the planet. I lower the opacity of this layer to blend it with the sky. This makes the planet look farther away and integrates it into the scene.

↑ I develop the landscape from the color sketch and the concept

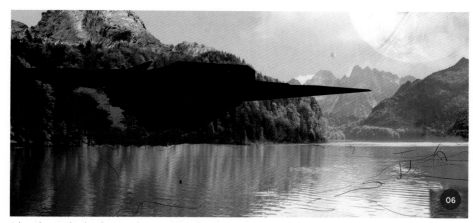

↑ I continue to develop the general scene, without focusing on the details

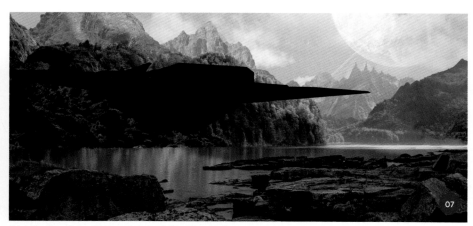

↑ I define the color and light, and start painting a few details

⚡ PRO TIP

Organized work system

Generally matte painting can be complicated work, full of detail, which is why it is necessary to pay a lot of attention even to the smallest of elements. A tree in the background is as important as an object in the foreground. Every element in the scene has to look good. To achieve this you should develop an organized work system. If possible, you should paint a few sketches before you start working in the main piece. It won't help you if you start cutting out pictures if you still don't have an idea of how the scene will be. It is important to know that the results depend on hard work.

Now I add the mountains and other elements to the background. I do not focus on a single detail; instead I work a bit here and there so the scene slowly emerges, little by little.

07: Detailing elements

The landscape is starting to look like another world. I can now begin to concentrate on a few details, such as painting the tops of the mountains in the background yellow to make them look more alien. I do the same thing with the sky. For the mountains on the left, I use a quick mask to paint some zones yellow, simulating a sunset light. I add the rocks in the foreground, making them darker and more contrasting, which helps create an impression of depth. With these new elements, I move the planet to the left to improve the composition.

PRO TIP

Let's become artists

As mentioned in the introduction to this tutorial, the techniques used for the creation of matte paintings have changed a lot since the times of traditional matte painting. Now we have Photoshop and lots of tools to create 3D images that also help us carry out our work. Nevertheless, the most important tool is still the same tool that all artists have, which is talent and artistic sensitivity. We have to develop these qualities. It is fundamental that we develop as artists and learn about composition, color, perspective, and painting so that we can become "real" artists without depending solely on tools.

08: The shipwreck

Once the landscape is almost complete I am ready to work on the abandoned ship. This is the principal element in the scene; I therefore need to pay extra attention to it. I begin by using the same perspective lines I created for the line drawing in step 02. I paint the in shades of gray to define the volume and the shape. I make its scale larger than the environment to create presence in the scene. In addition I add a new layer with more vegetation. Once

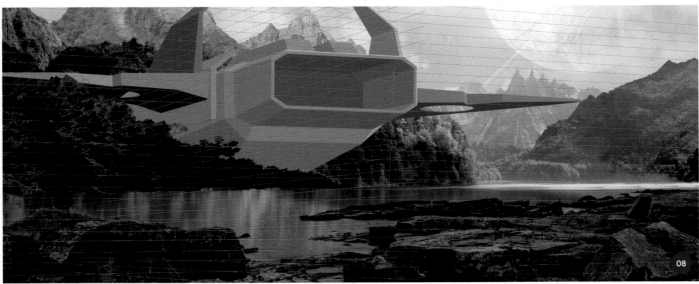

↑ I give the ship a lot of attention as it is the main focus of the scene

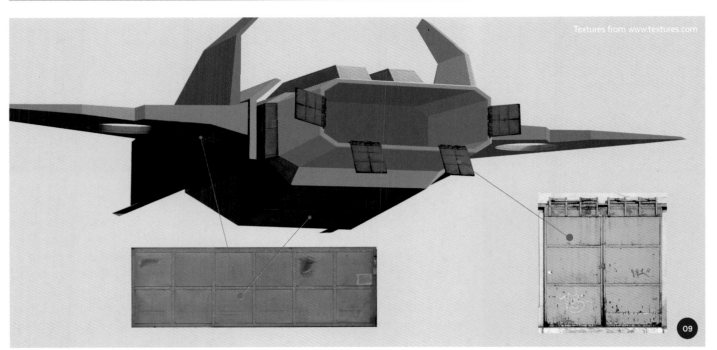

↑ The texture is worn-out and rusty, which makes the ship look abandoned

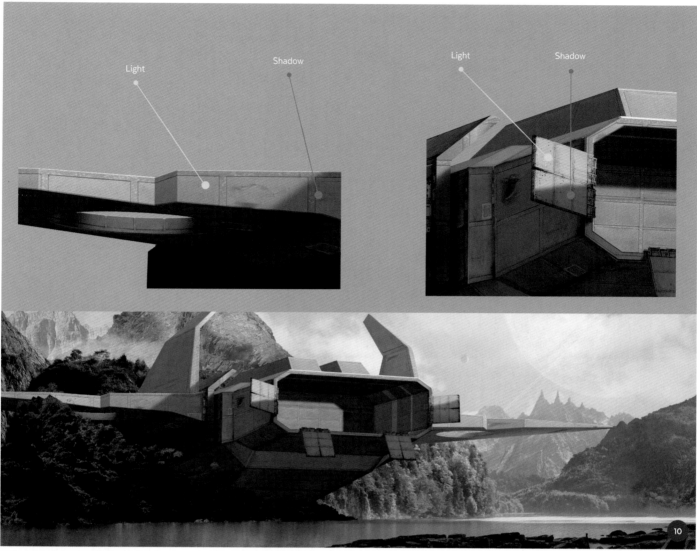

↑ The lighting is fundamental to making the scene to look integrated and realistic

completed, I am satisfied that this is the final composition, including all the main elements of the scene. From now on it is time to refine the details and finishing elements.

09: Ship textures

The texture of the ship should look dirty, worn-out, and rusty. To give it this effect I use two photographs of some beautiful iron doors with those characteristics. For the hull of the ship, I use the image of the door that is split into sections so I can cut it to adapt them to the smaller sections or bigger ones. I use the Free Transform tool to adapt the texture to each of the sections of the drawing that are painted in shades of gray. After that, I adjust the lighting of each of these sections to make them darker if they are in shadows, or lighter if they are closer to the light.

10: Lighting scheme

The ship should have the same lighting as the rest of the scene. The sunset light illuminates the objects from the middle of them to the top. With a quick mask I paint the areas where I want the light to reach. It is important that there is contrast between the light and the shadow to make sure there is depth in the scene. I consider the areas of the ship that project shadows over others, and also the pieces affected by the light. This way everything will look more realistic and integrated into the scene. I also use a very soft orange color to replicate the ambient light of a sunset.

⚡ PRO TIP
Portfolio originality

Visual effects studios hire talented artists for their staff. If you want to be part of this industry, you need to make your work known. To achieve this you should have a different portfolio that stands out from the crowd. In the portfolio you should show your skills and pictures with different themes, shapes, and moments. Play with different points of view, with forced perspective, and tell stories with your images. The best way to sell yourself is through your work.

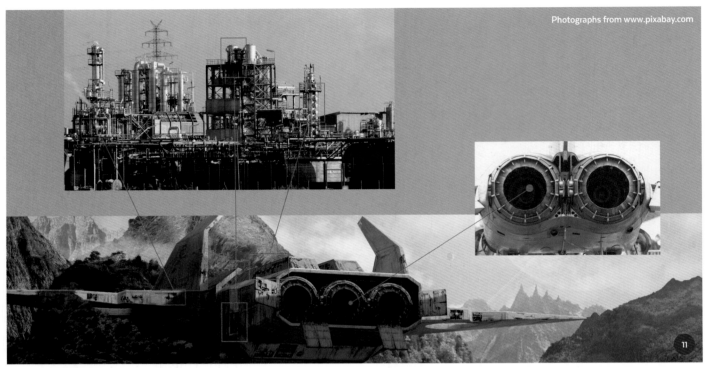

Photographs from www.pixabay.com

↑ Do not dismiss minor detailing

11: Wear and tear

The ship looks old and rusty, but not quite enough. It may have been abandoned for centuries and have been affected by the weather of this planet, which is why it should look really damaged. To achieve this, I paint scratches and rust stains with brushes all over the ship's hull.

I also want the ship's hull to be broken in areas so that the engineering inside is visible. For this, I use a photo of an oil refinery, from which I cut out sections that look interesting, and put these textures on the hull to simulate the engineering under the damage. I keep in mind that the lighting affecting these parts is the same that affects the rest of the ship. As a last-minute adaptation, I add the three engines, again using photo details.

12: Trees and vines

One of the elements that predominates in this landscape is the vegetation. It makes sense that the ship will be covered in it, and it is also fun to paint. I apply a picture of a tree to different zones of the ship where I imagine the vegetation will grow. After that, using the Clone Stamp tool, and taking the texture of the tree as

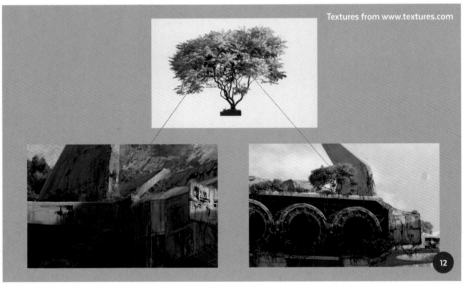

Textures from www.textures.com

↑ The trees and the vines covering the ship will help make the wreckage look more abandoned and decayed

a reference, I paint vines everywhere. Some are stuck to the structure, others are encroaching on damaged areas, and some are hanging between one section of the ship and another. This is a very detailed step which requires lots of patience, but it is really fun and rewarding.

13: Atmosphere and fog

The last details are now needed for the scene to come alive. I add fog between the trees and the landscape, which helps create the right atmosphere. The water falling from inside the ship, in addition to the birds, helps create movement and embellishes the scene.

Next I check the whole picture, making sure there are no mistakes, such as messy or badly cropped edges, or other details that I haven't noticed previously. The scene is complete, but this does not mean the whole work is finished.

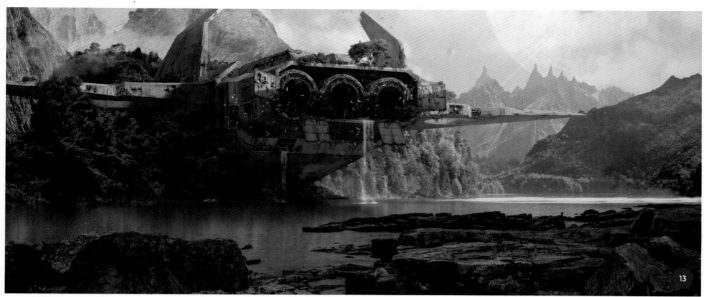

↑ I add elements that give the scene life and movement, such as waterfalls and birds

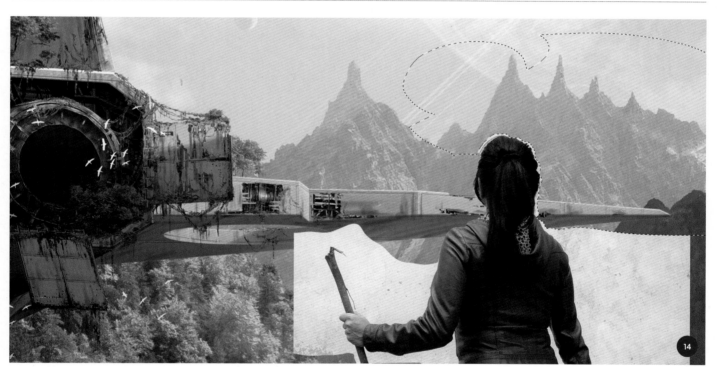

↑ The character will help complete the scene and tell a story

14: The character

At last I add the character into the scene, which gives a human scale to the image and helps the scene tell a story rather than look lifeless. The direction of the character's gaze forces the viewer to make a visual tour, and focuses their attention on the abandoned ship. This is essential, which is why I check almost twenty photos until I find the one with the correct lighting and attitude that fits the rest of the scene. To integrate the character into the scene, I cut the picture carefully. (Remember, the character is in the foreground so it must look good.) I also adjust the brightness and contrast a little. Finally, I paint the character's shadow to integrate her into the scene.

15: Final scene

The matte painting is now finished. A work like this requires patience, and a lot of attention to the details. That is why it is important to develop an organized work system. In the concept art stage I established how the scene would be carried out. I ensured I had a good composition and an attractive image so that in the realization of the matte painting I had no doubts about what needed doing. Every detail is important for developing the whole picture. I have to believe that if I work hard enough, I will achieve the intended result.

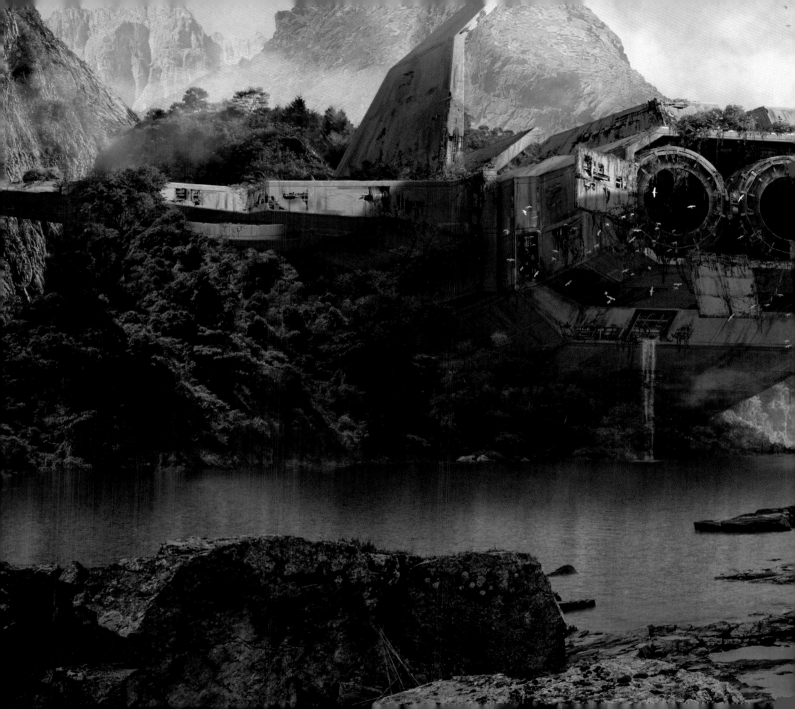

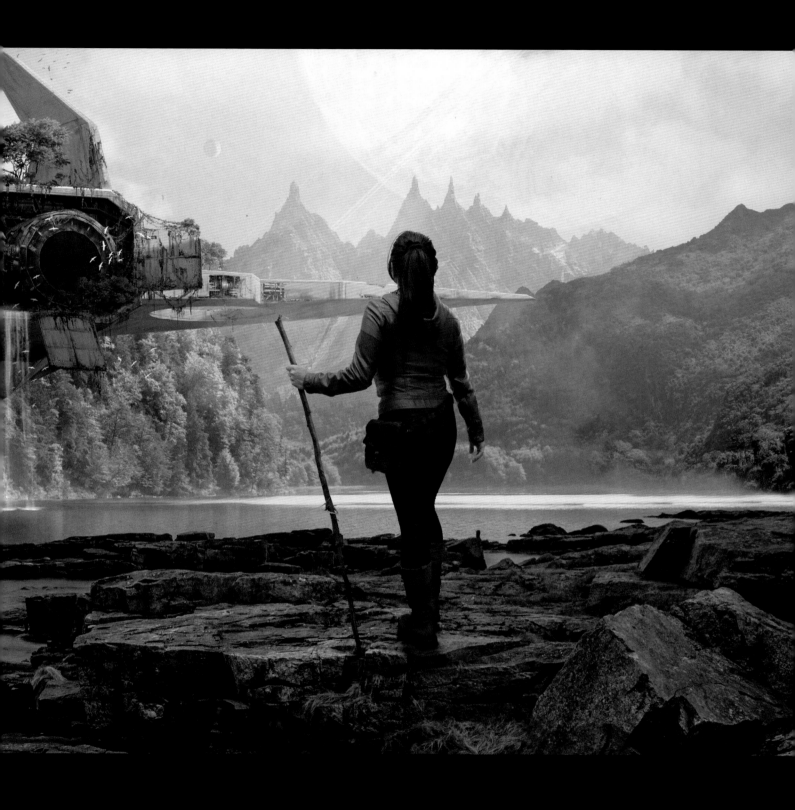

Custom Brushes

Designing your own custom brushes for specific painting tasks is a quick and efficient way to create digital images. These brushes can vary from multi-purpose brushes used to sketch out initial ideas or block in shapes, to intricate brush tips used to create detailed repeat patterns or textures. Many professional artists build a collection of custom brushes over the course of their careers, making their own brushes or gathering new brushes online or from friends and colleagues.

In this chapter six artists demonstrate how they construct and use brushes suitable for creating diverse scenes such as weather effects, sci-fi and fantasy themes, and cityscape and creature design. As you progress through this chapter the tutorials will show you not only the process of creating brushes but how individual artists incorporate them into their workflow.

Custom Brushes | Fantasy

James Wolf Strehle
Concept Artist & Illustrator
Software used: Adobe Photoshop

Painting digitally has many advantages, allowing you to conjure up things that are near impossible to do in other mediums. It is important to take advantage of these benefits as it will not only aid in the outcome of your work but will also increase the speed and efficiency at which you can produce your artworks. Another advantage is that it gives you the ability to construct a wide range of custom brushes. Through this tutorial you will learn how to create and implement custom brushes for use in your own fantasy image. I will show you how and why I create the brushes as well as explain the technical steps taken in their creation.

I will be making a general purpose brush to use as the default brush, a vegetation brush created from a photo to be used for organic materials, an additional vegetation brush using the negative space of a photo, and a mixing brush made to blend paint. These brushes will

be wielded throughout the development of my illustration, *Calm before Chaos*. I will also provide additional tips on the painting process in general such as using the Warp tool, masking out shapes, and duplicating layers to quickly fill in the scene.

01: The sketch

Before jumping into a painting it is helpful to have a good plan of action first. The sketch is an important step that can sometimes be overlooked or neglected, but having a well-planned blueprint will help you greatly throughout the painting process. It allows you to move forward with confidence and minimizes the need to second guess your decisions later down the road.

In the sketch in image 01 I have laid out a scene depicting a dragon watching over her eggs. I have the points of interest sketched in and the rest of the environment is filled out around them. Taking your time in this stage affords you the opportunity to think

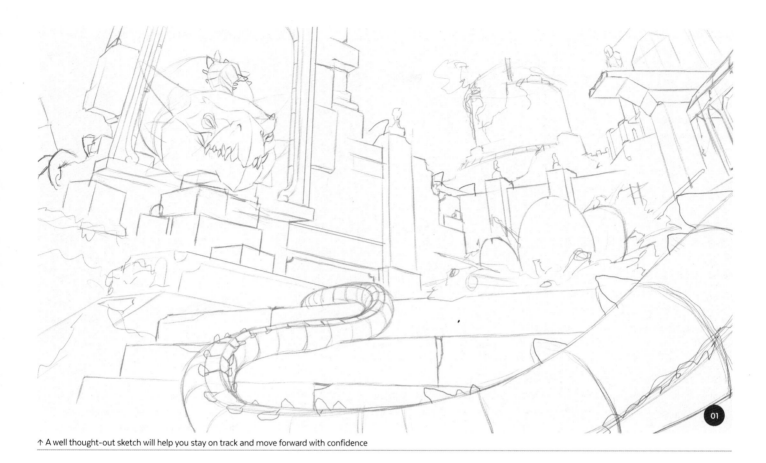

↑ A well thought-out sketch will help you stay on track and move forward with confidence

through your concept and plan it out. When it is time to paint I often already have a fairly clear vision of the outcome.

02: First brush

Now that the sketch is complete it is time to fill it in. To do this I first need an appropriate brush for the job. This brush should be a general purpose brush able to fill in large spaces with a favorable texture, and also have the versatility to be used in small detailed spaces as well. The first step is to create two separate brushes; one will act as the border of the paintbrush and the second will act as the texture inside that border.

I open up two new 400 × 400 pixel documents. The dimensions of these documents can vary as long as they are square. You can get more detail with a larger file but you also increase the risk of lag; 400 × 400 pixels is sufficient for our needs. I will create a brush in each document and then combine them. When creating brushes you need to work

↑ Two brushes can make for an exceptionally versatile brush once they are combined

in grayscale. Black will represent the paint at 100% Opacity (opaque), and white will represent 0% Opacity (transparent).

In image 02 you can see what the brushes look like. Brush A loosely simulates a traditional paint stroke. This is used to give the final brush a natural shape. Brush B simulates a nondescript gritty texture. This will also help the final brush look natural but

in addition to this the white spaces will allow previous brushstrokes to show through.

Both brushes were created by playing around with other Photoshop brushes, erasing, adding, mixing, until I had something that felt right. This is a very experimental step so feel free to be creative. When I am satisfied, I go to Edit > Define Brush Preset and name each brush.

03: Combining brushes

Now that I have two raw brushes it is time to combine them to finalize the first brush. I choose brush A under Brush Presets and open up the Brush panel. You can find this by going to Window > Brushes. Once there, I make the following adjustments.

- I first check and select Dual Brush and load brush B (the textured brush). You may need to adjust the Size slider until both brushes are a similar width. The preview window will help you do this.

- Next, starting at the top under Brush Tip Shape, I make sure the spacing is around 5%. The lower the spacing the smoother the brushstroke will be. Be aware though that if it is too low it can produce a lag at larger sizes.

- I then go into Shape Dynamics and move the Minimum Diameter slider to around 70% and set the control to Pen Pressure. Now the lighter I press, the smaller the brush will be. I set it to 70% because I want a bit of control but not so much that it becomes a challenge to keep at a steady size.

- Lastly, I set the Angle Jitter to Initial Direction. This allows the brush to have a defined edge when you apply more pressure. Select the Transfer setting so that the harder you press, the more opaque the brushstroke will be.

The first brush for general purpose painting is now complete.

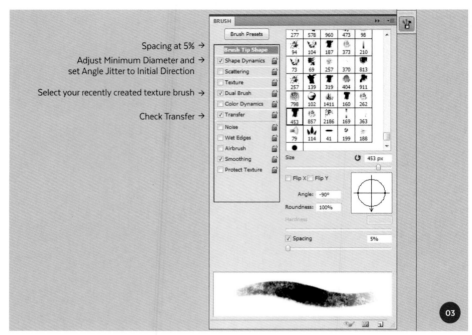

Spacing at 5% →
Adjust Minimum Diameter and → set Angle Jitter to Initial Direction
Select your recently created texture brush →
Check Transfer →

↑ Adjustments in the Brush panel can result in a wide range of brush outcomes

04: Adding in value

Back to the main image, I create a new layer under the sketch and begin to fill in the values with the new general purpose brush. I work out where the light is coming from and how it will highlight the main points of interest. The newly created general purpose brush is able to create both textured strokes as well as hard edges so it is literally two brushes in one.

At this stage I like to separate the foreground, mid-ground, and background into three layers. If you prefer to stick to one layer you can save out selections by using the Lasso tool, then right-click and select Save Selection.

This will add the selection to your Channels tab. I prefer to create layers when objects overlap and selections when they do not.

05: Adding in color

I prefer to start color work early on. It can be beneficial to work in grayscale first as it allows you to focus on one thing at a time. However I am impatient and like to work with both color and value simultaneously. It is really a matter of preference. At this point I work out how the colors will tie in together. I know that the evening light will play a major role in the scene so to emphasize this I use cooler colors in the

↑ Values are added in, taking into account the points of interest, and layers are created and organized into foreground, mid-ground, and background

↑ Make sure you are mindful of the hues, saturation, and temperatures when adding color to your artworks

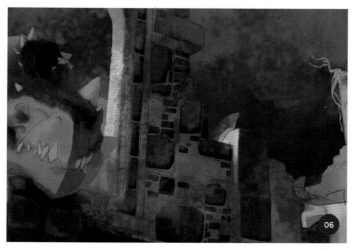

↑ Utilize the Lasso tool in combination with the general purpose brush to produce crisp edges with confident brushstrokes

↑ Sometimes building brushes from photos requires a bit of creativity; the obvious route isn't always the best one

shadows. This helps to bring volume to the form and enhance the sunlit areas.

06: Masking out bricks

Using the Lasso tool I begin to make selections down the walls in a somewhat random fashion. Once I have all the soon-to-be bricks selected I use the general purpose brush to fill them with texture, changing the size and color as I go. I work from big to small by filling in large spaces with texture and gradually decrease the size until I am using the brush to round out corners and add in smaller details. Hitting Ctrl+Shift+I will invert the selection allowing me to work on the space around the bricks. I again fill in the space with texture. This process is repeated throughout the painting.

07: A brush for vegetation

Now that the initial stonework is complete I can add in some vegetation. To do this I need another brush. For this one I will start from a photo. I look for a photo that can emulate the basic form of organic vegetation without being explicitly leaf-like. Creating textures that are too close to photo sources are quite jarring, often resembling a photo collage rather than a painting. After some searching I settle with a photo of a billowy cloud.

08: Turning a cloud into vegetation

As I did before in step 02, I open up a new 400 × 400 pixel document. I then cut out

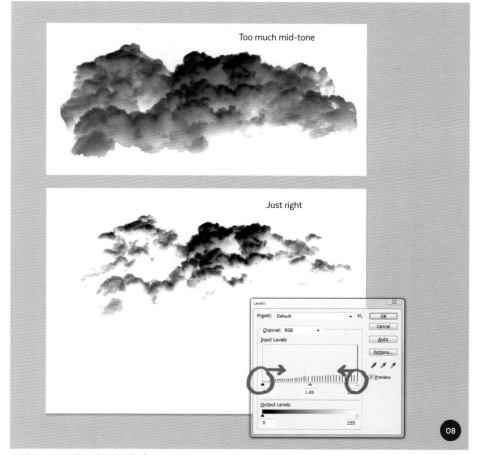

↑ Adjustment tools such as Levels, Curves, and Invert can help you tweak an image in preparation for your future brush

a portion of the cloud that looks the most appealing to me and invert the layer by hitting Ctrl+I. The highlights of the cloud are now black. Remember that the darker the value, the more opaque the paint will be when it comes to using the brush.

The inversion worked quite well but there is not enough contrast and an unwanted gray mid-tone is visible. To remedy this I open up the Levels panel by hitting Ctrl+L or going into Image > Adjustments > Levels. I slide the black and white Levels sliders

↑ Pulling shadows and negative space from a photo is a quick and easy way to create a new brush

↑ Brushes don't have to be constrained to their original purpose, so apply them in a variety of ways

towards the center to increase the contrast. This looks much better so I go to Edit > Define Brush Preset and name the brush.

This brush will act as more of a stamp so I open up the Brush panel as I did earlier and set Spacing to around 90%. I also check Scattering at around 40%. These settings will give the brush enough space between stamping to produce believable-looking vegetation without distracting the eyes with excessive detail.

09: A complementary vegetation brush

The second vegetation brush I will create will be produced from negative space. The process of creating and implementing this brush is going to be similar to before but this time I will pull from the shadows of an image. This process is a little more straightforward.

From a photo I go to Select > Color Range and color pick the darkest shadows. I move the slider until I have a suitable gradient. Once I have that, I click OK and cut out that portion from the photo. I remove the previous photo and flatten the image. Now I go to Filter > Artistic > Paint Daubs. This will remove some of the distracting photo texture and leave a simplified variant of the shadows. I mimic the Brush Preset adjustments from the other vegetation brush and name the new brush.

↑ Patching together new elements using the Lasso tool can be fun and efficient, but don't become lazy

10: Using vegetation brushes

With these newly created brushes, vegetation can be added quickly within a few strokes. Swapping between the two brushes can create a decent portrayal of organic materials. The first brush I created for vegetation using a cloud sample can also, of course, be used for clouds. One or two stamps with this brush is sufficient.

You do have to be careful however when using such a distinct brush so liberally. It can easily flatten the image if the same texture is present throughout. Try to be mindful of the size, color, and contrast. To make sure I don't fall into this trap myself I blur and smudge sections of the clouds slightly to differentiate them from the trees below. In image 10 you can see the versatility these brushes have when used in collaboration with a little creativity.

11: Duplicating pieces of a painting

One of the benefits of digital painting is the ability to duplicate whole portions of a scene with ease. This is a technique I use often: I

Lasso out suitable sections and piece them together to make whole new elements. It is quick and efficient. As you can see in image 11, with a little adjustment the new area does not look like a repetition of the original source and was created in a fraction of the time it would have taken to paint from scratch. It is easy to become lazy with this technique so stay alert and make sure you are still applying the art basics such as value and saturation.

12: Mixing brush

Mixing brushes are a powerful tool. They allow you to blend easily without the need to resample colors and paint values manually. To create a mixing brush I start out with a sample of the very first brush I created, the general purpose brush. This time I fade it to white on one side as this will help with the desired mixing I am aiming for. I save it like before.

I select the Mixer Brush tool by going to the Brush tool and clicking and holding it down or right-clicking to reveal the Mixer Brush. Once I have it, I choose my newly created mixing brush under the Brush Presets panel. In the Presets panel I check the settings Shape Dynamics, Scattering, and Transfer. I keep all the sliders low so that there is just enough variation in the brush edge.

13: Handling a mixing brush

With the brush selected, I go to the Options bar at the top of the screen. Here there is a set of unique options for the Mixer Brush

↑ Sometimes recycling brushes is the best method to use

including sliders for Wet, Load, and Mix, among other things. These will help me tweak the brush to perform in a variety of ways. Wet will dictate how far the paint will streak on the canvas. Load lets you adjust how much reservoir paint will be loaded onto the brush. Mix controls the ratio of paint you have loaded versus the paint on the canvas. Checking Sample All Layers allows the brush to use the paint on all of the layers.

I highly suggest you play around with these options to find something that works best for you. In image 13 you can see my mixing brush in action. Within seconds I transform rough paint strokes into a skin surface with volumetric folds and creases.

14: Final adjustments

With a combination of brushes and techniques, and a little bit of time, *Calm before Chaos* is nearly complete. I tweak the values and colors through the use of Levels and Overlay layers. Once I am satisfied, everything is saved out and a long awaited stretch ensues!

You can download the completed brushes for this tutorial from **www.3dtotalpublishing.com/resources**; you will also find a bonus scale brush which is useful if you are painting a dragon or reptilian creature. To add the brushes to your toolset, open up Tool Presets, click the drop-down menu, and select Load Tool Presets.

↑ With a few strokes, the mixing brush allows me to add volumetric form to the dragon's head

Custom Brushes | Sci-fi

Matt Heath
Illustrator & Concept Artist
Software used: Adobe Photoshop CC

In this tutorial I will explain how to create different brushes from scratch and go through Photoshop's Brush settings to give examples of how much versatility there is available. By the end of this tutorial you will have gained new ideas for creating unique brushes that will undoubtedly speed up your painting workflow.

Although many brushes can create quick effects it is important to have a reliable paintbrush to use for most of your work. I will create a brush similar to an old default oil effect brush that I see many people asking for in forums. Another interesting brush I will create will be a mech brush, which I will use to generate ideas as it allows me to throw random shapes onto the canvas which then lead to new design ideas. This mech brush is also fantastic for adding texture to metal surfaces and for abstract design, as my painting process will demonstrate.

In addition I will show you how to make a **block brush**, which is one of my favorite

types of brush. Once this brush has been created it can be used with the same settings for different images to quickly create elements such as crowds of people, grass, forests, and much more besides.

The fourth brush I will show you will be a cloud brush, which I will use in this painting to create a fire and smoke effect; with some slight variations of settings you can of course easily paint clouds as well. It is a good idea to make two or three cloud brushes to give your skies a natural feel using many layers and tones. The I will start the tutorial by preparing each of the custom brushes in turn. Although some stages of creating the brushes will be repeated, by paying attention to the changes in the settings you will be able to develop an invaluable set of custom brushes.

01: Getting started

The first brush I will create is a paintbrush that will be used for ninety percent of the painting. It is quite versatile and can be

↑ I use the default Hard Round Pressure Opacity brush from the Brush Presets panel to start my first brush

↑ I paint a horizontal shape with vertical teeth, using the Blur More filter and white and black tones to create texture

used for sketching and painting to create hard edges and flowing brushstrokes. I use this brush to avoid wasting time changing brushes; instead I can paint quickly adding ideas and texture with only one brush.

I create the paintbrush from one of Photoshop's default brushes. To return to the default brushes I first choose the Brush tool and then in the Brush Presets panel I click the Options tab. I choose to view the presets as a list then click Options again and Reset Brushes, and then choose Append. This gives me the default brush set with the brush's original settings. I choose the brush named Hard Round Pressure Opacity. Be aware that by pressing OK when resetting the brushes you may lose any previously added custom brushes.

02: Shaping the first brush

I open a new document of 800 × 800 pixels, set at 72 pixels/inch in Grayscale Color Mode set at 8 bit. I will do this for every custom brush in this tutorial. With the Lasso tool I draw an outline of a rough horizontal shape with short vertical strokes that look like teeth underneath (image 02). I hold down the Shift key to add the extra teeth. On a separate layer, using the Round brush, I color within the selection in black. I deselect the shape, select Filter > Blur > Blur More, then click the layer in the Layers palette holding Ctrl to reselect the shape.

I change the paint color to white, as I want to vary the darkness of the black and white ratio to as you can see in image 02. I also use the Lasso tool again to create more shapes and paint in more texture. Then I once again use the Blur More filter before flattening the image. I go to Edit > Define Brush Preset and click OK. This new brush shape can now be used to paint portraits, landscapes, and much more.

03: Exploring brush settings

If you try to paint with this new shape you will find that it is clunky and not very expressive, but here is where the fun begins. I open the Brush panel and adjust the settings. I set the Brush Tip Shape Spacing to 4% and select Shape Dynamics. In Shape Dynamics I set Size Jitter to 0% with Pen Pressure. I also set Minimum Diameter to 70%.

Then I select Color Dynamics, switch Control off, and set Brightness Jitter to 3%. I also select Transfer with Control on Pen Pressure and Minimum set to 20%. Finally I select Smoothing then go back to the Options menu and click New Brush Preset and name my new brush "Paintbrush." If you try painting with this brush you will see that it has flow and expression, depending on how hard you press on your tablet. Experiment with these settings and see if you can develop some good variations.

↑ Learning the functions of brush settings will unlock the key to painting efficiently

↑ This simple shape can create versatile ideas and be used for mechs and sci-fi buildings

↑ This will paint a city but the settings can be tweaked to create endless brushes

↑ The cloud brush can be used to create clouds or smoke but needs to match the light direction of the scene

↑ I create thumbnails then a very rough sketch of the best thumbnail to develop the composition

04: Creating a mech brush

I now move on to creating my next brush, the mech brush. I create a new document exactly as before and use the Lasso tool to make a simple shape that could be used for a mech (image 04). I try to not make it too specific so that the brush remains abstract when painting. With this technique I can create original shapes and happy accidents.

In the Brush Presets panel I set Spacing to 60% then select Shape Dynamics with Size Jitter set to 50% and Control set to Pen Pressure. I set Minimum Diameter to 20%, with Angle Jitter at 0% and set to Direction. Roundness Jitter is set to 50% with Control off. I also select both Flip X Jitter and Flip Y Jitter. I then select Scattering and set Scatter to 140%,

checking Both Axes then setting Count to 1 and Count Jitter to 1%. In Transfer I set Opacity Jitter to 0% with Control on Pen Pressure and Minimum at 50%. Again I select Smoothing as a final setting and click New Brush Preset to name my new brush "Mech Brush."

> "I can now drag this brush horizontally to create distant cityscapes in my scenes ... I can also try different layers of color to create more depth"

05: A city with a swipe

The next brush I want for my image is a block brush. I will use this brush for

sketching in cities and adding texture to hard surfaces such as metal.

With the Rectangular Marquee tool I create a simple rectangle and fill it, keeping the same default brush presets as before. Then I adjust the settings so that the Brush Tip Shape has 100% Spacing and Shape Dynamics is selected. Size Jitter is at 20% this time and set to Pen Pressure, and Minimum Diameter is also at 20%. I set Angle Jitter to 0% with Control off. Roundness Jitter is at 90% with Control also on Pen Pressure; I select both Flip X Jitter and Flip Y Jitter again. Scattering is selected and set at 100% with Control off and Count at 3. This time

I also select Transfer with Opacity Jitter at 0% and Pen Pressure; Minimum is at 0%.

I can now drag this brush horizontally to create distant cityscapes in my scenes. When using this brush I can also try different layers of color to create more depth.

06: Clouds made easy

The last brush I want to create is a cloud or smoke brush. This time I start with the default Soft Round Pressure Opacity brush and paint a cloud-like shape. I make sure I vary the tones and keep them fluffy. Spending about ten minutes on this shape, I take care to remember which side I want the light to come from in the image, which in this case is the right-hand side.

For the settings on this brush I use Spacing at 5% and again select Shape Dynamics. Size Jitter is set to 15% with Control on Pen Pressure. I set Minimum Diameter to 45% and Angle Jitter to 0% with Pen Pressure. Roundness Jitter is this time set at 50% with Control off and both Flip X Jitter and Flip Y Jitter selected. Again, I select Scattering with 50% Scatter and Both Axes selected. I set Count to 1 with Count

Jitter at 25% and Control on Pen Tilt. Then I select Transfer with Opacity Jitter at 75% and Pen Pressure. Minimum is 0%, as is Flow Jitter, and Control is set to Pen Pressure.

This cloud brush can be used for anything from painting smoke to clouds in a breeze. In the scene I am going to create here I will only be using this brush lightly, and want to vary between dragged strokes and light taps to create random clouds.

07: Sketching stage

When it comes to starting a new artwork I spend my first half hour drawing tiny thumbnail sketches. I always try to do at least thirty so that I get many different ideas for compositions. I find that if I just start with my first idea I often come across mistakes and make drastic changes later on. With thumbnails I can throw every idea on a page, step back, and then choose the best one.

For this sketch I will create a sci-fi image set in space. I have few winning thumbnail ideas so I decide to combine them. I take the character from one into the background

of another to create a rough sketch of a saboteur exploring a strange planet with the rings of Saturn in the background.

08: Value and composition

Very important to any composition is the relationship between light and dark values. Once the sketch is complete it is time to lay in the largest shapes with their values. Making sure this is correct early on helps to establish where the eyes will travel over an artwork and what the main focal point of the image will be once it is complete.

I already decide to switch my character to a more dynamic pose, but I also feel that the rings of Saturn might easily take over the picture. As epic as it might have been, I think that Saturn will have to be removed.

> "For some of the rock formations I make a new, full-sized file and paint them as quick sketches. When I bring them into the composition and scale them down it adds a lot of detail"

↑ Getting the composition values right early is important for a successful painting

↑ Adding in easy details and trying out different design ideas

↑ Using the new mech brush to generate abstract design ideas

09: Environment and character design

Using my brand new paintbrush I spend some time adding detail to all my background, mid-ground, and foreground elements. For some of the rock formations I make a new, full-sized file and paint them as quick sketches. When I bring them into the composition and scale them down it adds a lot of detail without too much time being spent painting every little rock and detail.

Saturn from my early sketch is replaced with Mars, which will create a pleasing red shape in the background when I color it later. I also make a rough sketch of the saboteur's exoskeleton design at this stage and add some rocks as foreground detail on a separate layer.

10: Abstract building design

Now it is time to experiment. Here I take the new mech brush and on a new layer I paint random shapes, using the Undo function if necessary, until I develop a pleasing shape for a sci-fi structure. You may want to try making a second brush using the steps shown previously

⚡ PRO TIP
Not too much detail

The great thing about custom brushes is the ability to fool the eye into seeing detail where there is not. In any composition it is important to keep the majority of detail in the most significant part of the image, for example in the character's face. So having every building detailed in my scene would detract from this main area of focus. Close up you can see the layers and mess but at full size the eye can interpret these marks as buildings and move back to the main focus while still understanding the piece as a whole.

↑ Let the brushes do the work and leave details out of less important areas

↑ Working on the abstract brushstrokes of the mech brush is a fast way to develop original ideas

to create shorter, blocky shapes and experiment with the Scatter settings to push the ideas.

It is also handy to use the mech brush as an eraser to cut into shapes. Depending on the design of the brush you can sometimes achieve a great sense of perspective, something that has not been very apparent in this artwork so far.

11: Making sense of the abstract

From my abstract brushstrokes I now have a design that I am reasonably happy with. I have made another simple square-shaped brush and some more abstract shapes to maintain a sci-fi feel in the design. With layers of the mech brush I am able to paint some machinery or buildings which are starting to form on the left. What I really like about this brush is that its results are quite open to interpretation; you could even use this brush to create a stylized landscape.

12: Painting a city in seconds

Now for the block brush. It actually takes me less time to effectively paint a city with the block brush than it did to make the

brush earlier, but it was definitely time well spent as I can use this brush again in future paintings. With groups of buildings scattered around the larger structure in the landscape the painting now has a greater sense of scale and depth. I will add more buildings later on when I take the scene into color.

Now I go to the Brush settings and change the brush's rotation angle to 90%. I can use it to add some lights to the city, which is another benefit of this brush. I will also use it with a tiny brush size in order to add some dirt and rocks to the landscape.

↑ Painting with the block brush creates a cityscape in seconds

13: Where there's smoke...

This is quite a simple step and, like the last brush, it is really quick for creating effective results. After looking up images of explosions I use the cloud brush to replicate this effect. Sometimes a really fast stroke is perfect first time but, as before, I keep in mind the Undo function until I create a shape I am really happy with. For the moment I paint the explosion in white simply to see where it will work in the composition. I will use this brush again when I go to full color with layers of smoke and explosions.

14: Lots of painting

Even custom brushes cannot replace the need for lots of painting; I use the brushes

for effects but am still using my reliable paintbrush to blend it all together. It seems that I have hardly used the other custom brushes in this piece but the fact is they have saved me thousands of brushstrokes.

Now I add stacks of mess to the planet, more rocks everywhere, and plenty of texture to the metal buildings. As a result I have a better design for both the character and the building.

15: Adding color

My coloring phase is usually fairly quick since I spend so much time putting my values down first. I create a new layer above all the others and set the mode to Color.

I want the landscape to have a brown, rock-like hue but I also want to add some complementary hues in the details. If you look at the cliffs on the right of the image you will see that I use browns and reds for the highlights and some blues and purples for the shadows. I am careful not to change the values that I established previously here.

16: Adding the explosion and detail

In this phase I spend most of the time painting and continue to make changes. I feel that the hills are too busy so I flatten

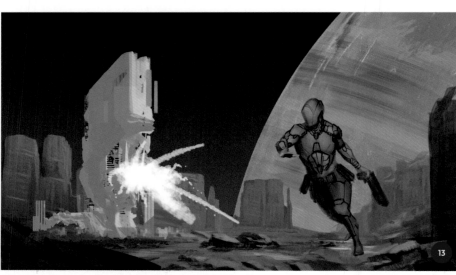
↑ Painting explosions and smoke is simplified using the cloud brush

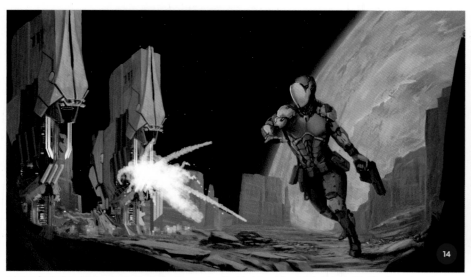
↑ Lots of painting with the standard paintbrush, as well as the block brush for details, helps to bind the image together

⚡ PRO TIP
Mini composition
It can be useful to isolate important segments of your illustration and address the composition in that part alone. There is a lot going on in this piece so decide to slow down the right side of the image. The planet in the background creates a gentle curve towards the character's visor and the colors here are more saturated to draw the eye into this focal area. I also design the scene so that it could be cropped as a vertical or as a larger horizontal image and still be interesting.

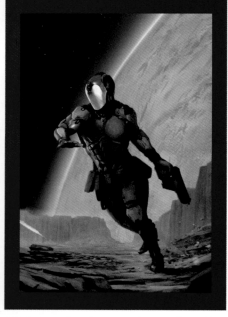
↑ Designing an alternate crop so an image can be used in different formats can be helpful

out the ridge line and add haze and dust to give the effect of distance. I also spend time adding detail to the explosion. I use the cloud brush and look at more reference images to make sure it has a realistic appearance.

I decide that the background is too saturated and pull the color back a lot. Most of the time here is spent painting the foreground rocks, using a complementary blue/gray against the red dirt and painting in dark contrast in the shadow areas. I also simplify the towers as I feel that there are too many angles and shapes distracting from the action in the scene.

17: The final push

Finally, I spend some time working on the character, pushing the contrast hard as it is the main focal point of the picture. I give the saboteur's visor a glossy metallic and painted feel using highlights, and apply the same to the bicep and abdominal area of the armor. I use the paintbrush and occasionally the Smudge tool to bevel or round off edges as I feel necessary. I also

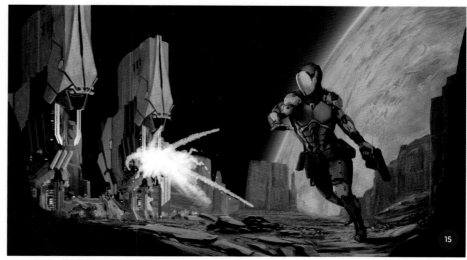

↑ Adding color can be simple if you have concentrated on the value painting

darken the towers, and add more fog and some rocky debris near the character's feet.

For the final touches I flatten the image and add a Film Grain filter and a subtle Lens Flare. I also use the Color Lookup tool in the Adjustments panel, which helps to pull all the colors in the image together. If you have never used it before you should definitely experiment with it. I have

found that Photoshop is only limited by the user's knowledge so this tutorial should help you to jump to another level of creativity.

"For the final touches I flatten the image and add a Film Grain filter and a subtle Lens Flare. I also use the Color Lookup tool in the Adjustments panel"

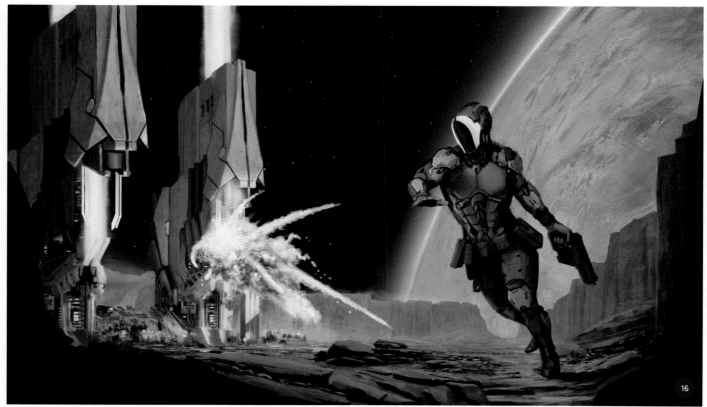

↑ I spend time adding and refining details, and making color adjustments to enhance the image

Custom Brushes | Otherworldly structures

Arthur Haas
Concept Artist & Illustrator
Software used: Adobe Photoshop

In this tutorial I will show you how to turn an abstract image into a full-blown science-fiction scene. You will discover how I find an abstract setting by creating a huge file in which I throw a mixture of custom brushes onto several layers and then zoom in, hunting for pleasing compositions. I will also demonstrate how the Smudge tool can be used to reshape parts of an initial image.

The main technique I want to show you though is how the incredible and versatile Mixer brush can be used. I will show you how you can quickly add detail to your scene by cloning existing areas of your work with this useful tool that can adapt to any brush shape. The key difference between a regular custom brush and the Mixer brush is that the Mixer brush can pick up and clone color information, whereas a paintbrush will only give you shades of gray.

I will be using this technique heavily in this tutorial – call it exploded enthusiasm, or newfound love. What I hope to convey is the

benefit of using both the Mixer brush and the Smudge tool quickly and in a playful way. I invite you to make your own variations of these tools simply because doing so can be very rewarding. In some places my method or brush shape is based on that of another artist so I will let you know when this is the case; we never stop learning from one another, whether we realize it or not.

01: First brush

The shape of the brush I am going to create here is based on a brush by David Levy (http://vyle-art.com) which I will adapt to make it more personal. It is a great brush for painting the hulls of spaceships and buildings, for example. I set the brush to 91% Spacing, select Shape Dynamics, and set Size Jitter to Pen Pressure with a Minimum Diameter of 0%. The Angle Jitter could be set to Pen Tilt, but as I use an art pen which has rotation control I set Angle Jitter to Rotation. Finally I set Roundness Jitter to Pen Pressure and select both Flip X Jitter and Flip Y Jitter for

↑ This first brush is useful for painting buildings and the main bodies of spaceships

↑ The second brush has an unusual shape but I find that it is quite versatile

↑ With the Dual Brush setting selected, the first and second brushes can be combined to create this effect

more unexpected results. I decide not to use Transfer because the brush already has a lot of gray values. I then save this brush by clicking the triangle in the upper right corner of the Brush Presets panel, selecting New Preset from the menu, and entering a brush name.

02: Combining brushes

This next brush looks a bit weird but it has quite a few uses. It is especially useful if, as will be in this case, you need a source for a dual brush effect. First I use the image shown in image 02a to make a regular brush with the same settings as the brush from step 01 and save it. Then I select the brush from step 01, check the Dual Brush option in the Brush panel, and click on "Dual Brush." I select the second brush image in the Brush Preset window and start playing with the settings below it. In this case I set Diameter to 929 pixels, Spacing to 71%, Scatter to 311% and Count to 5. However, I do invite you to play with these settings yourself. The brushstrokes this new brush effect generates are demonstrated in image 02b.

03: Deformed brush

The fun doesn't end with combining two brushes; in fact the possibilities with custom brushes are endless. I will

↑ A new brush shape can be created by altering a brushstroke with the Smudge tool

manipulate strokes of the combined brush to use as a base for yet another custom brush shape; a deformed brush. The Smudge tool is perfect for this job. I use square- and rectangular-shaped brushes with the Smudge tool at 99% Strength (or 100% if you are using Photoshop CS5 or earlier) to push and pull parts of that brushstroke in different directions. I have set the Smudge

tool so that Shape Dynamics is selected with Angle Jitter again set to Pen Tilt. I also set Size Control to Off; Transfer is left unselected.

I save this tool on the Tool Presets palette and switch back to the Brush tool. I then capture this new brush shape with Edit > Define Brush Preset and give it roughly the same settings as the first brush.

04: Finding a composition

A YouTube video by Scott Robertson called *Custom Brushes and Actions* has helped me discover a playful method for finding compositions. In a huge file I fill several layers using the previous brushes.

I start with the background layer, using a black color and a low opacity to put strokes down. Each layer has more opacity than the one below it, until the foreground layer has dark strokes which suggest abstract, technical-looking structures. Next, I zoom to explore the shapes and find pleasing images. I am looking for potential, using my imagination to see what might emerge.

Flipping this file horizontally and vertically and rotating it by 90 degrees all help me to see it afresh. I also find that turning layers on and off, and playing with their opacity or layer modes, gives me new options. With the Rectangular Marquee tool I select a part of the image, crop it, and save it under another name.

05: Imagining the composition

Now the choice for the composition is made. The fun here, I find, is the potential

↑ Experimenting with brushstrokes on layers, then selecting an interesting area with the Rectangular Marquee tool

↑ With a starting point for a composition, avoid letting your initial vision for the scene overpower new potential

of what I could create; the image can still go in many directions, which is an exciting and useful starting point. The trick is not to become too hooked on what you can see in your imagination. Not only is it frustrating to try to put the scene in your mind down on the screen, it can also get in the way of something

unexpected that may be more fabulous. In any case, I have not yet managed to come really close to my initial vision.

06: Adding color

Adding color early in the process helps to gain even more of a feeling for the atmosphere of the image. Because I cropped the image from the huge file in step 04 and saved under another name, I still have all the original layers. On top of each layer I add a new layer set to Color mode. I Ctrl+click on the underlying layer to select its pixels, and then Edit > Fill that Color layer with a color of my choice.

Having filled only the pixels of the underlying layer I can easily merge them (Ctrl+E) into one, keeping my original layer structure intact. With the Smudge tool I start displacing some of the shapes. Now I start to see a ground or water plane forming in the image.

07: Mixer brush settings

The process from the color sketch to putting down a hi-tech building is surprisingly quick, if you know how. After I have added a pinkish color and smudged the foreground

↑ Filling the image with color then using the Smudge tool again to displace shapes until defined areas are formed

↑ Adjusting the settings of existing brushes creates a pattern brush which can be used to paint buildings

↑ The Mixer brush enables the creation of experimental shapes and patterns

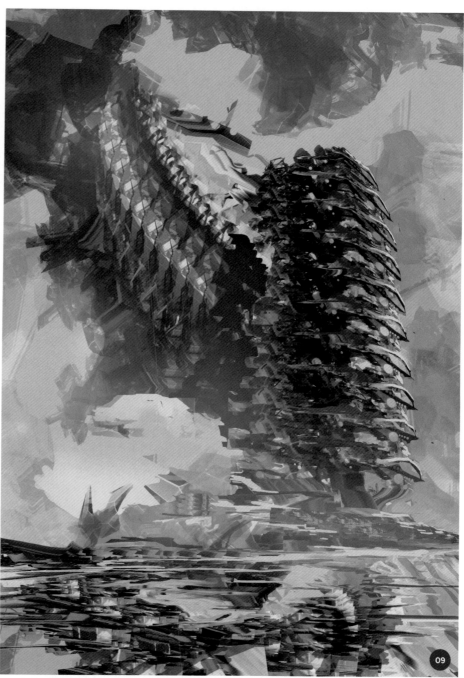

↑ I paint fog between buildings with a light color at a low opacity to create depth

shapes a bit, I select the Mixer brush, and on the Options bar at top of the screen I select a dry, heavy-load preset which has the following settings: 0% Wet, 100% Load, and 100% Flow. I select Sample All Layers.

Then I select the unusual brush shape from step 02 and modify it in the Brush Tip Shape settings of the Brush panel, where I set Spacing to 37%. I select Shape Dynamics by clicking on the word in the Brush Presets panel. I turn off Angle Jitter and Flip X and Flip Y Jitters, and make sure there is no Roundness Control. This gives me a nice pattern brush to play with, which you can see in image 07. I then save this in the Tool Presets panel.

08: Experimental brushstrokes

With the Mixer brush selected again I Alt+click in the image to pick up interesting patterns and put down some brushstrokes. The result is never quite the same, which makes for good experimentation.

I flip or rotate the source image, varying the Spacing settings on the brush.

It is good to understand that although the shape of the brushstroke may vary, the size of the source will stay the same. That is why you can see that the strokes at the top in image 08 have a different pattern than those at the bottom. Of course these strokes can themselves become the source for more strokes.

09: Painting depth

Getting carried away with all this experimenting, I simply abandon the original sketch. Sometimes that is how it goes and it is best to just go along with it. A building of some sort has emerged and it seems to be attached to a larger structure in the distance. To accentuate that distance I add fog using a cloud brush and a light blue horizon color with 30% Opacity.

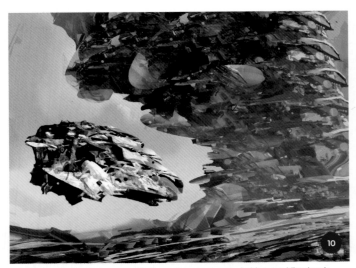

↑ A ship is added to the image and bulbous shapes are created with a new Mixer brush

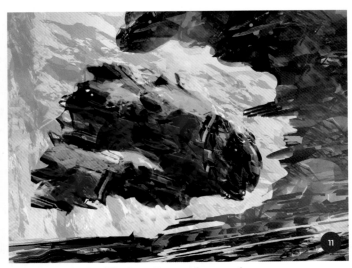

↑ The ship is replaced and Warp is used to correct the perspective

I add shadow to these forms too with a rectangular brush. A few random Mixer brush strokes in the foreground are smeared out with the Smudge tool set to 99% Strength and that same rectangular brush shape.

10: Building bulbs

By adding a spaceship and tilting the horizon, the image becomes more dynamic. The bulbous shapes on the building are made with a new Mixer brush which I design for this purpose. To make it I take a round shape with a gradual drop off at the bottom and then I Alt+click to pick up a pattern within the building. Because Sample All Layers is selected for the Mixer brush, a bit of the sky is accidently picked up too. I like it – happy accidents are very useful! The foreground also receives some more smearing and becomes a kind of technical rock formation.

11: A new ship

I find that the ship I have does not fit the image so using a ship-parts source file I have kept over the years (see the pro tip on the right here), I quickly put down a few strokes, add some shadow, and add a low-opacity black and light blue on a Luminosity layer.

I warp (Edit > Transform > Warp) the building slightly to correct the perspective, remove some fog from the top of it to make it more prominent, and add some rocks in the background.

12: Final details

Flipping the image regularly keeps my eyes fresh after hours of painting. I decide that this image looks better this way. A few more strokes from that ship source file bring a smaller shuttle into the picture, which I play around with for a while, deciding where the best place to put it is. Using the Custom Shape tool I make an ellipse which will be the landing pad, lock the layer's transparent pixels, and add light to it. With a Mixer brush with lower Spacing settings than before, I add a beam to the shuttle. I also add another building element in the foreground at the top of the image to direct the focus towards the ground. A bit of shadow on the top of the main building helps this too. Finally I add some people in to help give the scene some life, scale, and context. You can see the final image on the next page.

> ### ⚡ PRO TIP
> #### Ship parts
> The spaceship is no more than two or three strokes with the Mixer brush. I have created a ship source file by collecting almost every spaceship I have made in recent years and I use this to pick up shapes with the Mixer brush. On top of all those spaceship layers I put a layer in Color mode and fill it with a random color. This way I can give all those ships the same tone, preventing the new Mixer-brush-created ship from looking like a quilt blanket.
>
>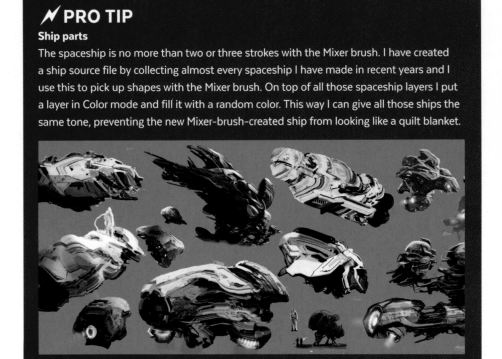
>
> ↑ Try collecting old ships together in one file to use in future works

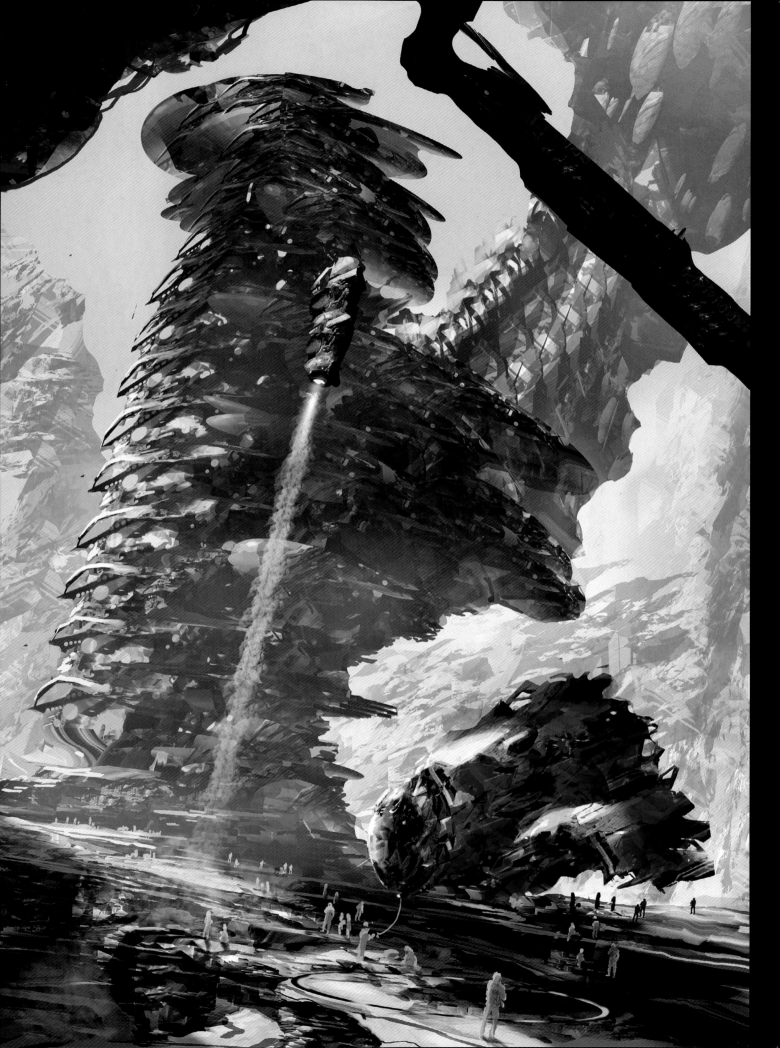

Custom Brushes | Cityscapes

Marcin Rubinkowski
Senior Concept Artist
Software used: Adobe Photoshop

In this tutorial I will explore how to make custom brushes for painting a city. These brushes can be used almost like stamps to build up an environment quickly. The process is simple: I will take photos of cities with my camera and also use my imagination before applying some organizational rules and a few useful tricks. I will not show you how I create the cityscape image itself but will instead focus on the brushes and the best ways to prepare material for them.

When you shoot photos for your brushes, think about background, mid-ground, and foreground, and observe where elements are placed in the city space. Learn from real cities and make sure you have some short- and wide-angle examples in your collection.

Try to have fun with this tutorial and know that the same methods for creating these custom brushes can be useful for many different situations; the only limit is your imagination. In the end it is not the tool making the painting,

but you. Remember that these brushes are only a device to speed up your process, usually in the sketchy beginning where you are looking for interesting compositions. Later when you are setting details they can ruin your painting if you rely on them too much. A tool cannot solve every problem and will certainly not make the painting for you. The main points you should keep in mind when creating custom brushes for cityscapes are:

· work in black and white only;

· make a few different documents to use in the pipeline;

· remember that white is transparent and gray is your enemy;

· make your own trips to cities to understand and get a feel for cityscapes.

The first few steps of this tutorial will discuss how to gather the best

photos for your brushes. I will then set up the various documents I require for the process before moving on to creating and testing the brushes.

01: Organization

The first rule for creating custom brushes is to work on at least three open documents. You need one document to be a place to open photo material, one document to be a "brush factory" in grayscale, and a third document (also in black and white) where you will test how everything looks and maybe start to paint some thumbnails as well.

To avoid becoming lost in the middle of making brushes and ending up with useless content, I categorize my city brushes into four categories: silhouettes, buildings, accents, and city lights. You can make your own categories but remember that you will definitely need main content brushes, accents brushes, and light brushes to be fully equipped.

02: Collecting technical resources

Sharp and clean resources equal nice looking brushes, which is why on my first city trip I choose to shoot in daylight. I try to avoid deep shadows; I know that they can look great but I do not need them here. I also take photos at a greater distance from the target to avoid distortions from the lens and viewpoint, especially for the silhouettes and building materials.

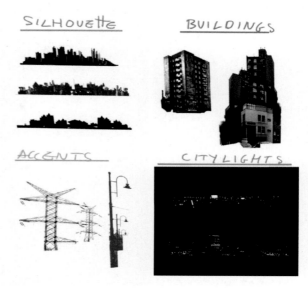

↑ Keep your brush creation organized by using three separate documents and categorizing the brushes you need

On the second trip, or later the same day, I shoot the lights for the cityscape. I focus on the city lights and light groups, and try to have as much particle light as I can in one picture. Lights on the buildings are also interesting so I want photos of these. This time I have a camera tripod and I need to give the camera enough time to catch the light (at night it takes longer for a camera to be able to capture an image). For city light brushes I will need to take mostly dark images so that the lights stand out.

03: Breaking down the city

There are two things that I will try to achieve in this step. First, I will take photos for my brushes, but I will also try to understand the city's rhythm. I observe the city's order of composition and the routines of its shapes.

Human-made elements have many different angles and silhouettes compared with natural elements, and the balance between these is key; for example a general rule for a post-apocalyptic setting is that there should be a relationship between the natural (rounded) and the human-made (rectangular). Make sure you examine this relationship properly. If you do not have a city near you to study, use resources from sites such as **http://freetextures.3dtotal.com**.

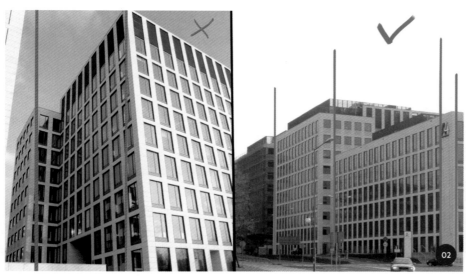

↑ When taking photos try to capture buildings without shadows or awkward angles

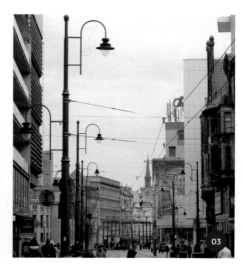

↑ Concentrate on the shapes and rhythms of the city; note differences between the human-made and natural

04: Sorting the material

After I have taken thousands of city photos I must sort the material. When you do this remember that you are not choosing the most beautiful photo – you need to find material that will be easy to cut out. Sometimes even a badly cropped picture can give you what you need if it is sharp and clean. I seek shapes that are visible on a flat background. This situation is a little similar to green-screen shooting in the movie industry. With computer software, it is easier to cut out content if it has a very different color from the background it sits on. This step can be dull but I need to make sure I pick readable content. In the end I try to have a maximum of fifteen good, clean daylight images and five from my night adventure.

05: Brush factory setup

For the brush factory, I make a new document of 2,000 × 2,000 pixels in grayscale. In this document I will create my brushes using the Define Brush Preset option. This will make a brush from whatever is visible on the canvas; the white color will be transparent, so it is important not to mess with the white background layer.

In the brush factory document, everything must be burned or over-contrasted, and you should consider white and gradient blending your worst enemy. You are a builder here and

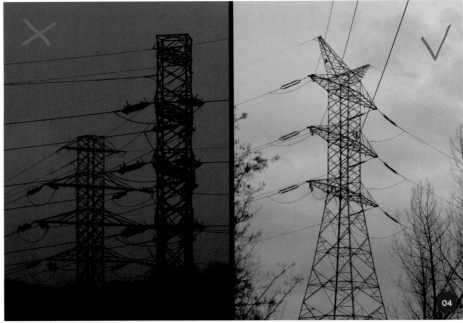

↑ It is easier to cut out content if it has a different color to its background

you can see only in black and white. As I do not want blurred particles on the edges, I will use either the Lasso tool or Quick Selection tool for cutting and adding selections with the Ctrl, Alt, and Shift buttons. I will use a wide aspect ratio for almost all of my brushes and will definitely need background brushes to be at a horizontal angle. The buildings and accents can be vertical, but I do not want to just make big cube shapes as they can be really hard to handle.

When I use the brush factory I try to think like a junior construction worker, using a test layer to be sure of what I am doing. When it comes

to making brushes, do not be afraid to make mistakes and try many versions. You should be learning here and this means making mistakes and fixing them. You can always use the brush manager to delete brushes you do not need.

06: Test and thumbnails document setup

To make a test piece, I create a black-and-white document and divide the canvas into a minimum of three wide shots. I use the Rectangular Marquee tool to make borders and fill them with color by painting on them with a brush or simply filling it with

↑ On a new canvas I experiment using Define Brush Preset to make new brushes

↑ I create a test document for my brushes, dividing the space into thumbnails with the Rectangular Marquee tool

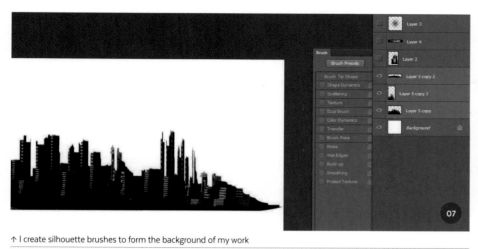

↑ I create silhouette brushes to form the background of my work

↑ Use a photograph taken at a greater distance to make a building brush with greater symmetry

↑ A brush made from only one floor of a building can create pleasing-looking architecture in your work

black using the Paint Bucket tool. I then copy that layer and build my three frames. Finally I either merge or group the three frames and lock them on the layer stack.

I will be painting below the borders in this document and it will become my chaotic play area for trying brushes and being creative. I will be painting from background to mid-ground to foreground, which means I might also be able to generate interesting new ideas or fresh environment concept thumbnails. My advice is to flip the canvas horizontally every once in a while and occasionally try to use an airbrush and atmospheric brushes for creating depth and adding atmosphere.

07: Silhouette brushes

Now my documents are prepared I can start to create the brushes. I will mostly be using silhouette brushes for the background. The point here is to make interesting cityscape brushes with appealing buildings inside. With Photoshop you can cheat a little bit, so do not be afraid to paint over and redesign your material to connect building lines to make an attractive, full horizon line.

It is important to note that, in the end, these silhouettes should look like they are from the same family and all the content must be desaturated to only one color. I make a couple of these kinds of brushes and try to make them as universal as I can, as I will mostly be using them as a base. The final effect should look like an island with buildings in place of palm trees, and I have at least three of them in my inventory. Refer back to page 83 for steps on creating and saving your brush.

08: Building brushes

For the buildings I make brushes that consist of one building or, at most, two buildings. I do not think of them as buildings but instead as big shapes. I will set my composition with them, so it is good to have at least four in my cityscape brush set.

I choose buildings shot from a distance as they will be more symmetrical and easy to manage (image 08a). I can try to fix small distortions with transformation tools but trying to paint with a warped building brush is not easy. Sometimes it is better to copy only one floor from a building and make a brush from that, as the spacing can give you attractive-looking buildings (image 08b). Have fun with the brush options, but remember that a city needs order and geometry. Do not change that order. Once I am happy, I save the brushes.

09: Accent brushes

The cityscape will need messy accents that you would find in a real-life city, such as water towers, signs, and antennae. They can be big or small, it does not matter. Accents are something it can be tempting to place everywhere, but they are only tools for fixing compositions quickly.

I do not want to make wire brushes as I can paint wires with a hard round brush. It is good however to have brushes for elements such as antennae, city machinery, and staircases. I make a general accent category for these brushes. Hard-to-draw items are more than welcome here. Having these types of brushes is very useful so it is worth making a lot of them.

10: City light brushes

Making a brush for painting city lights is slightly trickier. I take my night photos and increase the contrast in them using the Levels adjustment tool so that they are almost black with lights (image 10a). I then go to Image > Adjustments > Invert, which inverts the colors. I then redesign the image with the Lasso tool and copy and paste more lights in one place in a horizontal arrangement (image 10b). I save the brush and then test it with white in my thumbnail document. In my opinion this is the most interesting method for suggesting life in a city and is an easy way to add life to focal points. All the brushes I have created will work well if they are used wisely.

11: Experimenting with settings

At this stage I mix it all up and add textures to the brushes. You should research tools and find your own way of making adjustments to them. Personally I like to experiment with brush settings, particularly the Brush Projection and Dual Brush options. Sometimes when I feel stuck in my art and need to refresh it is good to try interesting brush options such as Scattering for plants or blending modes for lights.

The whole idea of these options in Photoshop is to speed up your workflow, but the brushes need to suit you because you must feel free using them. The brushes should be easy to

↑ I make a variety of brushes capturing the messy elements of a cityscape to be accents

↑ I invert a night photo and redesign it with the Lasso tool to focus the lights in one area

↑ I test out the new lights brush on the thumbnail document to see how it will add life to the scene

understand and find places for in a composition. Do not limit yourself but remember that while artists have really great ideas for brushes, it is more important part to understand how and why they are made and used.

12: Testing and using the brushes

I go back to the test document to play with the new brushes to see how they work. By now I have had lots of fun and have developed many ideas with this document, meaning I can now start to work on the actual artwork. It is

up to you what you will do with the brushes, but I have learned that content created by a fresh and stimulated mind is usually the best. Sometimes it is a matter of a little cleaning or some flips of the canvas to see how the composition is working. You can see how I use the custom brushes I have created to produce different cityscapes on the next page. This is the end of the tutorial, but your brush creation practice should not end here. It is something that I think all of us should expand upon often, and the same goes with other art tools.

↑ I experiment with the brushes using settings such as the Dual Brush option

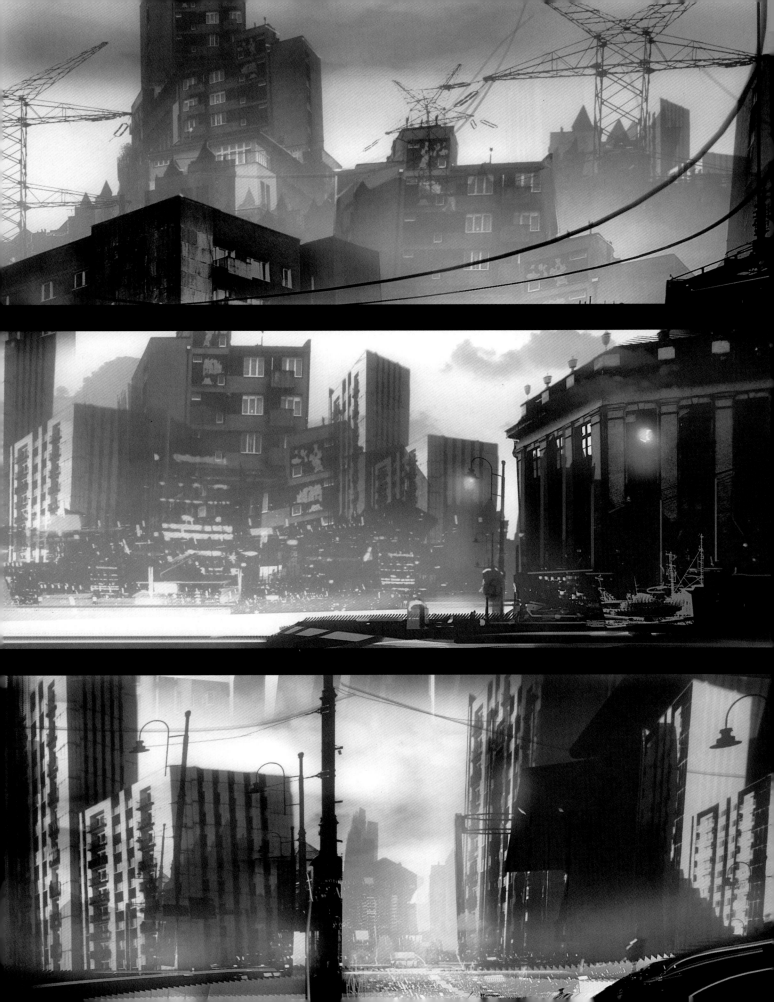

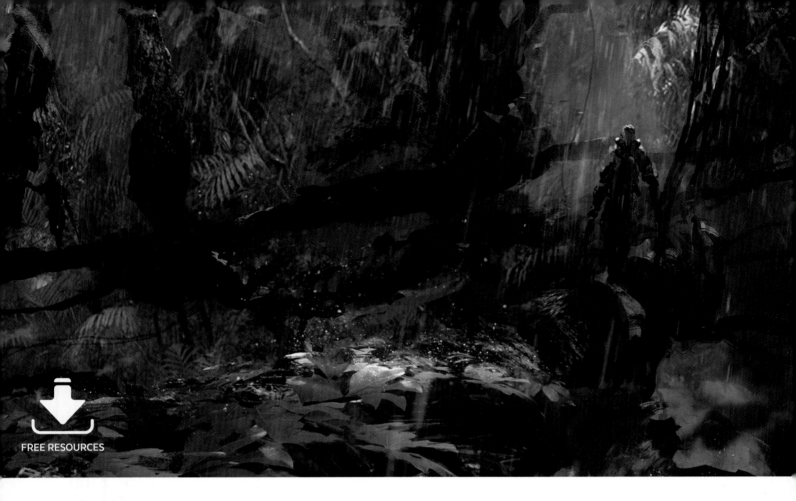

Custom Brushes | Weather effects

In this tutorial I will show you my process for creating illustrations like the image I am going to create here, called *Tropical Rain*, and how additional weather effects can be added with custom brushes. I will show you how you can create an interesting cloud brush to add weather and mood to your paintings, as well as demonstrate the stages of creating the work itself. The main sources of inspiration I use when I create an atmospheric work such as this are images of jungles, rain, humid atmospheres, and fantastic trees. I often like to invent a story about an adventure too.

01: Searching for an environment

At the initial stage of creating a work I focus my attention on the search for a scene which has a

Wadim Kashin
Freelance Illustrator & Concept Artist
Software used: Adobe Photoshop

Images from www.textures.com

01a

↑ Find interesting photos to use as a base and to introduce fragment elements into your scene

↑ I add fragments of other photo such as tree trunks by selecting areas with the Magnetic Lasso tool

↑ The technique of taking fragments of photos with the Magnetic Lasso tool quickly creates an interesting design to start painting over

general design and color that is interesting. To search for a design I start to view and analyze photos online. As the main elements of the artwork I want to create here are a jungle and a rain effect, I look for a tropical jungle photo which is best suited for this illustration.

Having found suitable pictures (usually four or five pieces), I change their colors with the help of the Color Balance and Match Color tools, thereby trying to unify the photos in one color. If I see a particular element of a photo I like, I add this to a base photo (image 01a) using the Magnetic Lasso tool, which makes it easy to select shapes with complex outlines (image 01b). This is a very convenient way to save time as you come across interesting scenes in your research.

I often find that when using this method of searching for a design and adding in fragments from other photos, I will not only find some interesting photos and compositions, but can also imagine and develop better, unexpected options.

> "This exaggeration will add an impression of futurism and mystery to the illustration as a whole"

02: Starting to paint

Now that I have made elementary manipulations with color adjustment tools and located fragments from other photos onto the base (image 02a), I proceed to paint the first strokes of light and shape outlines with a brush.

In the background I paint dark blue and gray colors to start defining the depth of the composition (image 02b). Then in the foreground and mid-ground I start to draw the first shapes and structures.

Since the idea of the tropics is quite extensive, I decide to experiment with creating huge roots and branches of trees. This exaggeration will add an impression of futurism and mystery to the illustration as a whole.

↑ I load a brush with dark blue and gray colors to begin defining the depth of the scene

03: Details and lighting

At this stage I continue to work out the overall depth of the scene by creating additional forms of roots and branches in the mid-ground (image 03a). It is important to think about creating a sense of light and shadow in the scene. I always try to over-analyze lighting, in both my works and in real life, as it will generally help me greatly in the future (image 03b).

In this image I want to place emphasis on the dramatic fall of light through the heavy foliage. I continue to paint and create new forms of roots and branches and also apply small pieces of photos using the Magnetic Lasso tool technique I mentioned in step 01. By distributing the photographic fragments across regions in the image I start to suggest the first details of the illustration. I will continue to use the fragments of the photos that I used in the beginning throughout the work.

04: Additional details

I continue adding details to the scene by placing additional textures of leaves and grass evenly on the giant roots. I also disperse the textures across all the different regions of the illustration for balance. I correct the new foliage textures with Color Balance and Levels

↑ I continue to detail the roots and branches

↑ I decide where the light will fall in the scene

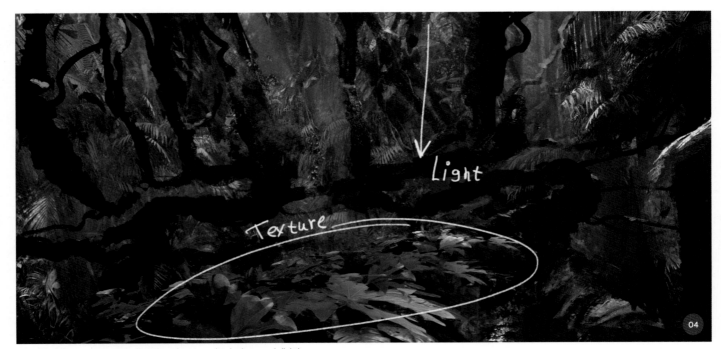

↑ I add in foliage textures and adjust the values to maintain the scene's lighting

↑ The Black & White settings I use when creating the cloud custom brush

↑ Inverting the photo for the cloud brush

↑ The usable cloud brush

and also use the Burn and Dodge tools. If a particular source of light is placed in your work that does not match the incidence of light in your scene, it can cause mistakes.

05: Evaporation effect

Now that I have passed the initial stages of creation, I will turn to studying the atmosphere and, later, the weather in the scene. To create atmosphere I will use a cloud brush. To create custom brushes for painting clouds I use photos found online as a starting point. I find an appropriate photo of the sky, create a new file at 2,000 × 2,000 pixels, and put the photo on a separate layer. Next I select Image > Adjustments > Black & White. Using the

Black & White option, I edit the Cyan values down to the extent that the main background is almost, but not quite, black (image 05a).

Next I invert the photo with Image > Adjustments > Invert (image 05b). I select my desired region with the selection tool and apply Layer Via Copy to this active area. I hide the main layer (the Background) and use Edit > Define Brush Preset to make a brush from the visible area. The cloud brush is now ready for use (image 05c). The settings could be adjusted, so with only one photo you can produce quite a lot of brushes. In my case I create three different cloud brushes for further work on the illustration.

The first thing I pay attention to is the creation of fumes in the air, both in the mid-ground and in the background, to suggest evaporation in this humid climate. When I use brushes for painting weather I set Opacity to 20–25%, and then select a white color from the palette to be the main color. Lightly, I start to randomly apply the first details of evaporation fumes (image 05d).

I want to mention one important point when using these brushes: to avoid the brushstrokes looking rough it is very important to include Transfer in the Brush Presets options. This option will help to smooth out the sensitivity to the pen pressure of your tablet.

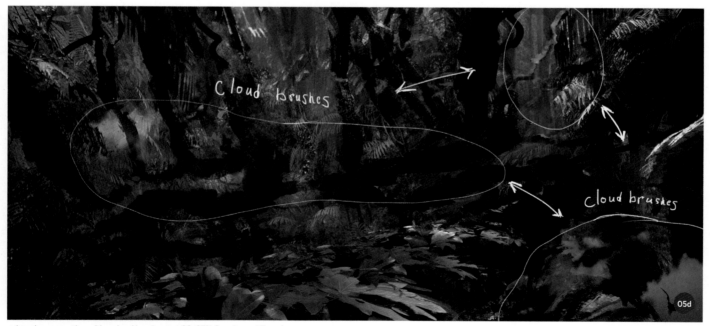

↑ I apply evaporation with a cloud brush set at 20–25% Opacity and Transfer

06: Atmospheric effects

I want to note that when creating atmospheric effects I use the Eraser tool with the same tip shape as the brushes I use. Having created some evaporation, I now erase the fragments that are unnecessary in my opinion. For each fragment of this effect, I create a new layer and, if needed, I also use the transformation tools.

To adjust the evaporation fumes I use the Levels settings and also the Burn and Dodge tools. Sometimes in my work I apply a clipping mask to certain layers. I fill the mask with a gradient with Opacity set to 50–60%. The color for the gradient I use here is close in tone to those of the evaporation fumes. In this way I try to create a more realistic effect and to develop a truly humid atmosphere in the jungle.

07: Adding characters

At this stage I decide to add some points of interest to the scene. Small storytelling elements in an artwork will always be useful, encouraging the viewer to be more than an interested spectator. In this case I add two characters moving at a distance from each other along the giant roots.

Through the posture of the characters I try to portray the idea that they are moving slowly, suggesting to the audience that they are on their way somewhere or are searching for something. I always try to show a little history or story in my works as this approach creates interest for the viewers. As I add the characters I also work in a few additional details, such as thinner vines in the environment in the background and foreground.

08: Rain effect

After creating and positioning the characters in the scene, I move on to the next stage of adding weather effects and building the humidity in the work. This time I want to add in a rain effect.

When working on rain it is important to remember that you also need to think about wind and imagine how this will affect the

↑ I use the Eraser tool to shape the evaporation fumes, then adjust them for realism

↑ I add in characters to create a storytelling element for the scene

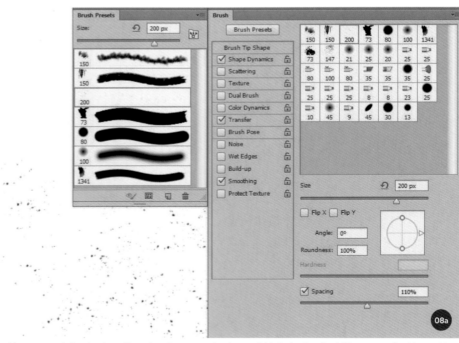

↑ The custom rain brush selected from the other custom brushes available in the downloadable resources for this tutorial

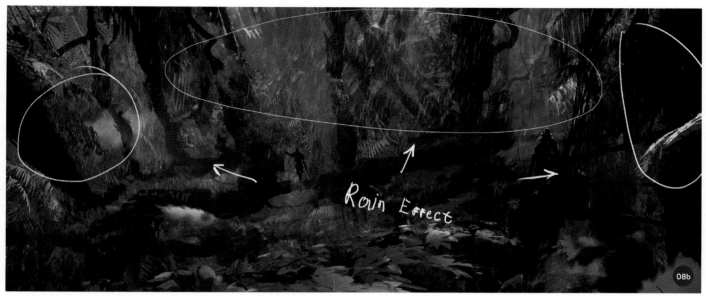
↑ I paint a rain effect evenly, remembering that wind will affect the fall of the raindrops

rain in the scene. The rain in this illustration should be evenly distributed because the streams of raindrops will fan in the wind.

To create the rain effect I will use another custom brush I have created (image 08a). Choosing a white color again as a base, I use a separate layer to add chaotic movements of these particles in the upper region of the illustration (image 08b). After painting the rain particles I apply the Motion Blur filter (see pro tip) and Lighten blending mode with 70% Opacity. With the same brush, but this time without applying the Motion Blur filter, I add small rain particles onto the foliage, trying to create the effect of splashing raindrops (image 08c).

09: Final adjustments

In this last stage of creating the illustration I use my standard methods of finalizing an image. I combine all the layers into one and play with the colors using adjustments such as Color Balance, Levels, and Hue/Saturation. I also use Color Lookup filters, trying to rid the image of excessive contrast. In certain situations I also change the intensity of color using Match Color, with the Color Intensity set at 115–120%. Finally, by using Color Balance I make the overall tone warmer, making the effects of rain and evaporation appear more realistic.

⚡ PRO TIP

Making a rain effect

One of the most convenient and fastest ways to create a rain effect is to use a Noise filter trick. I create a separate layer on top of my layer stack and fill it with black using the Paint Bucket tool. Next, I apply a Noise filter to the layer at 20–25% with Gaussian and Monochromatic selected. The value settings of the Noise filter will depend on how dense the rain will be in the illustration. After applying the Noise filter, I also use the Screen blending mode on the layer and adjust Opacity to around 75–80%. Finally I apply a Motion Blur filter to this layer with the angle set to the same degree as the rain in the scene.

↑ Motion blur can be used to enhance a rain effect

↑ I use the same rain brush to paint raindrops bouncing off the foliage

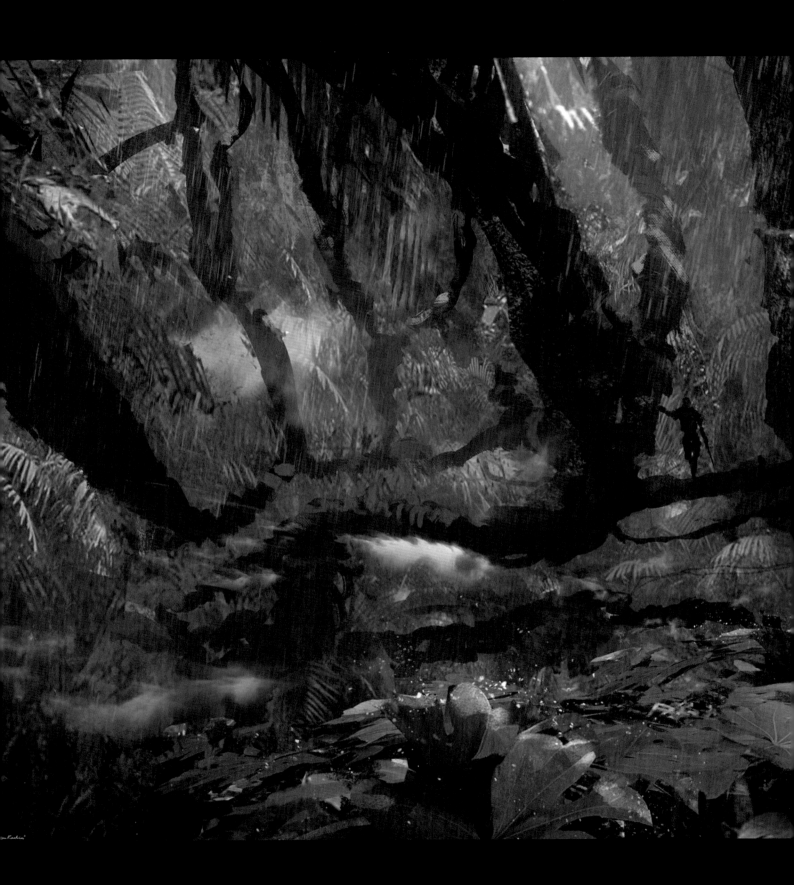

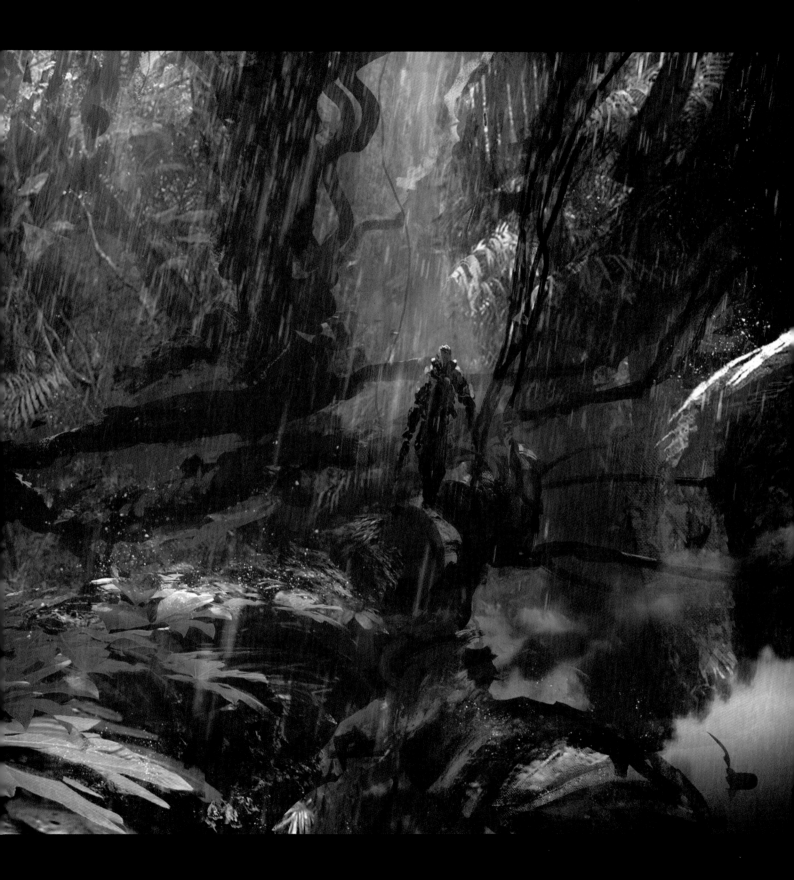

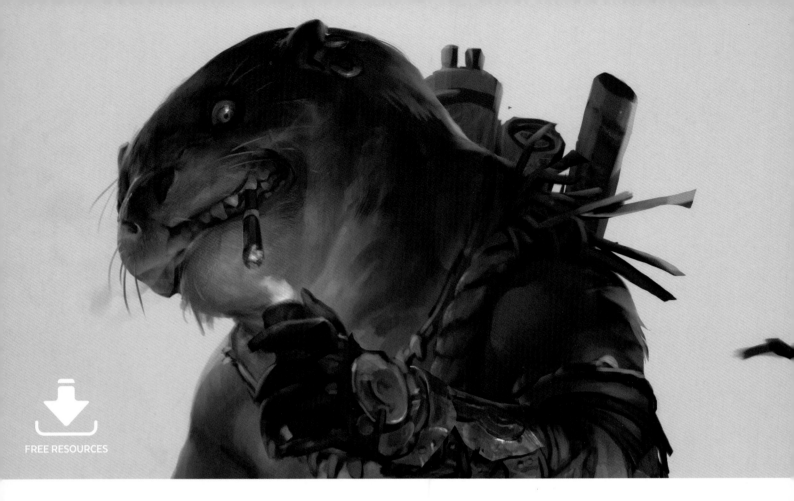

Custom Brushes | Creatures

Animals and creatures heavily inspire my work. Their unique characteristics are always fascinating to me. I also love to tell stories through my illustrations. That is why I always try to create story-driven images with creatures in them. In this particular piece, I would like to tell a story about a bounty hunter otter that is currently relaxing after finishing a job. I picked an otter because I imagined the character to be an agile and highly intellectual animal. I am also lucky enough to have a friend who owns an otter as a pet so I am excited to be able to observe it directly.

Rudy Siswanto
Illustrator
Software used: Adobe Photoshop

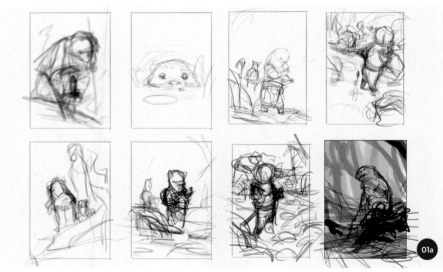

↑ Sketch as many thumbnails as you can to develop ideas you never knew you had

Otters are active animals; I also feel like their appearance would work well for a protagonist character. This is why I think an otter will fit the role in my illustration. In order to create this piece in an effective and efficient way, I will use custom brushes; I will show you how to create these brushes so that you can create your own.

01: Rough thumbnails

I tend to start a piece with a story in mind and then begin to sketch several thumbnails. Thumbnails are a great way to develop general ideas for your paintings, such as the composition and focal points. The first thumbnail usually looks fairly unremarkable but after several thumbnails I begin to see which ones I like, and which I don't.

At this stage, I don't dive into details; I merely focus on bigger shapes and my goal is to make those shapes as readable as possible, as fast as possible (image 01a). Once I have found one thumbnail that I like the most, I continue to the next step, developing it into a tighter sketch. I use a custom sketch brush for this stage.

To create the sketch brush, I open the Brush Presets panel and make sure a default brush is selected. I turn on Shape Dynamics, Transfer, and Smoothing, making sure everything is set to Pen Pressure. Then I play with the settings sliders to get the desired effect (see image 01b). In my opinion this brush is a better option for sketching than a regular round brush, since this brush has a more dynamic line weight.

02: Tightening the sketch

Once I have found the best composition from the thumbnails I made in step 01, I set the chosen thumbnail at a lower opacity and then create a new layer to draw on top of it. After applying a layer with a perspective grid (you can create a grid using Vanishing Point under the Filter menu), I start to define the overall shapes and design of the elements within the painting using the sketch brush I created, only this time I set it at a smaller scale.

I make sure I add elements that support my story, so I don't add unnecessary features that might clutter the illustration.

↑ The settings I use to create my sketch brush

I also begin to define and separate the foreground, mid-ground, and background. In this step, I avoid zooming in too close, since I don't want to become trapped in detailing the image too early on.

↑ Applying a perspective grid will help to make elements more believable

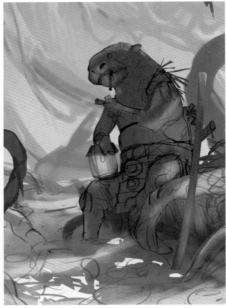

↑ Don't go too dark or too bright when establishing your base lighting. Use three to five values to keep it simple

> "I want to achieve a painterly effect with this brush, which I think will be great to use to block in big shapes quickly"

03: Value staging and basic lighting

Once the sketch is established, I begin to separate the background, mid-ground, and foreground using a single value for each. I make sure I separate those values on different layers and experiment with lighting scenarios, continuing to use simple values (image 03a).

I start using a custom impression brush here, which I make by taking a photo of a rock that has an interesting-looking texture. I apply a Threshold level of 117 under Image >

Adjustments > Threshold to extract its texture. After this, I select parts of the photograph that are interesting using the Quick Selection tool, and make it into a preset brush by going to Edit > Define Brush Preset. After it has saved, the brush will show up in the Brush Presets panel. Then I adjust the settings as shown in image 03b. I want to achieve a painterly effect with this brush, which I think

↑ The brush settings used to create a painterly effect for the impression brush

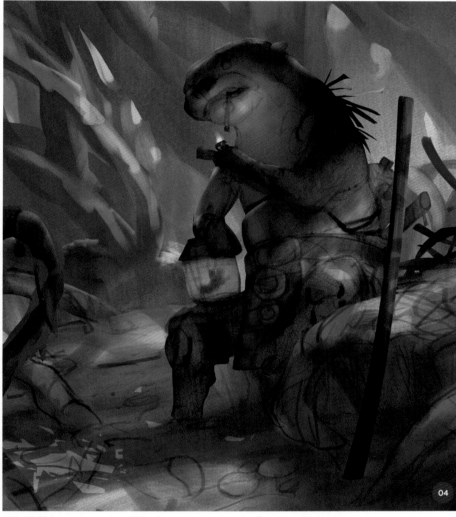

↑ Use Multiply to explore and establish colors to separate characters from the environment

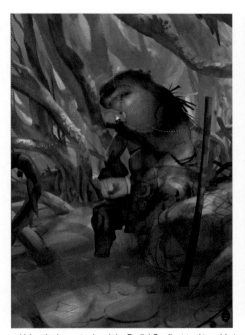
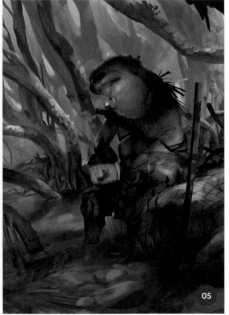

↑ Using the Lasso tool and the Radial Gradient tool to add atmosphere to the environment in order to create depth

will be great to use to block in big shapes quickly with some textures incorporated. Don't forget to save by hitting the folded square icon in the bottom-right corner of the panel.

Since I always paint with a story in mind, when I am deciding which lighting is best I ask myself, "Is this the best lighting to help sell the story of this painting?" I pick the second lighting scenario (far right on image 03a) because I want this painting to have a slight sense of mystery. Placing the spotlight on the body means the audience will look to the face after looking at the body of the character.

04: Applying rough colors

The next step is to apply some rough colors to the illustration. I create another layer on top of each layer stage, and set each new layer to Multiply. By working on separate layers, not only will my painting be more organized, it will also be easier for me to paint over the color base using opaque paint in later steps.

I pick a cool green-blue hue for the environment, and use a warmer color for the character and the light. This will help to separate the character from the environment.

05: Developing the environment

I usually paint the background first as it gives me the liberty to adjust the characters according to their surroundings. I have found that working on the environment first also gives me more control over the lighting scenario on the character.

I need to create some depth in this piece so I make several selections using the Lasso tool, and set Feather to 5 pixels, since I don't want the edges to be too crisp. After this, I introduce atmosphere by adding a cool blue hue with the Radial Gradient tool.

Moving on from the background, I begin to render the mid-ground. I need the mid-ground to be defined early so that the position of the character in the mid-ground will be clear. I also want to create a smooth transition between the background and the mid-ground, as I don't want them to feel "staged" and separated. I continue using the impression brush for all of this.

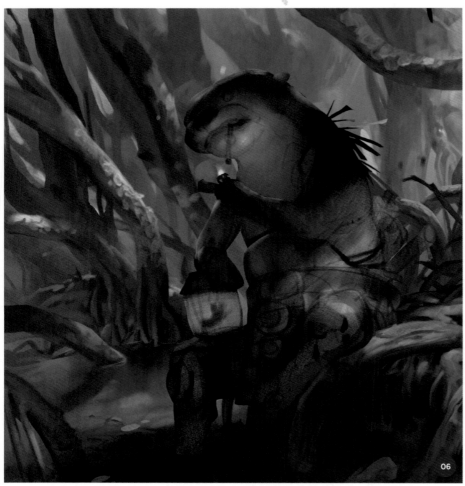

↑ Always treat the focal area with more detail and contrast; it is the most important part of the piece

06: Defining the focal area

Moving forward, I start to tackle the focal area. I make the staff on the right side of the image invisible because I want to render the focal area with a higher level of detail. I use a lot of references when I paint the water plants, branches, and elements that are underwater. References are so important to me; they make my paintings much more believable.

I also apply the perspective grid once more when I am painting the lotus leaves to help show depth in the image. I reduce the amount of atmosphere in the background after realizing that it actually distracts my framing, since it is too bright. Once I have toned it down using my brush set to Darken with a darker color, I feel that the framing is much better.

> "I use the hard edge blur brush to quickly shape the costume of the character. I render the design with the story in mind"

07: Rendering the character

This is the part that I find the most enjoyable: I begin to render the character and define most of its design elements. I turn off the background so that I will not be distracted by it.

↑ The finished hard edge blur brush has both a soft-edged side and a hard-edged side

↑ Rendering the character using the impression brush and the hard edge blur brush

However I still turn it on at times to check how well the character works with its surroundings.

I create a new custom brush for this step which I call the "hard edge blur" brush. Using a soft round brush, I create a soft circular spot. Then using the Marquee tool, I cut the soft circle through the middle. With the Transform tool, I stretch the half circle slightly upwards, and then go to Edit > Define Brush Preset, making sure I activate Shape Dynamics and set it to Pen Pressure. The result is shown in image 07a with a hard edge on one side and a soft edge the other.

Now I can get to work on the character. First, I render the overall character using the impression brush. At this point I again avoid zooming in. Next, I add a bounce light from the environment using a bluish hue. Then I start to tackle the design of the character's outfit. I use the hard edge blur brush to quickly shape the costume of the character. I render the design with the story in mind: this is a mercenary otter, so I have to make it look like one (image 07b).

> "Combining something common with something that is less well known, such as a lotus flower with a ginseng root, can result in something new and interesting"

08: Diving into details

Ever since the start of the tutorial I have rarely zoomed in when I paint. However, now is the time for me to do that. I use the Actual Pixels zoom from the View menu as I paint details, as this gives me a better view of the painting without being too close. I begin rendering the small details of the costume of the otter; I am influenced by Asian armor design for this character.

In order to make sharp details, I often use the Lasso tool. I have found that this Lasso tool really speeds up my workflow. The key to using the tool is having an understanding of shapes and silhouettes, so make sure you keep practicing these. However, be careful not to make everything sharp, as this can make the

image look flat. Always make sure the focal point is sharper than everything else.

I use the hard edge blur brush again heavily here, for example to quickly paint the elements on the character's belt. I have provided the brush in the downloadable resources for this tutorial, so you can try it out for yourself.

09: Rendering the jar

I begin to render the jar in the illustration using the impression brush at a smaller size. This element plays an important role within the storytelling of this piece as it is the captured prey. A preserved ginseng root inspires me as I design the prey. Combining something common with something that is less well known, such as a lotus flower with a ginseng root, can result in something new and interesting. I combine the shape of a ginseng, lotus, and mandrake to create a new creature. I did not plan to create this creature, but I developed the idea along the way when I was painting the piece. Now that I have worked on it I am quite pleased with the result.

↑ I work on the costume details using the hard edge blur brush and the Actual Pixels view

↑ Design a new creature or object by combining aspects of commonly known objects with aspects from less commonly known objects

10: Detailing the character

Now I begin to render the character to a polished level. Using the brushes I made earlier, I switch back and forth between the impression brush and hard edge blur brush. When it comes to detailing, I use the sketch brush from the first step to reach smaller spaces, such as the otter's teeth and armor pieces.

To finish the character, I create a new fur brush to give the otter an authentic look. Using a round brush, I create random dots that look like crumbs or speckles, and then go to Edit > Define Brush Preset. I adjust the settings as shown in image 10a with Shape Dynamics selected, Size Jitter on Pen Pressure mode, and a Minimum Diameter of 59%. Transfer is selected with both Opacity Jitter and Flow Jitter set to Pen Pressure and Flow Jitter set at 48%. Smoothing is also selected; the fur brush is ready to be used (image 10b).

> "I add to the rim light using a cool color, so that the character will stand out from the background even more"

Note that the fur brush must be used with care; if it is used too much the image will look overwhelmed with textures, which may result in a flat-looking artwork.

11: Final touches

After I am happy with the finish on the character, I turn the background layer on again and begin adding the final touches. I utilize the custom brushes I have made to create details and shapes in the background faster.

I add some details to the lighting and atmosphere, and smaller highlights on the water. I also add to the rim light using a cool color, so that the character will stand out from the background even more. I use Color Dodge to light the fire from the otter's lighter. Once I feel that the image has all the elements I want – mood, atmosphere, and storytelling – I am ready to call it complete.

↑ The Brush Presets adjustments for the fur brush

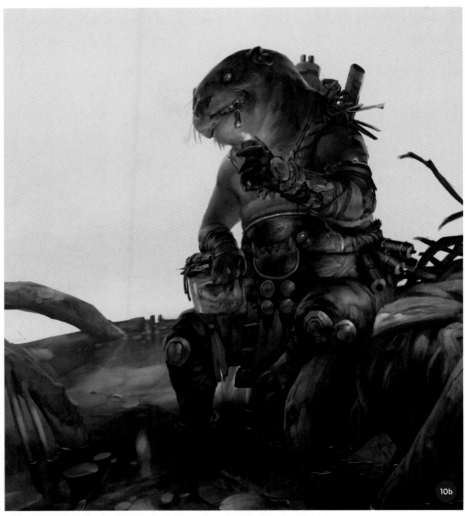

↑ The character is the focal point of the illustration so time should be taken to polish it

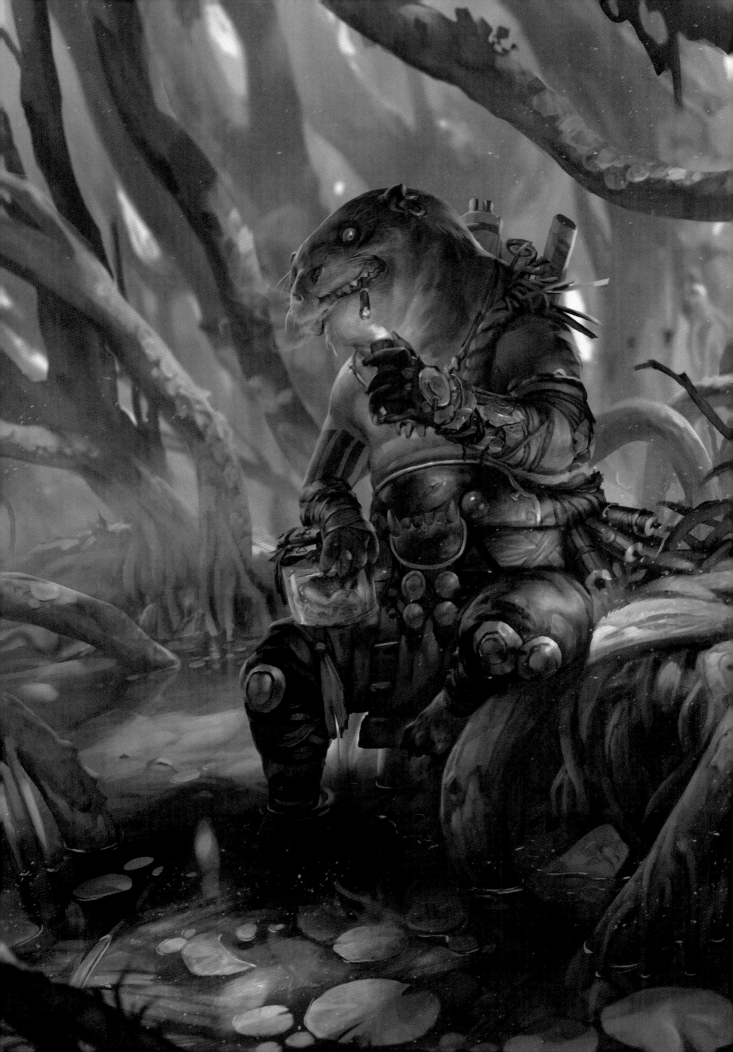

Costume Design

One of the most pleasurable aspects of character creation is inventing expressive details and clothing designs which act as indicators of the character's personality and cultural background. With small costume details you can suggest a character as wealthy or impoverished, scrupulous or slovenly, prepared for battle or just scrambling, unprepared, from their bed.

In this chapter five top character artists disclose their methods for designing and painting a costume specifically for a character, sharing research ideas, painting tips, and technical insights. Learn how to paint your own characters with these diverse projects covering costume design for historical characters, humorous illustrations, and sci-fi and fantasy characters.

Costume Design | Female assassin

In this tutorial I will show you how to paint a female assassin from imagination. I decided to go with a fantasy assassin over something more contemporary. I think most people are fairly familiar with what they think an assassin should look like. While there are certain aspects that viewers expect to see, there is still a lot of freedom when it comes to depicting an assassin.

It's also easy to fall into the trap of depicting a scantily clad female assassin, which I plan to avoid in this tutorial. My goal is to create something that looks more realistic with functional designs and armor. I think the controversy over the depiction of females in the gaming industry has been a hot topic over the years, so this will be a great opportunity to go against the stereotype. What I think a lot of people don't realize is that sometimes it isn't the artist's decision to create a scantily clad female, but rather the decision of their client. Since this brief is not too specific, I have the chance to make my own decisions.

↑ Find a pose that has some personality and attitude

My typical painting process is quite straightforward. I don't rely on too many fancy tricks or effects; most of my painting is carried out the old-fashioned way, painting everything by hand. One technique I use that has sped up my process is using

Daarken
Freelance Illustrator & Concept Artist
Software used: Adobe Photoshop

↑ A few quick sketches exploring outfit possibilities

clipping masks to add color. Keeping different elements on separate layers is key when working with clipping masks.

01: Pose with attitude

I want to create a pose that has both personality and attitude. Since the character is an assassin, I want to develop something that a victim might see a few seconds before their death. At the same time I need to make sure I do not hide too much of her design, so I should avoid anything with too much foreshortening or a crouching pose, for example.

The assassin should look tough and the victim should feel fear as she quietly and confidently glides toward them with her weapons drawn. Maybe she could have a slight smirk, pleased with the fact that her victim knows that they are about to meet their end.

02: Designing the costume

An assassin needs to be silent and blend in with their surroundings. Creating an assassin with a "cleavage window" or some other device that shows a lot of skin would therefore not make sense; areas of light skin would probably reveal an assassin's location, which they would not want. A cloak that can obscure their face would also probably be a good idea for staying hidden.

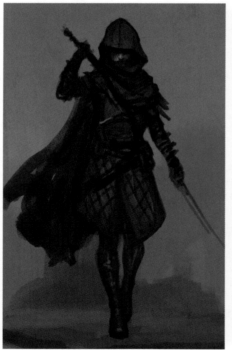

↑ I refine the pose after shooting references for the arms

I want to avoid using too much metal because metal is noisy. An assassin would not want clanking armor as they try to sneak up behind a target. Cloth and leather armor, while providing less protection, would be better for sneaking around.

03: Refining the pose

While functionality is important, you also have to remember that you are creating a piece of art. Creating interesting silhouettes is just as, if not more, important as creating a functional and realistic character.

Once I have the pose and outfit defined, I shoot some references for the hands and arms with a camera. You will notice in image 03 that I have to change the angle of the character's arm because when I was posing, I was unable to make my arm look like the original sketch.

131

Even if you shoot references, it is good to remember that you still have artistic license and you do not necessarily have to follow your reference completely. I will come back to the use of references later in this tutorial.

04: Creating clipping masks

I flatten my layers so that the assassin is on a single layer. This will make it easier to color the whole figure with a clipping mask. Sometimes I will keep certain elements separate so that I can color them individually, but this time I will color everything at the same time.

I create a new layer above the character, then right-click on the new layer and select Create Clipping Mask from the menu. This will lock the clipping mask to whatever is below it, meaning that I can't color outside the lines.

05: Adding color

In this step I start to add color. Sometimes I keep the clipping mask layer as a Normal layer, but since I have a fairly refined sketch, I set it to Overlay here. This will allow me to add color without destroying my black-and-white painting.

Things can get dark very fast when working with an Overlay layer, so you might need to pick a color that is lighter than you intend.

⚡ PRO TIP

To "cleavage window" or not to "cleavage window"...
When you are designing a female character in the fantasy genre, try to decide whether showing large amounts of skin makes sense. Look to real-world examples. If your character is living in a humid jungle, then large amounts of skin probably makes sense over full-plate armor. Most people can buy into something if it is justified, so just make sure you have a reason for doing something. It will help you create a better character in the end.

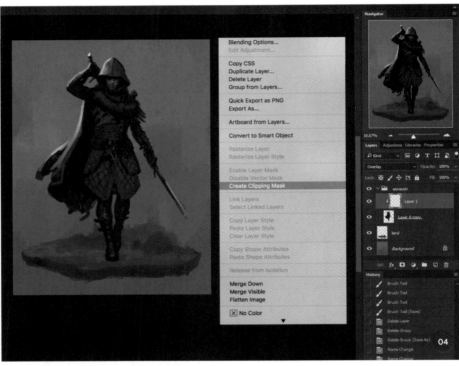

↑ Creating a clipping mask in preparation for painting color

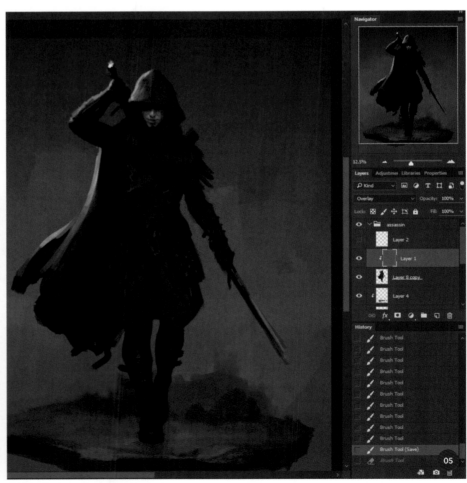

↑ Adding the base colors with an Overlay layer

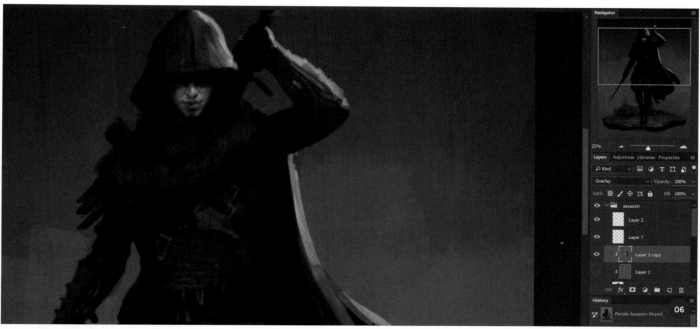

↑ Continuing to refine the base colors with an Overlay layer

↑ Painting the materials and textures of the outfit

I am only adding the base colors at this stage. I will still need to refine the colors by hand on a Normal layer. I make sure the shadows don't stay too desaturated.

06: Refining the base colors

I duplicate the Overlay layer because I want to make some changes, but also because I want a backup just in case I do not like the changes I make. I want to avoid making everything the same brown color, so I start to introduce other colors into the cloak and outfit. Maybe the inside of the cloak could have a bolder color to make it stand out more. You can see in image 06 that all of my shadows are still really muddy and desaturated. I will fix those as I refine the painting in the later stages of the process.

07: Materials and textures

I am now at the point where I can start thinking about and painting the different materials and textures of the outfit. While I don't want clinking armor, I do want a few pieces of metal in the design, just to give it a little interest and variety; I therefore consider adding metal studs to the tassets and bracers.

133

↑ Adding the lines of the quilted armor on a separate layer

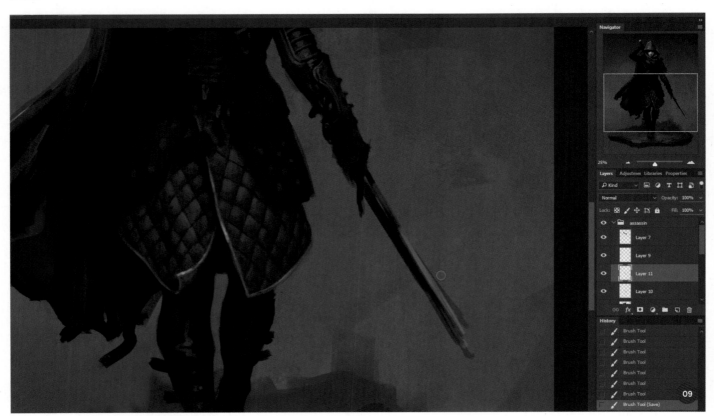

↑ Rendering the quilted armor, paying attention to highlights and shadow

↑ Starting to refine the face by painting opaquely on a layer in Normal mode

↑ Continuing to refine the face and adjust the colors, avoiding hard edges around the mouth

↑ Adding the final touches to the face and determining appropriate lighting

I want her coat to be made of quilted armor, so I paint the basic shape first, keeping in mind her legs underneath the coat. Little details like turning up the corners of a coat or cloak can give a sense of movement.

08: Refining the armor

Now that I have the basic shape of the coat blocked in, I can create a new layer and paint the lines of the quilted armor. I make sure the lines of the quilting follow the contour of the coat, otherwise everything will look flat. This also applies to shadows. Shadows should always follow the contours of whatever object they fall on.

I decide to add a gold trim to the coat for some color variety and to make things pop a little more. Look for ways to add interest to your designs. They could be things like buttons, trim, or buckles.

> "I keep the lighter values in the middle of the figure. As the armor wraps around the figure, the values should get darker in order to make it look like it has more form"

09: Finishing the armor

The final step of painting the armor is to render each individual quilted section of the armor. Usually I start painting these underneath the line layer. Once those basic shapes and values have been established, I create a new layer on top of the line layer and continue refining. All each shape really needs is a highlighted section and a shadow section to show the forms. I keep the lighter values in the middle of the figure. As the armor wraps around the figure, the values should get darker in order to make it look like it has more form. Once you put everything together, you achieve a nice quilted armor look.

10: Refining the face

When I added the base colors to the face, the colors were very muddy and desaturated. Now I can create a new layer and start fixing the colors on a Normal layer. To start refining the face, I need to saturate the shadows and block in the planes of the face. At the moment the face is fairly rough; it is easy to become discouraged when the face doesn't look as good as you would like. You have to be confident that it will look better in the end though – which is easier said than done.

11: Adjusting the colors of the face

I begin to add some warmer colors to the face. Before the colors were becoming a little too yellow and green, which gave it that muddy look. The area where the light meets the shadow is also a good place to add a more saturated warm color. I don't want to make everything warm though; I still want some areas that are cooler and some areas that are warmer.

Edge control of the brush is important when painting a face. You don't want too many hard edges around the mouth, otherwise it might look flat.

12: Finishing the face

This is the final stage of painting the face. I continue to work on the color variation and refining more of the features. I also add some more color to her lips and a cool fill light to offset the warm colors on her face. Having a strong rim light on the left doesn't work as well because of all the shadows around her bent arm. However, moving it to the right side and making it cooler and darker helps me to avoid that situation. Since her outfit is warm, the cooler light helps add color variation and interest.

13: Painting from reference

When you are painting a pose that you aren't very familiar with, it is a good idea to take your own reference photos. You don't need a fancy camera or a studio lighting setup. Most of my pictures are taken with my phone in the bathroom.

I've heard from people, including artists, who think shooting references is cheating. If your painting looks better because you shot a reference, that is all that matters. Your goal is to create something your client is happy with. Producing your own reference is also a lot safer than using images online because you own the rights to the reference you shoot; you often don't own the rights to images you find online.

Earlier I took a photo of my arm in the assassin's position to help me get the correct pose; I now finalize this by taking another reference shot to help me paint the arm and sword. Having a sword handy is extremely valuable as an artist. It helps me achieve the correct perspective on the hilt, and you can really get a sense of how you would hold a sword. You can see which poses work and which ones don't.

14: Adding more details

Almost finished with the painting, I now just add more details and continue to refine the painting. Originally I was going to give the assassin longer swords, but I have decided that it might make more sense if she has daggers. The problem with a sword is that it requires more room to wield, plus you have to worry about your scabbard hitting objects as you are trying to sneak around (which is why I put them on her back instead of on her waist). Daggers simply make more sense when it comes to stealth.

15: The final touches

I wasn't originally going to add quilted armor to her torso, but I do so now as I feel the repeating elements will unify the design a little more. It also gives me an opportunity to add more gold trim to the top part of the costume design for interest.

I also add metal studs to her tassets and to her bracers, again, repeating elements. Repeating shapes are often a good way to unify a design, but don't overdo it. I remove the right scabbard from her back because I want to streamline the silhouette, plus I am not sure people will know what that shape is. At last I am happy with the costume design and the image is complete.

↑ Finalizing the arm from references I shot myself

↑ Continuing to add details to the armor and weapons, thinking about their function

⚡ PRO TIP

Layers

I am always asked how many layers I use. I know some artists take pride in only using one layer for a whole painting, but that process might not work for everyone. Using more than one layer isn't bad, it isn't cheating, and it doesn't mean you are a lesser artist. When someone sees your work, they aren't going to know how many layers you used to create it. They are going to see either a good painting or a bad painting, and nothing else.

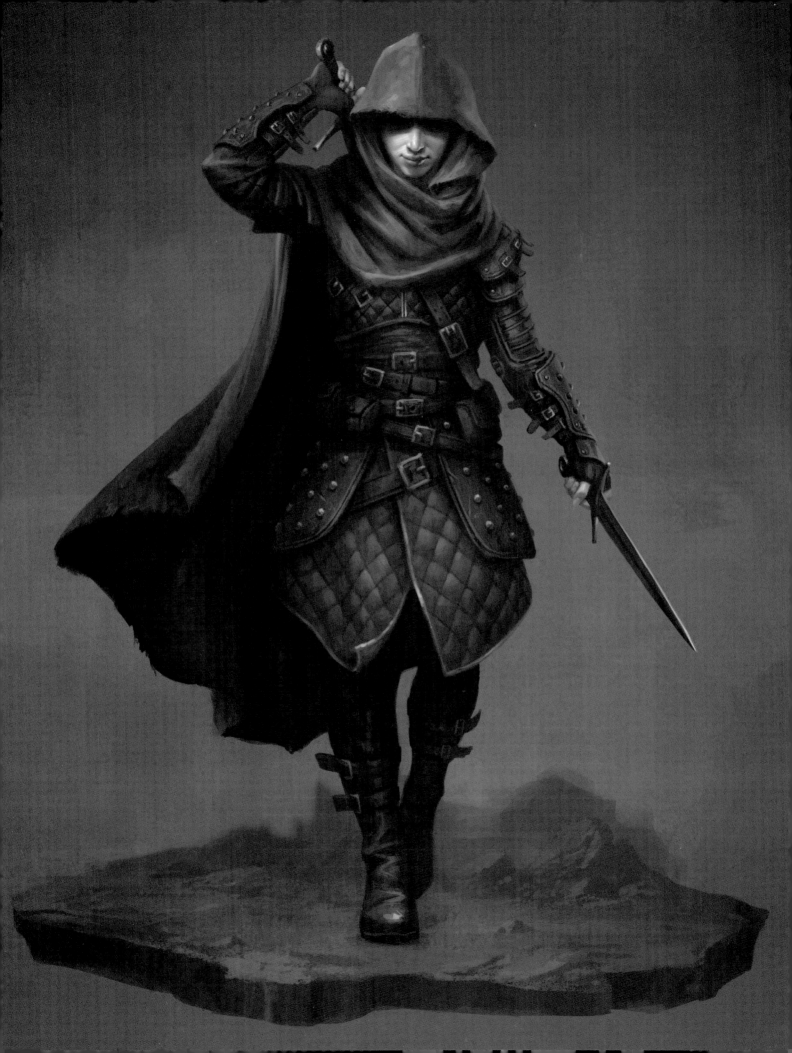

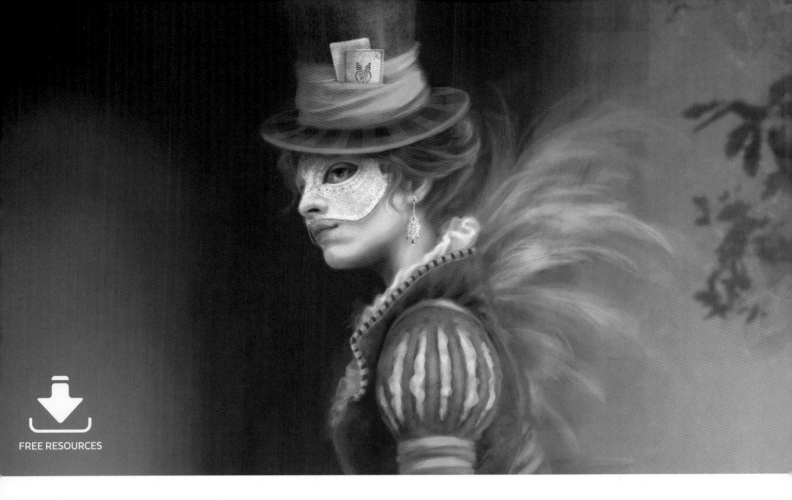

Costume Design | Masquerade ball

Research is often as important in creating a convincing design as the skill required to convey it. In most cases it is worthwhile researching deeper than a cursory image search. Although not knowing where to look and what to look for can sometimes make research daunting, understanding what you are trying to create adds more depth to any project. Instead of looking at films or even games for inspiration of masquerade ball costumes – and there are a great many that feature them – I want to go straight to the source and look at historical events, dresses, fabrics, patterns, and masks to give me ideas for the costume.

Photo: Patricia Glee Smith (patriciagleesmith.org)

01

↑ Exquisite Venice Carnival outfits, completely covering the wearers from head to toe

Nykolai Aleksander
Freelance Artist
Software used: Adobe Photoshop

Once I settle on a specific theme, I can either narrow my research field, or go straight to sketching out my ideas. Asking questions about where the ball might be held, or even what time period it is set in, can be very helpful in determining the look of the design (especially if it needs to be authentic) and of the finished painting.

From the start, I determine that I want to use some custom brushes for textures and patterns on fabrics, either from hand-drawn samples or photographs. Looking for some inspiration or images that are free for use is always a good idea. Armed with all this, I can properly start homing in on my design for the costume.

↑ Sketches of a few dress shapes dating between 1760 and 1880. Of course there are many style variations in between

↑ Developing color swabs appropriate for this specific outfit

01: Research: Carnival in Venice

Probably the best known and most elaborate masquerade event in the world, the Venice Carnival goes back hundreds of years. Costumes are always paired with masks that correspond directly to the outfit. What makes these costumes special is that they usually do not expose any skin at all, and the fabrics are often the most luxurious and colorful silk, lace, and brocade available. Some of the styles date back to Renaissance times, while the more elaborate gowns are in styles from the seventeenth to nineteenth centuries. While they are wonderful to look at, they would not be ideal for a ball as they can be cumbersome to move in.

02: Research: Museum archives

There are many museums in the world that have fashion as part of their exhibits, such as London's Victoria and Albert Museum or New York's Metropolitan Museum of Art. They have a mix of clothes and fabrics from various time periods, illustrations, and old photographs on their websites (however, the images are not free for use, just to look at).

Searching for Rococo, Baroque, or Victorian gowns, or simply "Robe a la Francaise," in online archives will yield results if you don't know the date. While these searches can be tedious, they will give you an idea of how complex fashion was in these times with its rules and regulations.

03: Finding a theme and colors

I already know what theme I want to play with, and it ties in nicely with what I have researched: *Alice in Wonderland*, first published in 1865. But not Alice; I want something quirkier, something that allows me to really play with the outfit. I will therefore aim for the Mad Hatter, or at least the overall spirit of him.

This theme also narrows down my choice of gown to mid- to late nineteenth century, and I feel that a Victorian bustle gown would be perfect due to the exposed layers of fabrics of the design combined with an elegant silhouette. I create several color swabs that I feel will be appropriate for this specific outfit. I use clashing colors, which can be surprisingly refreshing.

> "The outfit I have in mind would neatly combine both day and evening wear with an overcoat added to the ball-gown ensemble"

04: Sketching the outfit

Dresses in the 1800s were mostly two-piece ensembles, and often came with a conservative day top and a more revealing evening top. The day top usually had long sleeves and would not show too much, or any *décolleté*, while the more revealing evening top might show your shoulders. As a lady, it was only socially acceptable to show your shoulders in the evening. The outfit I have in mind would neatly combine both day and evening wear with an overcoat added to the ball-gown ensemble. As I will not be showing the costume in its entirety in the painting, I create a couple of sketches illustrating the evening corset, front, and silhouette, which I can use to keep the design as a whole in mind.

05: Dressing the character

It is time to put the design into a relevant setting. On a separate layer I sketch out my ideas for the illustration. I like the idea of showing the back of the dress. This means that to show the face, I will have to turn the torso and head, making the pose less static. It offers me a chance to show the often overlooked intricacies of a bustle and the pulled-back layers of the skirt. Showing her in an outside setting will add a whimsical, narrative feel.

06: Blocking in colors

While it may be tempting to jump straight in and work on specific parts of the illustration, or even details, I first want to lay down some really basic colors with no details, just rough strokes. For this I create a new layer beneath the sketch layer, while I simply use the main background layer created when you open a new canvas for the background. I like using the Hard Round brush for faces and figures, and a custom rectangular brush for everything else for this step, such as blocking in colors. In the Brush Presets I set Opacity to Pen Pressure and the Shape Dynamics of the custom rectangular brush to Direction.

07: Cleaning up the mess

I work all over the painting in the initial stages, to clean up the outlines and add a little more definition to everything. Throughout this clean-up process, I keep the sketch layer visible to

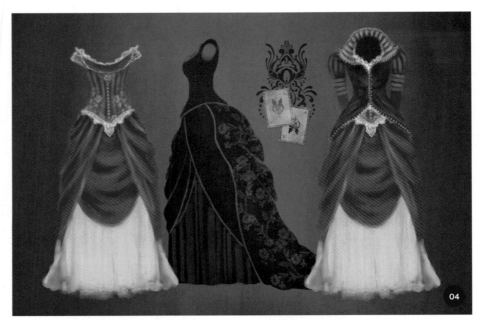

↑ Sketches, patterns, and a silhouette of the costume to illustrate the complete design

↑ I sketch on a separate layer so that it will not interfere with the painting

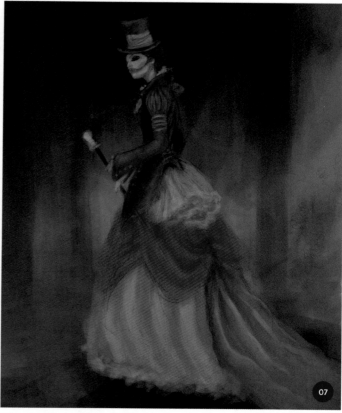

↑ Using rough custom brushes for blocking in colors adds some texture right from the start

↑ Brushstrokes should follow the direction of a surface's curves so an object looks less flat

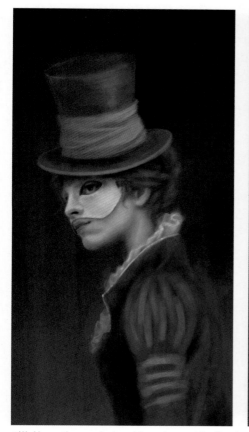

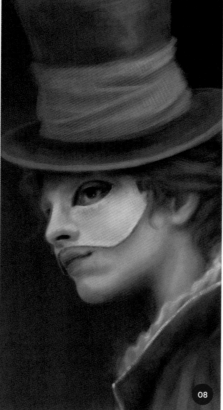

↑ Working on the upper body and face using a variety of brushes and the Smudge tool, trying to avoid a smooth look

guide me, though I reduce its opacity a little. To stop the costume looking flat I paint in the direction of the surface's curves. I still use the same two brushes as before, only now with more deliberate strokes. I set them at a smaller size to lightly begin refining some of the more intricate areas, such as the face and the folds of the dress.

08: A sense of purpose

I start working on the face, or rather everything from her shoulders up, to get a sense of who this woman might be. I stick with the somewhat dark, desaturated colors for now.

I love using rake brushes to get supple textures into surfaces, and leave some runaway brushstrokes in place. Using various brushes to paint, and a Rough brush for the Smudge tool (setting the Scattering at around 50%, Angle Jitter at around 20%, and Transfer to Pen Pressure), I do not make things too smooth. Rather, I let the textures work for me. I also do not add too much detail; it would become lost anyway unless viewed at its original size.

↑ This is a good stage at which to make adjustments to the outfit and ground the character with shadows on the floor

↑ Leaving things slightly loose, with some visible brushstrokes, can add a little movement and depth to the fabric

09: Adjusting the dress

Moving on to the outfit, I first make adjustments to its general shape and the character's posture, and pay attention to how the fabric behaves in regard to her movement. I also work out the shadows cast by the various fabric layers – the jacket's lace bustle for example. Just like any other transparent fabric, it would cast more diffused shadows than the heavier damask jacket or brocade overskirt.

In terms of brushes, I mostly use the custom rectangular one mentioned earlier, with Opacity and Flow set to Pen Pressure. I paint the cane on a separate layer, and add vague steps to the background.

10: Bringing the fabrics to life

Satin silk reflects light differently from damask or brocade, and again differently from lace, voile, or muslin. Satin silk has sharp highlights and shadows in folds and where it is reflecting light, while brocade tends to diffuse light. Knowing which layers of the dress are made of which fabric will help me portray the dress correctly.

Using custom brushes that hint at the way these fabrics work or just adding texture

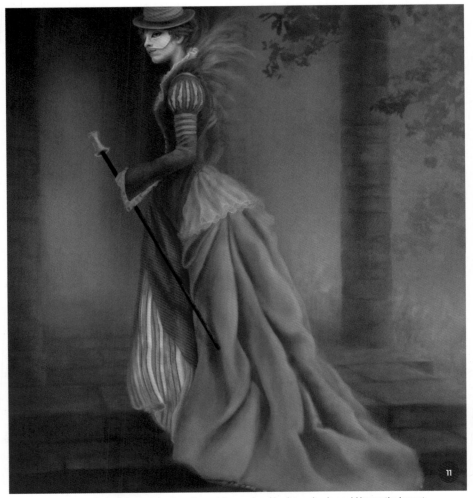

↑ A simple background helps bring out the character and dress, yet making it too simple would lessen the impact

↑ The various patterns painted directly onto new layers in the painting

while painting can really add another dimension to the piece. Using the Smudge tool on Satin can be very beneficial. Stripes are best painted by hand to properly integrate them into the fabric flow.

11: Working on the background

Following the same steps, and using the same brushes I used for the figure, I develop the background, first working on the whole then moving on to separate areas in stages. I leave it vague to draw attention to the woman, except for right under her feet as otherwise it will look like she is standing on fluff.

I add trees behind the arches (using brushes in part made from cutouts by Vyonyx from **www.gobotree.com**), suggesting that this might be an English country estate. At this point, I re-add her right arm, which I had left out since the sketch stage, and also add plumes of an extravagant feather brooch to balance the composition.

12: Patterns

I leave the patterns until last purely because I am not sure what patterns I want. I know I want to use brush patterns, but not for all areas. The mask receives just a very faint lace decoration, which is a good starting point. I then move on to the cuff and bustle lace, using the Round brush with Size Jitter and Opacity set to Pen Pressure. I also use

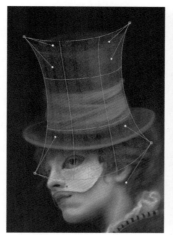

↑ I use the Warp tool to fit a pattern to the hat

the Smudge tool here and there to soften it. The jacket pattern is created with both my rectangular brush and the Round brush, hinting at ribbon embroidery and beads.

13: Patterns continued

Moving on to the hat and dress train, I decide to use brush patterns. For the hat, I paint a scroll pattern segment that could be used on

its own or stacked. Turning it into a brush, I add a new layer and adjust only the brush spacing so the segments fit neatly together. I then mold it to the hat using Transform > Warp (image 13a). For the dress train, I reuse an old photo brush I made, and randomly stamp it onto a new layer. Then I adjust it until it works with the folds, and set the layer to Overlay (image 13b).

14: Overall adjustments

Once all the patterns are in place, I go over them again and fix certain areas as required. I give the character some earrings, refine her hair a little more, and also change the cane to resemble a rabbit's head (a subtle reference to *Alice in Wonderland*) carved from ivory (legal at the time), including some scroll work. Moving on, I paint playing cards in new files, and add these to the hat, once again harking back to Wonderland. I also copy the jacket's sleeve decoration and add it to the back panel, as it seems not quite correct left plain, molding with Free Transform and Warp.

↑ The brush pattern used for the dress (see the pro tip below for tips on adjusting pattern brushwork)

⚡ PRO TIP

Adjusting pattern brushwork

While continuous brush patterns can be a quick way to add detail, especially if you already have them, they will still need some adjustment to wrap around three-dimensional objects or move with fabric folds. One way to do this to use Transform > Warp as you saw in step 13.

For more intricate spaces, like fabric folds, Filter > Liquify works a little better, as the pattern can be pushed and pulled according to the folds using the Forward Warp tool. The result can later be tweaked even more by lightly erasing the areas of pattern that fall into the recesses of the folds.

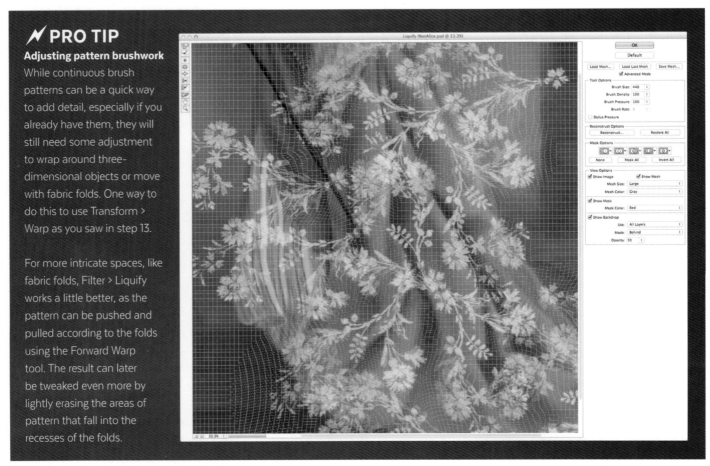

↑ Patterns can also be adjusted with the Liquify tool

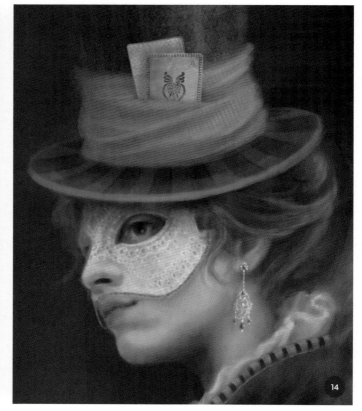

↑ Adding small details here and there is fun, but be careful, they can make or break an image

 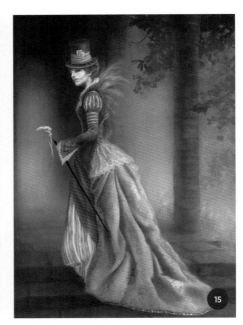

↑ The various stages of adjustments, from Exposure and Levels to additional color glazing layers

"Another wonderful thing about digital glazing is that you can use texture brushes to add variation. These can be used to create the illusion of dust particles in beams of light, or soften edges and color transitions"

15: Adjustments and glazing

Once I am happy with the overall look of the painting, I add an Exposure adjustment layer and lighten it significantly. Then I add a second one for Levels and play with it until I am satisfied. Using these layers gives me the option to go back to them and adjust them further, or mask areas within them without compromising the painting.

Next I carry out some digital glazing with various colors. I use a large brush on new painting layers that are set to Overlay and Soft Light, as this really helps the light and shadow colors to pop. You can find out more about digital glazing in the pro tip on the right here.

16: The finishing touches

The last things that remain now are to flatten the image, and then see if anything needs more adjustment. Sometimes adjustment layers like Levels or Exposure can make color

gradients look jagged, and it can help to smooth them out with the Smudge tool or some mild over-painting with a soft-edged brush set at a low opacity. I notice that

some edges would benefit from a little blur to integrate them better into the whole, so I use the Blur tool, again with a soft-edged brush. All that is left then is to sign the piece.

⚡ PRO TIP

Digital glazing: depth enhancement

Adding a new layer on top of the image and setting the layer mode to Overlay or Soft Light, you can paint transparent layers of color over it much like you would do in an oil painting. Thus you can change the overall look and depth of the painting in a more targeted approach than filters or color adjustments can generally offer.

Another wonderful thing about digital glazing is that you can use texture brushes to add variation. These can be used to create the illusion of dust particles in beams of light, or soften edges and color transitions without making them look blurry or smudged.

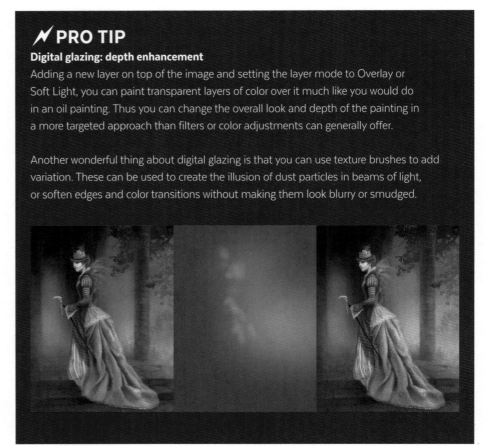

↑ The original (left) and glazed image (right). The brown background (center) shows the targeted glazing color layer

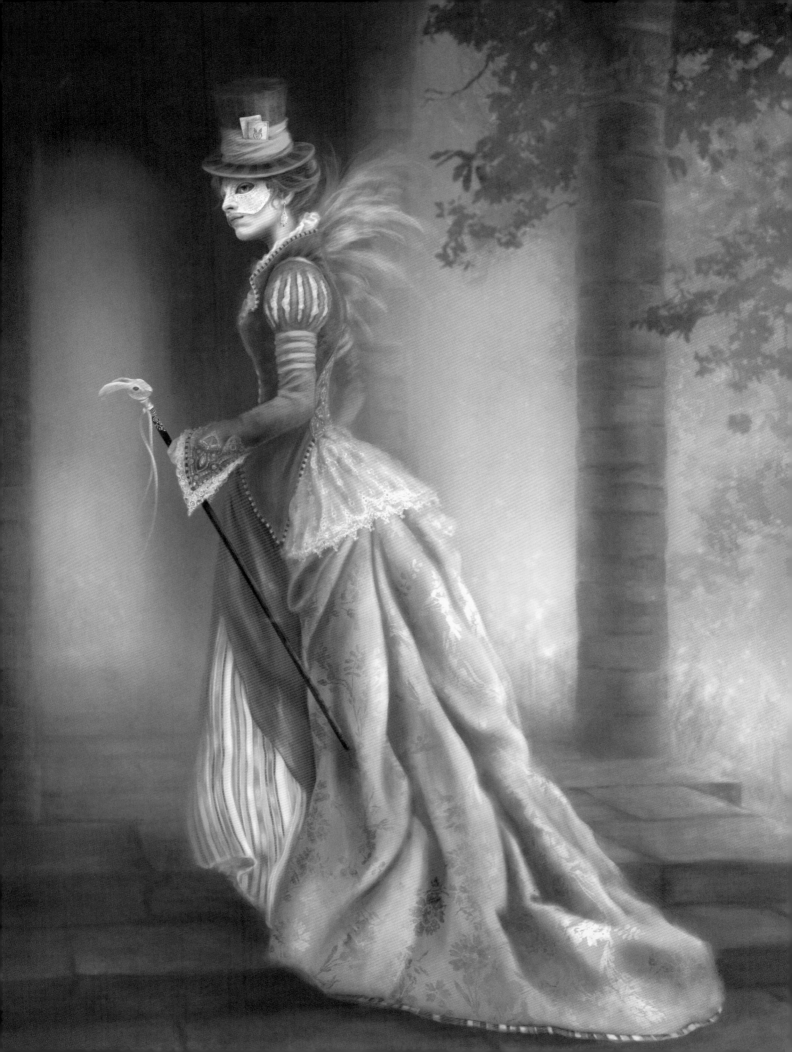

Costume Design | 1920s dress

In this step-by-step tutorial I will take you through my process for designing costumes for characters. Costume is an important part of character design and should not be overlooked or done half-heartedly. For every character I design,

I try to familiarize myself as much as possible with the relevant fashion and lifestyle of the character's environment. If the character appears in a story that is based in reality, it is important to know the cultural climate that the character

↑ I roughly sketch between three and five concepts

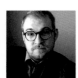

Randy Bishop
Character Designer & Illustrator
Software used: Adobe Photoshop

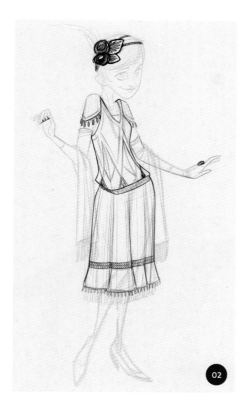

↑ Refining the sketch by drawing on a new layer over the rough sketch

lives in. A big part of costume design is therefore research. It is essential to know how clothing is constructed, how different materials drape over the figure, and how to communicate all of that in your artwork.

Almost all of my work is created digitally, so for this tutorial I will be using Photoshop. There are a lot of advantages to working digitally and I will try to illustrate a few of them in this tutorial. This isn't the process I use one hundred percent of the time, but it is a process I have found a lot of clients appreciate.

01: Rough concept sketches

For this 1920s-themed character I have learned a lot from my familiarity with J. C. Leyendecker's work. He was an excellent American illustrator who was working during the 1920s and 1930s, and he had an exceptional ability to portray the clothing of the time. Knowing a little bit about 1920s fashion from the beginning, I start to work on costume designs with a few rough sketches using a pencil brush. I generally like to have between three and five solid concepts at this stage.

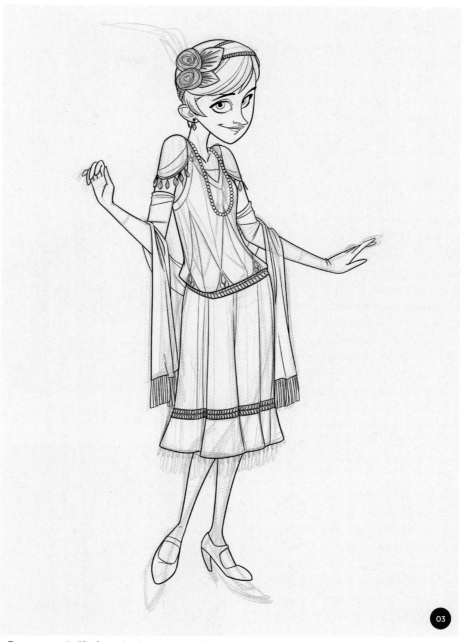

↑ Try to preserve the life of your sketch when you are inking

02: Refining the sketch

I usually gather a lot of images to use as inspiration for my work and then use different elements from different sources in my design. For this concept, I draw directly over one of my initial sketches on a new layer to add details that are inspired by my reference images.

Using multiple layers is really helpful when designing costumes for a character. I make adjustments to her proportions and change aspects of her clothing, adding

details to keep the viewer's interest a little longer. Once I have a fairly refined sketch, I will move on to drawing clean lines.

03: Inking clean lines

When you are inking new, clean lines over a sketch, it can be hard to maintain the life and integrity of your original sketch. To avoid losing this aspect of my sketches, I ink my pieces with an ink brush as if I am drawing them for the first time. As a result, not every line will lie directly over the sketched line that

sits on the layer beneath it, but the design will still be as I want it. It is also important to put lines down confidently at this stage. If you hesitate as you are placing a line, it will show. If you want really clean lines, you need to make them like you mean it. For me, it helps to put lines down quickly so that there isn't as much time for my hand to shake or stray too much from the sketch underneath.

04: Flat color

Once I have completed the line work, I add a new layer underneath it on which to add color. At this point I only worry about the local color. As a character designer, knowing how the local colors of a design work together without any light hitting them is more important than worrying about the values in a composition. Designing a character is about creating something that is going to look good regardless of the lighting situation. In this case, I decide that a red-violet, green, and red-orange palette suits the character quite well. I paint blocks of color with a paintbrush and try to make sure that the values of each color contribute to an overall appealing color scheme.

05: Colored lines

Once the flat colors are there, I apply colors to the line work to add a little more complexity and appeal to the design. Black lines are great for many purposes, but in this case I want things to feel softer and warmer to fit the character. I particularly want the translucent sleeves of her dress to communicate well and I can't bring that about with a black line. Instead, I achieve this by locking the transparency of the layer that my line work is on by clicking the square checkerboard "Lock transparent pixels" button in the Layers panel, and then simply painting over the lines with the color I want them to be. Locking the transparency on a layer ensures that only the elements that are already there can be affected by any changes on that layer.

06: Background

When presenting a character design, the color you choose for your background should complement the colors you have already

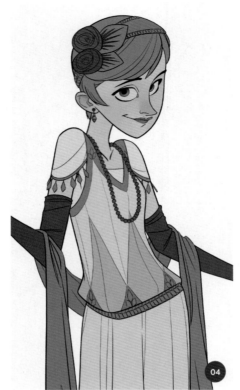

↑ Learn how to combine colors in appealing ways. Your choice of color says a lot about your character

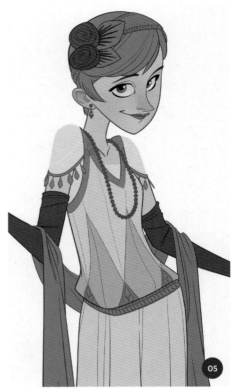

↑ Coloring your line work adds another level of complexity to your image

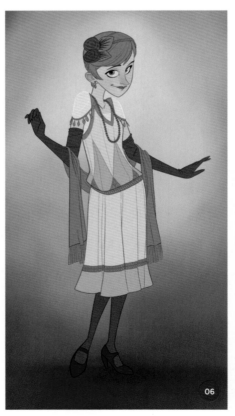

↑ It is important to choose a background color that complements your character, and doesn't detract from it

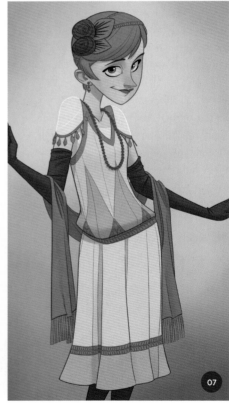

↑ Keeping your shadows and highlights on a separate layer can streamline the process of making several iterations

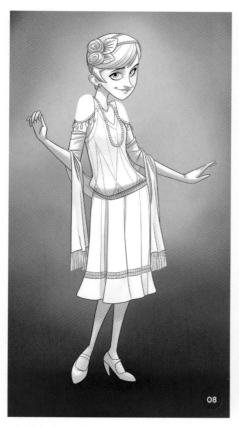

↑ I add shadows to the character on a Multiply layer using the line art as a guide

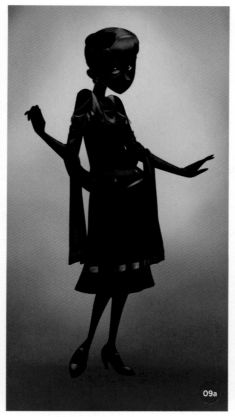

↑ The Screen layer mode is a useful tool for adding highlights to an image

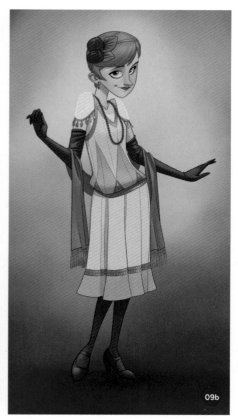

↑ How the image looks after shadows and highlights have been added

established in your character rather than act as a distraction. Blue-green acts a pleasing complement to the red-orange accents in this character's costume and also contrasts nicely with the warm tones in her face.

At this stage I also make sure I indicate a shadow beneath the character to make her feel grounded. I do this by painting a darker patch directly around her feet. To achieve the soft, atmospheric feel in the background, I block in the values I want with a heavily textured brush and then use a Gaussian Blur filter on the whole background to blend the values together (Filter > Blur > Gaussian Blur).

07: Shadows

Once the background is in place, I move on to indicating values on the character by adding shadows. It is important to study how light reacts to form. There are a lot of soft, gradient-like shadows in this piece as well as some harder cast shadows. Photoshop is a great tool for character designers because it offers

you tools that can aid you in producing several iterations of a character; I will use a Multiply layer (which darkens the colors beneath it) in the next step to add the shadows. If you are going to produce multiple color combinations of a character, or if you want to be able to change the local colors on your character easily, it is a good idea to keep your colors, shadows, and highlights on separate layers.

08: Multiply layer mode

The Multiply layer mode allows you to add shadows to a painting without having to worry about mixing the colors yourself. The way I use it is to duplicate my color layer so that I have two – one on top of the other. I make sure I lock the transparency of the top layer and then fill that layer with white. The reason for this is that white does not show up on a Multiply layer; I only want to add shadow at this stage, which I will do by painting over the form of the figure in a light brown. This also allows me to think about form without being distracted by the values of colors.

Once the form is defined the way I want, I change the layer mode to Multiply, which blends the values and colors of that Multiply layer into the values and colors on the layers beneath. This means that if I decide to change the color of the character's dress or gloves later, I can simply make the change on the color layer without worrying about indicating the forms over again.

09: Screen layer mode

I now use the Screen layer mode to add highlights (image 09a). Screen acts like Multiply mode except that instead of darkening the colors beneath it, it lightens them. I duplicate my color layer again, lock the transparency, and then fill it with black. Just as white doesn't show up in a Multiply layer, black doesn't show up in a Screen layer. It is hard to paint highlights in an entirely black layer, so before I begin on the highlights, I change the layer mode to Screen so that I can see what I am doing. You can see the design once highlights and shadows have been added in image 09b.

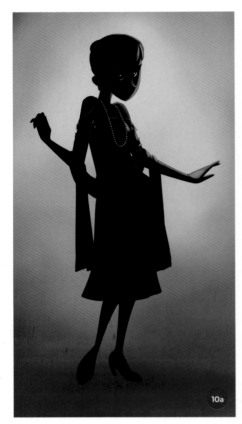

↑ Creating light from a second light source with Screen mode can add even more appeal to your image

> "I look over the entire image to make sure that everything looks correct, as it is always a good idea to review your work once you think it is finished"

10: Rim light

After I have added the highlights, I want to add a second light source creating a blue-green rim light to blend the character and background. I use the Screen layer mode again, but I use a separate layer so it is easier to edit (image 10a). Using Screen mode also blends the two light sources together just as they would blend together in the real world (image 10b).

11: Final artwork

After the rim light has been added, I look over the entire image to make sure that everything looks correct, as it is always a good idea to review your work once you think it is finished. I make a few small adjustments to some of the layers and decide to call it finished.

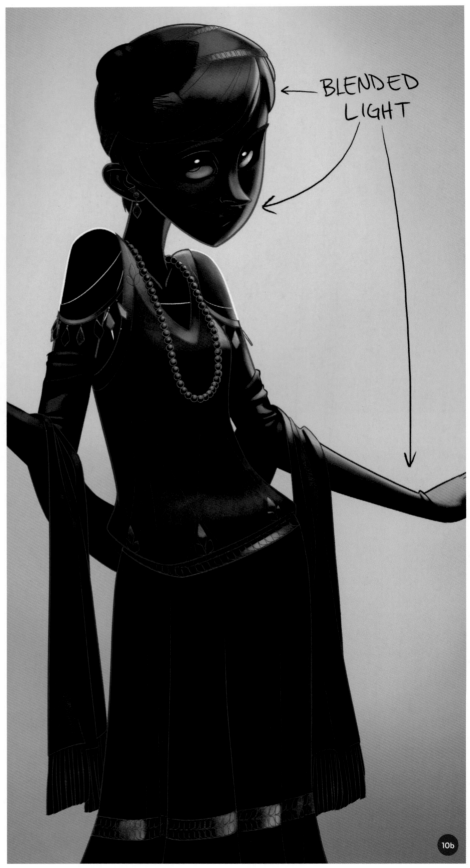

BLENDED LIGHT

↑ The two light sources blend as they would in the real world

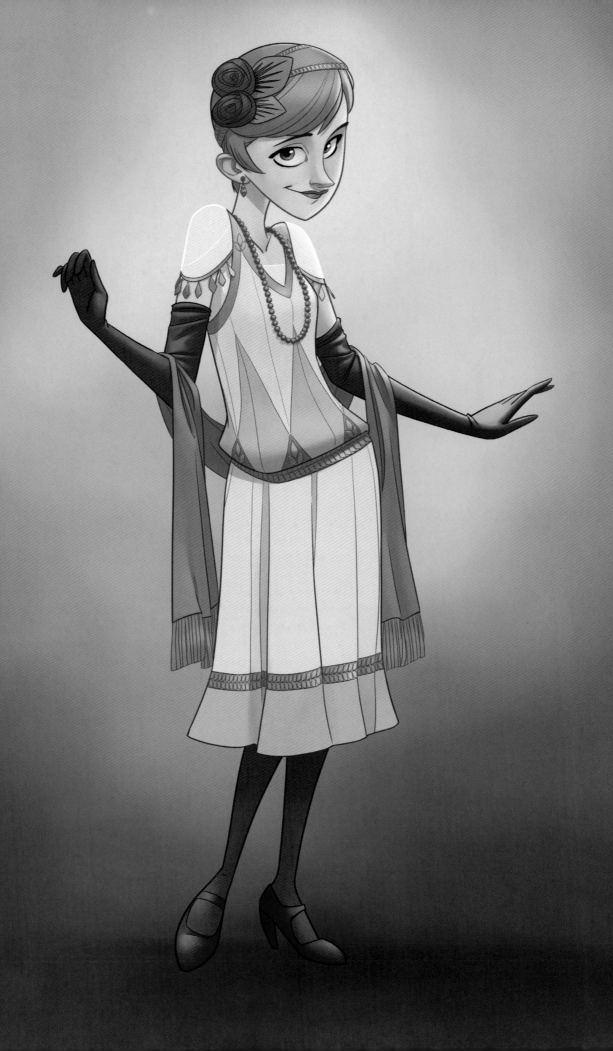

Costume Design | Aged jester

Loopydave
Freelance Illustrator
Software used: Adobe Photoshop

There are times when I carefully plan an illustration, collect resources and references, solidify my ideas with a series of increasingly tighter sketches, and systematically work through an orderly painting process. Other times the process is much more free-flowing and creative. This is one of those latter times.

For this particular tutorial I will start with a simple loose sketch of an aged female jester that is more about shapes and ideas than precision or detail. This is for a number of reasons. First, I have a natural tendency to tighten things up as I paint, so this will help keep the underlying shapes fun and cartoon-like. Second, I find that being a bit looser in my process can be a fun way to discover new approaches.

The process I show you here will offer you some effective ways to modify and develop a piece, mid- and even post-paint as well. I will use Photoshop CC, dealing with basic

paint tools, layers, and how to modify them. However, the actual processes and even most of the specifics should be applicable to whatever paint program you may be using. I like to start with a simple pencil and piece of paper first though; despite painting digitally for many years now, I still find that these tools are the fastest way to play with ideas and develop concepts.

01: The not-so big idea

My initial sketch is of an elderly lady dressed in a jester's outfit, sitting on a single seater lounge chair, surrounded by cats while looking at a photo of her younger self. However, I reject this sketch as being a bit too melancholic, plus I have a dog that I am sure would disapprove of all those felines. Instead I decide to be a little less reliant on narrative and look for a straightforward character study – the idea of an aged female jester offers enough potential interest and fun all on its own. And my dog will approve!

↑ I create a loose sketch with an interesting focus

↑ It is good to scan your sketch in the highest resolution possible in case you need it larger later on

↑ Selecting a few colors appropriate to my subject

02: The big scan

Digitally painting something small and then some time later wishing you could make it into a larger print is frustrating. I therefore scan my pencil sketch at quite a high resolution (around 6,500 pixels high in this case) before importing it into my paint program of choice: Photoshop.

Next I convert my image to RGB by going to Image > Mode, then create a new layer with the sketch on it and change its property from Normal to Multiply. I add a layer underneath it and am now ready to start blocking in colors.

03: Pick colors, not your nose

Knowing some color theory is very useful and it is a good idea for you to read up on this if you have not already done so. I mostly choose my colors instinctively. If you are working instinctively it can be useful to work out your background first as it will help inform your other color choices.

Ask yourself what the appropriate colors for the subject are and what the mood is that you wish to create.

Don't over complicate your color scheme if you can help it as it is easier to make colors harmonious if there are only a few. I borrow a little from the common themes found on joker playing cards, so my background will be white while my character's colors are bright and simple.

04: Lights, camera, action!

Now that I have chosen the background and basic flat colors, I need to work out the lighting, as this will inform the image's shadows and volume. Sometimes I mark the direction of light sources on my image, though I do not feel it is necessary in this case as the lighting setup will be quite simple.

As I am focusing on the character and costume design rather than a complex scene, I choose a three-quarter light from the direction the character is facing and just the faintest hint of a backlight diametrically opposite and below from the white background.

This is the same lighting as I used on my *Catchaser3000* illustration from *Digital Painting Techniques: Volume 4*, so I have added the lighting sketch from that illustration as a demonstration here (image 04). In both illustrations a warmish light, cooler shadows, and funny shoes are the order of the day.

05: A wrinkle in the works

After loosely mocking up the shadows and volume in a layer above the flat color one, it is time to start painting the face. Normally the face is the main focus of a character piece and my usual beginning point. I create a new layer above the one containing my initial sketch and start

↑ Three-quarter light facing the character and a soft back-light as in this past sketch is a good choice for the jester

↑ On a new layer I mark out how the skin will move in order to help me detail the face

↑ Once I know where the wrinkles will be I use a small brush to gradually detail the "character" lines on the granny's face

drawing where I think there should be wrinkles and pull-lines and build up from there. I work almost entirely with a standard hard-edged brush set to a low opacity. This is my default working mode, but it is particularly helpful in this case, as I want to avoid smooth skin.

For me, painting faces follows a basic principle that I use for painting just about everything else: use broader strokes and basic shapes first and then refine them until the desired result is achieved. You can see in image 05a how I build up details in the face. In part A the brush is fairly big, but the colors are in place. I want to work out how the wrinkles will look on the jester's face so, on a separate layer (part B), I draw some quick lines and arrows to work out the direction the skin would pull with her

↑ Using real-life hand poses for reference, I spend time carefully detailing the hands

↑ The Smudge and Dodge tools are particularly useful for painting hair

↑ Materials have different properties so create sharp creases for stiff materials and loose creases for soft

expression. It is only a rough guide, but it helps me work out her "character" lines, which I paint with a much smaller brush in part C. You can see a close up of the details in image 05b.

06: Handy hands

I look at a few images of old wrinkly hands to get an idea of the level of wrinkle exaggeration that will be required; I take a rather poor photo of my own hands and start painting. Finally, after years of regretting the long and delicate nature of my hands for not being "manly" enough to serve as references for barbarians, knights, or kings, I find them to be an appropriate resource for a ninety-year-old lute-playing female jester.

I rank hands second only to a character's face in importance so I spend a corresponding amount of time working on them.

07: Pink hair

I use a simple approach to painting hair here: I draw the basic flow of shapes, going over them with a soft brush to create underlying colored "waves," and then paint lots of strands using a 2-pixel hard-edged brush. It is simple, but time consuming. On the whole I avoid using either the Smudge or Dodge tools, but they are useful for hair. The Smudge tool is useful for softening the edge of the strands and the Dodge tool can be used to create highlight bands. I would usually introduce more colors when painting hair, but colored wigs such as this tend to appear as a single color with variations in the tones.

08: She's a material girl

The key to painting materials and clothing is to understand their properties. Silk has a particular sheen, while felt is textured but matt, and tight cotton has thin folds which are sharper than a looser material. Using my basic knowledge of some of these material features, I paint each fabric differently. I use sharp creases on the tights, harder folds for the cloth around her elbows, and looser creasing for the neck piece.

For the patterns on her tights, I first paint the basic leggings. Then I paint the pattern

↑ Detail your accessories using references as a rough guide rather than replicating them exactly

↑ I transform an ellipse and use the Pen tool to create a slightly imperfect wheel

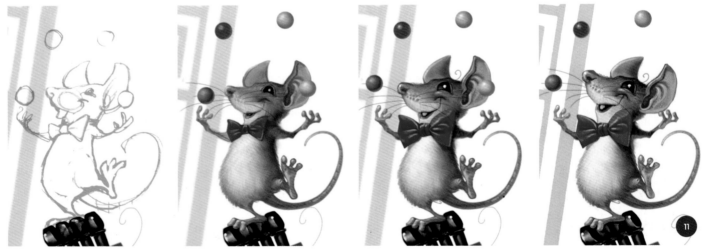

↑ Detailing the rodent using a basic flat brush and the Smudge tool

in flat colors on a new Multiply layer to create instant diamond leggings.

09: Show me the lute!

As I am not familiar with lutes, I search for some images online and use them as a guide to understand the instrument's structure and the textures of its various elements. Like everything else in this illustration, representational accuracy is secondary to the characterization and costume.

References are basically used to understand an object and its properties rather than provide something to replicate. I look at old faces to understand wrinkles and pull-lines, lutes to understand structure and textures, and unicycles for a feeling of nostalgia for when I used to ride one many years ago.

10: Mechanical shapes

Even with the powerful tools that a program like Photoshop has, painting technical

and mechanical objects can still be fairly time consuming. I use the Ellipse tool, the Edit > Stroke menu, and Edit > Transform > Rotate to create clean tire shapes on a layer above the scanned sketch.

I also use the Pen tool to create selectable areas to paint in for some of the other hard-edged elements. Unfortunately using perfect ellipses and precise shapes make the unicycle appear rigid and out of place, so

to fix this I use Edit > Transform > Warp to add a bit of bend to the unicycle's form.

11: Oh rats!

The initial sketch of the juggling rodent, or Hubert as I call him (after Danny Kaye's character in *The Court Jester*), is rough and lacks sufficient personality. Being consistent with my stated approach to this painting, I develop him as I work.

I create a new layer above the sketch for Hubert. I have a number of "fur" brushes I sometimes use, but in this case I stick to a basic flat brush set to a very small size as well as using the Smudge tool, a combination I have found effective for fur in the past.

12: Make alterations as you go

Occasionally I am asked about the number of layers I use when painting in Photoshop, and the answer in this case is "lots!" There are times when I only use one, but here I create at least one layer for each major image component – face, hands, legs, and so on. This allows me to adjust their scales, shapes, position, and colors separately, which is a necessity as

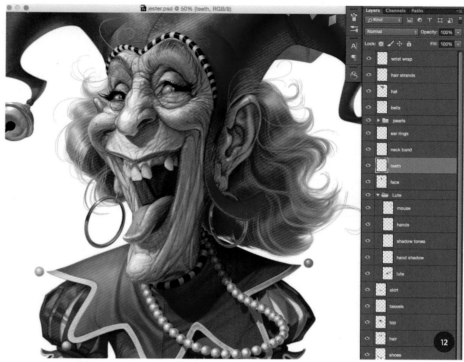
↑ Keep your illustrations on lots of layers so that elements are easy to adjust

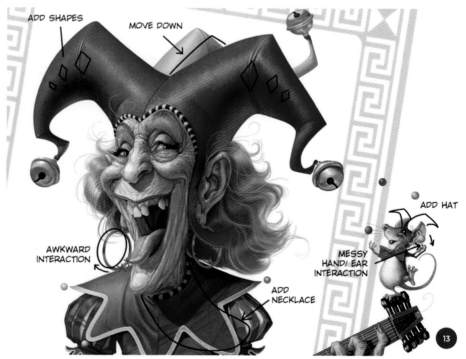
↑ I critically evaluate the image, looking for anything that is missing or awkward interactions

I am working from a rough sketch with a few proportional and placement issues. For this illustration I scale the face and rotate her left leg; I also have the ability to change elements of her uniform without compromising other details.

13: The final countdown

Towards the end of a project I sit back, cast a critical eye over the image, and write down a list of all the things I need to do in order to finish it off. I look for little details I may have missed until this point. This helps me

⚡ PRO TIP

Keep track

At semi-regular intervals I like to copy and paste a smaller version of the file I am working on as a layer in a separate "step-by-step" file. I then label each layer with an end-of-day point to note the time I finished working on it. This is useful for later if time frames are needed and helps with billing similar projects in the future.

It is also useful for giving me an idea of how well I am progressing. Spending hours on intricate details can be daunting if, at the end of the day, you don't feel like you have advanced very far. Keeping a record can show your actual achievements.

focus so that I don't miss something I may later regret, as well as giving me an effective countdown to the final piece. Among other things in this illustration, I need to fix the yellow section of the main character's hat, give the mouse a hat too, and tinker with a few awkward-looking shape interactions.

> "Now that all is said and done, it is time to compare the image against both the initial brief and my stated aims at the beginning. I decide I am happy with it as a fun character and costume study and there is enough in there to make it entertaining"

14: Beads and bells

I decide to add a pearl necklace to help add some dynamism to the main character's movement as well as to make the costume a little less masculine. First I draw a line which the pearls will follow and then on individual layers I create a circle for each bead. When the necklace looks about right, I paint each bead, and then merge them all into one layer, painting the shadow cast from her head onto them.

Being metal, I make sure the bells have intense specular highlights, well-defined contrast, and some hint of reflectivity. I cannot verify the accuracy of the reflections, but I think they look convincing enough.

15: Final image

Now that all is said and done, it is time to compare the image against both the initial brief and my stated aims at the beginning. I decide I am happy with it as a fun character and costume study and there is enough in there to make it entertaining. Considering the looseness of my initial sketch, exaggerated proportions, and non-reliance on references, the final image is tighter and maybe more realistic than I had thought it would be. Most importantly, I have finally found a good reference use for my ninety-year-old female jester's hands!

⚡ PRO TIP
Use multiple copies
A particularly useful feature of Photoshop is its ability to show multiple copies of the same file as you work. Found under the Window menu (Window > Arrange > New Window for "filename"), this allows you to work closely on details in one window while also having a smaller one where you can view how the changes are effecting the overall image.

↑ It can be helpful to keep different views of your image visible at all times

↑ I create circles on individual layers to paint a pearl necklace, then merge the layers together

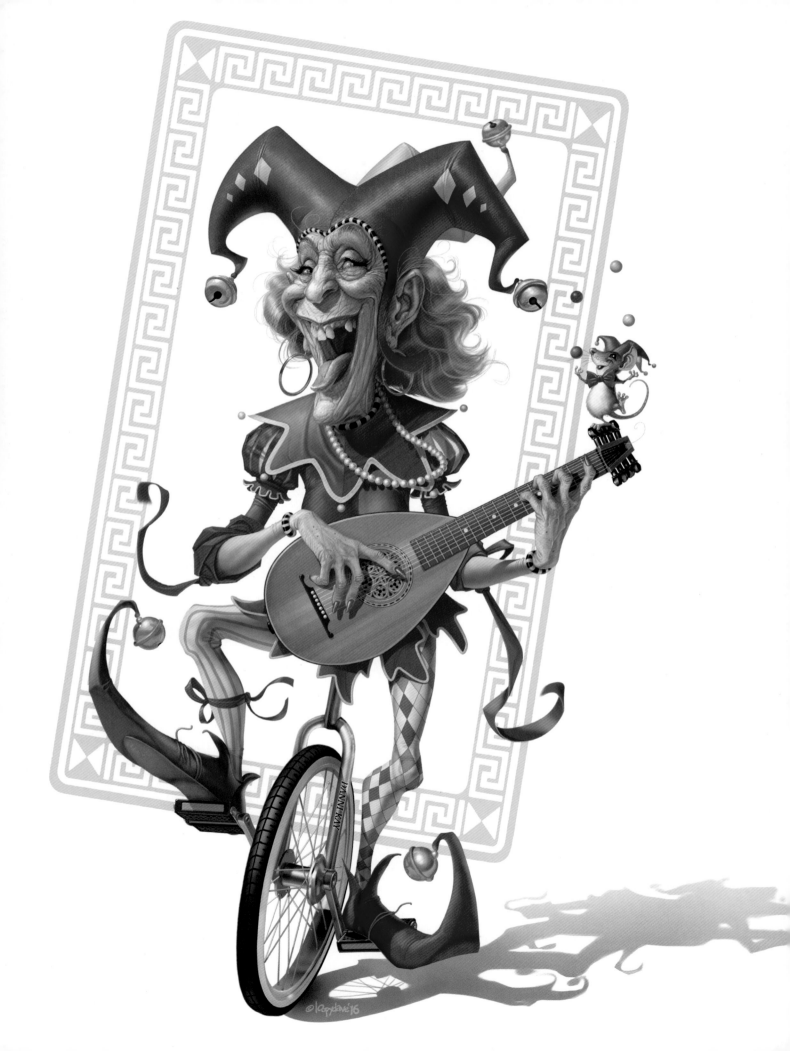

Costume Design | Thirteenth-century knight

In this tutorial I will go over how to paint a believable thirteenth-century knight. While this painting will be created from the imagination, a lot of research needs to be carried out in order to produce a fairly historically accurate depiction. I do not claim to be an expert on the matter, but doing some research online can help you achieve something that most people will find believable.

Luckily in this day and age you can find virtually everything online in a matter of minutes. As I mentioned in the female assassin tutorial on page 136, what you have to keep in mind when looking for references online is that most of the time you are not going to have the rights to use an image; shooting your own reference is always the best thing to do, but of course not everyone has a suit of armor lying around.

Although my brief gives me the choice of creating a twelfth- or thirteenth-century

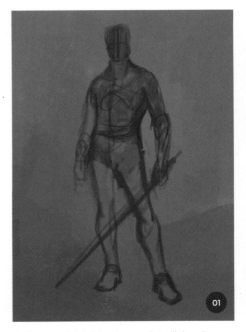

↑ After research, I sketch out a pose that will show the personality of the character

knight, I decide to go with a thirteenth-century design because by the end of the thirteenth century pieces of plate started

Daarken
Freelance Illustrator & Concept Artist
Software used: Adobe Photoshop

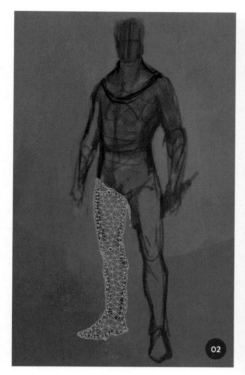

↑ You can use Puppet Warp to fix the pose of your figure without having to redraw everything

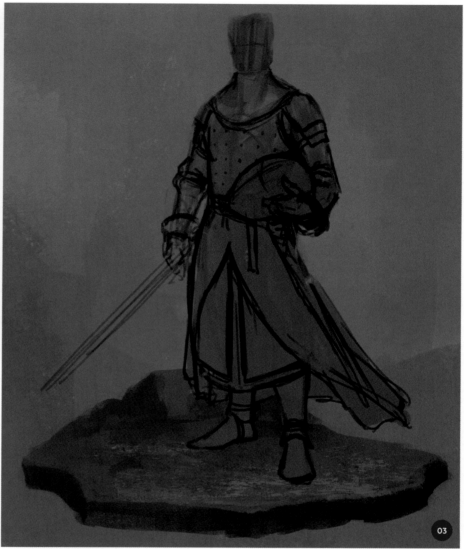

↑ Changing the pose to feel a little more natural and to allow the viewer to connect with the character's personality

being incorporated into armor. Before the thirteenth century armor mainly consisted of mail and a helmet – not quite as visually appealing to me as plate. Full plate had not been introduced by this point, but small pieces such as gauntlets, greaves, cuisses, poleyns, and couters made their appearance. Mail still played a big part of a knight's defense, but painting large areas of mail can be difficult and time consuming. That is why I will use my own custom mail brush which I created several years ago. It is easy to use and gives quite a convincing look.

01: Creating a pose

After researching online, I try to find a good pose to start with. When you are designing a character, always try to inject a little personality into the pose. Most of the time when you are designing a character, you should avoid picking a pose that will cover up too much of the design. People need to see the design clearly, but they also need to get an idea of who this character is. What are they like? Who are they as a person? For this reason you should not choose a pose where there is a lot of foreshortening of the limbs.

02: Fixing the pose

I usually go through a few different poses while trying to find the right one. One great way to change your drawing without completely redrawing everything is to use the Puppet Warp tool. Just select the area you want to warp and click Edit > Puppet Warp. You should now see a mesh covering the selected area (image 02).

Once you see the mesh you will need to place the points that you will use to distort the image. Think of joints on an action figure: place one at the hip, knee, ankle, and so on. Once the points have been placed on the mesh you can grab them and distort the image.

03: Refining the sketch

I carry on making changes to the pose and thinking about what the character should be wearing. Originally he was wearing a helmet, but this would mean that the viewer would not be able to see his face. I decide to draw him holding the helmet so that the viewer can connect with the character a little more.

Based on my research I have a general idea of what he should be wearing. He needs mail, pauldrons, greaves, gauntlets, couters, a gambeson, a great helm, and a surcoat. Since plate only had just been introduced in the late thirteenth century, these were probably fairly simple in their design; to maintain historical believability I will not make them too fancy.

04: Adding color

I am now at a good point to start adding color. My lines and values are on separate layers, allowing me to lock the transparency on the value layer so that I don't have to worry about painting outside of the lines. Normally I would use an Overlay layer to add color to a black-and-white image, but since I have not done much rendering at this point, I will not really need to preserve my black-and-white painting. It is much easier and faster to just paint in a straight color.

05: Coloring the face

After quickly sketching in the face, I start adding the base colors with an Overlay layer. Adding color to a black-and-white painting isn't a quick and easy process; you can't just add color to one layer and think that your painting will be finished. It takes a long time to build up color and then you have to paint opaquely on a Normal layer the old-fashioned way.

Adding the base colors with an Overlay layer can often make your shadows look desaturated and muddy. This can be fixed once you start painting opaquely. For now I am only trying to establish the base colors.

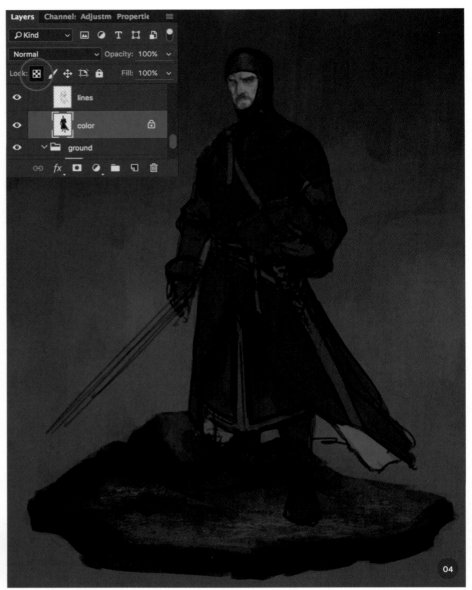

↑ Adding the base colors by locking the transparency on the value layer and painting in straight color

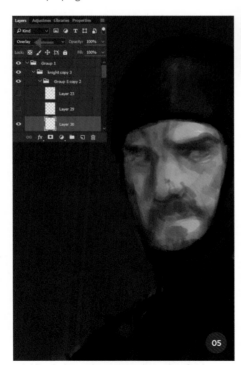

↑ Adding the base colors on a new layer set to Overlay

06: Refining the face

Now that I have established the base colors, I can create a new Normal layer and start refining the face by painting opaquely. One problem I often see from my students is that they make the shadows too desaturated. Remember that colors tend to saturate in the shadows and desaturate in the light.

I also try to think about color variation in the skin. Don't just paint the skin all one color as there are many temperature shifts in the face. Around the mouth and eyes you will typically have cooler colors and around the nose, ears, and cheeks you will have warmer colors.

07: Final facial adjustments

Even after over a decade of working professionally, I still struggle with proportions. I can't remember the last time I drew something correctly the first time. In this case, the character's eyes are a little too small and far apart, so I make them larger and move them closer together. I continue to refine my shapes and push the color variation within the face.

When painting facial hair, make sure you paint larger shapes first. All too often I see people trying to paint every strand of hair. Once you have the main shapes established, you can then pull out a few strands of hair. Also watch

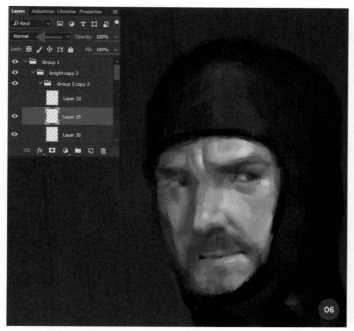

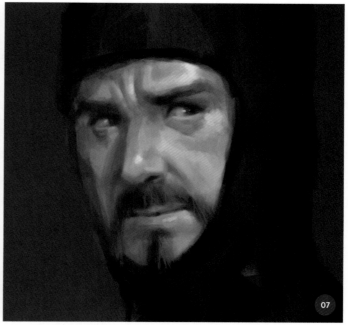

↑ Refining the face by painting opaquely on a Normal layer

↑ Fixing the proportions of the face and continuing to add more detail

↑ Painting mail using a custom mail brush with the Angle Jitter set to Direction

↑ Painting strokes in opposite directions creates rows of rings

your edges; you don't want everything to be too hard-edged, otherwise it will look fake.

08: Painting mail

The idea of painting mail can be extremely daunting because trying to paint thousands of tiny circles is not exactly easy, or fun. It is like trying to paint leaves on a tree: it will drive you insane if you do it all by hand.

Many years ago I created my own custom mail brush to help me paint large areas of mail. The brush itself looks like three Cs in a row. It may not look very impressive, but the secret is in the Shape Dynamics. By selecting Direction under Angle Jitter (image 08a), the brush shape is allowed to change direction based on the direction of your brushstroke. When you alternate your brushstrokes, it creates the look of rows of rings. Now you just need to keep alternating your brushstrokes for the entire area (image 08b).

Sometimes the brush can become a little unsteady if you try painting curves, so it works best if you can paint in fairly straight lines. The rings don't always line up, but they look quite good when you zoom out, and create the desired effect for this costume design.

> "I also create more shadows, highlights, and color variation using an Overlay layer on top of the mail layer"

09: Painting fields of mail

I suggest painting the mail rings in a middle value on top of a dark background. That way you can achieve more depth and then easily add shadows and highlights. All you have to do is repeat this process until you fill the entire area that you want to paint.

I make sure I paint outside the lines so that I don't miss any parts around the edges. Since I am painting on a separate layer, it is easy to erase the parts that go outside the lines. The mail may look ugly now, but this is just the base coat; it will look better once I add the final touches.

10: Refining the mail

The mail is also on a separate layer, so now I can lock the transparency on that layer to paint the shadows. I also create more shadows, highlights, and color variation using an Overlay layer on top of the mail layer. After that I add even more highlights on a Normal layer.

It is important not to add highlights to every single ring. That would that be very time consuming and adding highlights in only a few areas makes the mail feel more realistic, as if it is actually sitting on the body and only certain parts are catching the light. Now when you zoom out you will see a fairly convincing depiction of mail.

11: Fixing the pose

Now there is an opportunity to fix the pose of the character by checking it against a reference image. As I mentioned on page 136, shooting your own references is an extremely important part of creating a realistic painting. There are a lot of artists out there who don't need to shoot references, but in my opinion they can really help your painting.

↑ Painting the rings outside the lines and then erasing the extra parts

↑ A combination of Overlay layers and opaque painting gives the mail a realistic look

I often take photos of myself if I am not sure how to paint something, or if I want to make something a little more realistic, such as when I am painting hands or drapery. Shooting your own reference also helps you understand how the body works and what limitations the human body has. It is important to know those limitations so that you can exaggerate your painting to create something more dynamic.

↑ I shoot some pose references and then make changes to the character's pose to ensure realism; I also start to add a rim light to the character's face at this stage

⚡ PRO TIPS

Color variation

Lack of color variation and harmony is something I see a lot of my students struggling with. When you are painting something, don't just change the value of the color by moving the cursor in the main color box; also change the hue in the right color strip.

When I was in school, one of my teachers always told us that whenever you change the value of something, you also need to change the hue. This will give your painting more color variation and it will also help unify the color palette.

Adding movement

Even when I have a standing figure, I always try to add a sense of movement to the painting. Clothing and hair are always good devices to add movement.

Using opposing diagonals and twisting the torso of your figure is another good way to add movement. If the main direction of your figure is pointing to the left, try turning the figure's head or torso to the right.

It's the little things

Often it is the little things that can sell your painting. For example, when you are designing armor, try to figure out how the armor would really work or how it could be constructed in real life. Adding features such as rivets and straps can really help your design appear more realistic and functional.

Other details such as rust and scratches can also help make your painting feel more lived in. If everything looks too perfect and clean, it might come across as too "digital."

12: Adding more details

Now that I have all of the elements in the right place, I can continue to refine the painting and add small details. It is important to get the large details in place first before working on the small ones. This will help your client get a better idea of what the final design will look like and it will prevent you from becoming overwhelmed by the details early on.

Early in the sketch I had painted a shoulder strap, but I forgot to paint the heater shield it attaches to. I don't want to cover up the character with a big shield, so I put it behind his back instead. It is important to make sure that everything works realistically. I also work on the highlights on the armor more.

13: Gauntlet reference

I know my character is going to be wearing gauntlets, but I am a little unsure of what they would look like in this pose. Luckily I know someone with a pair of gauntlets and a sword, so I ask him if he could shoot some references for me. Shooting your own reference can help save a lot of time. If I go ahead without taking references, most of the time I end up spending even more time fixing my painting because I wasn't sure how it should look.

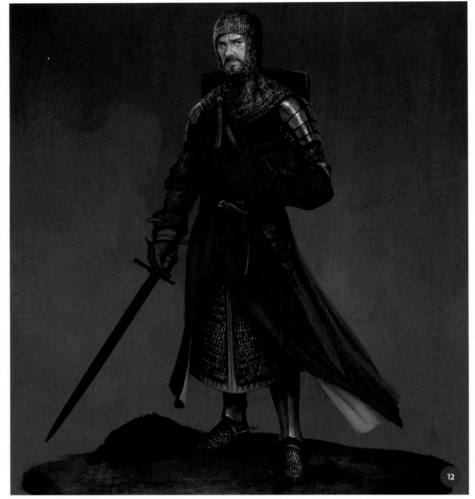

↑ The painting is nearing completion, so continue to refine and add details

↑ Shooting references can be extremely helpful and save time in the long run

> "Even if you feel that your painting is finished, you should put it away for a few days and then look at it again. Usually you will notice something"

14: The final painting

After I finish the painting, I put it away for a couple of days before looking at it again. Returning to it, I notice that the heater shield is too short and that you would probably be able to see more of it, so I make it longer. I also add some scars to the knight's face to give him more of a unique look.

Even if you feel that your painting is finished, you should put it away for a few days and then look at it again. Usually you will notice something that you forgot or find something that you can fix or improve.

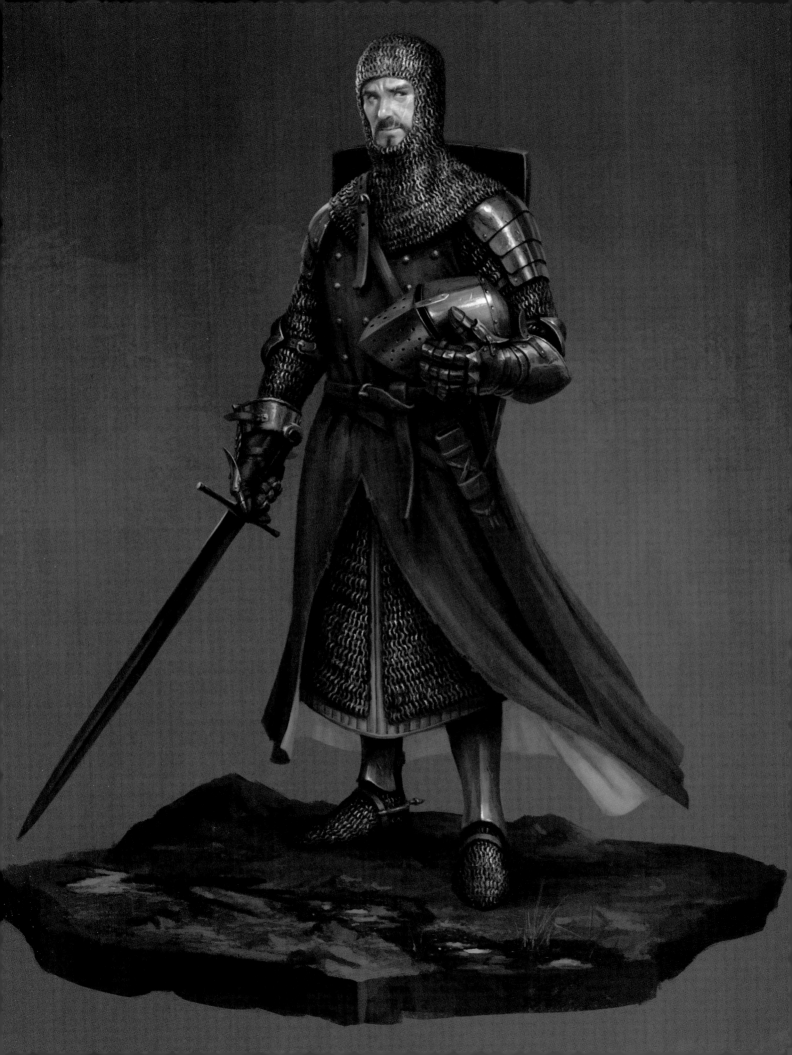

Costume Design | Space pirate

In this tutorial I will walk you through a fourteen-step process outlining how I go about researching, designing, and painting an illustration of a space pirate, complete with an original costume and weapon. The design will combine classical pirate dress, elements of science-fiction costumes, as well as real-life space-wear.

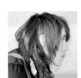

Valentina Remenar
Freelance Artist
Software used: Adobe Photoshop CC

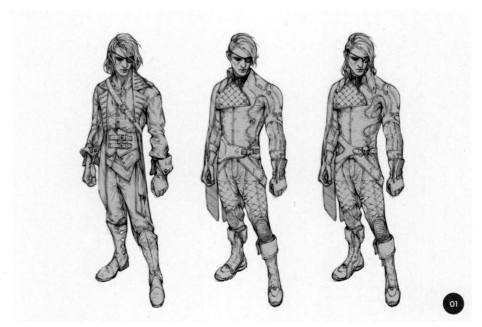

↑ Trying to find a middle ground between a pirate costume and the sci-fi genre

01

The first portion of the tutorial will focus on how I conduct my research and design and paint an appropriate costume for a cross-genre character, as well as how I design and illustrate a unique weapon. The latter parts of the tutorial will focus on the illustration. I will walk you through creating a composition, adding appropriate light sources, detailing the background, coloring, and incorporating the character and weapon design to create a striking scene.

I will discuss the Photoshop tools used throughout, including standard brushes, custom brushes, and textures, as well as the techniques applied to create the effects seen in the final product. The tutorial will instruct you on both matte and normal painting, as this is the style I have chosen to use for the illustration.

01: Initial costume design

First I research pirate costumes so that I can brainstorm ideas for the design of the character. I aim to keep the classical characteristics of pirate clothing, including boots, eye patches, gloves, a cape, and a coat, but I want to stylize the design to bring it closer to the science-fiction genre.

Looking at image 01, the design on the left is closest to a classical pirate costume, without any elements of science fiction or space wear. On the middle design, I keep elements from the pirate's costume, including the eye patch, cape, gloves, and boots. However, I feel this design has lost a lot of the pirate concept and looks too much like an astronaut. So, in the design on the right, I try to find a middle ground that I am happy with. I have been using a pencil brush to sketch in this step.

02: Toning the costume design

In this step I break down the outfits based on which values and contrasts I feel would work best to fit with the space pirate theme. While the left outfit in image 02 remains the most pirate-like, the middle and right ones are closer to the look I

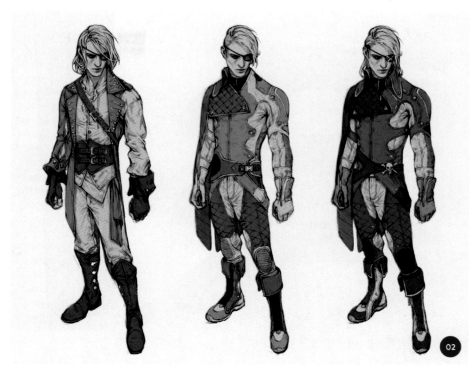
↑ Adding tones to each of the designs to decide which one works best

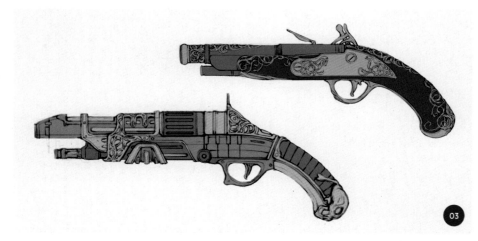
↑ Playing with the initial gun design by comparing and contrasting an old-fashioned Flintlock pistol and adding elements of modern guns

am trying to achieve. However, I choose to make the design on the right darker to reflect the classical pirate look more, since space-wear tends to be white or lighter in color.

03: Initial gun design

I now move on to designing my space pirate's key accessory, a gun. I take a similar approach as I did to the costume design. I base my first design (top in image 03) on a real Flintlock pistol that is commonly associated with pirates. This gives me a basic

idea for the design, which I will again try to bring closer to the science-fiction genre.

For the second design (bottom in image 03), I keep the general shape of the Flintlock gun, but add several extra mechanisms that would be more reflective of a modern weapon, including a grip and a more up-to-date barrel and trigger. I do however keep the ornate carvings from the first gun and apply the design to the second gun to maintain the archaic, pirate look.

↑ Painting the gun and adding texture and color to finalize the design

↑ A brief overview of the adjustment layers and colors used on the gun

04: Finalizing the gun design

I now spend time detailing and finalizing the gun design by painting and adding colors. The major difference between the three steps you can see in image 04a is the use of color to bring out and highlight specific aspects of the design.

On the top gun, I start by applying basic colors using the Multiply layer mode and then continue painting on Normal layers. The painting progress is carried out in black and white initially. Throughout the middle and bottom images, I add the tones with adjustment layers.

To paint the gun, I use a soft round pressure opacity brush (with Opacity set to 60–70% and Flow to 60%). I also add metal textures from www.textures.com to make the gun look more realistic. In the last image, I add some more color to the gun.

In image 04b you can see an overview of the adjustment layers and colors I use for the gun. I always paint in black and white and add adjustment layers for the colors and contrast afterward. Here, I use the Color Lookup adjustment layer (found on the Adjustments panel), and play with

↑ Initial composition sketches created in black and white, focusing on the general shapes and basic concept

different filters and layer blending modes.

The blue tones that highlight areas of the gun are located in the group marked in yellow. For both the green and yellow layer groups, I first add colors on the Overlay layers, and then add adjustment layers on top to change the colors. I play around with the filters and blending modes because each blending mode creates a different effect and I want to work out which one works best for the gun.

05: Initial illustration sketches

Once the character and gun are designed it is time to place them in an appropriate scene. I first create a very rough sketch

of the basic concept: a space pirate in an action scene. My first idea was to sketch the pirate hanging from a pole in outer space.

At this stage, I am just trying to get a grasp of the composition and shapes in the image while playing around with ideas for the background. Everything is in black and white, and at this point, the details are not important. I focus only on setting the composition.

06: Setting the colors

After selecting the composition sketch that I liked best (the central sketch in image 06), I work on setting the colors for the illustration. I use a similar process as I did

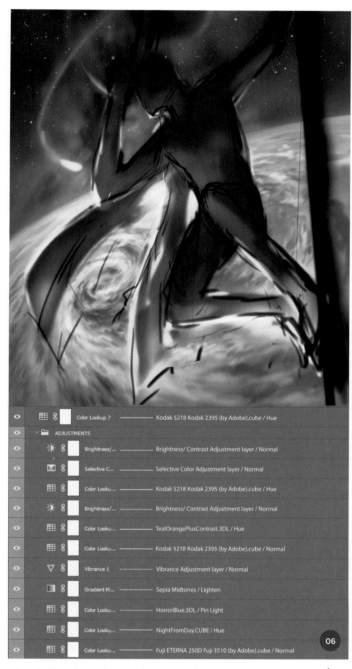

↑ I set the illustration's colors using Color Lookup, Gradient Map, Vibrance, Brightness/ Contrast, and Selective Color

↑ In this step I establish the light source and detail the background with spiral-shaped clouds and shadows

when coloring the gun; the illustration is initially painted in black and white and then I play with Color Lookup so I can get cold blue tones for the shadows and warm orangey tones for the light. I then add a Gradient Map to create more orangey tones on the lighter parts of the illustration. I also add a Vibrance adjustment from the Adjustments panel to alter the saturation of the colors. I adjust the Brightness/

Contrast setting and change various colors using the Selective Color adjustment.

07: Painting the clouds

In this step I focus on the illustration's background where there is a cloud-covered planet. I use a soft round pressure brush (with Opacity set to 60–70% and Flow to 60%) to draw on the layers below the adjustment layers, so that everything is still painted with

grays. I also pick the light source for the scene, which is located on the edge of the planet.

The clouds are painted in spirals which follow the same direction, giving the appearance of a hurricane. I begin detailing first with a big brush and then work my way down to a smaller brush as the details become more intricate. I also paint the shadows under the clouds, which would be cast over the planet's ocean.

08: Sketching in the character

Now that the background is mostly complete, I sketch in the character. I have a pose which I have settled on from the original sketches, but I feel that the anatomy needs to be worked on. I also have to incorporate the design I made earlier for the space pirate's costume. I do all of this in black and white at this point.

I also begin designing the helmet (since the character is in space!), and play with different color combinations. I consider using red on the character's clothing. At this stage I am still using a soft round pressure brush (Opacity at 60-70% and Flow at 60%). I also add in the completed gun design to the scene.

09: Adjusting the composition

At this point it is time to adjust the composition. In the previous draft, the character's head was on a dark background,

making him less visible. Because of this, I decide to adjust the location of the planet in the background so that the light is on the side and the character's head is no longer against a dark background. This helps bring out the focal point of the piece and highlights the character more.

A grid can help break down and establish a strong composition, whether it is a golden ratio arrangement or diagonal composition. When you are sketching, it is good to try a few different variations of a composition so that you can see which one is the most appropriate and striking, and draws attention to the focal point of the illustration. Using a grid to play with light and shapes can help you build a solid composition and make adjustments throughout the illustration process.

The red lines you can see in image 10 represent the base grid, which helps me to

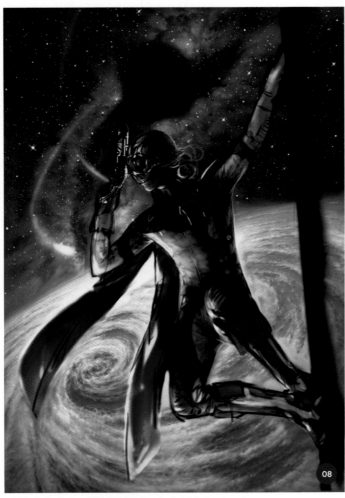

↑ With the background finished, it is time to sketch in the character

↑ Adjusting the composition to bring out the focal point, making the character more visible

↑ I add complementary contrast and color with blue hues on Overlay layers and orange hues on Color layers

break down the composition. The yellow lines help set the position of the character, while the blue diagonal line helps position the planet. The green lines show the golden ratio (an aesthetically pleasing way to divide shapes), which is used to set the focal point of the piece, just left of the gun.

10: Adding colors

It is now time to set the colors of the whole composition. Since the previous draft, I have decided to abandon the red hues because they were not working. I add colors on Overlay and Color layers. I want to create a complementary contrast, so I decide to use blue tones and then add orange hues to the character's outfit to accomplish this effect.

The orange tones are added on the character's Color layer, while all the blue colors are added on the Overlay layers to add color and create contrast and vibrancy. This is painted above all of the adjustment layers.

11: Detailing the planet further

Evaluating the scene, I decide to change the style of the illustration and take it in a more painterly direction. I add cloud and sky textures from **www.texturepilot.com** to

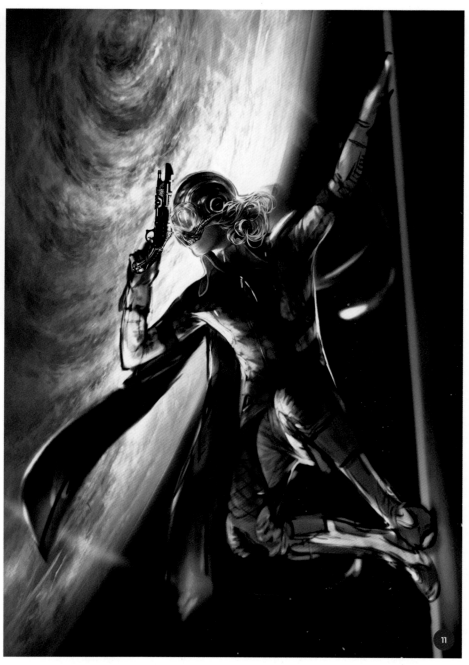

↑ I give the illustration a more painterly feel by adding textures and using a custom brush, then detailing with a soft opacity brush

✎ PRO TIP

Textures for realistic effects

When working on a matte painting, using textures can help you quickly create realistic effects. There are dozens of great resources for textures online, both free and for a reasonable price. Textures are based on photographs, so they already look realistic. This saves you from having to struggle with painting these effects from scratch. Textures are a very versatile tool, as you can warp, crop, change, and paint over them to fit your needs.

enhance the matte painting effect. I use the same base from before, and after adding textures, I switch to a custom brush to again achieve a more matte-painted look. After this, I return to the soft round pressure brush to add details and soften out the rough edges that the custom brush created.

12: Detailing the fabric

Here, I select a light source so I can properly detail the fabric. Since the planet is on the left, this is where the main light source comes from. I also create a backlight on the right, and add some adjustment layers to fix the colors.

I then create new layers to start painting with colors using the same soft round pressure brush (again with Opacity at 60-70% and Flow at 60%). I have to add blue tones on the highlighted areas to show the reflecting light from the planet. I use a bigger brush first to set the light and the shadows. Once I start to draw the fabric of my character's legs (wrinkles, zippers, creases, and so on), I use a

smaller brush to help with the detailing. If you take a look at image 13 you can see that I have also started to add detail to a comet.

> "In the final stage of the illustration, I focus on repainting the helmet, face, and hair so that it will fit the backlight"

13: Adding visual effects

At this stage, I begin adding finishing touches and visual effects such as embers and sparks, as well as a lens flare texture pack available at www.photobash.org. I add ember textures to the comet's tail and change the color from red to blue so that it will realistically fit with the comet's color. I then use the Warp tool to adjust the texture so that it fits the curve of the tail. I also draw sparks and add vivid and bright colors with Color Dodge layers, which gives a nice glowing effect.

Finally, I add lens textures on to the comets, the edge of the planet, and at the top of the piece. I use a sparks texture to give the effect of grainy sparkles around the planet. I place the lens flare, as well as the ember and sparks textures, on a Lighten layer so that the black parts will be transparent.

14: Finishing touches

In the final stage of the illustration, I focus on repainting the helmet, face, and hair so that they will fit the backlight, since the planet's position in the background was changed. I use the same soft round pressure brush (still with Opacity at 60-70% and Flow at 60%) to do this. I also add finishing touches to the space pirate's outfit by adding the reflected light from his leg onto the cape.

For the final finishing touches to the illustration, I add a Lens Flare effect (Filter > Render > Lens Flare) to the comets (using 50-300 mm Zoom and 105 mm Prime). I also apply Chromatic Aberration (a Lens Correction tool) and add Noise so that the whole painting gets a grainy texture, which brings the image together.

↑ Selecting the light source and setting the lights and shadows before detailing the fabric and adjusting colors on new layers

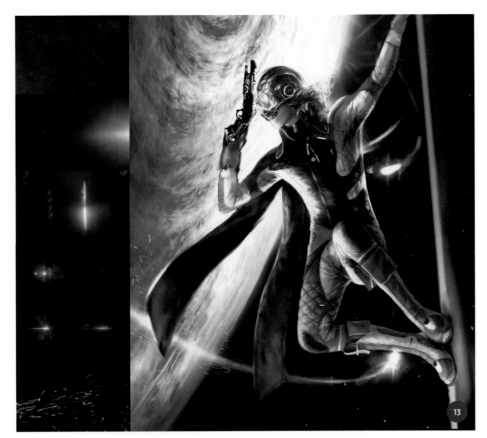

↑ Adding visual effects such as comets and lens flare, as well as textures, to create a more realistic illustration. Textures from www.photobash.org

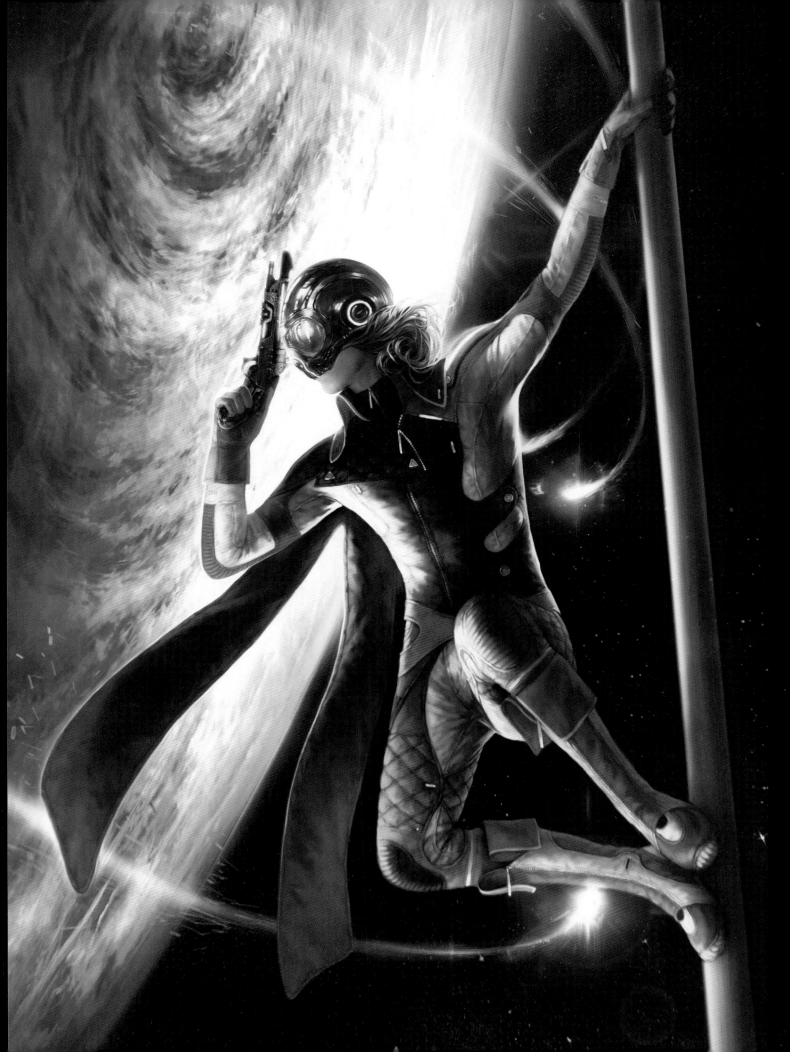

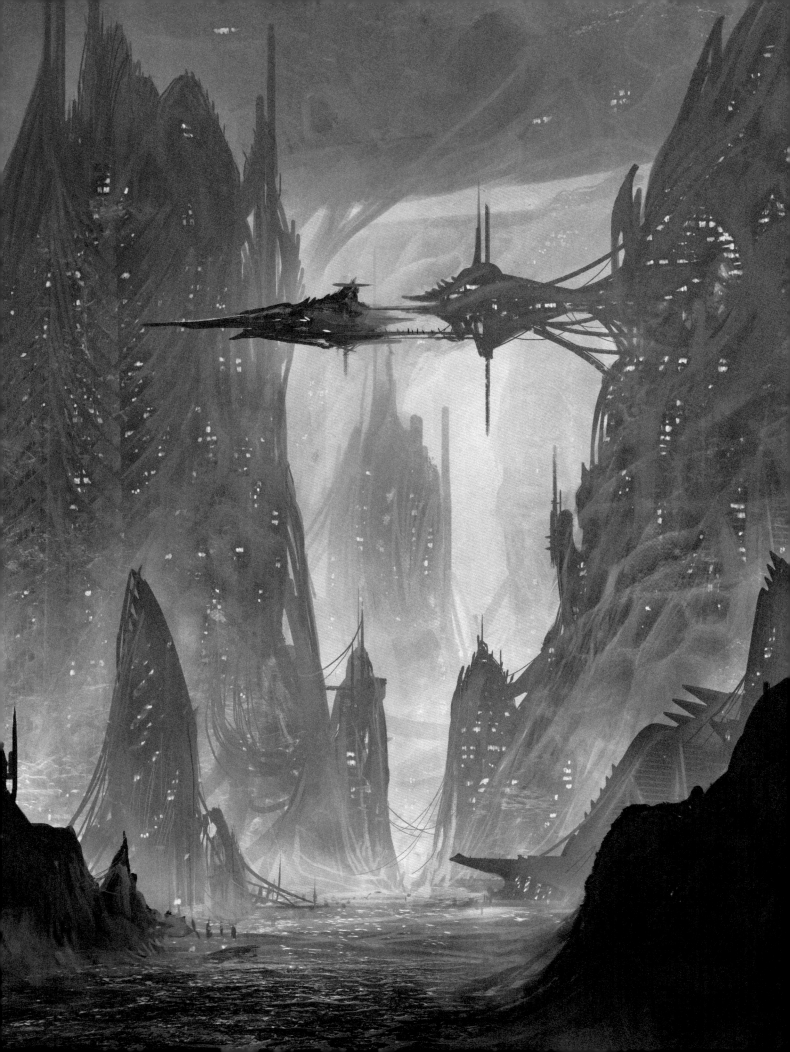

Imaginative Landscapes

Expansive and detailed environments can be time consuming to create, requiring a strong understanding of how perspectives and compositions are used to draw the viewer's eye into and around the scene. Often in a cityscape or landscape there will need to be plenty of variation between different structures and objects, indicating both depth of field, points of interest, and a sense of life in the scene.

The projects included in this chapter will take you through the process of creating vastly different imaginary landscapes, showing you how photos and textures can be manipulated into your work to save time and generate new ideas. You will also learn useful tips for adjusting the light and mood of an environment, as well as gain an insight into the artists' personal painting processes.

Imaginative Landscapes | Alien badlands

In this tutorial I will demonstrate how to create and develop a concept art illustration for a sci-fi fantasy project, which in this case portrays a hunter and his animal companion traveling in an alien desert. When creating a piece of concept art, you have to appreciate that you will be establishing the direction that the project takes with your preliminary concept illustrations. This helps and inspires art directors and concept designers to develop a general understanding of how the project will look. This tutorial will therefore be more focused on the artistic aspects that set the tone for a project than the design of the specific scene elements.

The following steps in this tutorial will cover how I find inspiration for this painting and

Amir Zand (San)
Concept Artist & Illustrator
Software used: Adobe Photoshop

Images from www.textures.com

01

↑ Photo research helps you to focus your initial ideas and select a color palette

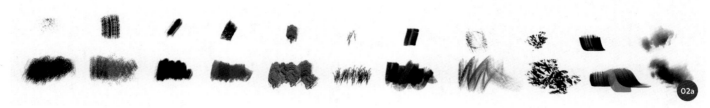
↑ A selection of brushes I will use in this painting

↑ Select textures from websites that provide images for personal and commercial use. Source: www.textures.com

how I perform my research and brainstorming session in order to form an initial concept with a fantasy atmosphere. Later on, you will learn how to use handy tools such as the Lasso tool to create the shapes that you need. You will also learn how to fill the artwork with the right amount of detail, as well as how to adjust colors and lighting to enhance your atmosphere.

01: Inspiration and idea

My main inspiration comes from movies, games, and music that I listen to while I work. For this piece I am inspired by ancient Egypt, the Orientalist art movement, and artworks by past traditional artists. I start thinking about a rider on a camel. Drawing my inspiration from movies such as *The Martian* and the game *Destiny*, I imagine that the rider could be an astronaut, an assassin, or a hunter with a hood, in order to add a narrative element to my artwork. I start to look for random images of rocks, deserts, and camels to gain a general idea of what I need to work on. These images provide enough to get rough idea of the color palette that I want to use and the kind of scene that I would like to draw.

02: Tool set

In the images above you can see the selection of brushes (image 02a) and textures (image 02b) that I will be using in this tutorial. I have gathered most of these brushes from the internet and modified some of them to fulfill my needs. The textures have all been downloaded from **www.textures.com**.

03: Brainstorming

This part is where the fun really begins. I have many different concepts and ideas in my mind, and now I get to try them out. I start up the engine of my brain and brainstorm these ideas by speed painting different landscapes and color palettes in both vertical and horizontal frames. I try to paint every idea that comes to mind, leaving no stone unturned in order to find the perfect concept.

Some of the speed paintings are basic while others are more detailed, and these details can be used in future steps. Once I have several different ideas down, I choose the combination that I like the most. In image 03, you can see the thumbnails of my speed paintings and early concepts. I realize that I like the composition of the thumbnail marked 1, and the color scheme of the thumbnail marked 2, the most. I decide to use a combination of the two for my artwork; however, it is good to note that my brainstorming session has resulted in alternative ideas that can be used in future paintings as well.

↑ Speed painting initial concepts and composition tests to generate ideas

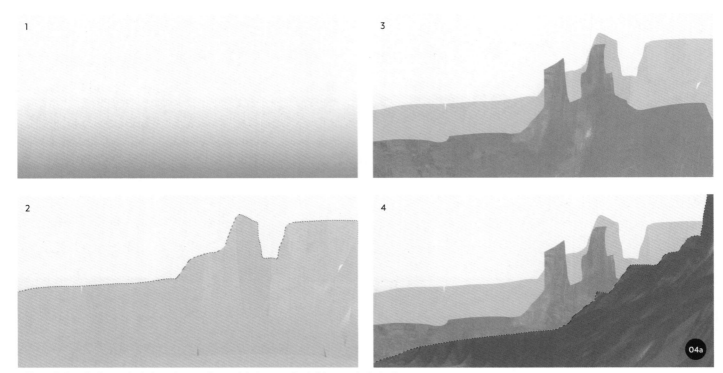

↑ The preliminary background painting, using a gradient and the Lasso tool to build atmospheric depth

04: Starting up

Now that I have an idea of the concept I want to create and the color scheme I will be using, I start to work on the background of the artwork. This starts with a simple gradient, which is then divided into four different layers using the Lasso tool in order to add a field of depth to it. You can see the progress of this in image 04a.

I want a cloudy atmosphere, so I create the sky by painting the clouds and then I use the same brush as an eraser to remove any unnecessary parts. This is a technique that I use very often in my work and I repeat this with other areas of the landscape. Image 04b illustrates the brushes that I use from my brush set to add details to different parts of the background.

05: Shaping the artwork

Another technique that I very often use for my paintings involves the Lasso and Gradient tools. I use the Lasso tool to draw the basic shapes that I need, and add colors to them using the Gradient

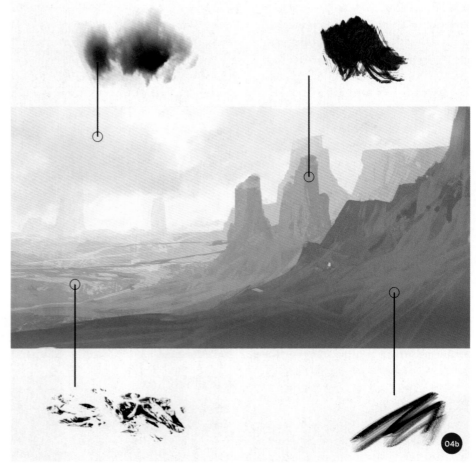

↑ Different brushes are used for each segment, then used as erasers to remove any unnecessary areas

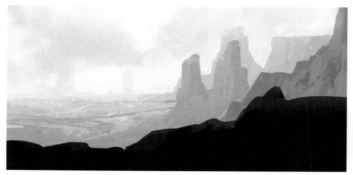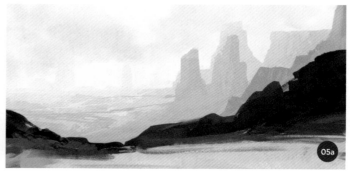

↑ I shape the foreground using the Lasso tool to draw basic shapes which can be refined with a brush

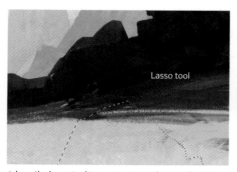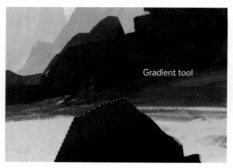

↑ I use the Lasso tool to create a stone shape and color it using the Gradient tool, then I add details with brushes

tool. Then I refine the shapes by painting with my brush while the layer is locked down to get the exact shape that I need. In this case, I flatten the background and use the Lasso tool to create the foreground and rocks using the technique as described. Finally, I use brushes to differentiate the highlights (images 05a and 05b).

06: Creating a character

As I said in the introduction, I want this scene to feature a hunter and his animal companion, so this is the time to decide the position of the character and his camel. Based on my initial research and concepts, I decide to go for a fictional theme that portrays a hunter on an unknown planet with a camel.

I produce some rough sketches of my character, and pick a position for the camel. Then I position them inside the frame to gain a better idea of how I would like to paint them (image 06a).

I decide to equip the camel with a futuristic hi-tech helmet (which can be an indication of

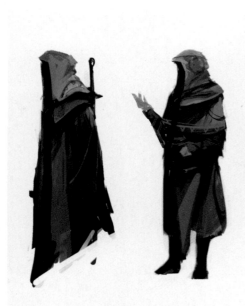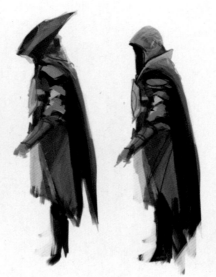

↑ Rough sketches of the character and the camel, and positioning them inside the frame

↑ Trying various futuristic helmet designs for the camel. I like the first option the best

a post-apocalyptic age) so I do some rough sketches of different types of helmets (image 06b) and choose the one that I like the most.

07: Retouching

I always try to work on different areas of my artwork at the same time. As I make progress, I keep retouching the sky, background lights, and the character itself, and try to improve them throughout the process. This helps me to get a better understanding of the amount of detail that is required for each segment of the painting. If I were to finish one part and move on to another, I might have unnecessary details in one area, and miss some details in another.

The primary modification of this painting is carried out with Color Dynamics. It is tricky, but it gives the impression of a higher amount of detail. As you can see in image 07a, I use the default brush for this purpose, adding Pen Pressure and Transfer to it. Finally, I apply Color Dynamics. By adjusting the Color Dynamics

settings such as Hue Jitter, I end up with different color mixes. Then, by using the Color Picker, I mix my primary and secondary colors to achieve an appealing texture. In this step, I retouch some areas of the sky, character, and camel. At the same time, I try to work on the ground in order to prepare a base for the addition of more details in the next step.

08: Detailing the ground

The four parts of image 08 depict how I paint and add details to the ground. I start the process with a color-saturated brush. Then I use the Eraser tool to remove parts in order to mimic dust and bushes. Finally, I polish it with more brush work. It is a simple trick, yet it results in a great amount of detail.

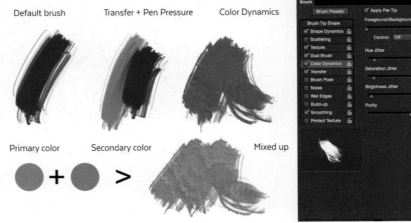

↑ Brush Presets can be used to create interesting textures when colors are combined

↑ Refining the details of the whole artwork maintains consistency

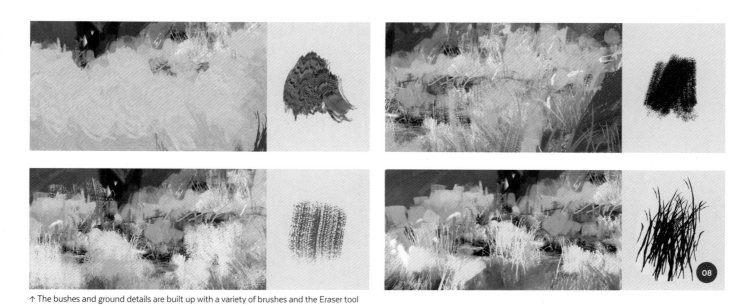

↑ The bushes and ground details are built up with a variety of brushes and the Eraser tool

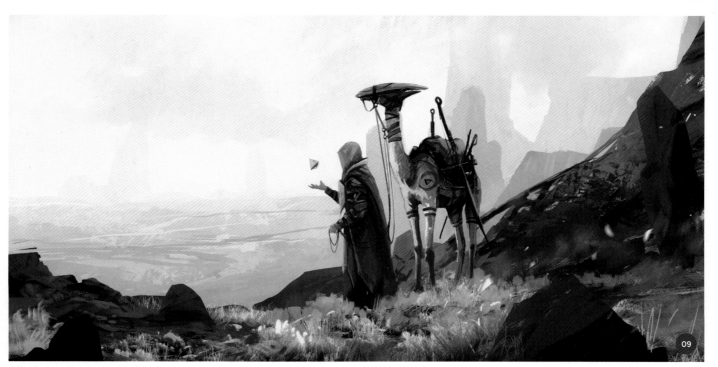

↑ The final combination of color adjustments gives the image a much stronger fantasy feel

09: Adjustments and visuals

At this point I like to think of my painting as a playground, and start playing with the colors and lighting. The right combination can really enhance the atmosphere of an artwork.

In this case, I flatten the layers and adjust the Hue/Saturation, Levels, and Color Balance settings. After some testing, I pick the combination that I feel fits the most. I adjust these settings to include more magenta, which brings a stronger fantasy feel to the atmosphere.

10: Final adjustments

Before I finish off an image, I often take a short break and come back to it after a couple of days. This helps me to notice any small details that can be adjusted in order to enhance the composition. I use Edit > Content-Aware Scaling to make the whole frame a bit wider without damaging it, and improve objects such as the main character. I add some planets in the atmosphere and even adjust the contrast and sharpness one last time.

Finally, I flatten the painting and sign my work. This artwork is a single work of concept art, and once it is combined with other concepts, it can help an art director at pre-production stage to form a general idea of the project in their mind.

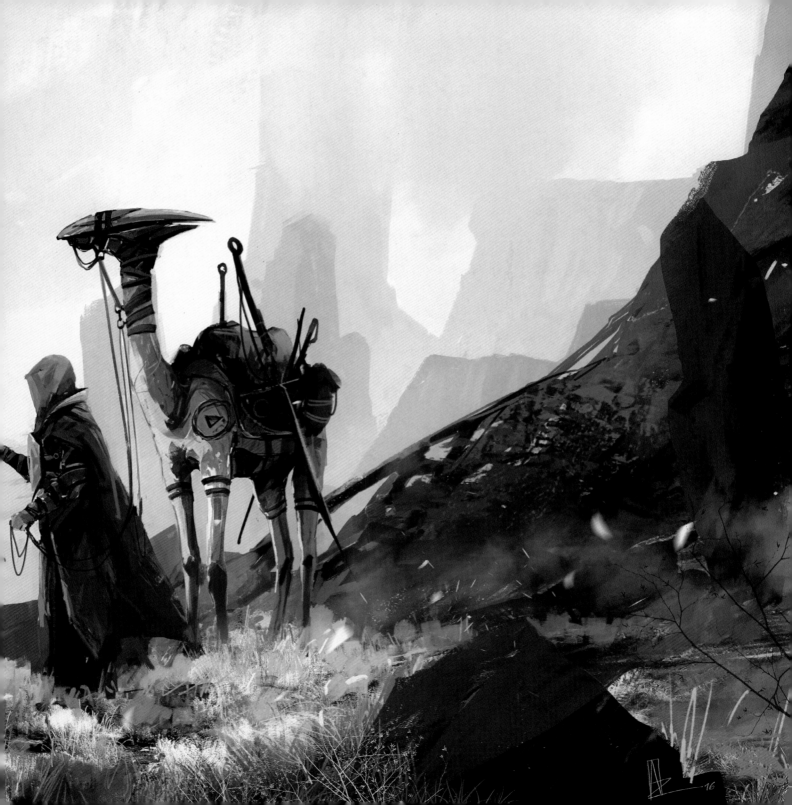

Imaginative Landscapes | Cyberpunk city

In this tutorial I will show you the methods I use to create futuristic cities. The art of cityscapes (whether realistic, fantasy, or sci-fi) is one of my favorite topics. The act of imagining and creating worlds that don't exist is one of the most gratifying jobs, but becoming lost in the sea of little details can also be dangerous and frustrating. However, new technologies and the use of comprehensive graphic tools can help us to push away these frustrations and reduce the never-ending

↑ I spend time searching for the right frame to base my work on

Guillem H. Pongiluppi
Freelance Illustrator & Concept Artist
Software used: Adobe Photoshop

hours that working on miniature details can take when creating a masterpiece.

> "If you want to create an illustration, a movie, or even a science-fiction novel set in the future, it is very important to show a small amount detail that the viewer can recognize"

This tutorial is highly influenced by the incredible work of Syd Mead in *Blade Runner* and also by Neo-Tokyo created by Katsuhiro Ôtomo in *Akira*. The image I work on will be one of a series of illustrations I want to create in which I turn my home city, Barcelona, into a classic and dystopic city surrounded by neon lights and smoke.

Depending on the type of city I want to create, the initial process that I follow can be very different. I can either spend my time composing simple concepts until I find a composition I like, or create a more precise concept art when I have a clear idea of what I want. Sometimes I create a few 3D geometric figures and try to find a point of view I like the most. For this topic my base will be a real photo, using digital illustration and photobashing techniques to finish the details.

01: The beginning

As mentioned, I will use a photo base to make this illustration. My intention is to take a reference point of the city that is easily recognizable for everybody who knows Barcelona. If you want to create an illustration, a movie, or even a science-fiction novel set in the future, it is very important to show a small amount detail that the viewer can recognize. In my experience the piece will be more successful with these little details than without them.

In this particular case, I decide to go to La Sagrada Família, the most famous construction from the master Antoni Gaudí. Once there, I start to look around, searching for my perfect frame. I take lots of pictures and dedicate a few minutes to imagining

↑ The composition should direct the viewer's eye to the main point of interest

↑ Placing elements in a spiral can create an unexpected narrative

how this frame of Barcelona would be in two or three hundred years' time. When I finally have a clear idea of what I am going to do, I go straight home to start working.

02: The composition

Already in my studio and with all my photos ready it is time to start composing. Normally when I take pictures, I already have the first composition or frame I will use in the illustration. Nevertheless, it is always good to experiment and try different frames, as well as do some sketches on top of the picture, just to see how everything is going to work.

In this composition it is very clear that all the figures in the image should be facing towards La Sagrada Família, since this will be the main point of interest (see the composition lines in image 02a). I place all the other narrative elements around the building. After trying out a few compositions I finally place some of the elements in a spiral position as often this can create narrative lines that are unexpected and interesting (as shown in red in image 02b). When I finally have a clear composition and the narrative visual, it is time to work on light and color for the painting.

03: Light and color

The truth is that I would have liked to have
taken all of my pictures in the evening
or, even better, at night. If you want to
create a city full of lights and neon, the
best way to show it is when the scene
is dark. Since all my pictures were taken
during the day, the work of fixing the
lights and shades is much more intense.

I have already decided that I want to use
a degraded color palette from violet to
blue (image 03), also adding little touches
of more extreme light on all the publicity
posters, windows, and flying cars that will
be in the scene. Adding these components
into the image, I improve some of the
building walls by removing the trees
and any other elements that I think will
interfere with the cyberpunk theme.

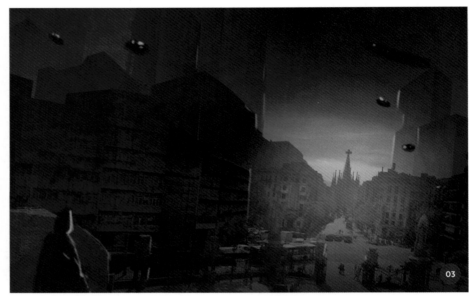

↑ The colors of the scene generally need to be dark so that the neon lights will stand out

04: The storytelling

A lot of the time with landscapes, artists
leave aside the narrative of their work.

Sometimes, when a landscape is majestic
(especially with nature), an image does
not need specific storytelling. However,
I personally like to add a few narrative
elements. I always like to approach

my drawings as key frames of a movie or
videogame in order to make sure there is
a story behind everything. My father is a
historian and I spent my childhood looking at
illustrations such as those by Peter Connolly or

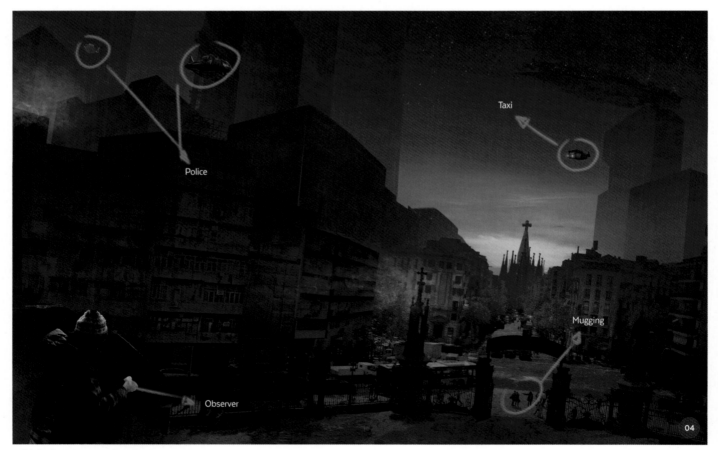

↑ Subtle elements are used to tell a story

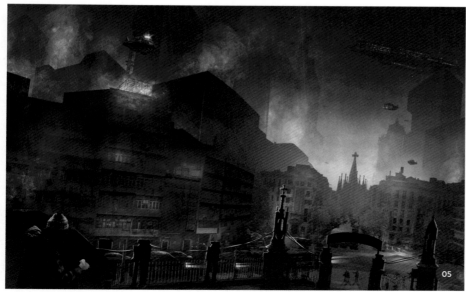
↑ I work on the colors with a soft brush and add a smoke effect with a smoke brush

↑ I select images of buildings at night as window textures

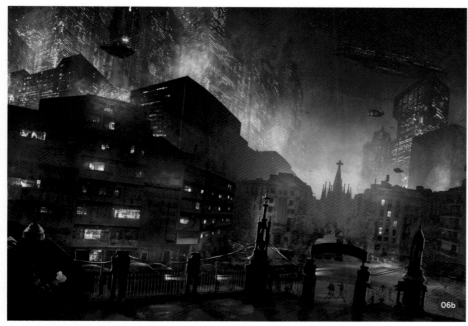
↑ I add the textures into the scene on layers, making use of blending modes to embed them into the image

Angus McBride. Historic illustration is pure narrative and I loved to see how the artists created, for example, the interior of a Roman house; you could see lots of little details and could also read lots of stories happening in every single room. My imagination basically continued all these little stories. As a result of this, I place subtle elements in my painting that help to explain what is going on when it comes to the history of the setting, as you can see in image 04. The environment here is a dangerous place, downtown of the city where police and crime coexist with smoke and neon lights.

05: Color and smoke

I already have the composition, the color plate, and the interest points, so it is time to prepare the image for battle. Before I begin setting all the lights for the windows, signs, and so on, I continue giving a little more color to the scene, creating a new layer set to Color mode. With a soft brush and low opacity I finish all the retouches of the prime colors. I also build up inner city layers of smoke. I make the smoke with a brush from my library; you can even take smoke textures from photography and play around with the layer's style to find what works the best. All the layers of smoke or, as I like to call them, "environment layers," create a great atmosphere in this kind of illustration.

06: Windows

When it comes to painting lights in the windows, I always use the same technique. It is very simple and fun to do, and always gives a great result. First of all, I select a few pictures of cities and night buildings. To get started with all the windows, I take a picture of a building, placing it on top of the face of my building with the correct perspective. After that I play with the different layer modes such as Lighten, Screen, Color Dodge, Linear Dodge, and Lighter Color, to see what works best. If you don't have your own pictures, you will find many great ones at **www.textures.com**. In this illustration I use many different images and have to keep repeating this step until all the buildings are full of illuminated windows.

07: Neon lights

Neon lights, advertisements, and other intense lighting effects are made in exactly the same way as the window lights. Using **www.textures. com** again you can find great photos for this, however I sometimes like to make my own. The main tools I use are my Wacom Cintiq and an SLR camera. I use a Canon EOS 5D Mark III with a 24-105 mm lens that is very versatile. I also use an iPhone as a third tool. There are many apps for smartphones with photo filters, but the Hipstamatic app I use is exclusively for iPhones. The different kinds of filters that this app offers are amazing. Many of the photos that I use are made with this app, especially the ones I can take at night time in a city.

The resulting effects are spectacular to introduce into illustrations. Playing with the layer modes mentioned in the previous step and visualizing the resulting photos, I get the lighting effects that you can

see in image 07a. You can see the lights added into my illustration in image 07b.

08: Details

One of the advantages of working with photobashing techniques is that the photos provide a large quantity of detail in a painting. By just making small corrections with brushes I can achieve very powerful and realistic images in no time.

My experience in the fields of cinema and advertising make me see that photobashing techniques are the ones that art directors like the most, precisely because they are very realistic and because they can give a very clear idea of how the final image should be filmed.

In addition, photobashing allows you to finish a complex picture very quickly, in only a day or two – or if you are making a concept picture you can potentially make two in half a day.

If you want to succeed in the entertainment industry it is not enough to be good; you have to be fast as well. As you can see in this tutorial, getting to this point in the process is relatively simple. At this stage, I work on giving the image some atmosphere, improving the smoke and lighting with standard Photoshop brushes.

09: The main character

As mentioned, this particular illustration is going to be part of a series of images about the futuristic city of Barcelona. The

↑ Try to create your own photo textures making use of photo filters available in smartphone apps

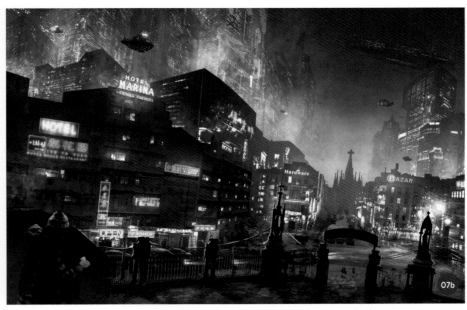

↑ I place the photo textures into the scene on layers in the same way the window lights were added

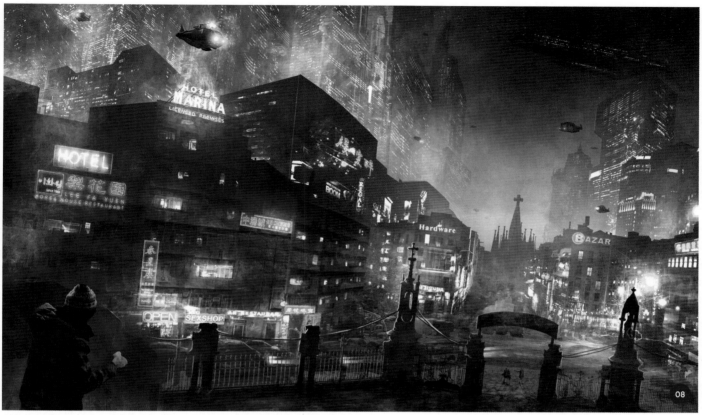

↑ I increase the atmosphere of the image with standard brushes to enhance the photobashed work

person you see in the foreground is the main character. Every time you work in realistic images, it is good to use a model like the classic painters used to do.

I shoot a portrait and paint over the cut-out image. A lot of artists use the paint-over technique, especially to make quick concepts. For example, I might take a picture of a soldier with a color and shape base already, and repaint it all over again

to improve the design, adding weapons, a robotic arm, or whatever I require. On the character in this illustration I only dedicate time to illuminating the body and adding a futuristic device to make him fit the setting.

10: The end

Once an image is finished, I sometimes like to carry out one more step, just to test it out and find out whether there are any other unexpected but better texture results.

I take different pictures of textures, expand the textures outside the canvas, and play with the different frame styles. The image can take on a different environment or you can even add a texture that is more picturesque.

I finished this illustration in two days, but if I had to do it using only brushes it would probably have taken about a week. Hopefully by using similar techniques you will be able to save time in your own work.

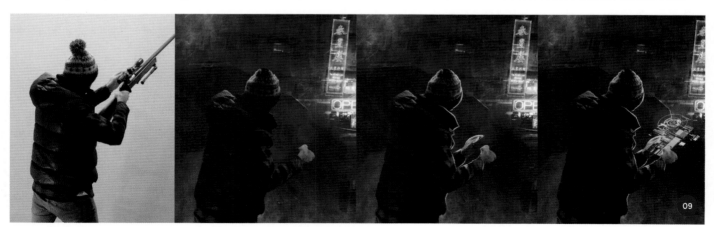

↑ Simple photobashing techniques are used to illuminate the figure and create a futuristic device

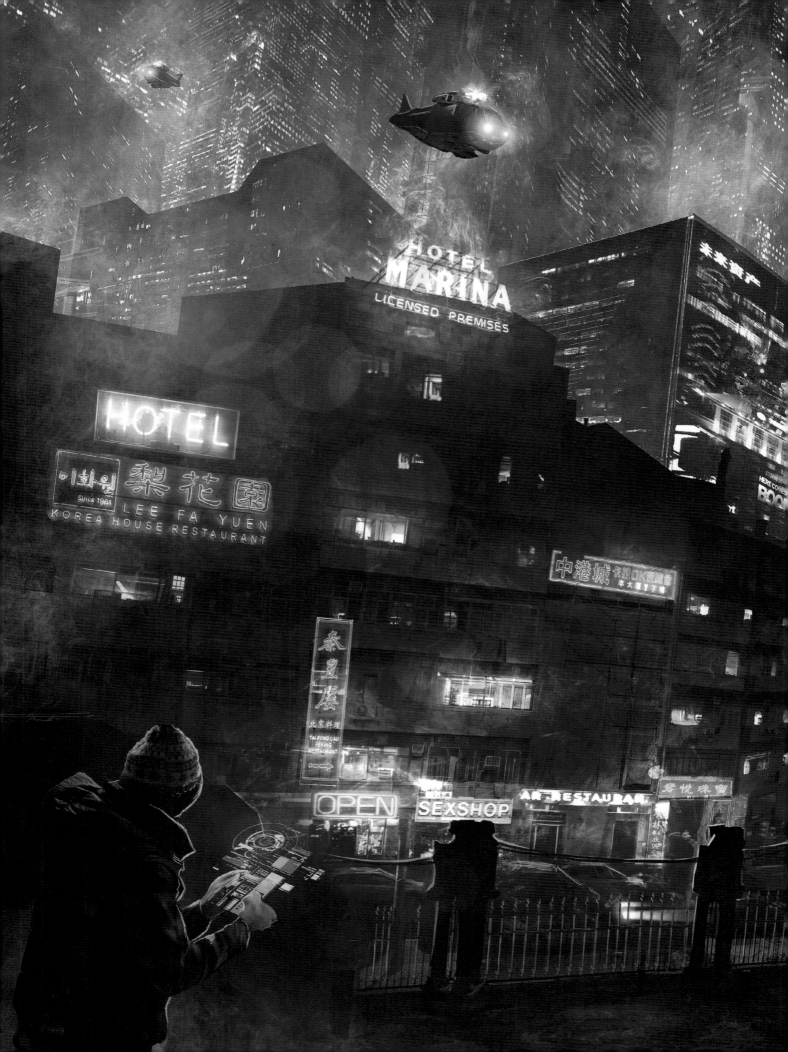

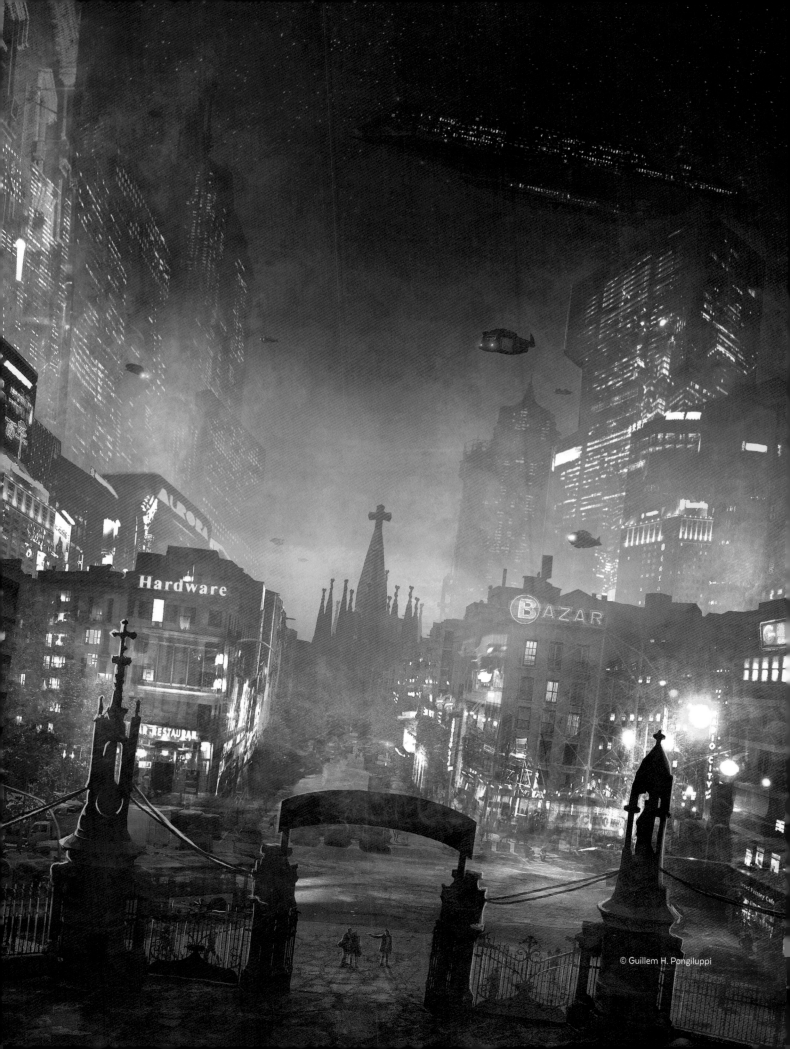

Imaginative Landscapes | Organic alien city

In this tutorial I will show you how to paint an organic alien city. I am fascinated by environments and science fiction, so through this topic I will be able to show you how most of my paintings are produced. The process I will cover here is typically how I work for clients every day.

As with most of my artworks, I will start with some black-and-white sketches, spending only about ten or fifteen minutes on each, just to find interesting ideas and develop my imagination. The main word I will focus on for these sketches will be "organic." Then I will work on the storytelling within

Florent Llamas
Freelance Illustrator & Concept Artist
Software used: Adobe Photoshop

↑ Think about shapes and interesting blocks to find an idea without a lot of detail

the composition and add mood and color, with the help of references. Later in the process I will use photos and textures to increase the speed of production, and thus have a more realistic and attractive image. I will finish with the addition of final details such as lights and characters.

01: Sketch and silhouettes

Every time I start a new project, I always begin with a simple sketch to find a composition, or even just an idea. For this kind of image, I start by painting shapes everywhere in the canvas and just try to refine my idea for the city. I think about organic shapes and how an organic environment can look chaotic, so I just experiment to see what happens. Then I add some quick details, such as antennae and cables, to make the thumbnails more refined and in this case signify an organic city.

02: The Fibonacci spiral

After selecting one of the thumbnails I concentrate on composition. The formation of shapes in this particular thumbnail means that the viewer's eye is easily led from the left to the right of the image. I decide to work further on the composition using the concept of the Fibonacci spiral, a common composition tool. I want the central element of the composition to be a platform, so as you can see in the top part of image 02 I add this where the composition guidelines converge.

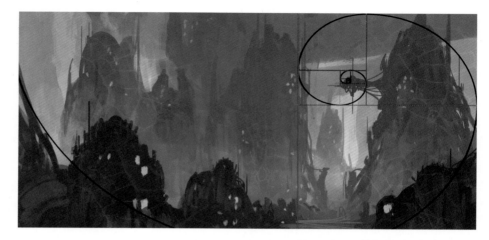
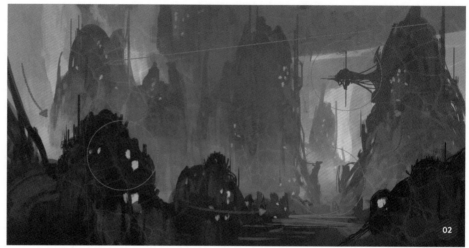

↑ Using the Fibonacci spiral to locate a focal element (top) and checking the reading direction of the image (bottom)

If you take a look at the bottom part of image 02 you will note that the large building in the background closes the composition and sends the reader back to the left of the picture, where the reading direction restarts.

This enables the viewer to quickly gather information from around the scene and begin to get a feel for the setting and narrative behind the painting.

03: Cleaning and defining the image so far

I now define the different levels of the image more accurately, adding atmosphere between each plane in order to separate them. The plane furthest into the distance should be the lightest and the closest plane should be the darkest.

I add some details at this point but nothing significant, and define the forms of each building a little more. This finalizes the first part of the process. I want to clean my Photoshop file too so I make one layer for each plane, which will be more convenient in future steps.

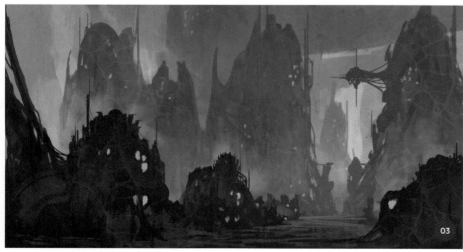

↑ I separate the different planes and add more details to clean the shape

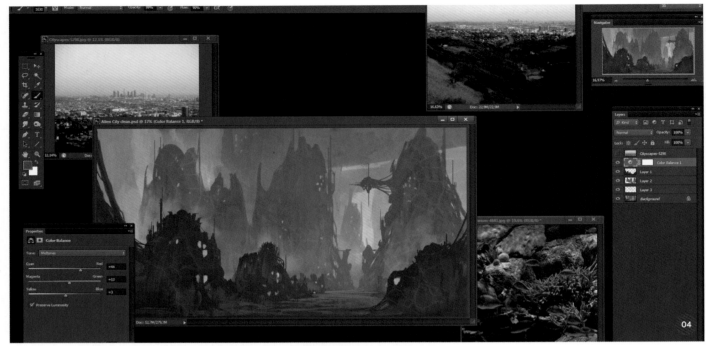

↑ I define the mood of the image and research photos for inspiration. Photo source: http://freetextures.3dtotal.com

04: Choosing the mood

It is now time to choose the mood of the image so I start to research photos. For this research I mostly select images of cities, but they could be anything so I also use an aquarium image because of its colors. The most important aspects of the images are that they have the colors and atmosphere I want.

I start to play with Color Balance to find a base color using images from **http://freetextures.3dtotal.com**, where there are very good resources if you are looking for photos. Many artists also share their image bank for free or for a small fee, or you can get royalty-free photo packs from sites like **www.photobash.org**.

05: Adding more color

In this step I import selected images to save time in the color process. I have fun with each image, adapting them with layer blending modes (image 05a). When I find an interesting effect, I move on to the next image. This is a very chaotic but interesting way of working and makes finding interesting colors easy.

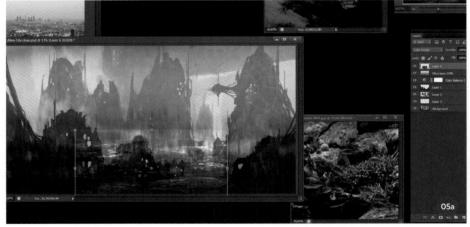

↑ Adding colors with photos to save time and experimenting with different blending modes

↑ The atmosphere is quickly enhanced and the final mood is established

Exploring colors in this way can also produce imaginative ideas that can be used for the rest of the image. It is a method that is widely used, allows you to get atmospheric results quickly, and is a good basis for further work. Do not be afraid to go back or delete images if they do not look good. The most important thing is to find the main colors and mood you want (image 05b).

06: Texture integration

It is now time to add texture to the image. For this I select images or parts of images from my reference file. I place my chosen texture on a new layer above the layer that I want to be affected (hold the Alt key between two layers to bind the texture layer below).

I repeat the process as many times as I need, choosing new textures and playing with blending modes. I adjust the opacity of the texture if it is too strong, and erase areas as I see fit. In this case, I choose some coral images for the organic elements as well as modern architecture for the city aspect, which fits well with the design I want to achieve.

⚡ PRO TIP
Reference files

You can easily search the internet for royalty-free images to use in your work. Take your time looking as it will help you to find inspiration and return to your work with new ideas. I use images to both find inspiration and to add details to my painting.

The images here are from **http://freetextures.3dtotal.com**. You can also simply search on Google Images for inspiration. Before starting a project I advise that you create a reference file that will allow you to find inspiration and save time later. Think about the mood, atmosphere, colors, and lighting of the images. All of these elements could be used in your work.

↑ Search for royalty-free images and textures that will help you to add details later. Photo source: http://freetextures.3dtotal.com

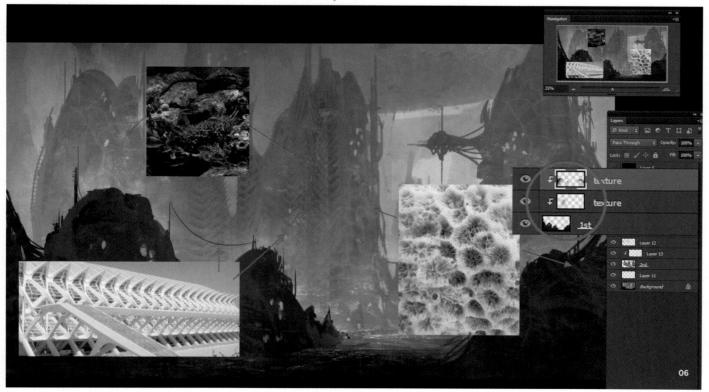

↑ You can integrate texture for a realistic look or to add interesting shapes into the silhouettes. Photo source: http://freetextures.3dtotal.com

07: Checking the values

At this stage of the process I need to check the values. When you add textures with different blending modes to a painting, you can alter the values of the illustration significantly. To easily check the values, I create a new layer in black, and change the blending mode to Saturation or Color. Then I can see if the values are correct or not. If I see that the texture is too dark I can easily adjust it at this stage. I can also create a new layer in between planes, for example in between the foreground and the mid-ground, to add more depth.

08: Painting details

I can now go back to painting again. Using a simple brush from Photoshop's default set, I create a new layer and start to paint. I try to merge the elements together so in this case I follow the shapes of the textures.

I also add new smaller buildings between the foreground and mid-ground plane and define more clearly the shapes of the larger buildings. I add some little cables too and further define the background with a large organic shape inspired by the buildings. At this point the design is almost finished.

09: Adding light and mood

Now I need to add lights to the city. For this I use a very simple but quick and efficient method. I import an image of a building at night from **http://freetextures.3dtotal.com**. I then select the Lighten layer mode and position the image where I want light. I make adjustments to the image using Levels to tweak the lights to suit my scene.

> "I add more organic details and work on the light and atmosphere with a Color Dodge layer. I also decide to add a little more light between the buildings, again with the Color Dodge layer mode"

I repeat this process as many times as I need to create a city with lots of life. At the end of the operation I merge all the light layers together to get a clean working

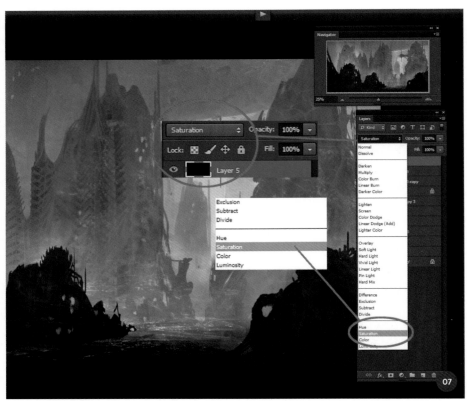

↑ Checking values is important for texture integration and shows if more depth is needed between planes

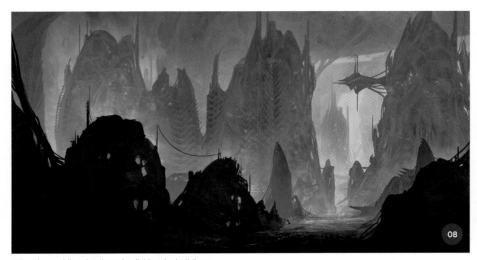

↑ I work on adding details and polishing the buildings

file. I use one picture for this step, but you can also use several different images.

10: Adding more details

The image is now nearing completion so it is time to add the final details. For this I create a new layer and just start painting. I add little details everywhere but am more focused on the foreground plane, which is an important part of the image.

I add more organic details and work on the light and atmosphere with a Color Dodge layer. I also decide to add a little more light between the buildings, again with the Color Dodge layer mode. The image is now almost finished.

11: Adding some life

It is now time to add some signs of life to the painting. For this I decide to add a few

figures in the foreground. I imagine these characters to be in full discussion. I add their antennae to show their alien side. If you are struggling to paint characters do not hesitate to seek poses on the internet. You can also quickly take some photos of yourself in different poses.

I decide to also add a ship moored to the platform at the main focal point of the image. This adds to the storytelling and helps the reader to imagine the rest of this alien world.

12: The last adjustment

Now that the image is almost finished I merge all the layers into a new layer (Ctrl+Alt+Shift+E) and make a few adjustments. I start by creating a Color Balance layer to test other color variants. I try adding a bit of blue in the image, which adds contrast and makes the image less red.

Eventually I create a new layer in which I add noise and reduce the opacity to around 10-15%. This helps to merge the colors and painted elements, bringing the whole image together. I also add an extra organic element in the upper left corner of the image to close the scene and emphasize this aspect of the brief. You can see the final image on the next page.

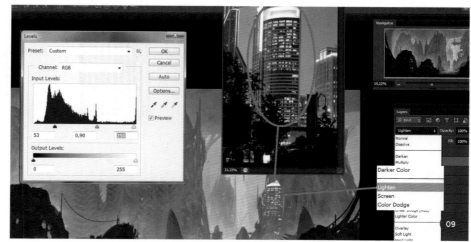
↑ Using a night city image to create lighting quickly. Photo source: http://freetextures.3dtotal.com

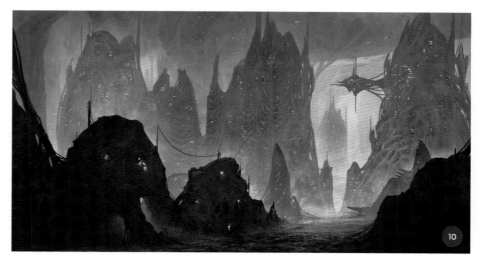
↑ Polishing the image using Color Dodge to bring it closer to completion

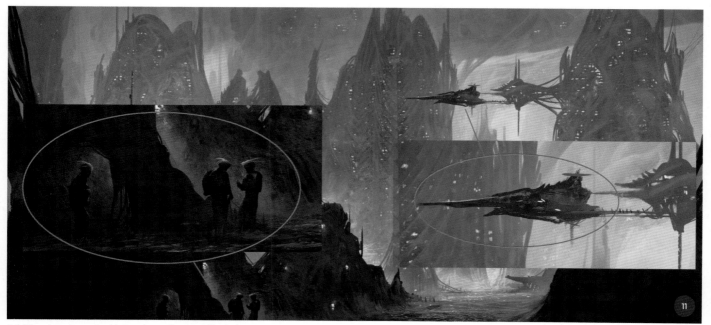
↑ Adding characters and a ship to enhance the storytelling in the scene

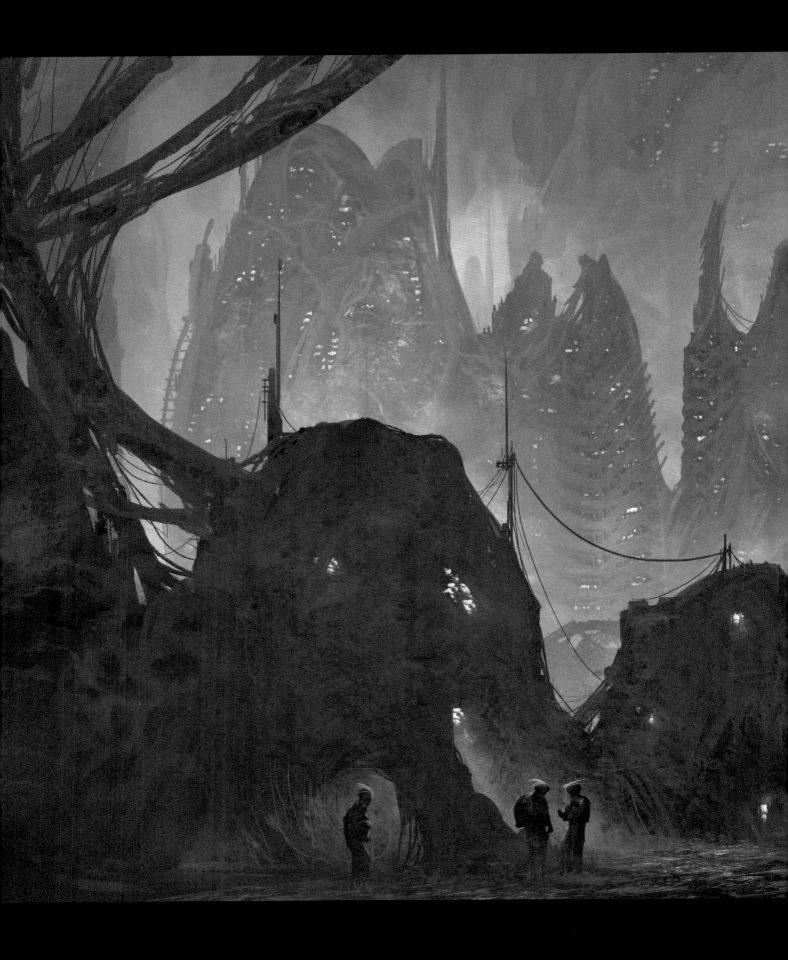

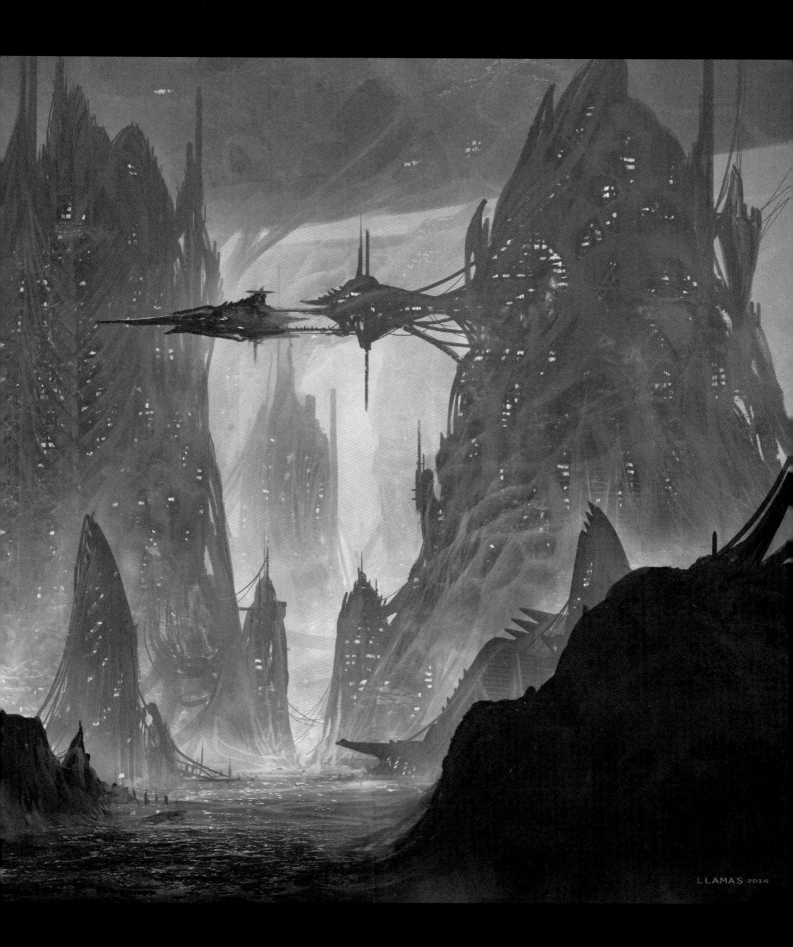

Imaginative Landscapes | Glass city

↑ I select a background photo with global lighting and a pleasing horizon

Marcin Rubinkowski
Senior Concept Artist
Software used: Adobe Photoshop

The brief for this piece is to create a futuristic glass city with light beams and reflections. In this tutorial I will show you how to create "wow" factors in your environment images and also teach you some time-saving tricks.

There should be a pleasing range of attractions in the image, but I need to stay focused and pay attention to the composition and fundamentals of concept art. To do this I will check the composition throughout by flipping the canvas horizontally or zooming out to thumbnail size. You can also limit your color range to black and white in order to check how your values are working at each stage of the workflow.

↑ I crop and resize the photo using the Clone Stamp tool, then clean the image

↑ I use Quick Mask mode to check the sky area I have selected

This will be more of a photobashing tutorial so it will be important to create order for the layers. I do not want to lose too much time trying to group my layers perfectly here; I must still keep my mind excited while not becoming lost somewhere in a disorganized layer stack.

The same applies to cutting and edges. The time for perfectionism will be near the end of the artistic workflow when I will spend hours polishing and setting the final details.

> "At this stage I do not need to be very precise but I try not to mess with the image too much. I clean up elements such as the crane on top of one of the buildings, and any other aspects that do not fit the idea of a glass city"

01: Base photo

In the beginning I must prepare the background for my workflow. I use a photo to speed up the start. All I need is a photo of an appealing modern cityscape with noon global lighting. If it has plant areas or small green parks too that would be great.

You can choose to use your own photo or take one from **http://freetextures.3dtotal. com** as I do here. Try to choose wisely with midday ambient lights, a good horizon set, and do not use panorama materials or images with deep shadows. I only want to find a background suitable for my process; this is not a photo contest for the best cityscape.

02: Cleaning and ratio fix

After I have browsed through thousands and thousands of cityscape photos I select my start-up photo. I must crop the picture to a wide-shot view, which is best for landscapes. Remember, you can make your canvas bigger and rebuild the rest of the shot with the Clone Stamp tool if you want.

At this stage I do not need to be very precise but I try not to mess with the image too much. I clean up elements such as the crane on top of one of the buildings, and any other aspects that do not fit the idea of a glass city. I only need clean objects that are easy to edit.

03: Warming the sky

Before I go any further, let's refresh our knowledge about using selection tools.

I will use the selection tools (Lasso, Quick Selection, and others) on the sky throughout this glass city project. Using Alt, Ctrl, or Shift is key to using them with ease by cutting and adding to your selections.

Quick Mask mode can be useful for certain areas, although I only use it at the bottom of the Layers panel to check the selection area (image 03a); I do not use it to paint the mask. Note that Ctrl+Z (Undo) also works with selection tools. Selecting all the sky from my picture, I make a new layer (Ctrl+Shift+N) and fill the Paint Bucket tool with the same color that dominated the sky in the original photo (image 03b). This is all I have to do for now. Later I will use this layer to clip in some clouds.

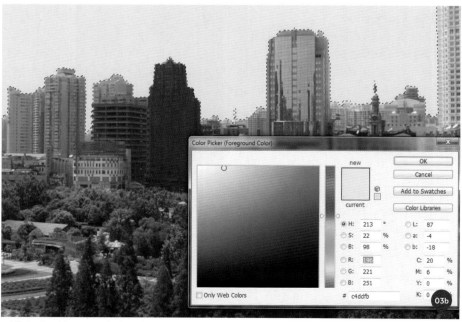

↑ I fill the sky with a warm color from the original photograph

↑ I use the Selection and Adjustment tools to change the look of buildings slightly

↑ The buildings are now starting to look much more futuristic

04: Basic fun

Now I use the selection tools on some of the buildings. I make sure the Quick Selection tool is sampled from all layers and use Ctrl+Shift+C to copy all visible content. I then hit Ctrl+V to paste it flattened onto a new layer. I can now copy and paste easily wherever I am on the layer stack. Free Transform and size settings can be used to change the look of buildings and place them in the scene. I have to be careful not to go too far with this, however, as the buildings should not be too modified because they are only background detail. I use Levels to correct each object, managing their value and making them look like they are the same distance from the viewer in terms of atmospheric perspective (images 04a and 04b).

05: The Warp tool

I will now select elements as I did in step 04, using parts of buildings or whole buildings, cut them to pieces, and edit them with simple transformation warps. The Warp tool can be extraordinarily useful on any area of a design. You can use it to easily make buildings that are spherical, spirals, or any other interesting shape (image 05a).

Do not be afraid to flip or shrink versions of the same custom shape to build the weirdest ideas for your buildings. It is wise to use Hide Selection (Ctrl+H) here and in the rest of the process so that you can see what the selection will look like when it is integrated into the image. As before, I use Levels to help integrate the buildings into the scene (image 05b).

↑ A simple warp can be used to easily alter a selection into any shape

↑ I use Levels again to fit the new shapes into the scene

06: Using Puppet Warp

In this step I will introduce some awesome futuristic elements in the scene, but I will not add too many of them so as not to overwhelm the image. I try to avoid selecting white or very dark areas, otherwise you will be able to see the warps. After I have picked and placed my building materials as before, I use Puppet Warp (Edit > Puppet Warp). By clicking Puppet Warp I add anchor points to

the selection, and Photoshop creates a mesh which I can use to modify the shape freely (image 06a). With the Alt button I can also remove pins and rotate those anchors. Use your imagination and courage when editing the object. As you can see in image 06b, the image is now starting to look like a glass cityscape.

07: Grass

I now flip the image horizontally to see how everything looks. The point of this step is to rest a little bit from all the warping in the previous stages, and to find the balance between human-made and natural elements,

↑ You can freely modify a shape with the anchor point mesh created with Puppet Warp

↑ The buildings now look completely different from the original image

↑ I select grass areas in the image to manipulate them

↑ If you do not have green areas use silhouetté brushes to add to the background

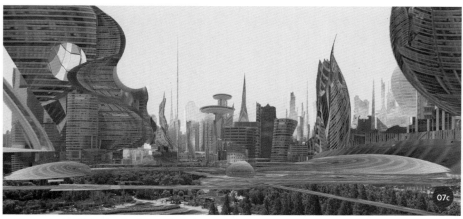

↑ This stage is about balancing the elements in the image

as well as tidying up any issues you might spot with the canvas flipped. I select an area of grass I like from the photo. I copy and paste on the layers and start to multi-copy and place them properly, paying attention to the value of the grass (image 07a). If you decide to not have vegetation in your art, you could create some cityscape silhouettes into the background at this stage (image 07b; image 07c). You will find some interesting cityscape silhouette brushes included in the downloadable resources for my custom brushes tutorial on page 106.

included in the downloadable resources for my custom brushes tutorial on page 106.

⚡ PRO TIP

Experiment!

In concept art jobs, high-quality and clean pictures will not be quite as important as an inspiring and fresh design. Do not be afraid to explore your own ways of editing content that distort and make strange effects, so long as they show your idea and clearly communicate your message.

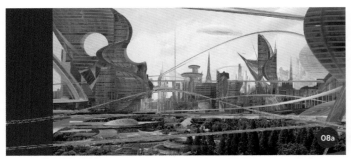

↑ Use the Warp and Transform tools to stretch and curve smooth lines to form roads

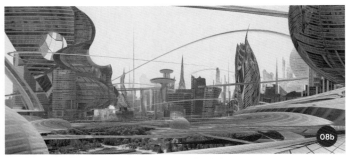

↑ These roads will improve the visual coherency of the design

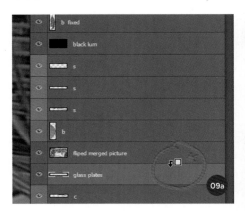

↑ I use a clipping mask to attach a flipped, merged picture to a glass plates layer

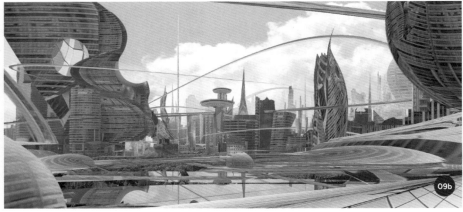

↑ The addition of clouds and the reflection of the clouds adds to the concept of a glass city

> "I use the airbrush with the Lasso tool to add depth and expose the most interesting places in my picture and hide others in fog for depth"

08: Where are the roads?

In this step I again use the Warp and transformation tools I used before to multiply the same content. But the main aim this time is to stretch or curve the content over the limits of the canvas and make smooth lines for the roads.

I use all the tools available to create interesting long and spiky elements. Trying to make a perfect curved street with only the Perspective transformation option will not usually work. It is better to use a couple of different Warp tools; you can also take advantage of the Photoshop History panel rather than using only one tool. As I make a few of my weird streets, I choose the best one and use it a couple of times, sometimes smaller in the background, or flipped or rotated (image 08a). The

line and geometry will improve the visual coherency of the design. All these roads and lines are compositional repair kits to be used if I need them (image 08b).

09: Sky and reflections

I now go back to my filled sky from step 03. I find some interesting-looking clouds from http://freetextures.3dtotal.com. I paste the clouds above the sky in the Layers panel and create a clipping mask by using Alt and left-clicking in the middle between layers on the Layers panel (image 09a). As the layers are connected I can easily move and rotate the clouds in relation to the marked sky.

I also decide to use large, mirrored, glass-like plates in my piece with reflections. To do I first select the whole image and use Copy Merged. Then I flip it vertically and paste it on a new layer and hide. I use the Lasso tool to select the places where I want to see reflections and make a new layer from the selection. I fill this with white and then clip the merged picture to this layer. I need to edit the position of the reflection. It is also

important that the reflection does not have stronger values than the original object. It also needs some distortion (image 09b).

10: Flipping and focal points

I flip the canvas horizontally again and try to set my focal point and read the composition. It is important to do this after the flip so you can view the painting with a fresh eye and see where composition, lines, and shapes on the picture will lead you.

I also suggest that you choose only two focal points, but it is up to you. Remember that the more focal points there are the more attractions you must give to the viewer on the way, making the path for the eye more complicated. You must be honest with yourself; if something is wrong, make a new layer and try to fix it by cloning content you have already made with the Clone Stamp tool, or go back to layers and fix your mistakes.

11: Depth and light beams

Next I will add depth and light beams to the scene. I will then manage the focal points

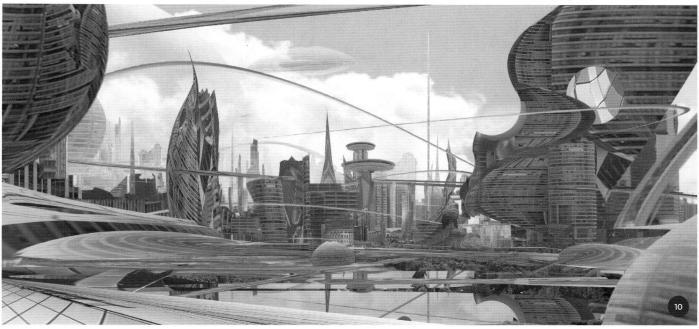

↑ Flip the canvas to check the flow of the image, noting focal points to draw in the viewer's eye

and lead the eye down certain paths. I use the airbrush with the Lasso tool to add depth and expose the most interesting places in my picture and hide others in fog for depth.

I also add light beams, but I do not let them rule my picture (image 11); they are meant to be accents, like the roads, which will help sell the piece to the viewer. Here I paint with the airbrush again. I use a mixture of Overlay, Normal, and Screen blending modes on different layers.

12: Overlay and Smart Sharpen

Usually at this stage I have fun with effects on an Overlay layer at the top of the layer stack, painting and sharpening focal points. It is good to manage things like contrast, color, and saturation. I also have a mask clipped to it. The next step is to create another layer with Overlay. I paint on it in a low opacity with white to only highlight certain parts of the piece. I paint with black to make an overall deeper value.

The last touch is to use Smart Sharpen, but just on focal points and elements at the same distance. Mostly I cheat with Sharpness depending on what looks good to me, and I do the same with the Blur filter.

13: Final image

You can see the final image of my sci-fi glass city on the next page. Remember that it is up to you how you use your tools, and that you should carry out some exploration throughout the process. The weird connections you make when experimenting can give you really interesting effects, so have lots of fun with it and be willing to try new things.

↑ Do not use the maximum value on lights as they will overpower your image

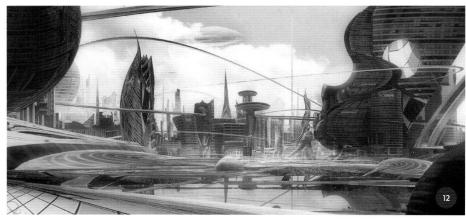

↑ Use a layer with overlay mode and Smart Sharpen to highlight your focal points

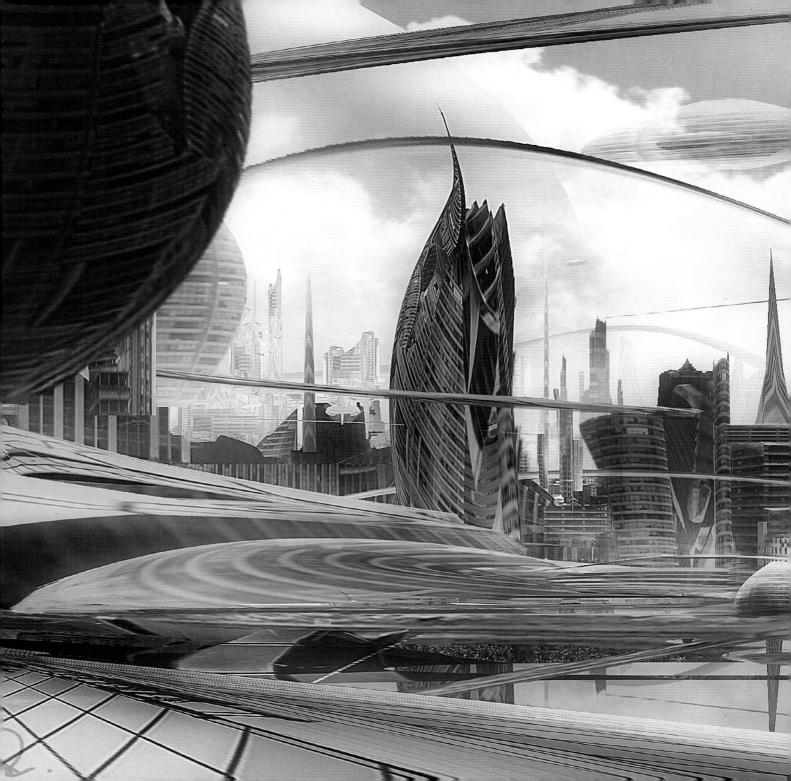

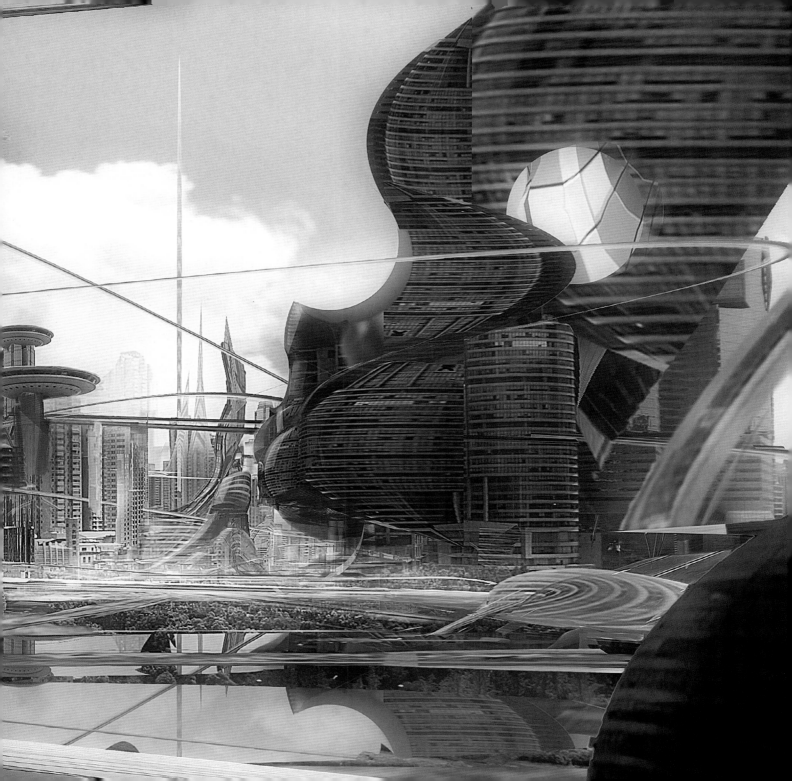

Functional Transport

Creating a vehicle design for a particular purpose can be a difficult task for a 2D artist, particularly if the design and subsequent artwork is going to be used, for example, as a concept for a videogame which other artists will need to work from. Many professional 2D artists are now starting to incorporate 3D work into their vehicle design process in order to quickly develop technical elements such as lighting or perspective before they begin painting.

In the following chapter you will find a series of tutorials covering different types of functional transportation devices and vehicles. Some of these projects focus on ways to create such scenes purely using 2D software while others show how 3D software and plug-ins can be utilized to accelerate the design process, ready for painting.

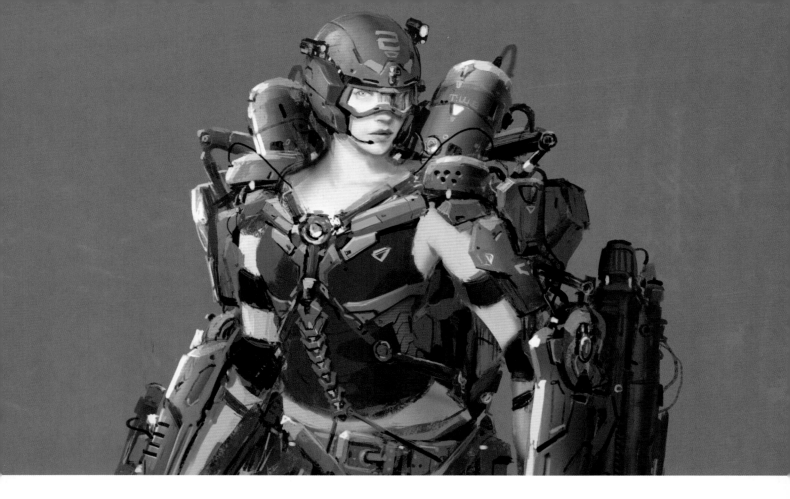

Functional Transport | Movement enhancer

If you are using this tutorial for study you can expect to increase you ability in designing and drawing a high-tech wearable machine which acts like a body suit. For this project I imagine a machine that is wearable and that will also increase the power and speed of the person wearing it. It could also have additional functions such as the option to receive essential information through the suit's eyeglasses or weapon elements making the wearer ready for combat.

During this tutorial I will show you some of the methods I use starting from designing a rough silhouette to making a complete piece of concept art. I will show you how to add parts of the suit design to a basic human figure and how to make the overall

J. C. Park
Concept Artist
Software used: Adobe Photoshop CC

↑ I focus on the overall silhouettes and explore different armor options

↑ I roughly paint the silhouette, defining parts that are body and parts that are suit

silhouette stable. I will also discuss the importance of using balanced tones and color details. The contents of this tutorial are based on my own style, opinion, and process so take the information that you feel is useful for your own practice.

01: Creating a rough silhouette

I start drawing quickly using a basic rough brush. I draw simple, loose strokes in this step and do not draw exact lines, structures, or contrast; I just let intuition guide my hand. Some artists prefer to refine each part individually; however, making a detailed silhouette can be a bit wasteful in this step. Creating a rougher image is often better in order to get the idea down quickly so I draw a few basic human bodies and add heavy and light-weight equipment options in rough silhouettes.

There is no need to add full coloring here. I just use monotone color because the point of this step is simply to see the overall shape of the character and machine. It gives me a sense of what my final image could look like.

02: Changing silhouettes

I choose the more light-weight silhouette from the rough concept images I created in step 01. I decide to change the body

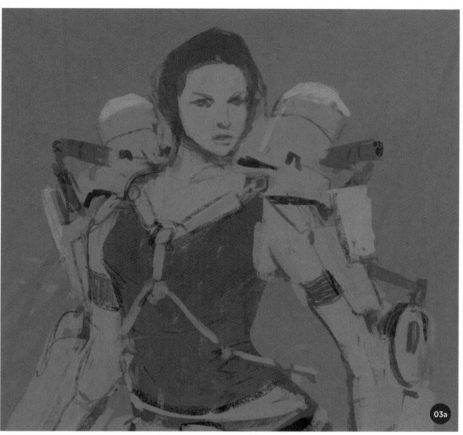

↑ With a basic rough brush I decide on a few design details for the character and suit

to a female figure because I think that the mechanical suit is very masculine. If a woman is wearing this suit then the contrast between body and suit will be increased, which makes an interesting combination.

Set up with a female body, I over-paint parts of the silhouette that will become components of the suit. In this step I have to think about how the character will move easily and locate the joints on the body. I can then paint around each joint of the silhouette and decide the basic color for each part ahead of the next steps. I decide to use a gray color that mixes in blue tones because blue tones are related to cold, and cold is a good match for a machine like this.

03: Using shaded sections

I have to imagine more detailed design elements at this stage, so the next step in my drawing is to indicate shaded sections for the details on the suit. For this I am still using a basic rough brush. I progress through this

↑ I shade areas that will become details like winding and screw bumps

step very quickly and comfortably because all I am doing is identifying where details such as parting lines, winding elements, holes, and screw bumps will be (images 03a and 03b). After these details are added I can adjust small areas which will improve the design and overall shape of the suit. At this point I also decide on some rough facial details and basic clothing for the character.

215

04: Making details functional

To make sure the machine is functional I imagine situations in which the character is moving to work out how each joint would move. I then add some wires that would help to improve the character's movement as well as supply power to the machine from the battery (image 04a). It is very important to consider function in this design. The location of the battery could be a random designation on the suit but I place it on the character's back as in image 04b. Even if this battery pack is really heavy it could be lifted easily when worn on the back.

I also express a sense of volume on parts of the suit using a basic airbrush. I decide that the direction of lighting in this scene is from left to right, but the lighting direction could be from anywhere; it is your choice.

05: Controlling thicknesses

The machine needs to be functional and wearable so at this stage I think about how the mass of the machine will be distributed over the body according to the functionality of each separate part. For

↑ I paint some wires to supply power from the battery pack to the rest of the suit

↑ I locate the battery pack on the suit and decide on a general lighting direction for the scene

example, the arm plates should have a thick shape because these parts are important for improving the character's endurance power. The chest plate should be thinner than the arm plates as the function of the chest plate is only to give support to other sections of the suit. This way of thinking will also distinguish areas and provide the suit with a good overall balance in terms of design.

06: Adding contrast and detail

The next two steps focus on the lighting and materials of the overall suit, as the parts I have just defined should have a solid feeling now. The face is also important and should match the level of detail in the suit so I describe it vividly by giving the character a strong expression – the face of a heroine that you might expect to come from a superhero movie.

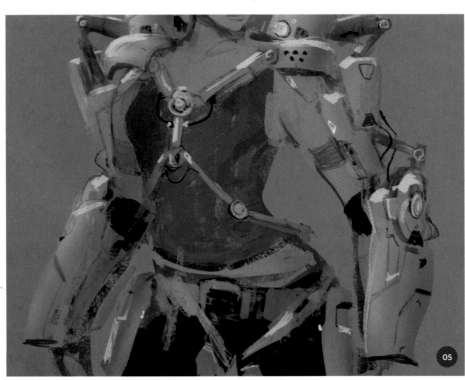

↑ I think about the overall balance of mass on the character when designing the suit

↑ I use a Levels adjustment layer to build contrast

↑ Once in the Levels panel I move the sliders to create a greater lighting contrast

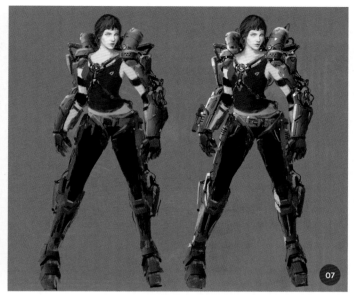

↑ I improve each section with glossy strokes of a sharp brush

> "I also polish the character's silhouette and the suit using the basic Sharp brush. This brush is very useful for drawing the edges of a mech suit"

In this step I still have to keep in mind the direction of the lighting in the scene, so the light should fall in the same direction as when the suit was lit previously in step 04. I now increase the lighting contrast by using a Levels adjustment layer and moving the sliders to increase the contrasts (images 06a and 06b).

07: Metal textures

I keep adding more detail to each section in order to express the texture of the metal parts of the suit. I do this by using the Dodge tool (see the pro tip on the right here) and by painting some highlights at the edge of each section. This may sound like an elaborate process but it is an easy way to make areas appear glossier, as you can see by comparing the figures in image 07.

I also polish the character's silhouette and the suit using the basic Sharp brush. This brush is very useful for drawing the edges of a mech suit, such as around thin parting lines and screw spots, or for expressing very thin wires for movement. You will see that the image has a more complete look when this brush is used.

⚡ PRO TIP

The Dodge tool

If you want to add gloss to metal parts of the suit you can easily use the Dodge tool. Of course, if you try to use this too much the result will not be good. Ordinarily I adjust the Range setting located at the top bar of the Dodge tool to Highlights. I then cancel the selection for the Protect Tones setting beside that because you can see results more clearly when using the Dodge tool.

You can see in the image below that this tool is very useful when you try to produce metal texture highlights. To use this tool, however, you will need to merge all of your layers, otherwise it will only affect the layer you are painting on.

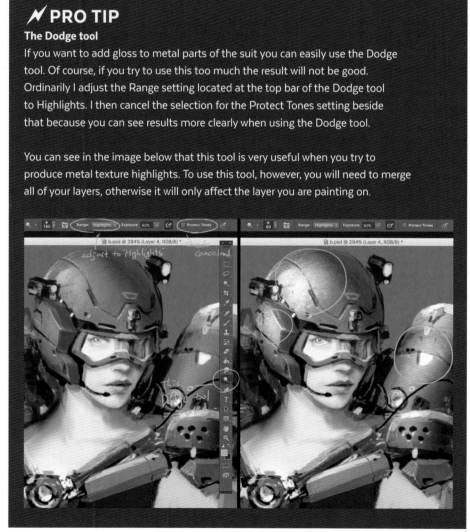

↑ You can use the Dodge tool to add gloss to metallic areas

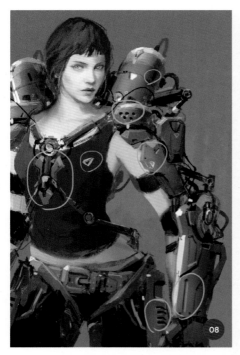

↑ I add a warm color to balance the cold colors of the suit and continue adding details

08: Adding more detail

I can now add various elements of microporous material on areas of suit, adding more small details which will help to express the depth of the parting lines and ridges. These small details will help the image approach a more completed look. You can see in image 08 that I have added metal parts that have a different, warmer color tone to the rest of the suit. When you look at the body as a whole it now has a more stable feel because the warm and cool colors are evenly mixed. By adding small areas with a yellow hue I give an impression of a greater profusion of colors.

09: Controlling the body balance

I now need to check the balance of the piece to ensure all the proportions are correct, for example the ratio of length between the arms and legs. I check the size of the head compared against the body and also compare the proportions of metal suit to skin and clothes. If all of these elements are in proportion and pleasing to the eye then I can consider adding more equipment to the wearable machine suit, as I will in the next step.

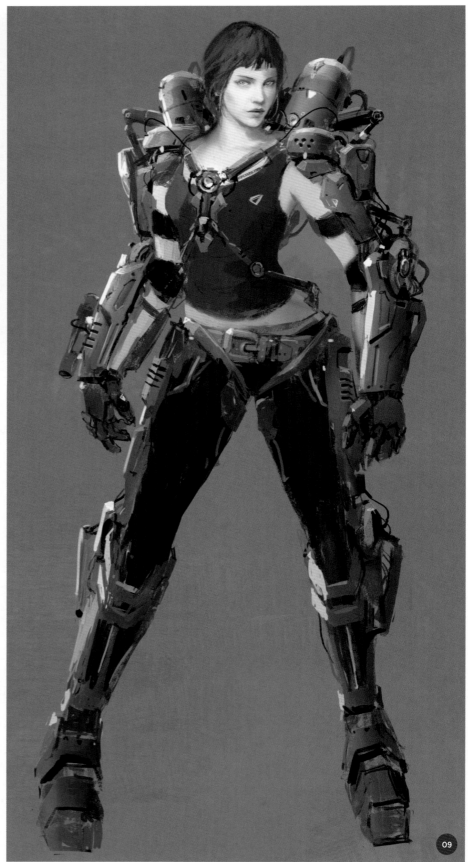

↑ I check the proportions of the figure are correct before adding any more equipment

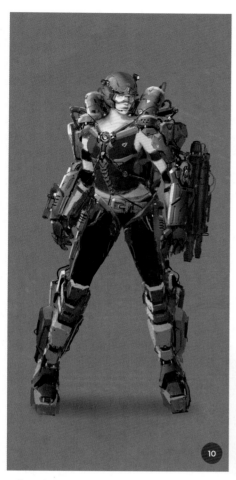

↑ Always keep in mind the functionality of any additions you make to a machine

↑ The soft airbrush used to smooth areas of the image

10: Additional parts

In this step, I want to make the suit look like a full suit of armor as well as a machine designed to enhance movement. I do this by adding a helmet and weapons, and also an additional battery to power the weapons.

> "As I used a rough brush when I drew in step 01, I can now use the airbrush to smooth out rough surfaces and express a more matte texture"

Of course these additions each need to have a function; for example the helmet is designed to protect a soldier's head, but it could also function as a communication device with a microphone and ear piece. The goggles on the helmet have a small screen which shows valuable information like the weather, the amount of bullets left in the suit, or a map of the area the character is exploring, which could be used in a battle emergency. The weapon below the arm could also be used at times of emergency so it should have storage for plenty of bullets inside. Finally, an additional battery is attached to the legs of the suit, so if the back battery pack is discharged, these could be used instead.

11: Refining surface curves

As I used a rough brush when I drew in step 01, I can now use the airbrush (image 11a) to smooth out rough surfaces and express a more matte texture. In image 11b you can see that the key areas of the concept where it is important for me to use the airbrush are curved and smooth.

↑ The airbrush is used to give a smooth, matte finish to the helmet, battery, and arm of the suit

12: Adding color details

At this stage the image is almost complete. As the majority of the suit has an almost blue-gray tone, I add a little more warm color in parts so that the overall color tone will be enhanced and balanced. I add warm color to the helmet and to small detail areas, as circled in image 12a. I use colors like orange and red, which have a high chroma (color intensity). See image 12b for more color details added to the leg area.

13: The final image

The image is now complete. The character is prepared for battle in a battery-powered mechanical suit which enhances her movements, has additional weapons, carries bullets, and gives her important information through a high-tech helmet. I am satisfied with the balance of the figure in terms of shape and color. Keeping the functionality in mind throughout means that the suit is believable and could easily be part of an interesting sci-fi narrative.

↑ It is important that there is harmony between warm and cool colors in the suit

↑ I match warmer tones to cool blue-gray tones in order to balance the colors

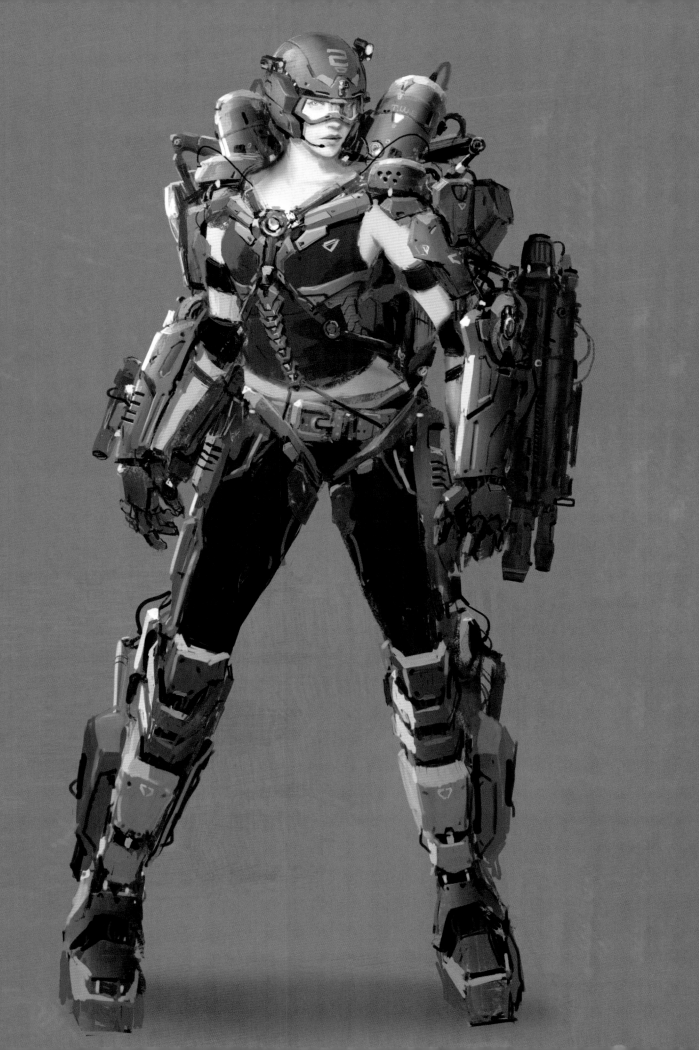

Functional Transport | Bicycle power generator

Markus Lovadina
Senior Concept Artist
Software used: Adobe Photoshop

When I received the brief to create a bicycle power generator for this tutorial, I immediately thought it was a great topic with many possibilities. This could range from a fantasy style wooden bicycle with glowing hot embers to a futuristic, clean sci-fi scene. In the end I decide on a sci-fi scene, but with a twist. Instead of going for one of those super stylish penthouse apartments, I will paint more of a student room scene. It will still be set up in a futuristic world, but with a messy touch to the environment.

As for the tutorial itself, I will try to capture and explain my process for this project as simply as possible. My process tends to differ from project to project and really depends on the topic. For this one, I will start with some sketching, moving on to a final rough sketch and developing a silhouette that will be very useful when putting the scene together. My focus will be to set up the entire scene and to get as much storytelling in it as possible, rather than solely focusing on the generator itself.

01: Sketching

Sketching is always a great way to start a new project. It really gives you the freedom to explore, free your mind, and create new and interesting things. Since this tutorial is about a bicycle power generator it would be a good idea to start with the bicycle, especially as the shape of the bicycle could provide enough hints and ideas for the audience to understand how the whole generator would work. I try to explore different shapes and looks, but always keep the sci-fi theme in mind. To be more precise, I ensure there are simple geometric shapes, and of course a logical functionality on top.

02: Final rough sketch

After I have found an interesting shape which combines the sci-fi and functionality aspects I mentioned, I move on to a more finalized sketch. I scan in all of my sketches and play around with copying and pasting. I do not find anything that works however, so I start with a blank new file and sketch in a rough silhouette.

↑ Sketch with whatever you feel most comfortable to bring some ideas to paper

Now happy with the shape, I create a new layer on top and use the standard Round brush to draw the outline. The outline will be essential for the shape as it will need to be clear how the bike functions with the generator.

> "A quick note on the production side of things: try to avoid too many anchor points. This could cause issues if you have to print anything vector based"

03: Path tools

I use paths tools to finalize the outline of the bike. Path tools, such as the Pen tool, allow you be precise when drawing and so can be quite handy if you have to work as accurately as possible. Paths are really helpful for creating straight shapes and are in my opinion a "must" when you have to work with rounded edges or more complex shapes.

I check the box for the Rubber Band option on the Pen tool (image 03a), which shows you precisely the path that you create (image 03b). A quick note on the production side of things: try to avoid too many anchor points. This could cause issues if you have to print anything vector based. For example a circle is just made out of four anchor points, no more, no less.

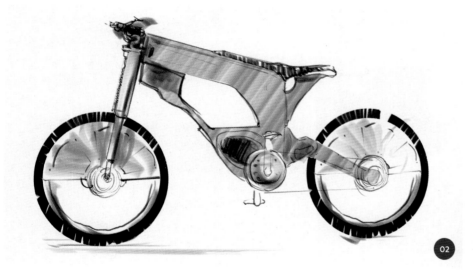

↑ The sketch has futuristic shapes that can be used for the bike and generator. It's fun to reuse earlier sketches and combine them to see if anything sparks fresh ideas

↑ I check the Rubber Band option for the Pen tool

↑ Working with a path tool gives you the most precise and accurate shape and allows you to create a customized shape

04: Final bicycle shape

As the shape of the bicycle will become quite handy later in the painting process, I spend some time developing a clean silhouette of it. This shape is produced entirely using the Pen's path tool as described in the previous step. Having a clear shape will allow me to quickly flesh out the design to fit the scene later on, and is essential for portraying how the whole generator will work, without the generator being the only focus in the scene. At this stage I think the shape works well so I am ready to move on to the next step: the generator. I save the bike as a separate document.

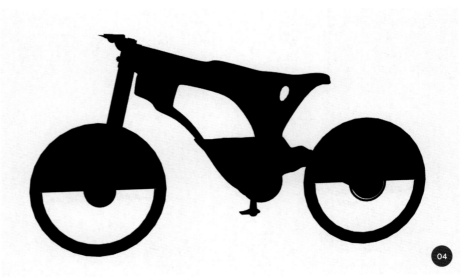

↑ I make sure the silhouette of the bicycle is very clean

05: Ideation for the generator

The brief for this tutorial is to create a bicycle power generator. What could this look like? How would it work? With these questions in mind, I start to scribble directly in Photoshop. I keep it quite loose to see if there is anything that jumps out.

From this I develop the idea of a kind of docking station. I create a new document, roughly 2,500 × 2,500 pixels, add a new layer, and start to draw a rough shape for the docking station. The entire sketch process is carried out using the Round brush and a square brush for the silhouettes.

In this step I focus purely on shapes and not on details. Details will change during the painting process anyway; I do add some hints of details though for a better proportional aspect. One important step is to decide how the bike will fit into the generator. Based on a docking station principle, the idea is simple: drive into the docking station and "upload" the energy that you have already produced during your day's cycling. Or just dock on and spend a bit of time cycling in your docking station. Both of these methods will power-up the energy.

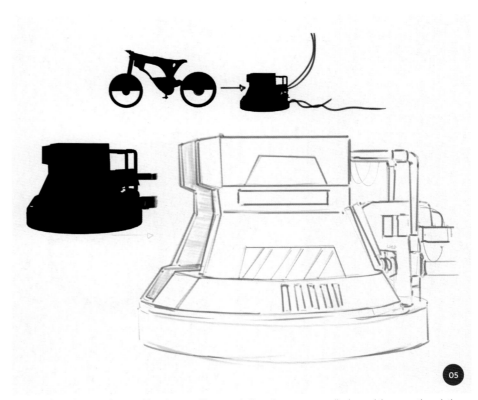

↑ It is all about shapes, at least at this early stage. Shapes and silhouettes are more easily changed than an entire painting

06: The scene setup

All the shapes and ideas for the bike and generator are now set, so it is finally time for the real painting. I talked briefly in the introduction about the scene I had in mind and now consider more of the details: a student room that is a bit messy, with sci-fi elements such as huge screens, a sliding bed, and a simplified chair and table. All these elements will be quite clean in form and function to add to the sci-fi theme. I create a new document and a new layer. I like to have as many layers as possible as it allows me to go back and forth within my file so I don't have to worry if I make a wrong stroke. On the newly created layer I use the Lasso tool to draw the floor. With the selection made, I paint in rough color and play around with the Texture setting in the Brush palette. I follow a similar procedure for the wall on the left- and right-hand side.

With the floor and the wall in place I can easily create some perspective guidelines on another layer, just to make sure everything

↑ Once you have an idea in mind the rest is just filling blank space with color, but it is important to make sure your perspective is correct

↑ Adding small details to fill the room and to set up the mood

is positioned correctly. The next step is to draw a fridge and a shower using the Lasso tool on a new layer again, painting with the Round or Square brush and playing around with textures and structures.

07: First details

The room and perspective are set so I can move on to the first details. I add a new layer and paint the rough shapes of a table and a chair. The painting can be loose since it will be defined later on.

Satisfied with the look of chair and table, I start to use the Lasso tool to make the edges and lines sharp and crisp. Then I invert the selection (Ctrl+I) and erase all the brushstrokes to get a clean line. The design patterns are made the same way, using the Lasso tool, but this time I draw more precisely and fill them with a round hard-edged brush.

The bed on the right-hand side is made in a similar way, but with one big difference: the blanket can't be straight edged so this requires

a bit of freehand painting. I make the base with the Round brush and add more and more wrinkles with a squeezed square brush. You can see some of the overlapping brushstrokes on the blanket in the lower right-hand corner of image 07. They work nicely for a painterly feeling, but would destroy the look of a clean-edged shape such as the table. The lines on the floor are painted straight with a round brush (with no settings at all) on a new layer. Then I transform (Ctrl+T) it based on the perspective lines I have on another layer for reference.

↑ Adding color splashes helps to set up the early color palette, creating a focal point and leading the eye

08: First color splashes

Now it is time for some color splashes. I create a new layer and fill the selection I have drawn of a rug with a reddish-orange tone. I add another layer on top and use a customized brush with a pattern. The pattern is painted straight (frontal) and then I transform the layer to match the perspective. The pattern layer is set to Soft Light as I would like to make the pattern more subtle and not too bright.

09: Bringing in the bike

Since I have spent quite a lot of time developing a clean shape for the bike, it is now time to use it properly. I open the bike document, select the bike, and copy and paste it into the scene document.

The next step is to transform it so that it fits the perspective and also creates a pleasing dramatic angle. The idea is that the bike points towards the shower. Why? You will find out more later. At the moment I am only concerned about having a shape of a bike since this already gives me enough information to make it appear three-dimensional when adding detail in the next step.

↑ Preparing elements early will definitely speed up your process and in this case gives enough information to get started

⚡ PRO TIP

Get used to 3D

Sometimes a task can require working in a 3D environment, or at least the task will be easier if you can work in any of the industry-standard applications. While I remain in Photoshop here, designing a bicycle power generator has the potential to be such a task.

It is fun to work in just a 2D environment and I really enjoy it, but the more complex the task is, the harder it can be to do in 2D. Becoming familiar in a 3D software package of your own choice is therefore not a bad idea. Just imagine if you had to design the inner workings of the power generator properly. It would be possible to do it in 2D, but it would take so much time.

↑ Sometimes loose brushstrokes create interesting effects, shapes, or overlays leading to really interesting results

10: Details

The focus now is on the bike. By Ctrl+clicking on the bike layer, I get a selection of just the bike and as usual my next step is to create a new layer on top. If you press Ctrl+H you can hide the selection while it is still active. With the newly created layer, I start to paint a light gray in as the base color for the bike. I keep the strokes quite loose and see what happens. Sometimes "happy accidents" are quite useful, as they are in this case.

The loosely painted strokes give me the impression of a layered material. Based on that I add more and more details, varying with the Hard and Soft Round brushes. The "stickers" on the frame are made with the Lasso tool on a separate layer, set to Overlay.

In terms of details in the rest of the room, on the left-hand side of the scene is a shelf-like object. This could be a futuristic bookshelf with a transparent user interface (UI) to show the content. The light effect of the reflection on the floor is made from an old image, where I reused a part of the painting. I copy in the part, transform it to match the perspective, and set it to Color Dodge. Then

↑ Flipping the canvas from time to time not only refreshes the eye, but it can also lead to a more pleasing composition

I duplicate the layer, flip it vertically, and move it down, so that it can be recognized as a reflection. To make a reflection blurry, I mostly use the Motion Blur filter. There is no rule to this, so you have to play around with the angles and amount until you are happy.

Finally, I add a silhouette of a person taking a shower. This is the reason why I pointed the bike towards the shower earlier, to lead the viewer's eye to the human element in the scene. I pick a female silhouette. On top of

the actual layers, I copy and paste in another part of my previous painting and match the perspective, but this time it is set to Darken with a Transparency of 65%. You could change the look of such a Darken layer by either reducing the transparency or by adjusting the levels. Press Ctrl+L and play around with the high tones, mid-tones, and shadows.

11: Flipping the canvas

After the previous step, I merge all visible layers into one by pressing Ctrl+Alt+Shift+E.

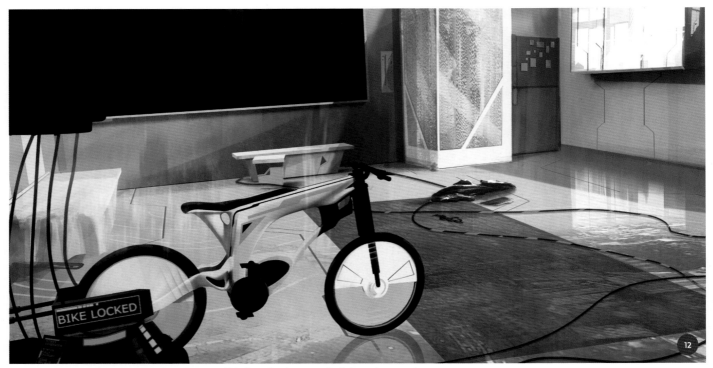

↑ Little elements can tell a story or give a hint of a story, which allows the viewer to make their own interpretation

This keeps all the other layers and adds a merged layer on top. I flip the layer to refresh my eyes and to see how the composition in this direction looks. I actually like it more this way. It has more dynamism and leads the eye a bit more comfortably.

On top I add a photo filter from the adjustment options at the bottom of the Layers panel and choose the Cooling Filter 82 option and Underwater. This is a simple way to play around with color moods and slight (or sometimes dramatic) changes of the color values.

> "A small UI element in a sci-fi scene tells you only a little bit of the story but suddenly the whole scene makes sense. Simple things are often the most important ones"

12: Telling the story

The scene is mostly set up so it is now a good point to start to tell the story. This can be achieved through simple hints, personal elements, or, since we are talking sci-fi, UI elements.

↑ Graphic design and concept art are a good combination; both ways of working and creating design can be really helpful

On a new layer I paint in some really simple strokes that give a hint of clothing lying on the floor. Like the bike, this also points in the direction of the shower. To communicate the functionality of the power generator I add UI elements to it, such as the Bike Locked indicator you can see in image 12. I mentioned earlier that my idea was not to just focus on the generator and how it will work. Instead I want to create a scene where the generator is part of the story and is shown in a more subtle way. This is another reason I only offer hints of how and why it exists in the scene.

13: Big-screen user interface

UIs are a really great way to tell a story or give hints of a story. Sometimes you see an image and ask yourself: What? Why? A small UI element in a sci-fi scene tells you only a little bit of the story but suddenly the whole scene can make sense. Simple things are often the most important ones.

For the UI elements on the large screen in the background I make a new document of 2,500 × 2,500 pixels (I will copy it back to the scene later on). I don't worry too much

↑ The UI element adds to the story and gives a nice sci-fi styling touch

about how it looks as long as it has the right information in it. However, the nicer it does look, the more attention it will receive and the faster the information will be transferred.

I really enjoy working on graphic design (I was a graphic designer for twenty years), but keep in mind that you can easily become lost in details. It is all about the story and not just the UI element in the background. In this case it is necessary to point the story towards the bike, the fully recharged energy generator, and to some kind of AI that gives our student advice.

With the new document, I keep all elements on separate layers so that each stroke, line, and block has its own layer. These layers can be easily duplicated by pressing and holding the Alt key and moving the object in any direction. As soon as I am happy with the look, I group all the layers, duplicate, and merge them.

14: Adding the UI

I copy the layer which I have just merged and match it with the big screen in the background. The next step is to duplicate the layer and add some Gaussian blur. I keep Radius low and if necessary I repeat the effect (Ctrl+F).

Then I set the layer to Color Dodge and see if I like the result. If not, I press Ctrl+L and re-adjust the highlights until I am satisfied.

As we have a glossy floor in the apartment, I add in the green UI reflection by duplicating the Color Dodge layer and flipping it vertically. I then move it down and erase all the parts that overlay elements that are not glossy or are in the foreground. Sometimes adding a motion blur with a low Distance number can add to the look.

15: Final touches

All is set and the only things that are left are the small but final touches. On a new layer I paint in a shadow for the bike, blur it with the Gaussian blur, and set the layer to Darken. On the next new layer I paint in the cables on the upper left-hand side with a simple round hard-edged brush.

I select the cables by pressing Ctrl and add a new layer. With the Eyedropper tool I select the green color from the screen and paint in some highlights. The strokes could be bold as I erase the parts that look odd or are unnecessary for a highlight.

I then make a new layer and with the Gradient tool I create a white-ish round gradient on top of the shelf. This one is set to Soft Light. Once again on a new layer, I use a round orange gradient on the left side, also set it to Soft Light.

The final step is to create a new layer, fill it with white, and add a Noise effect. This is set to Monochromatic, Gaussian, and has a low percentage amount. Happy with the look, I merge all layers and add a Sharpen filter. You could add an Unsharp mask if you like super crisp edges. On the next page you can see the final sci-fi-style student apartment with a bicycle power generator!

Functional Transport | Sci-fi delivery truck

Col Price
Concept Artist & Art Director
Software used: Adobe Photoshop
CC, Autodesk 3ds Max

This tutorial will give you a step-by-step guide to creating a sci-fi delivery truck. I have chosen to combine 2D and 3D techniques because this method of working is now so common in both the film and games industries. Using 3D in your workflow can have a multitude of advantages: working with grayscale models or compositing full 3D elements into a 2D concept is not only fast; it is also incredibly flexible. It is easy to create basic objects which you can then develop in 2D and it can allow a client to see a design from multiple angles and lighting conditions. After working twenty years in the games industry I know that this process is invaluable for today's markets.

As this tutorial is all about being flexible, I will use lots of layers in Photoshop so that the whole image can be tweaked and changed at any time. If a client at some point asks you to make changes, having a setup like this will allow you to quickly turn around solid-looking results. I will not dwell

on the 3D elements too much but I have tried to keep the model as basic as possible with a minimum amount of texture work.

> "You can see that in terms of components the truck is really minimal. This model takes me approximately twenty minutes to build"

01: Sketching
In Photoshop, I start by sketching out a really rough idea for a shot of futuristic delivery trucks that can fly. I will use this as my guide image throughout the tutorial. The idea I am working on will be one in which the delivery trucks look almost like flying futuristic cardboard boxes.

02: Modeling in 3D
If you have used 3ds Max or 3D software before, you will recognize that the model I create here is extremely basic. I create it with the Extrude and the Bevel modifiers at face

level (Select a shape > Modify > Object-Space Modifiers > Extrude/Bevel Profile), which is extremely versatile and quick. You can see that in terms of components the truck is really minimal. This model takes me approximately twenty minutes to build.

The textures also are very basic. I use one for the truck and one for the ground that I will quickly run through later, but again this whole tutorial is about using digital techniques to maximize your speed and creativity. I render with mental ray and the lighting is 3ds Max's Daylight system, so there are no external plug-ins used here, just what is already in the software. The trucks are rendered out into a 32-bit TGA file.

The advantage of using this process is that once the model is built I can copy and paste it and therefore easily place multiple trucks at different angles. I can change the lighting and camera without having to spend hours and hours repainting; again, time is the key factor in the industry today.

↑ I make a quick sketch of my idea in Photoshop

> "The most common brush I use is a hexagon-shaped brush which gives me solid strokes, fine lines, and great angles"

This method also allows me to change the composition as I go by moving the camera or trucks. In one scene I can quickly create multiple scenarios for a client. You can use the same VFX and background but get multiple shots in a fraction of the time.

03: Custom brushes and textures

Now I move back to Photoshop. First I will discuss brushes. Custom brushes can save time and help you create impressive-looking work fast. I have hundreds that I have made and also sets I have downloaded for free from places such as DeviantArt (www.deviantart.com). Serg Souleiman's brushes (www.artofserg.com) are great: a good mix and well worth downloading.

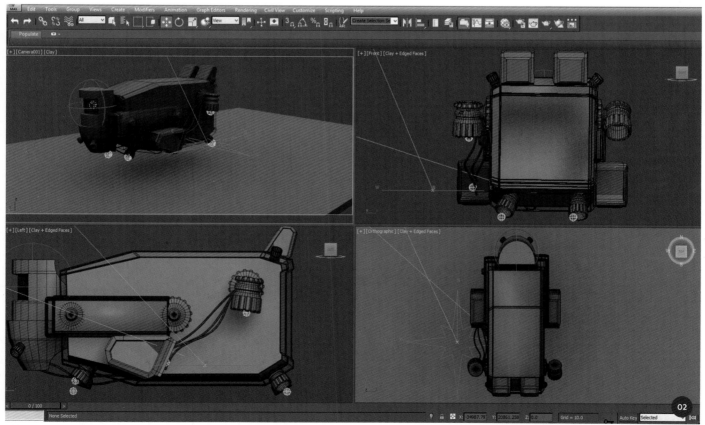

↑ The delivery truck is modeled in 3ds Max with Extrude and the Bevel modifier

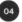

↑ The texture for the truck is created with a hexagon brush used as a stamp and filled with a gray-green color

↑ I quickly create a logo using circular selections and the Paint Bucket tool to produce basic shapes

Later, in step 09, I will show you how to develop really fast and effective clouds and skies with just a few clicks. Some cloud brushes would therefore be very useful for this image. The cloud brushes by Javier Larios (**http://javierzhx.deviantart.com**) are good starters, but it is a sensible idea to build up your own collection to have a go at making custom brushes yourself – it will help you increase your speed and creativity (see the Custom Brushes chapter of this book to find out more about how to do this).

I also need to create some textures for my trucks. I work at 3,000 × 2,500 pixels for a basic texture and use a few brushes a lot. The most common brush I use is a hexagon-shaped brush which gives me solid strokes, fine lines, and great angles. I make up a grid, just by duplicating layers, merging, and duplicating again. Effectively, I use this brush as a stamp.

Then I use the Paint Bucket tool to fill the grid with a gray-green color. This will be the base layer for the truck. I put the grid on top of the fill layer and take the opacity down to about 8% so that it is really subtle. The truck texture is now complete.

04: Creating a logo

The trucks need to have a brand logo on them so I want to make a really simple logo design. I grab a font from **www.DaFont.com** to use. Then with a circular selection I paint and fill a few circles to make planets.

> "A bright yellow truck on a bright blue sky can work as well as a dull yellow truck on a dull blue sky; keeping colors in the same range will help to ground the image in reality"

To get a hoop for planetary rings I create an oval and again fill it with the Paint Bucket tool. I duplicate this, fill it with a new color so I can see it, and then scale it down. Then I select that shape and delete it from the other layer; the hoop is complete. I don't flatten these layers, just save them as a PSD.

05: Floor textures

For the floor texture I use some free textures from **http://freetextures.3dtotal.com**. I use the same size image as in step 03 and decide to use a ribbed metal texture. I drop it onto the canvas and scale it up a little. Then I duplicate it and slightly overlap the textures. Selecting a large, soft Eraser brush I blend the edges together. If your textures are dark at the join, use the Burn and Dodge tools to dab the join and you will be able to blend them.

I merge these layers and repeat the steps above to make larger textures. By

↑ Textures are duplicated, layered, and adjusted to make floor textures that fit the scene

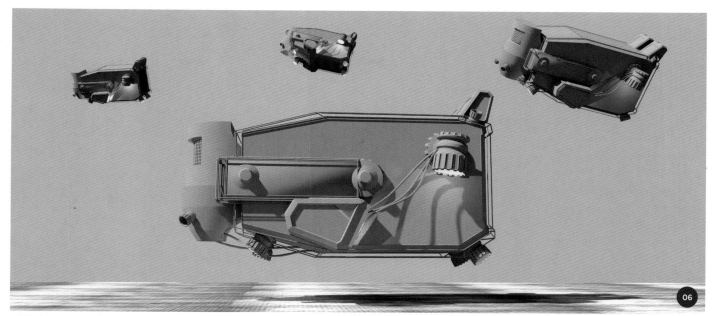

↑ I fill a large canvas with a gradient then bring in the rendered truck model file to compose the scene

merging the layers each time I add to the texture I am able to quickly fill the page by copying each progressively bigger piece.

Now that I have my textured base, I can layer up some dirt. I use a new red and gray rust texture and rotate it 90 degrees, then stretch it across the canvas to fill the horizontal space. I duplicate this and move the duplicate down, using the Eraser brush again to blend. I also want to change the color, so I open up Image > Adjustments > Hue/Saturation and slide the color settings until it is more to my liking. In this case I go for a natural brown/yellow color. By doing this I keep the color palette of my scene more uniform.

06: Starting the scene

When adding color to a scene I try to pick a few key colors and stick to them. I also try to keep the same Hue/Saturation levels throughout the scene, so if your trucks are muted in color it is best to keep the rest of the image muted too. For example a bright yellow truck on a bright blue sky can work as well as a dull yellow truck on a dull blue sky; keeping colors in the same range will help to ground the image in reality.

The third texture I create for my scene is a green metal texture. I stretch this

↑ Inverting the objects in the scene means that they can be modified by one pixel to remove outlines

fully over the image, and change the color, using Multiply and also reducing the opacity until I am happy with it. I save this as I did the floor texture.

The main canvas I use for the scene is filmic so it is 7,500 × 3,339 pixels with a resolution of 600 pixels/inch. To this canvas I add a simple gradient fill and set the first color to a really pale blue, but not white! The end point of the gradient needs to be darker and not so heavily saturated. A good rule of thumb is to never use a full black and a full white color in an image. Following this will always give you the space to add in a super bright light or a super dark shadow. I now bring in the TGA file of the truck, which is rendered out at the same resolution as the canvas, to create several flying trucks.

07: Removing fringe outlines

Using the Alpha channel, I select the Inverse and grab the white areas in my scene. I modify and contract them by one pixel as doing this sometimes removes any fringe or outline the render may have picked up.

I go back to the Channels panel and while everything is still selected I click on the RGB channel layer and copy and paste into the main canvas.

08: Painting a worn surface

I cut out each of the trucks as separate images so that I can change the order and composition if need be or apply different VFX. Using the layer with the main truck I duplicate this again and bring in some

color, turning the hue to yellow. I will use the gray render layer as a base metal.

Using the Eraser with a noisy brush I remove sections of the paint so that it looks like a worn paint surface. You can do this as many times as you need to. I then merge the layers and repeat the process on all of the other trucks. This can prove a handy modification to a render if you are not happy with its original look. You can add stripes or shapes in any color, and using blending modes like Overlay or Multiply you can also achieve great effects.

09: Depth and clouds

To work on the depth in the composition, a simple drop in opacity can help to give a distance cue, allowing the blue hazy atmosphere in the distance to come through. Even taking sections out of the truck with a soft Eraser will help the clouds that I am going to add in show through. I also duplicate one truck and turn it fully white before taking the opacity down, just to knock it back in the image.

To paint the clouds I use a large, dense cloud brush and the color from the base gradient layer. This means that the clouds remain in keeping with the hue of the sky. Using this color also leaves room for basic highlights, which I add into darker areas using almost white and a second cloud brush. This helps to create volume.

Adding a third dense layer closer to the floor of the scene, I gradually build up the clouds in layers. It really is that simple. I do not have to over-complicate these clouds as the main focus in this scene is the trucks.

10: Planets

I will quickly paint some effects which, as you will see, can be used in various ways. It is a great idea to build up a library of VFX; I have hundreds of VFX in my library, from rendered smoke to lights and muzzle flashes. Having your own library enables a quicker turnaround in your workflow as it saves you hunting around for hours on the internet.

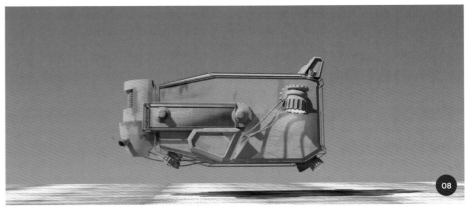

↑ A worn surface is created by erasing with a noisy brush

Planets are very easy to make and they can be as simple or as complex as you like. I could use a circular selection and a Gradient fill, but in this case I use a Radial fill instead. I set the values to Transparent and drag at an angle to softly build the radiance up.

Now grabbing a brush with noise, I gently paint the selected circle so that I can build up some layers. The trick here is to use a dark color to paint with and select Screen mode to blend the brushstrokes. I also use the Warp tool to slightly curve the pattern so that it fits the curvature of the planet. Finally I use a rock texture from the 3dtotal free textures library, overlay it, and warp it to fit the planet. I take the opacity down to around 20% and flatten the layers.

↑ Clouds are painted onto different layers to help build depth in the scene

I drop the planet into the main shot behind the cloud layer. I duplicate and scale it before changing the color and finally apply Screen blending mode so that the new planets look like they are peeking through the atmosphere.

11: Rockets

To add to the VFX in the scene I also want to create some rockets. To do this I first paint on a layer with a small cloudy brush, trying to avoid making a uniform pattern. You can also use this first layer as dust VFX if you want.

On a second Normal layer I use the Gradient tool and choose a Radial fill. I then draw out a rough triangular shape and fill that. I make the triangle big enough so that it just reaches the edges of the dust, as I can feather the edges with the Eraser tool. I use three stages to build up the rocket flare: almost white, red, and transparent.

On a third layer I duplicate and distort the work and Screen blend it. Finally I flatten the image and place these flares all over the trucks' engines.

12: Smoke trail

Back in my scene, with the VFX added, the planets now fade into the sky and the engines appear to be turned on (image 12a). I use the same principle of a simple Radial fill process to create tail lights on the trucks. The only difference is that this time I use a round selection tool rather than a triangular one.

I also want to make a smoke trail for the trucks' rockets so I create a long canvas and choose a soft cloud brush. I run the brush along the length of the canvas in a line, adding a bit more width towards one end so that it is built up like a rocket trail (image 12b). I use Screen blending mode on the trail and position it on the main image, using the Warp tool to add some shape. If you wish you can duplicate and add color, then fade the trail off to add variation. I duplicate this trail for the second truck.

↑ A circular selection is given a Radial fill then painted with a noisy brush to be used as planet VFX

↑ I layer up triangular shapes using a Radial fill to create a rocket VFX

↑ The new VFX elements enhance the sci-fi feel of the scene

↑ I paint a smoke trail with a cloud brush on a long canvas, making it thicker at one end

13: Adding in the logo

I place some more detail on the trucks now, adding in the planet logo I created earlier using Overlay and transparency settings. I then add some numbers onto the side of the trucks using Overlay. Again, I use a rough noisy brush to remove some of the layer and set my Eraser brush to about 50% Opacity or lower to paint. You can do this on multiple levels so that it looks like layers of paint removed over time and from wear.

14: Dust and debris

I still want to add a few more bits of wear onto the main truck, so I take rust and metal textures from 3dtotal's library again and add bits to the truck with Overlay mode. I then add another layer to give the horizon some haze by making a rectangle of off-white with a Gaussian blur. Then I use a splatter brush to paint small pieces of debris underneath the main truck.

Using the same methods I build up dust clouds for the launch field in layers. You can use any soft airbrush for this, in fact the softer the better. I use four layers of various size and opacity on this section, then use the Warp tool to move it around to create a better shape. Using a soft Gaussian blur again I make an orange shape in Overlay mode which will be the light from the engine

thrusters. Finally I paint in highlights with a cloud brush and add a touch of motion blur.

15: Creating a figure

I am going to add a frame to give the viewer the impression of looking out from a hangar and I also want to add a few figures to create scale. The hangar frame is drawn with the Polygonal Lasso tool and a solid fill of dark brown.

For the figures I start with a simple silhouette. I paint with a hexagonal brush as this gives me a wide range of edges (image 15a). I start with a basic pose and build it up, adding interest with headphones and pockets. From this I add in small details such as the yellow color from the scene and highlights like a broken rim light detail for the helmet (image 15b). I keep

my opacity down to let the paint build up, as it only needs to be a subtle effect. Finally I add in the logo on my figure's costume, keeping the Opacity around 50% for this (image 15c).

> "The Curves tool is hugely powerful and you can completely change the mood of an image by adjusting the settings. I now have a set of about thirty different versions of my scene"

16: A second figure

I follow the same process for the next figure. Notice that I keep the tones almost monochromatic, and just sketch in a light buildup on the body. I am conscious of where the light in my scene is coming from and how

↑ The logo is added onto the trucks and numbers are painted with a noisy brush

↑ I continue adding details such as debris and dust clouds using Overlay layers, soft brushes, and blur filters

↑ I paint a simple silhouette of a human figure using a hexagon brush

↑ I gradually build up the silhouette, using colors from the scene to paint details

↑ I add in the logo to create more unity with the truck design

↑ I create a second figure, paying attention to how the light of the scene will affect the figure

strong it is (image 16a). Because I want this figure to be further away from the trucks than the first figure, I need to make him darker. I add a slight buildup of orange on the face as the skin reflects more light than the jacket, but these are just a few brighter highlights. Notice too that I have used a very dark brown to paint with rather than pure black, even though he is in a lot of shadow (image 16b).

17: Final touches

Back in the scene I use the rocket engines to create a flare shape. I duplicate and flip this

so it can be used to add highlights to the scene such as at the edges of the frame.

With all the layers in place I save and flatten the layers. The final process I use is to grade the image with the Curves tool. The Curves tool is hugely powerful and you can completely change the mood of an image by adjusting the settings. I now have a set of about thirty different versions of my scene I can play with so it is something that is well worth taking the time to explore. At last I am happy with the mood and call this project finished.

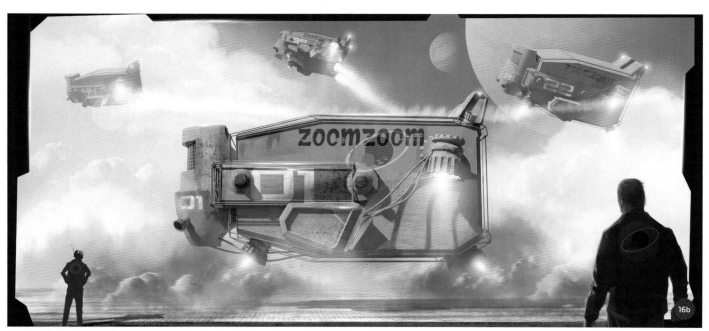

↑ The figures and the frame of the hangar indicate scale

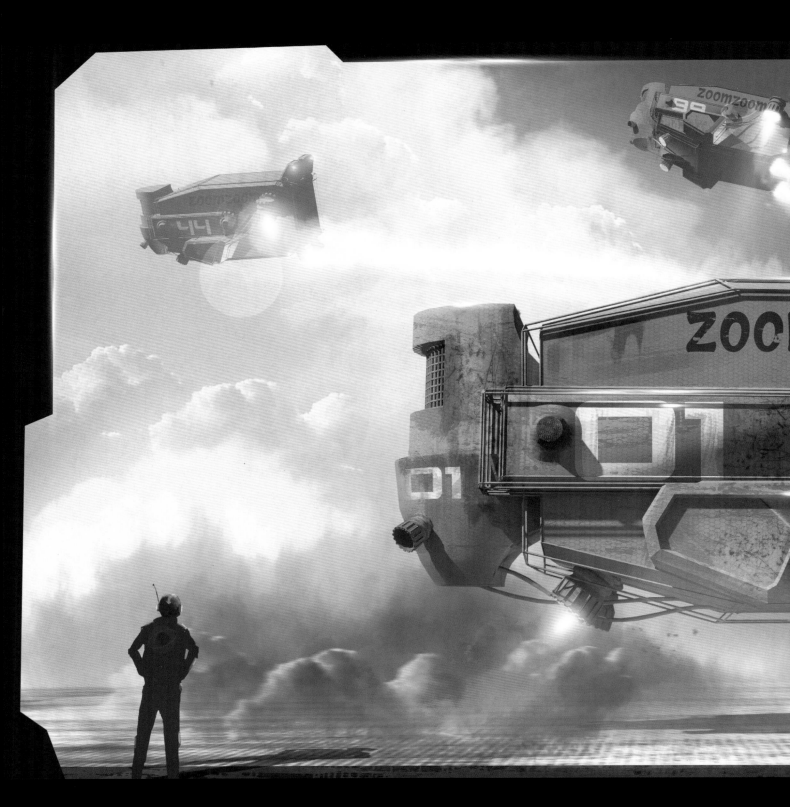

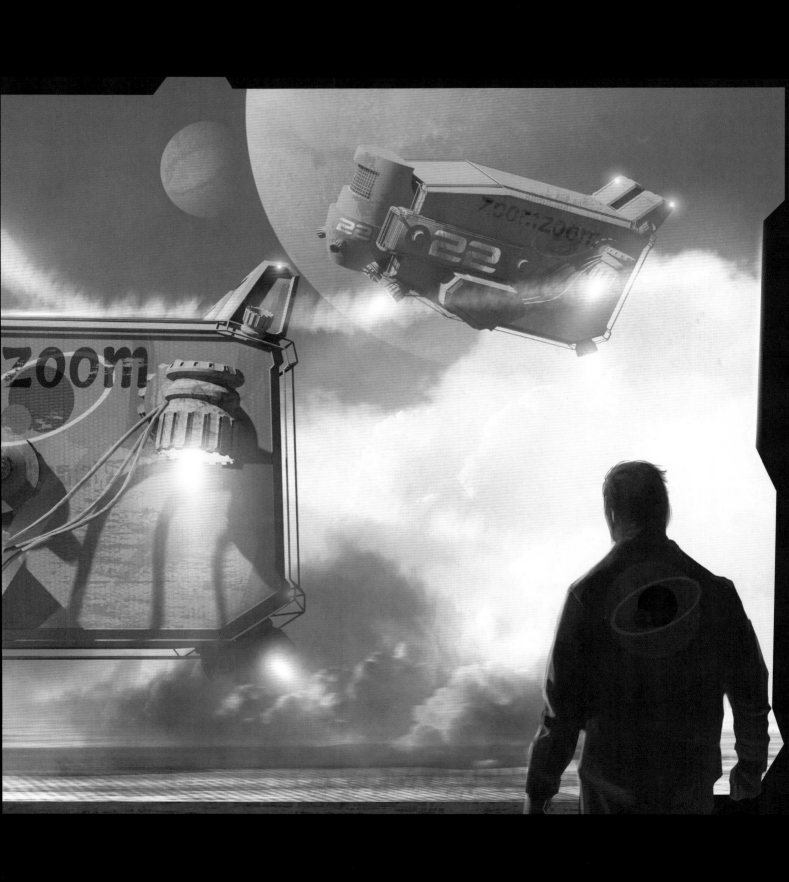

Functional Transport | Prison vehicle

Nick Foreman
Concept Artist
Software used: Autodesk 3ds Max,
Corona Renderer, Adobe Photoshop

In this step-by-step tutorial I will go from thumbnails to 3D to create a basic scene with textures and lighting. I will then move into Photoshop where I will paint over everything and add the final details. My aim is to show you how useful 3D can be for setting up your paintings. Even if you only know the basics of 3D this should still help you get more out of your work.

For 3D work I use 3ds Max but you can use any software you are comfortable with and still follow this guide. If you have not used any 3D software yet but want to start, check out www.sketchup.com. SketchUp is free and relatively easy to learn. For those that also use 3ds Max, I will be talking about an impressive render engine called Corona. It is very easy to use and will give you brilliant lighting.

01: Photobashing thumbnails
Making thumbnails is a vital part of any project. You can quickly filter out uninteresting designs and refine the good ones with minimal effort. Everyone has a slightly different technique and I tend to use messy photobashing.

The most important part of this step is having good reference materials. I use Pinterest to collect all sorts of photos, and because I love big trucks, I knew exactly where I was going to start with this piece. Taking just three photos for inspiration I quickly turn a four-wheeled military truck into a 6 × 6 vehicle and start sketching different cab designs. Do not worry if your thumbnails look ugly, as they will be improved during the refining process.

02: Refining the design
Once I have a thumbnail that I think is worth developing, I take it onto a new canvas and duplicate it. Then I start to make changes to small details and advance the design. This can be carried out as many times as you like, enabling you to add a bit here or

remove a bit there. With each iteration of the design you will see what works and what does not. I add some color, decals, and pinch and stretch my truck until I have something that I am happy with.

03: Adding fine details

This is the fun part of the initial design stage. By this step I have a dirty, messy, but solid design to work with. Now I have to polish it up and make it more readable.

Taking my thumbnail onto a new canvas, I increase the canvas size to about 3,000 pixels across, and then spend an hour just cleaning up the larger elements and

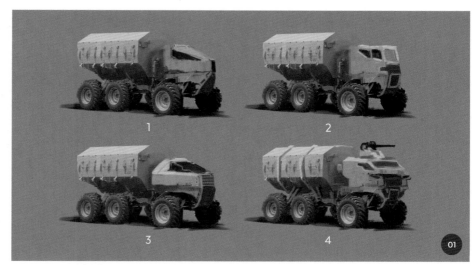

↑ I quickly paint over reference images to create a variety of thumbnail designs

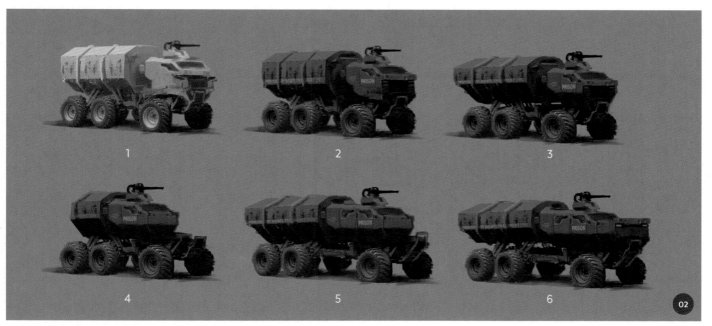

↑ I duplicate one of the thumbnails and develop different iterations of it to refine the design

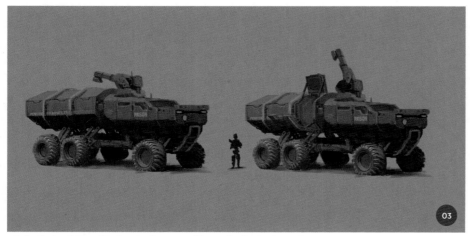

↑ In the final evolution of the thumbnail you can add more detail to inspire you later on

working in the small details. First I swap the roof-mounted gun for a pivoting crane and open up the rear to show where the prisoners go. Then I move on to creating panel gaps, shut lines, scratches, wheels, and improving whatever I am not happy with (which is most of it at this stage).

There is no limit to the number of thumbnails you can make in this phase, so the more the merrier. I usually aim to make around thirty to fifty in total but this one comes together very quickly, mainly because I really want to make a massive sci-fi truck.

04: Making the design in 3D

The first step of working in 3D involves setting the thumbnail sketch as a background image in the viewport of the 3D software. I will explain how to do this in 3ds Max but almost all other 3D software has this feature, so you should be able to copy this method fairly easily.

In Perspective view, I press Alt+B to bring up the Viewport Configuration window. Then in the Background tab I select the Use Files radio button. Now pressing the Files button at the bottom, I find my sketch. Once I have selected the sketch I press the Match Bitmap radio button to size it correctly in the viewport, then press OK.

> "I duplicate the wheel and tweak the camera position until all the wheels also match the perspective"

↑ Setting the viewport in 3ds Max with Match Bitmap selected to begin working in 3D

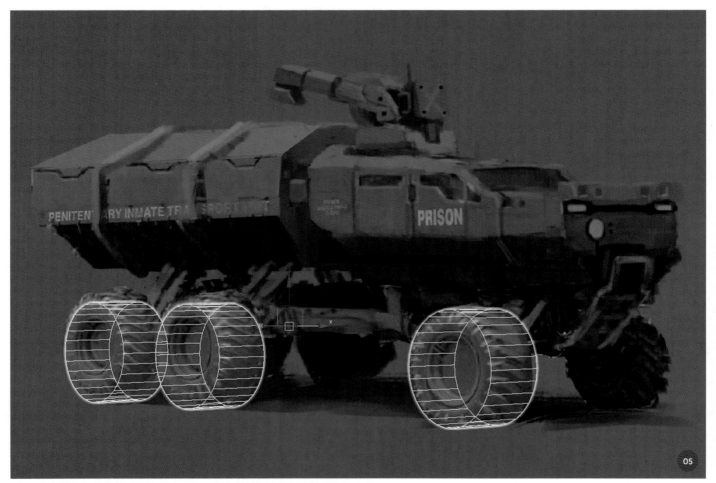

↑ I use the Orbit control on the wheels to line up the model with the sketch for quick, simple results

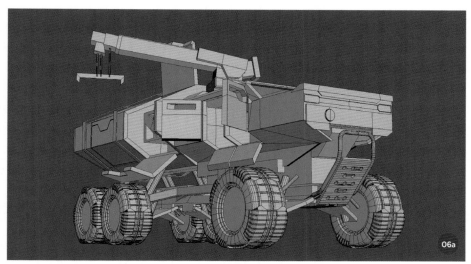

↑ A view of the front end of the truck model, based on the thumbnail sketch

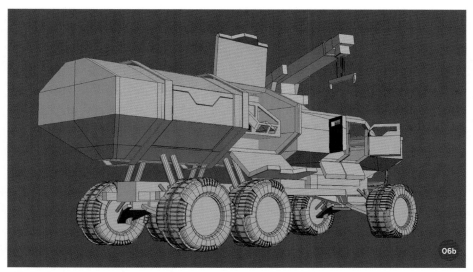

↑ The back end view of the truck. The model does not have to be perfect, just good enough to paint over

05: Laying the groundwork

Now it is time to lay the groundwork for the 3D model of the vehicle. I create a basic wheel using a cylinder. I press F3 for Wireframe mode, which draws objects without shading, and using the Orbit controls (Alt+click and hold the middle mouse button) I move the view until the wheel is aligned with the sketch. I then fine-tune the Zoom and field of view options to suit the sketch.

When the view and sketch is lined up, I create a camera in that position (Ctrl+C). I duplicate the wheel as shown in image 05 and tweak the camera position until all the wheels also match the perspective. I now have a starting point from which I can begin to make a rough 3D model of the vehicle.

06: Making the model

When it comes to creating a 3D model to paint over you do not have be a pro-modeler, as detail will be added in the painting stage. My finished vehicle model is not perfect, but it inspires me and is quick (images 06a and 06b). All the missing detail will be painted in later.

I make my wheels a little more detailed because on trucks wheels seem to draw the viewer's attention more than anything else. If you can make them look interesting you are off to a good start.

⚡ PRO TIP

Simple, subtle, believable detail

3ds Max has something called the Shift tool (Shift+Ctrl+X) which is similar to Photoshop's Liquify tool. It can be used for awesome results, such as deforming the tires to look as if they are reacting to the truck's immense weight.

Simply make your object an Editable Poly by selecting the object and choosing Editable Poly from the Modify panel. Once you have done this an option will appear under the Freeform tab, called Paint Deform. Hover over that to bring up a second window; Shift is in the top left. In the image on the right here you can see that I have pushed the rubber tire up and out slightly to add an extra level of realism to my model.

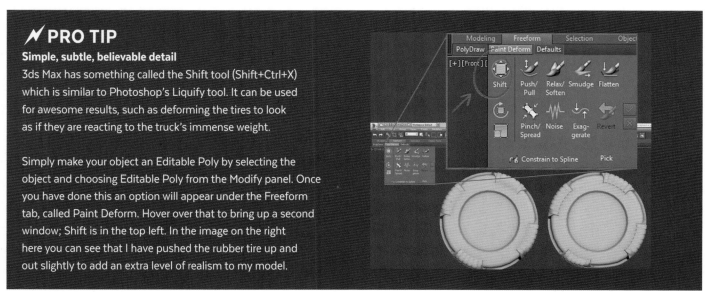

↑ Subtle details like deforming the tires, made with the Shift tool, can make models feel less artificial

> "Adding good lighting and some basic textures can give a 3D scene a few highly detailed areas to start improving upon. It is like hitting the ground running"

07: Why use 3D anyway?

The main advantage to using a 3D model in your scene is that you can get an accurate perspective, which is perfect for complex hard-surface scenes such as this. Also, if you are working for a client who likes your painting but wants to see it from a different angle or two, you can render your scene again with minimal extra work needed. In the following steps I will walk you through a few easy ways to add large amounts of detail in a relatively short space of time.

08: Lights, camera, textures

If you use 3ds Max or Cinema 4D software my top recommendation is to download Corona Renderer (**www.corona-renderer. com**). It is easy to use with a guide on their site to follow, and the results are spectacular.

Adding good lighting and some basic textures can give a 3D scene a few highly detailed areas to start improving upon. It is like hitting the ground running. For this tutorial I just use two basic metal textures for the truck, a texture for the tires, and two concrete textures for the prison buildings.

09: Starting to paint

Starting to paint the scene can often feel daunting when using 3D models. However, breaking the scene into sections can make this easier. Back in Photoshop I cut out elements in the scene and treat them as separate layers, so that I can paint directly onto them. For this image I have the

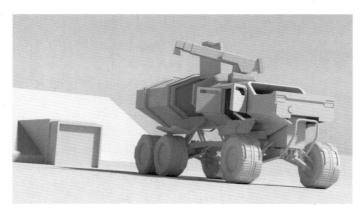
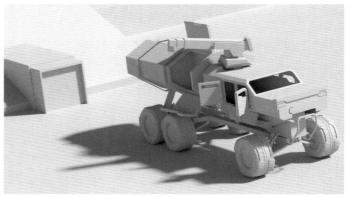
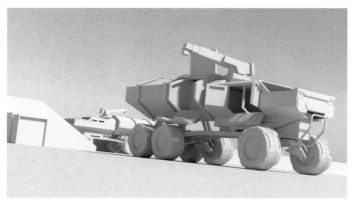
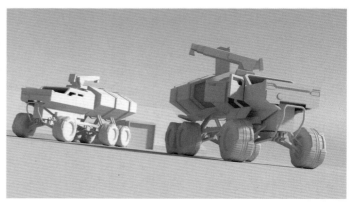
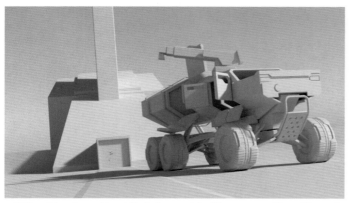
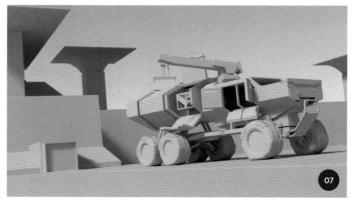

↑ A 3D model can be used to quickly design a scene in different ways and from different views

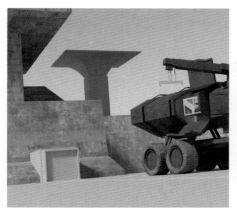
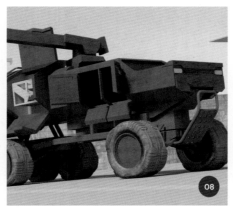

↑ Even just a few textures can provide a base to work on and to direct the viewer's gaze

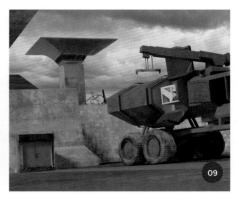

↑ I separate elements into layers to make them easy to manage, then set the initial mood for the scene

truck, ground, prison wall, and the main building behind on their own layers.

> "The best way to make any building feel convincing is to use elements of an existing architectural style. This gives your image a feeling of solidity and it can greatly enhance your designs"

Next I choose a suitable sky to set the mood of the scene. Then I can start covering up all the objects without textures with some quick brushstrokes and photobashing. Nothing is set in stone here so I can come back to these later on if I change my mind.

10: Increasing detail density
Moving on to the truck, I create a new layer and start sketching some panel lines and hinges. Adding detail like this is an easy way to break up the large sections of the model, using them as blank canvases.

I start by segmenting the bigger panels, cutting into them, and adding new shapes. You can be neat or untidy with this, depending on how much time you have or how you like to work. I keep it loose at this stage and plan to tidy the messier bits later on with more painting and photo textures.

11: Building the prison
The best way to make any building feel convincing is to use elements of an

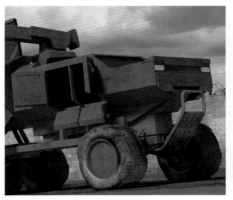
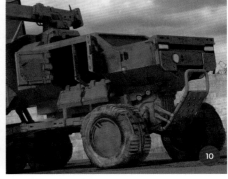

↑ The first detail pass really helps to establish the design, creating a solid base to work on

↑ Sketch in detail on the building and use photo textures to quickly add decorative elements

existing architectural style. This gives your image a feeling of solidity and it can greatly enhance your designs. For this image I choose a texture from a Baroque church for my prison entrance because I want

something that feels strong, imposing, and has a slightly decorative look. There is just enough detail in the texture to add to the scene while not taking the main focus away from the prison transport vehicle.

247

12: Painting the truck

Now it is time to start photobashing and refining my earlier sketch lines. The reference materials I use are key. I start off by covering over the larger areas such as the wheels, prisoner-transfer crane, doors, headlights, and chassis. When using photos it is important to pick ones with similar lighting to your scene, otherwise it can make your final painting look inconsistent.

To tie everything together, I add a subtle dirt layer using an appropriate brush. To do this I create a new layer and change the blending mode to Soft Light, pick a suitable brown, and build up the dirt where I think it might collect in real life. Also, as change is good, I decide to swap the sky for a more interesting dusky sky. Swapping the bland, miserable sky for something with a little more interest greatly improves this painting and helps the vehicle stand out more.

13: Adding a scale reference

I will be the first to admit that I struggle to paint people, but as they are really useful for establishing scale and narrative I have found a good way to cheat. By using a "donor image" you can overlay a photo reference

↑ I paint over the truck model and add details such as dirt with a brush and blending mode for realism

to create a base on which to paint. Here I cut out a few robot limbs from a DARPA robotics (**www.darpa.mil**) photo pack, line them up, then using the sketching techniques from before I am able to make a simple cyborg prison guard. I do a little more cheating by cutting the cyborg into pieces and reassembling them over more donor images. Then I paint over the cyborg using the same thumbnail technique as for the vehicle. I soon have my scale references.

14: Fine details and major changes

Decals and small accents of color are a good way to build up detail and they also help to make the overall color palette richer. I choose orange and highlight a few areas of interest, such as access panels, hinges, and controls.

I then paste in some stickers to make the vehicle look authentic. I find that cranes, garbage trucks, and construction vehicles are a great source for these. Bigger changes are also

↑ Using images as a base to build photo textures and painting on top is an easy way to develop designs

↑ There is nothing wrong with admitting a mistake and replacing an element, such as the guard tower in this image

made, such as the new photobashed and painted guard tower. Here I can appreciate another advantage of using 3D as I re-render the scene with a cylinder in place so that it is perfectly aligned with the new section.

15: The final color pass

I like to use a few different, subtle methods of finalizing an image in the last stage. I use a couple of gradients on various blending modes, followed by a few value tweaks to bring out the most important areas. Then I add a High Pass filter to pick out some small details (Filter > Other > High Pass; see the pro tip on the right here) .

Next I create a new layer and use the Marquee tool to make a box in the middle of the image, about a quarter of the size of my painting. I fill this with 50% gray then go to Filter > Noise > Add Noise. I set the Amount to 5, and select Gaussian and Monochromatic. Finally I resize the layer to cover the canvas, and change the blending mode to Overlay on 20% Opacity. You can see the final image on the next page.

⚡ PRO TIP
Boosting detail with a High Pass
A simple way to improve the level of detail in your artwork is to use the High Pass filter. Select the top layer in your layer stack and press Ctrl+Shift+Alt+E to make a new layer from everything you have visible. Desaturate it completely (Ctrl+U) and then go to Filter > Other > High Pass and change the Radius to 3 pixels. Now set the blending mode to Overlay.

The whole image will now look sharper but the detail needs to be more focused in a few places. Go to Layer > Layer Mask > From Transparency, then click the white box that appears in your layer stack and invert it (Ctrl+I). Now, using white, simply paint in the detail to the areas that need more focus.

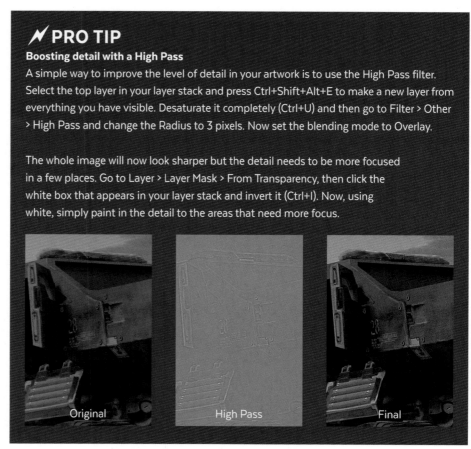

↑ Use a High Pass filter to increase the sharpness of an image

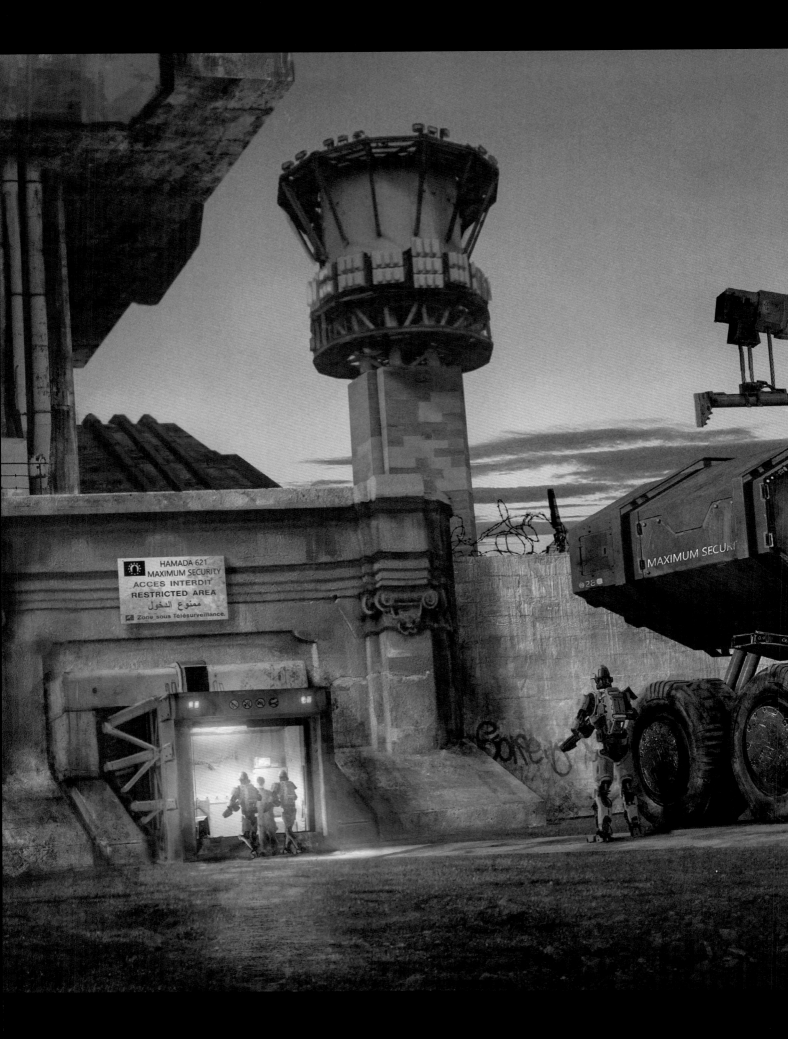

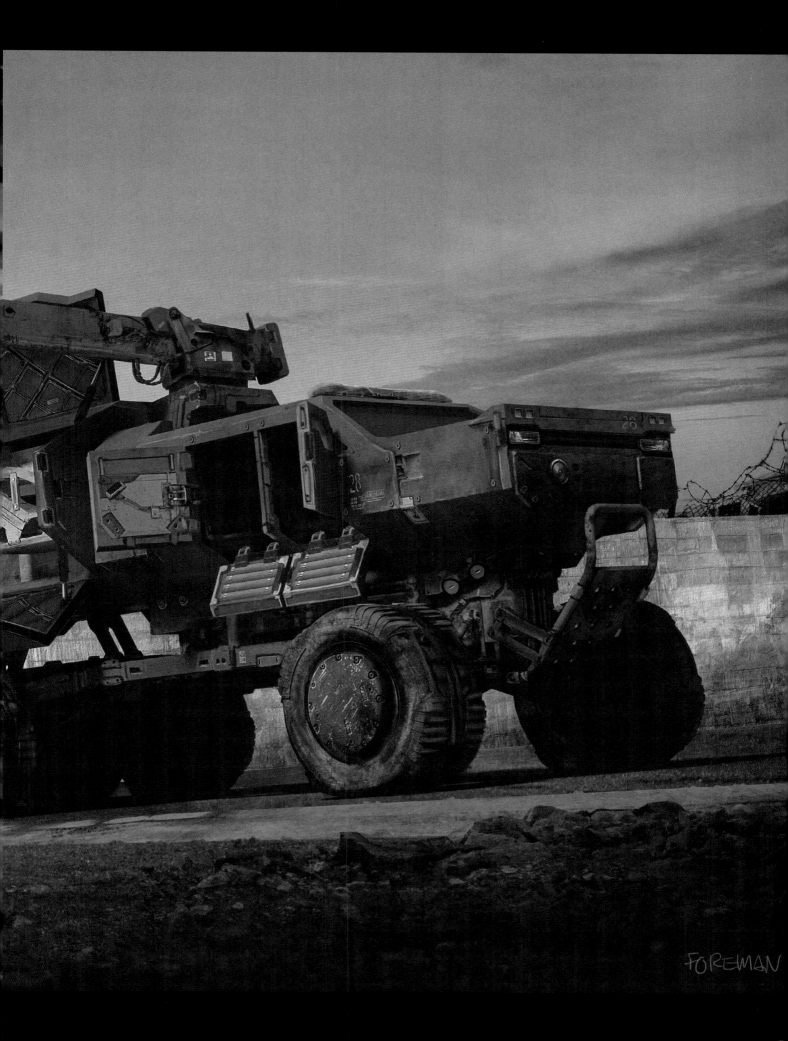

FOREMAN

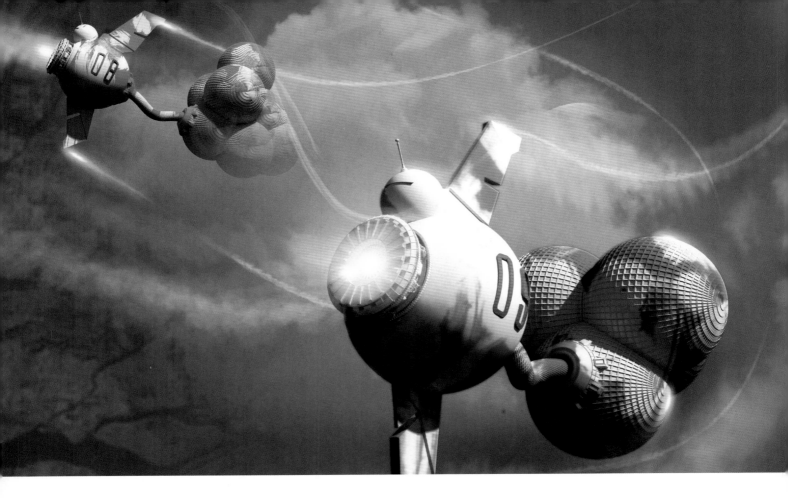

Functional Transport | Sci-fi cloud scooper

In this tutorial I will show you how to create a sci-fi image with a viewpoint taken high up in the air. My idea for this image is that in a sci-fi world there are cloud-scooper ships that fly around at a high altitude and suck in clouds. Those clouds are then stored inside the ships in balloon-style bags so that they can be used to re-seed the rest of the planet to help terraform it.

Although the majority of this image will be created in Photoshop, I also want to show

Col Price
Concept Artist & Art Director
Software used: Adobe Photoshop;
Autodesk 3ds Max

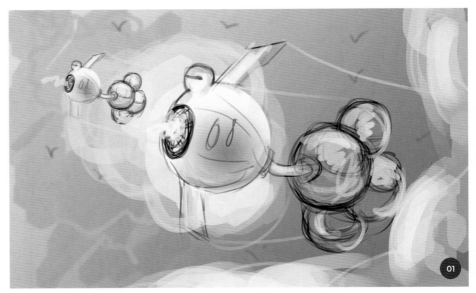

↑ I rough out a thumbnail sketch as a mental note for the rest of the process

how quick and easy it is to get a 3D mesh up and running. As you may have read in my sci-fi truck tutorial on pages 232–241, using basic 3D models in your work can help you create a complete image in double the speed.

After twenty years in the games industry I have learned that not everyone is an artist. Sometimes people need to be shown ideas in a finished way or close to an "obvious" standard. By this I mean an image that does not need to be explained; not all executives or studio heads can understand sketches, speed paintings, or just an explanation, so the higher degree of finish you can get in a work, the better! Conveying ideas over so that everybody is on the same page is vital to achieving a brilliant finished work, and getting it finished fast is an even greater asset.

> "All the objects I have created for the scooper can be recreated during your first steps in 3D"

01: Thumbnail sketch

I first make a quick thumbnail sketch, which I will use as a mental note to myself more than anything. I can use it as a guide and then see where it takes me during the painting process. I include a few colors in this and decide I want the image to have a stormy look to it.

02: The 3D elements

Using 3D allows me to rapidly turn my idea around and offers maximum flexibility. I guarantee that if you get into the games industry you will be using 3D models and sets given to you from the art team. Over-painting on these grayscale models will soon become the norm.

All the objects I have created for the scooper can be recreated during your first steps in 3D. In image 02 I have labeled the different components with letters A–G to briefly describe the elements of the cloud scooper to you. This will demonstrate how easy it is to develop a rough model. I am using 3ds Max, created by Autodesk who also produce Maya, another 3D software you can try if you prefer. The components are created as follows:

↑ A breakdown of the basic 3D objects used for the cloud-scooper ship

A: The antenna is a profile line drawing that has been turned into a 3D object with the Lathe Modifier.

B: These are 2D-drawn outlines which have been extruded, and then a few faces are extruded again for depth.

C: These are spheres which are duplicated and then the Lattice mode is placed to make a cage detail.

D: Two differently sized spheres are stuck together, and then using a cube as a Boolean object the left side is cut away.

E: Text is extruded and then bent to fit onto the sphere.

F: A Lathe profile with faces extruded and duplicates of **G** are added. The whole object is duplicated again and Lattice caged.

G: A basic tube is bent, and then scaled and duplicated to fit onto **F**.

All of these are made using basic 3D functions and a basic supplied ceramic white material rendered in mental ray, a rendering software built into 3ds Max. It

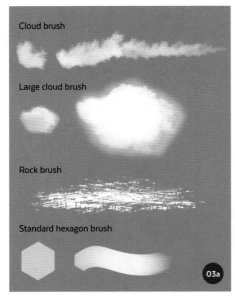

↑ The set of brushes used during this tutorial

↑ The impression of rivers on the ground is created with the Magic Wand tool

↑ I add shading with the Bevel and Emboss option

↑ I paint the ground using a rock texture brush and the Poster Edges filter

uses an internal sun/daylight system so you don't even have to worry about lighting effects on your objects. The ship is effectively built so now it is time to paint the rest.

03: Brushes and river shapes

I use a set of four brushes during this tutorial (image 03a); I prefer to just change the attributes of brushes for varying effects rather than using a lot of different brushes. I want to create a feeling that the viewer is high in the sky looking down, so there is almost a satellite viewpoint feeling.

I create the surface far below the clouds by using the Magic Wand tool and drawing out a few river shapes (image 03b). If you look

at shots of rivers from space you can see them almost as trees and branches. From this height they become abstract shapes. I fill these shapes with a basic block color.

04: Texturing the ground

Keeping the river shapes on a transparent background, I also use Bevel and Emboss in the Layer Style drop-down list to give the rivers some simple shading on the edges (image 04a). I can then duplicate sections of these and place them around the canvas.

I add a rock base to the river shapes by painting with a rock texture brush. I keep the colors to a minimum on this as it helps to keep the pattern more subtle. I use the Poster Edges

filter, just enough to get some extra shading on the image (image 04b). I duplicate this on a few layers, repeating the same process. I also find using the Unsharpen tool can create some fine but noisy outlines that help to bring the rock texture brushes to life. It is a really quick process. I am not too concerned about detail for this as it only needs to have shape and form. I could use a Gaussian blur to achieve a depth of field but for now I will save a backup sharp image just in case I need it later.

05: Sky and clouds

Next up are the sky and clouds. I use a gradient fill, set at a slight angle from right to left, to help with the depth of the image (image 05a). I add in the ground plane

↑ The gradient fill added to create more depth in the image

↑ I use a standard airbrush eraser to remove some of the gradient

↑ I choose colors from the Color Picker window, maintaining the overall hue of the image

↑ Levels and a soft eraser are used to give the cloud shape and volume

and then with a standard airbrush eraser begin to remove the right-hand side.

> "Using a large soft airbrush, I dab on a few blobs in a brownish-gray color so that the image starts to gain that stormy feel"

I also use a Gaussian Blur filter on the ground plane as it gives a better impression of the distance between the ground and the viewer. You can choose to keep this sharp if you want though. You can see from figure 05b that it is not necessary to take it fully back to the gradient. You just want the color to subtly come through so that you can build up the color and clouds in layers.

06: Storm colors

Using a large soft airbrush, I dab on a few blobs in a brownish-gray color so that the image starts to gain that stormy feel. I add over this with a single large cloud brush in a softer gray color. You can take this color by sampling in the Color Picker window from the brown you have just used, and this way you can stay within the hue of the overall image.

07: Cloud volume

I duplicate the layer and then raise the levels of the white just a touch. Using a Levels adjustment rather than Hue/Saturation gives you finer control over everything. I use a soft eraser to begin to take away the top layer so that the darker layer of cloud is revealed. Using the soft eraser you can also create a more volumetric cloud shape.

↑ I create side clouds then duplicate and darken them

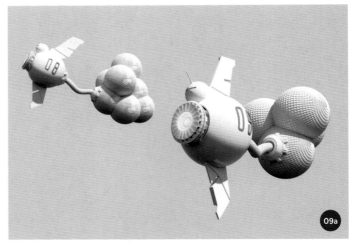

↑ The cloud-scooper ship base layer

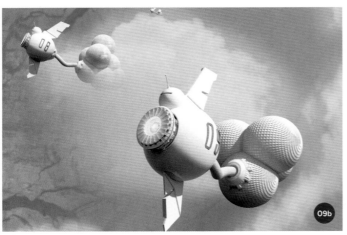

↑ Adding the ship layer into Photoshop and blending with the image base

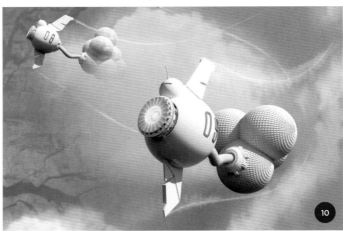

↑ Adding smoke trails to the ship using Screen mode and the Warp tool

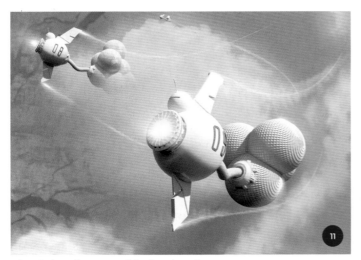

↑ I manipulate a flare to create lights from the engines

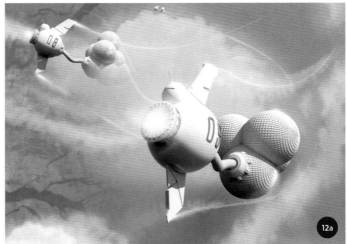

↑ I add a plume of cloud being sucked into the scooper

08: Side clouds

I now add in some side clouds on a new layer, but not fully white ones; they should be just bright enough to be distinguishable from the main cloud. I duplicate this then darken the clouds using the Levels sliders. I then drag this layer so that it sits on the inside of the side clouds.

09: Adding in the cloud scoopers

I drop in the cloud-scooper ship layer using the Alpha channel (image 09a). I will cut out the ships so I can put them on separate

layers in case I need to move them around. On the smaller ship I erase the back slightly so that it looks like it is emerging from the clouds. I also duplicate and scale a third ship for a distance cue (image 09b).

10: Smoke trails

I now add a smaller white cloud to the bottom-left of the image, sitting on top of the other layer to create more depth. I then place a rocket trail I have created previously in Screen blending mode, and use the Warp tool to move the trails around, creating that swooping feeling (see page 237 for tips on making smoke trails).

For the larger ship, I set Opacity to 50% and with a medium-sided cloud brush paint over the tops on a separate layer. This will produce a dusty outer cloud section which will complement the core white air trail.

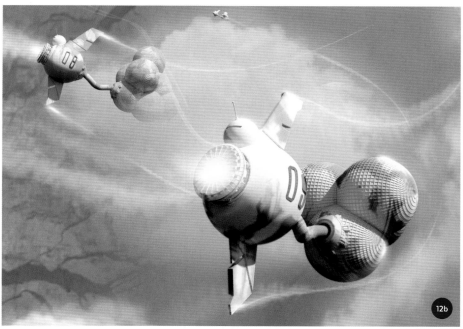

↑ I add color to the ships using Colorize and the Gaussian Blur filter

11: Engine glows

I bring in a jet flare image from my VFX library and place it over the front of the ships, scaling and warping this as needed. I duplicate the flare, scale and distort it, and place it on the wing tips of the ships to look like the glow of engines, keeping it on Screen blend mode as I do so. Duplicating the flare a few more times and using the Warp tool, I create light highlights around the ship's body.

12: Cloud vacuum and color

As a quick layer addition for the second ship, I add in a plume of cloud as if the ship is sucking the cloud in (image 12a). This will help to communicate the functional purpose of the ship to the viewer. For the ship nearest to the viewer, I duplicate the vapor trail and warp this so that it is curving towards the engine on the ship, which is acting as a cloud vacuum.

As I reach the final stages of the image I now add in a bit of color to the ships, duplicate again, use Colorize, and then remove with an eraser, using a slight Gaussian blur throughout. You can see the additional color in image 12b.

13: Curves and final touches

I now flatten the image, making sure I have saved it. I duplicate it and go to Curves, setting the Red, Green, and Blue channels to values similar to those shown in image 13. I also add the same setting twice to this image and then drop the saturation down slightly, so that the browns remain and the pinks are brought out in the clouds. This gives that stormy feel.

14: Image complete

After making these changes to the feel of the painting I am satisfied with the image. You can see the final version on the next page.

↑ The Curves values I use

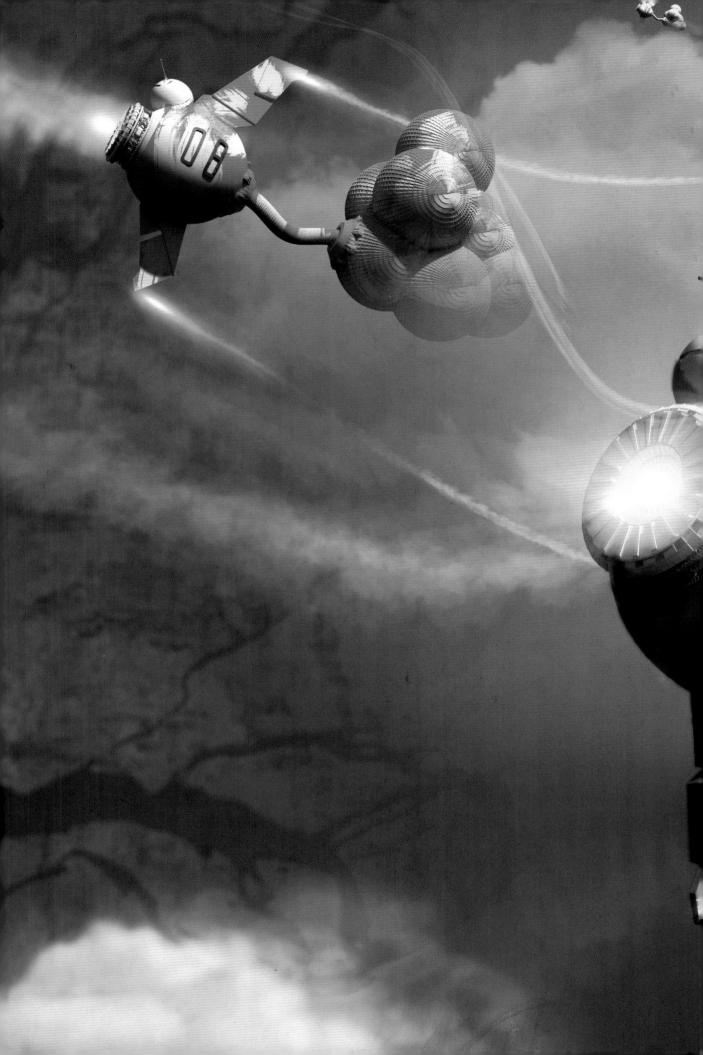

Gallery

Now that you have explored the detailed tutorials in this book, you can use the gallery chapter to help you generate new ideas for your own creations. In the following pages you will find a selection of inspiring works from leading professional digital artists to get your creative juices flowing! Each completed image is accompanied by four smaller images of the work in progress so that you can see how the artists have gradually developed their artworks.

Father & Son research

Florian Aupetit
www.florianaupetit.com

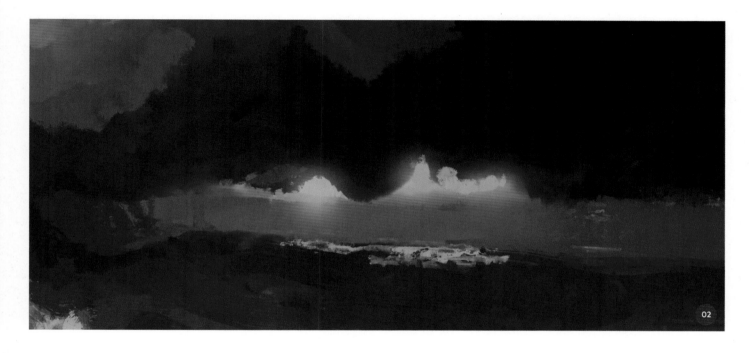

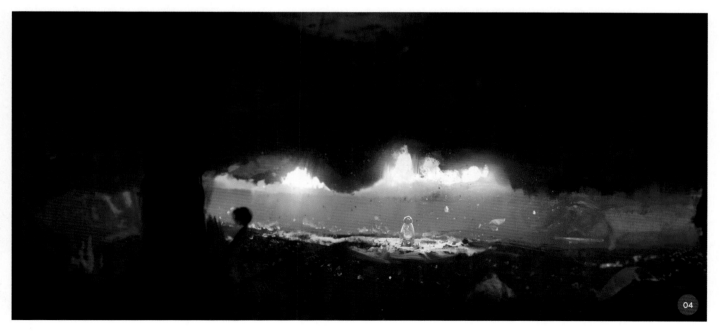

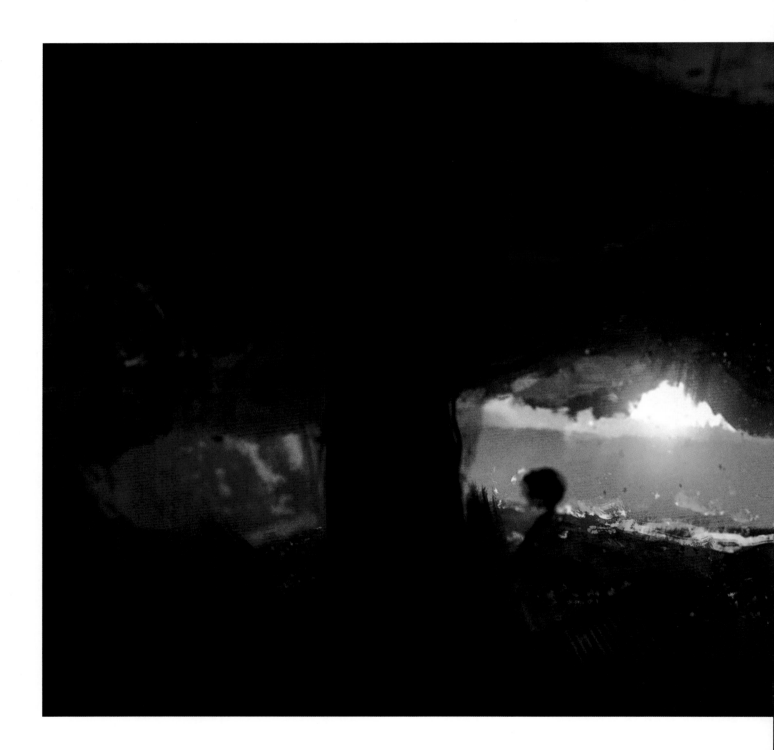

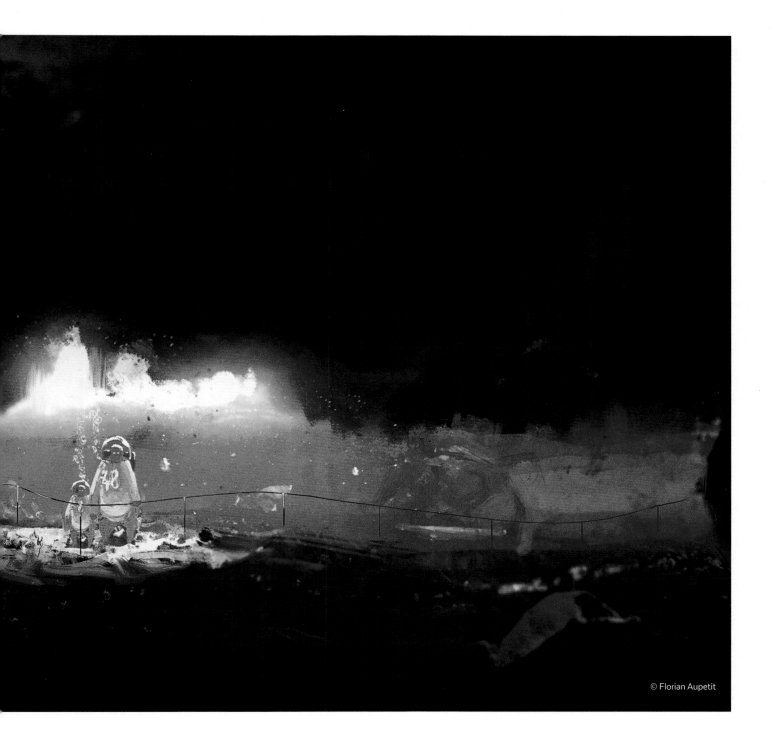

© Florian Aupetit

Bone Collector

Victor Mosquera
www.victormosquera.com

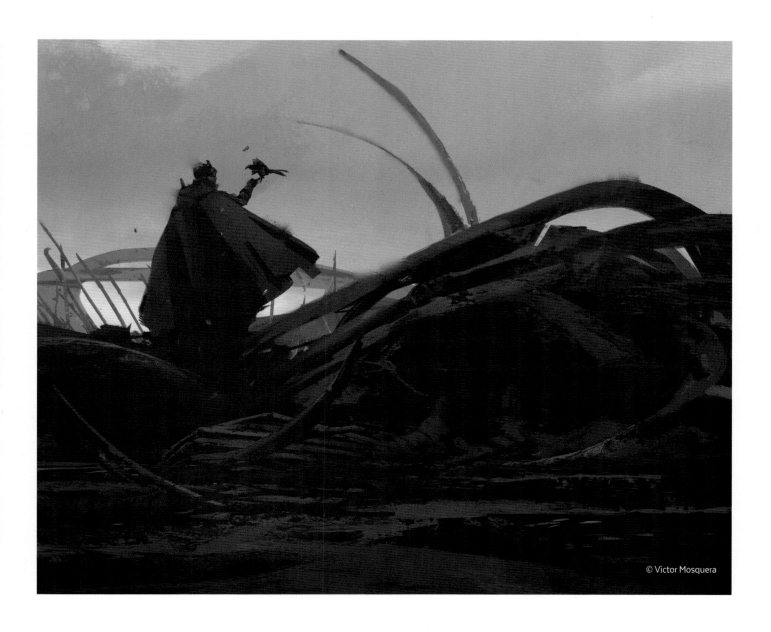

© Victor Mosquera

Hades

Davide Tosello
www.davidetosello.blogspot.co.uk

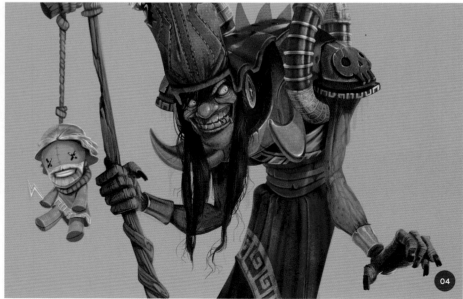

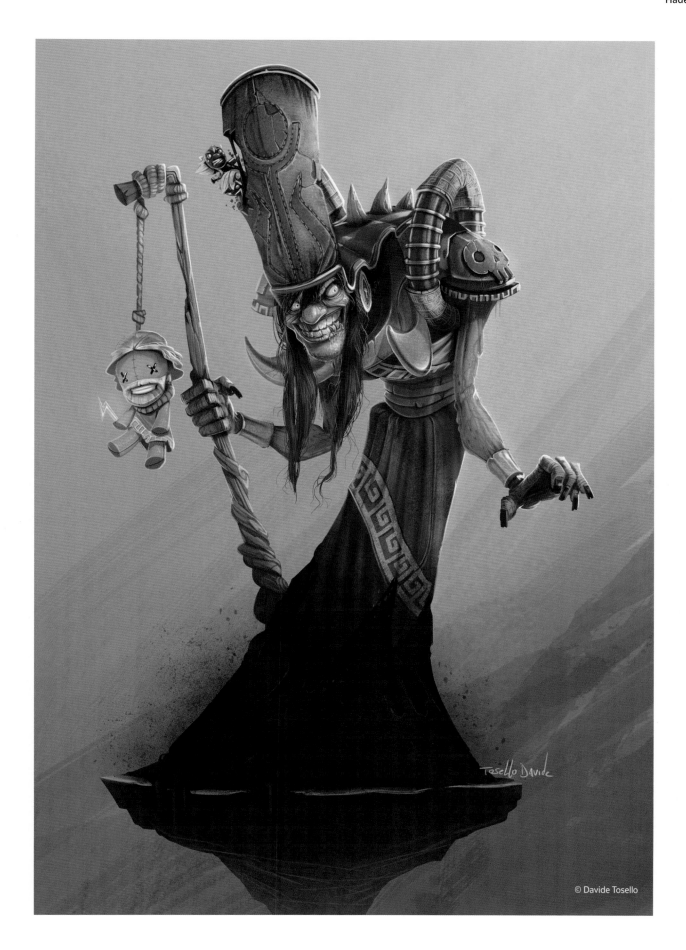

© Davide Tosello

Gates to Sikri

Finnian MacManus
www.fmacmanus.com

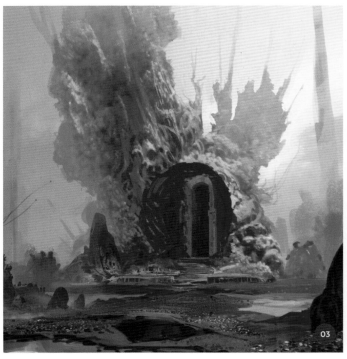

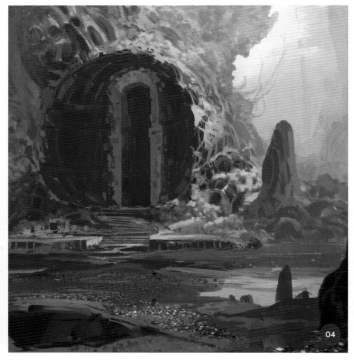

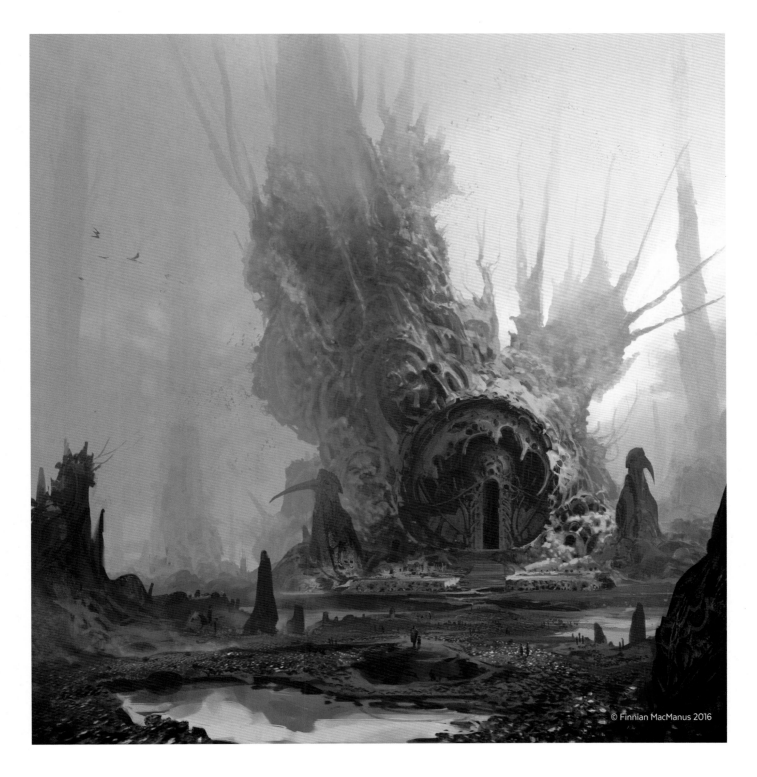

Sclavenian warriors

Andrei Pervukhin
www.artstation.com/artist/firstear

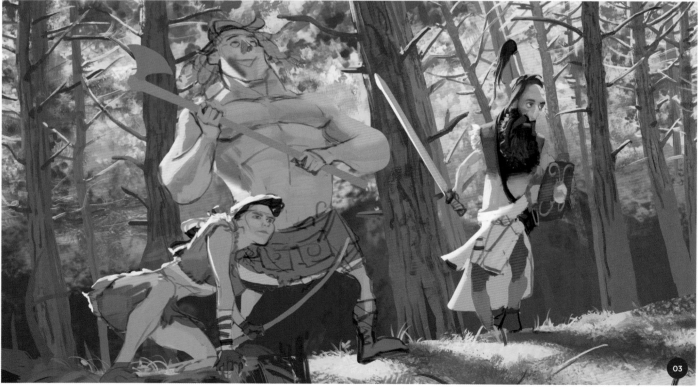

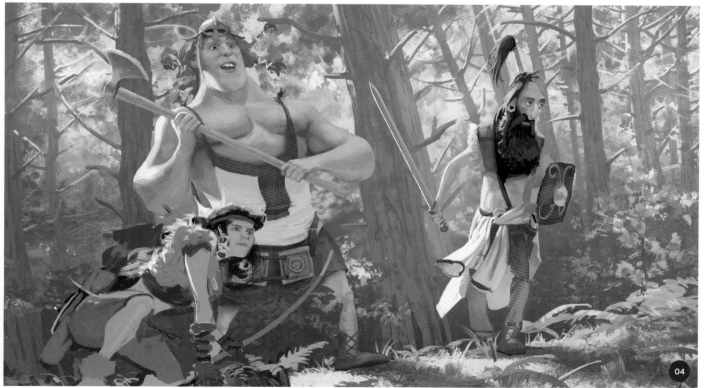

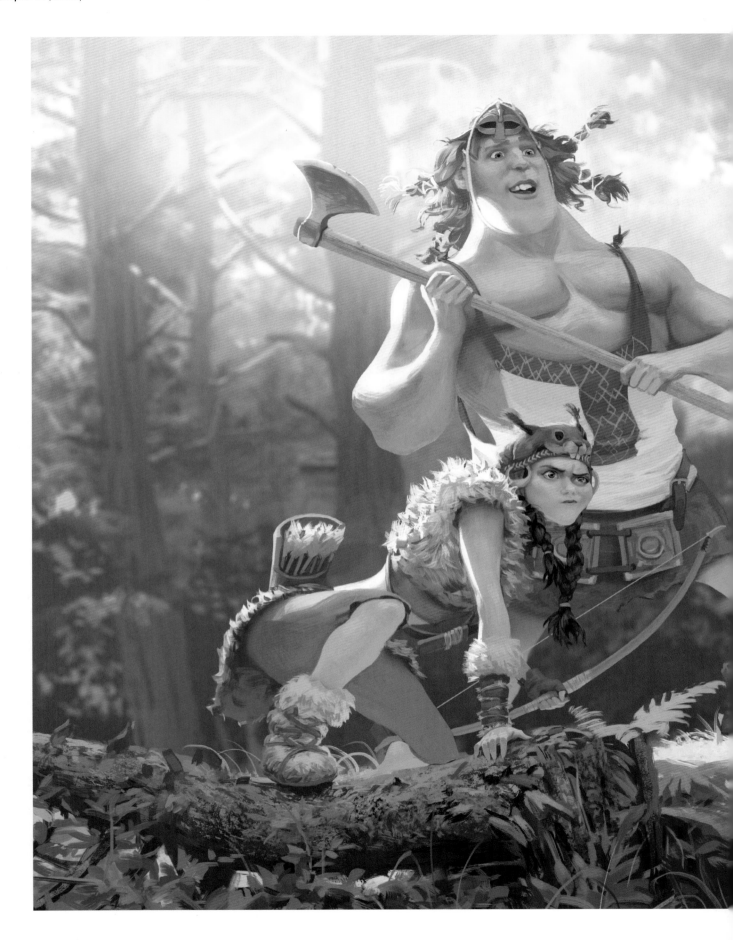

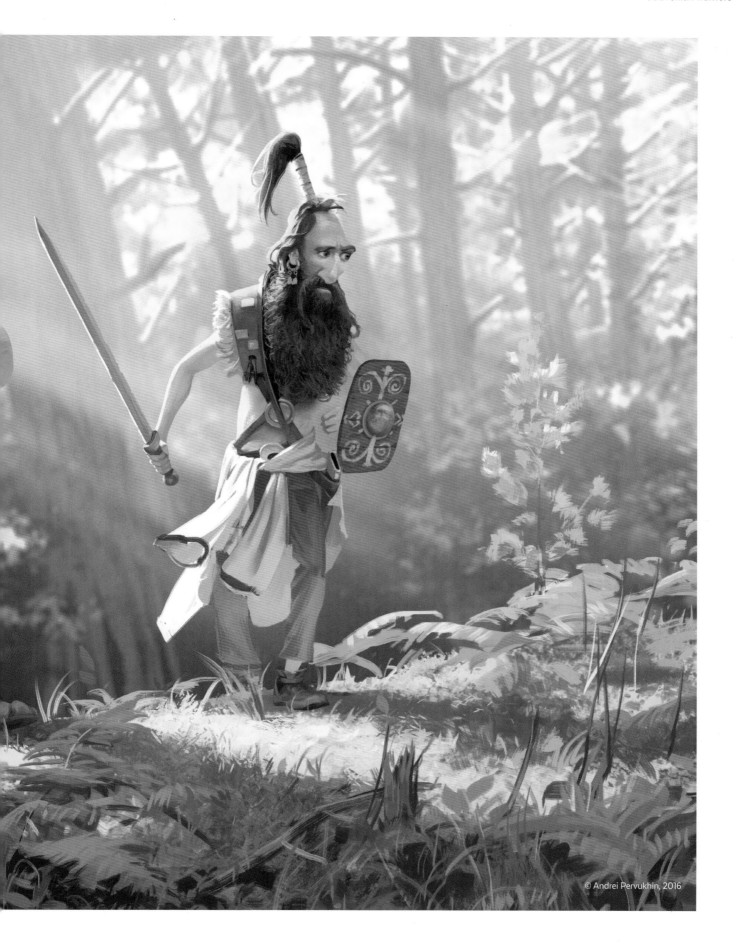

© Andrei Pervukhin, 2016

Once Great

Jesper Friis
www.maaskeikke.artstation.com

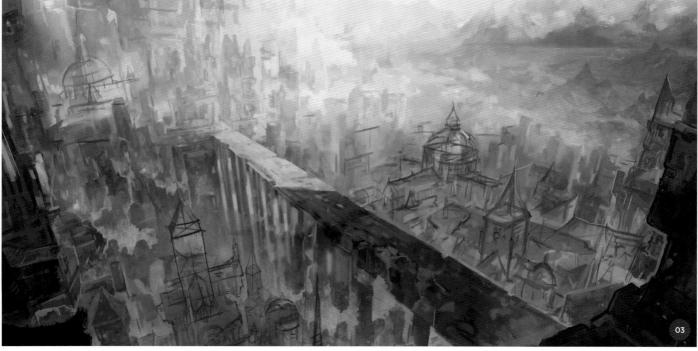

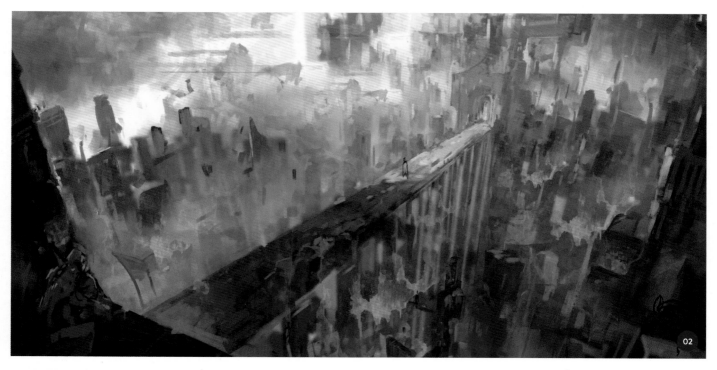

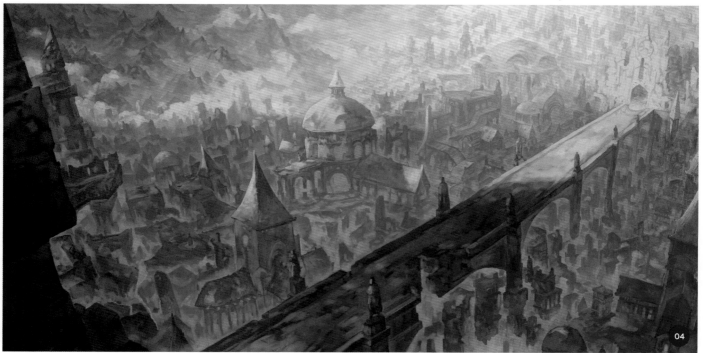

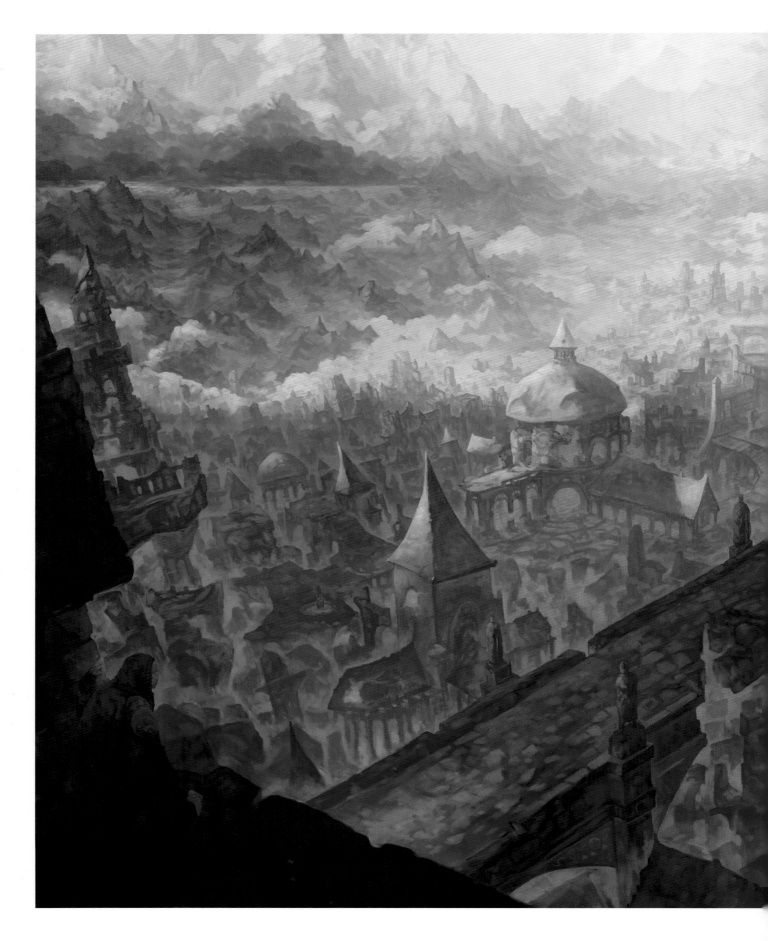

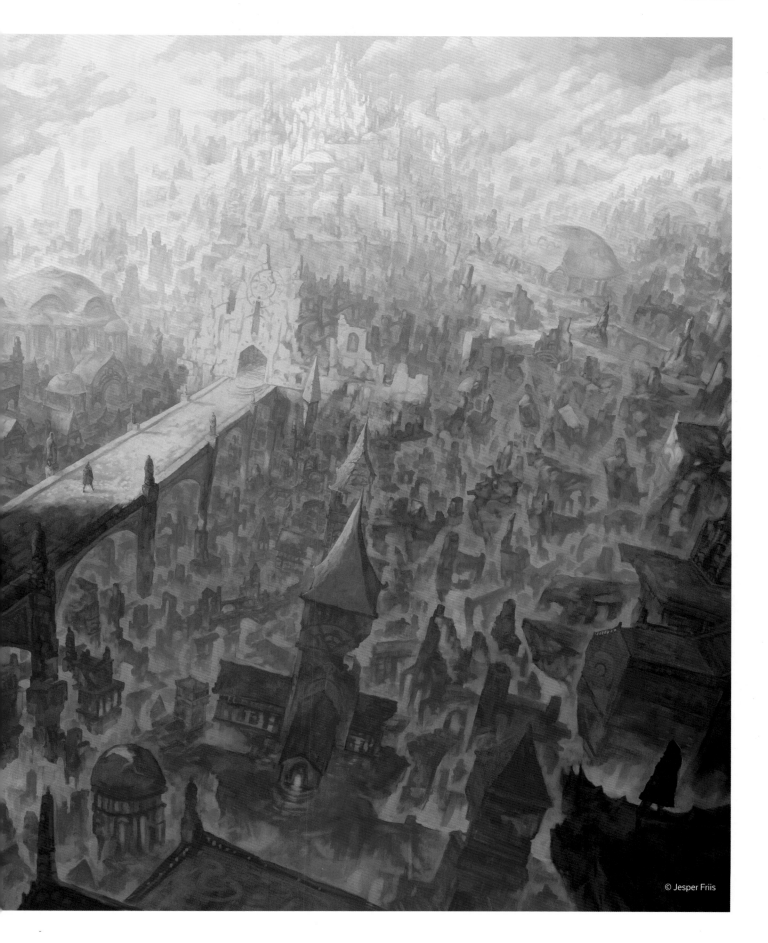

© Jesper Friis

Hidden Sietch

Finnian MacManus
www.fmacmanus.com

Featured Artists

Nykolai Aleksander
Freelance Artist
www.admemento.com

Randy Bishop
Character Designer & Illustrator
www.randybishopart.com

Falk Boje
Matte Painter
www.falk-boje.de

Steven Cormann
Matte Painter
www.stevencormann.net

Daarken
Freelance Illustrator & Concept Artist
www.daarken.com

Nick Foreman
Concept Artist
www.artstation.com/artist/kilo_three

Arthur Haas
Concept Artist & Illustrator
www.ahaas.nl

Matt Heath
Illustrator & Concept Artist
www.mattheath.com.au

Wadim Kashin
Freelance Illustrator & Concept Artist
www.artstation.com/artist/septicwd

Florent Llamas
Freelance Illustrator & Concept Artist
www.florentllamas.tumblr.com

Loopydave
Freelance Illustrator
www.loopydave.deviantart.com

Markus Lovadina
Senior Concept Artist
www.artofmalo.com

Pablo Palomeque
Matte Painter & Concept Artist
www.pablo-palomeque.blogspot.com

J. C. Park
Concept Artist
www.j-circle.net

Guillem H. Pongiluppi
Freelance Illustrator & Concept Artist
www.guillemhp.com

Col Price
Concept Artist & Art Director
www.coldesignltd.com

Nikolay Razuev
Concept Artist
www.artstation.com/artist/koly

Valentina Remenar
Freelance Artist
www.valentinaremenar.com

Zac Retz
Visual Developer
www.zacretz.com

Marcin Rubinkowski
Senior Concept Artist
www.rubinkowski.com

Rudy Siswanto
Illustrator
www.artstation.com/artist/crutz

James Wolf Strehle
Concept Artist & Illustrator
www.patreon.com/jameswolf

Amir Zand (San)
Concept Artist & Illustrator
www.amirzand.tumblr.com

Index

A

airbrush, 109, 208-209, 216, 219, 238, 255
alien, 7, 49, 70, 73, 180-181, 183, 185, 196-197, 199, 201
architecture, 60, 62, 64, 109, 199, 247
arm, 131, 135-136, 143, 193, 216, 218, 219, 248
armor, 97, 125-126, 130-136, 162-163, 167-168, 214, 219
aspect ratio, 38-39, 48, 70, 108, 149, 199, 201, 224
assassin, 7, 130-133, 135-137, 162, 181

B

background, 15, 17, 19, 23, 26-27, 32, 41, 44, 49, 53, 61, 64, 72-73, 84, 93-94, 96-97, 102, 104, 106, 108-109, 113, 115-116, 121-124, 126, 129, 140, 142-143, 146, 150-152, 155-156, 166, 171-174, 176, 182-184, 197, 200, 204-208, 228-229, 233, 244, 254
backlight, 26, 60, 62, 65,156, 176
Bevel, 97, 232-233, 254
bicycle, 7, 222-227, 229
Blur, 39, 56, 67, 86, 124-126, 146, 229, 238
body, 101, 123, 141, 166, 193, 214-216, 218, 238, 257
Burn tool, 115-116, 234

C

characters, 8, 10, 14, 17-19, 22-23, 26-27, 34, 36, 38, 41-42, 72, 77, 93-94, 96-97, 116, 120-121, 123-126, 129, 131-132, 140, 142, 144, 148-152, 154-157, 159-160, 162-164, 166-168, 171-172, 174-176, 183-185, 192-193, 197, 201, 215-217, 219-220, 282
Clone tool, 51, 62-63, 76, 100, 205, 208
clouds, 7, 49, 52, 61, 73, 85-86, 90, 92-93, 96-97, 103, 112, 115, 173, 175, 182, 205, 208, 234, 236-238, 252, 252-257
Color Balance, 35, 44, 51, 62, 113-114, 117, 185, 198, 201

color blocking, 22, 31, 63-64, 155
color grading, 60-62, 65-67
costume, 7, 10, 124-125, 129-132, 134, 136, 138-142, 144, 146, 148-152, 154, 156-158, 160, 162, 164-168, 170-172, 174, 176, 215, 218, 228, 238
creatures, 7, 81, 87, 120-121, 123, 125, 180, 183
curves, 51, 62-63, 65, 85, 239, 257

D

desaturate, 51, 109, 133, 135, 141, 164, 249
dirt, 95, 97, 235, 248
distort, 62, 65, 163, 207, 237, 257
Dodge tool, 33, 36, 39, 42, 115-116, 126, 157, 176, 191, 200-201, 217, 227, 229, 234
Dual brush, 84, 101, 110
dust, 97, 146, 184, 237-238

E

engines, 76, 181, 237-239, 242, 256-257
environment, 14, 18, 22, 26 27, 47-48, 53, 70, 74, 82, 94, 106, 109, 112, 116, 123, 125, 148, 179, 191, 193, 196-197, 204, 222, 226
Eraser tool, 33, 73, 95, 116, 182, 184-185, 234-238, 255, 257
evaporation, 115-117

F

fabrics, 138-139, 142-144, 157, 176
faces, 27, 49, 94, 123, 131, 135, 140 141, 151, 156-159, 163-165, 167-168, 176, 191, 216, 233, 239, 253
fantasy, 7, 81-83, 85, 87, 129-130, 132, 180-181, 185, 188, 222
feet, 63, 97, 143, 151
filters, 35-36, 44, 57, 67, 86, 91, 121, 144, 151, 176, 228, 249
fish, 7, 47, 60-61, 63, 65-67
flares, 97, 176, 237, 239, 256-257

fog, 27, 53, 76, 97, 103-104, 208-209
foreground, 17-19, 23, 26-27, 32, 34, 56, 61-65, 72-73, 77, 84, 94, 97, 102, 104, 106, 109, 113, 116, 121-122, 183, 193, 200-201, 229
fur, 126, 159

G

Gaussian blur, 33, 56-57, 67, 117, 151, 229, 238, 249, 254-255, 257
geometry, 54, 109, 208
glass, 7, 204-205, 207-209
gradients, 36, 44, 57, 86, 116, 123, 146, 151, 173, 182-183, 229, 235-237, 249, 254-255
grass, 90, 114, 207
grayscale, 15, 17, 23, 83-84, 91, 107-108, 232, 253
gun, 34, 42, 171-175, 243, 248

H

hair, 144, 157, 164, 167, 176
hands, 8, 23, 30, 32, 34-35, 38, 40-41, 62-63, 73, 93, 130-131, 133, 143, 150, 157, 159-160, 165-166, 215, 224-225, 227, 229, 255
Hard brush, 91, 110, 140, 227
hat, 143-144, 160
haze, 52-53, 55-56, 61-62, 97, 238
head, 31, 70, 87, 138, 140, 144, 160, 167, 174, 218-219, 248
helmet, 163, 174, 176, 183-184, 219-220, 238
hero, 7, 13-14, 19, 22-23, 25, 27, 30, 38-39, 41-45
horizon, 61-62, 103-104, 109, 204-205, 238
humid, 112, 115-116, 132
hunter, 120, 180-181, 183

I

industrial, 49, 55
interior, 39-40, 191
Invert, 51, 85, 110, 115, 225, 235, 249

J

jester, 7, 154-157, 159-161
Jitter, 16, 84, 91-93, 100-101, 103, 126, 141, 143, 165, 184
joints, 163, 215-216
jungle, 112-113, 116, 132

K

knight, 7, 157, 162-163, 165, 167-169

L

lace, 139, 142-143
landscapes, 7, 16, 25, 48-49, 60, 62-64, 70-74, 76, 91, 95-96, 179, 179-182, 188, 190, 192, 196, 198, 200, 205
Lasso tool, 32-33, 35, 41, 56, 62-63, 84-87, 91-92, 108, 110, 113-114, 123, 125, 181-183, 205, 208-209, 224-225, 227, 238
layers, 16-17, 25, 27, 32-36, 40-44, 53, 55-57, 67, 71, 82, 84, 87, 90-96, 100, 102-104, 116-117, 122-123, 131-132, 136, 139-140, 142-143, 146, 149, 150-152, 154, 159-160, 164, 166, 172-176, 182, 185, 191-192, 199-201, 205-209, 217, 224, 227-229, 232, 234-236, 238-239, 246-247, 254-255, 257
leather, 42, 131
legs, 15, 18, 135, 159, 176, 218-220, 248
lens, 48, 67, 97, 107, 176, 192
Levels, 23, 26, 33, 42-43, 60-62, 85, 87, 110, 114, 116-117, 146, 185, 192, 197, 200, 206, 216-217, 227, 235, 238, 255-256
light, 17-18, 22, 24-27, 32-36, 39-43, 50, 52-53, 56, 60-63, 65, 67, 71-73, 75, 84, 92-93, 103-104, 107, 110, 113-115, 123, 125-126, 131, 135, 142, 146, 150-152, 156, 164, 166-167, 171, 173-174, 176, 179, 189-190, 200, 204, 208-209, 215, 217, 226-227, 229, 235, 238-239, 248, 257
limbs, 163, 248
lines, 22, 24, 33, 42, 72-74, 109, 132, 134-135, 149-150, 156-158, 164-166, 174-175, 189, 208,

215, 217-218, 225, 233-234, 243, 247-248
Liquify, 144, 245
luminosity, 39, 104

M

machine, 70, 95, 110, 214-216, 218-219
market, 7, 47, 60-61, 63-65, 67, 232
material, 32, 40, 54-55, 57, 82, 86, 106-109, 133, 149, 157, 192, 205-207, 216, 218, 227, 242, 248, 253
mesh, 54, 163, 207, 253
metal, 42, 90, 92, 96, 131, 133, 136, 160, 172, 217-218, 234-236, 238, 246
Mixer brush, 87, 100, 102-104
modeling, 10, 32, 42, 54, 232
Motion blur, 19, 35, 39, 44, 117, 227, 229, 238
mountains, 52, 72-73
Multiply, 32, 36, 123, 151, 155, 158, 172, 208, 235-236

N

nature, 64-65, 70, 157, 190
neck, 157
Noise, 36, 44, 61, 117, 176, 229, 249
nose, 155, 164

O

opacity, 15, 17, 31, 36, 44, 56-57, 61, 63, 66-67, 73, 83, 91-93,102-104, 115-117, 121, 126, 140-143, 146, 156, 172-176, 191, 199, 201, 209, 234-236, 238, 249, 257
opaque, 83-85, 123, 166
organic, 7, 82, 85-86, 196-197, 199-201
outlines, 65, 91, 113, 140, 170, 223, 235, 253-254
overcoat, 139-140
overlap, 84, 225, 234
Overlay mode, 36, 52, 57, 63, 67, 87, 132-133, 144, 146, 164, 166, 172, 175, 209, 227, 229, 236, 238, 248-249

P

Paint Bucket tool, 16, 109, 117, 205, 234
palette, 16, 32-33, 35, 61, 64, 91, 101, 115, 150, 167, 180-181, 190, 224, 226, 235, 248
particles, 27, 107-108, 117, 146
patching, 86, 151, 171
path, 208, 209, 223-224
patterns, 40, 81, 102-104, 138, 140, 143-144, 157, 225-226, 236-237, 254
Pen tool, 84, 91-93, 100-101, 121, 125-126, 140-143, 158, 184, 223-224
pencil, 149, 154-155, 171
perspective, 8, 19, 24, 27, 32, 34, 40, 53, 55, 60-62, 64-67, 72, 74-75, 95, 104, 121, 124, 136, 191, 206, 208, 213, 224-227, 244-246
photobashing, 73, 176, 189, 192-193, 198-199, 205, 242, 247-249
photorealism, 60, 72
pirate, 7, 170-177
pistol, 171
planets, 73, 185, 234, 236-237
plants, 27, 110, 124, 205
polygon, 24, 54, 238
portrait, 25, 91, 193
pose, 19, 34, 93, 130-131, 136, 140, 162-163, 166-168, 174, 238
posture, 116, 142
presets, 66-67, 84, 87, 91-92, 101, 103, 115, 121-122, 126, 140, 184
prison, 7, 242-243, 245, 246-249
Puppet Warp tool, 163, 206-207

R

Radial blur, 123, 236-237
Radius, 33, 44, 67, 229, 249
rain, 112-113, 116-117
realism, 116, 167, 245, 248
Rectangular Marquee tool, 40-42, 92, 102, 108, 125, 249
references, 25, 40, 47, 49, 51, 57, 124, 131-132,

136, 154, 157-158, 160, 162, 166-168, 197, 248

reflections, 160, 204, 208

resolution, 15, 31, 39, 48, 52, 61, 72, 155, 235

rim light, 18, 26, 126, 135, 152, 167, 238

roads, 51, 82, 208-209

robotics, 193, 248

rockets, 237, 239, 257

rocks, 52, 72-73, 93-97, 104, 122, 181, 183, 236, 254

roof, 34, 243

roots, 113-114, 116, 125

rust, 70, 76, 167, 235, 238

S

saloon, 31-32, 34, 39-40, 44

sampling, 61-62, 255

scale, 23, 31, 40, 62, 64, 71, 74, 77, 87, 93-95, 104, 121, 159, 234, 237-239, 248, 257

scan, 31, 155, 222

Scatter brush, 92-93, 95, 101

sci-fi, 7, 47, 81, 90-95, 129, 170, 180, 188, 220, 222, 224, 228-229, 232-233, 235, 237, 239, 243, 252-253, 255, 257

scratches, 76, 167, 243

screenshots, 23, 25, 35, 201

shadows, 18, 34-36, 41-44, 51-53, 56-57, 66-67, 73, 75, 77, 85-86, 96-97, 104, 107, 114, 133-135, 142, 146, 150-151, 156, 160, 164, 166, 173, 176, 205, 227, 229, 235, 239

Sharpen filter, 36, 44, 57, 67, 209, 229

shipwreck, 7, 47-49, 51, 53, 55, 57, 70, 74

silhouettes, 15, 19, 42, 62, 65, 107, 109, 125, 131, 136, 139-140, 197, 199, 207, 214-215, 217, 222, 224, 227, 238-239

sketching, 14-15, 22-23, 91-93, 121, 138, 140, 164, 174, 222, 232, 242, 247-248, 288

skin, 87, 131-132, 139, 156, 164, 218, 239

sky, 24-25, 50-53, 56, 61-62, 65, 67, 72-73, 104, 115, 175, 182, 184, 205, 208, 234-237, 247-248, 254

smoke, 55, 60, 66, 90, 92-93, 96, 189, 191-192, 236-237, 256-257

Smudge tool, 97, 101-102, 104, 141, 143, 146, 157-159

spacecraft, 70-71, 73, 75, 77

spaceships, 100-101, 104

sparks, 176, 223

stamp, 86, 106, 144, 234

stickers, 227, 248

stone, 49, 181, 183, 247

storm, 255

storytelling, 30, 34, 36, 38, 42, 44, 116, 125-126, 190, 196, 201, 222

structures, 7, 22, 32-33, 40-42, 44, 62, 65, 76, 94-95, 100-103, 105, 113, 158, 179, 215, 225

style, 8, 139, 171, 175, 191, 193, 215, 222, 229, 247, 252

sun, 52, 60-61, 254

sunset, 60, 62, 73, 75

surfaces, 26, 41, 62, 87, 90, 92, 141, 219, 235-236, 246, 254

sword, 136, 168

T

tail, 176, 237

teeth, 91, 126

temperatures, 25, 84, 164

texture, 15-16, 25, 32-33, 74-76, 83-86, 90-92, 96, 122, 141-142, 146, 172, 176, 184, 193, 199-200, 217, 219, 224, 232, 234-236, 246-247, 254

themes, 75, 81, 155

thumbnails, 30-31, 38-39, 92-93, 107-109, 120-121, 181, 197, 242-243

tires, 158, 245-246

tone, 85, 104, 116-117, 180, 218, 220, 226

torso, 136, 140, 167, 248

towers, 62, 97, 110, 249

Transfer, 84, 87, 91-93, 101, 115, 121, 126, 141, 184

transparency, 36, 150-151, 164,

166, 227, 238, 249

transport, 7, 213-214, 216, 218, 220, 222, 224, 226, 228, 232, 234, 236, 238, 247, 252, 254, 256

tree, 23, 65, 73, 76, 113, 165, 206

tropical, 112-113

truck, 7, 232-239, 242-243, 245-248

U

UI, 227-229

uniform, 36, 44, 60, 159, 235, 237

Unsharp, 44, 229, 254

urban, 47, 60-62

V

values, 14-18, 22-23, 25-27, 30-33, 35, 41-44, 53, 61-62, 65-67, 84-85, 87, 93, 96-97, 101, 114-115, 117, 122, 135, 150-151, 164, 166-167, 171, 200, 204, 206-209, 228, 236, 249, 257

vegetation, 72-74, 76, 82, 85-86, 207

vehicles, 7, 10, 70, 213, 242-243, 245, 247-249

VFX, 52, 233, 235-237, 257

viewpoint, 64, 107, 252, 254

villain, 7, 13-15, 17, 19, 30-31, 33-39, 42-44

W

Magic Wand tool, 17, 73, 254

Warp tool, 65, 82, 104, 143-144, 159, 163, 175-176, 206-208, 236-238, 256-257

warriors, 272-273, 275

water, 56, 61-63, 76, 102, 110, 124, 126

weapons, 8, 131, 136, 170-171, 193, 214, 219-220

wind, 116-117

wood, 33, 42

wrinkles, 156, 158, 176, 225

3DTOTAL**PUBLISHING**

3dtotal Publishing is a small independent publisher specializing in inspirational and educational resources for artists. Our titles proudly feature top industry professionals who share their experience in step-by-step tutorials and quick tip guides placed alongside stunning artwork to offer you creative insight, expert advice, and all-essential motivation.

Initially focusing on the digital art world, with comprehensive volumes covering Adobe Photoshop, Pixologic's ZBrush, Autodesk Maya, and Autodesk 3ds Max, we have since expanded to offer the same level of quality training to traditional artists. Including the popular *Digital Painting Techniques*, *Beginner's Guide*, and *Sketching from the Imagination* series, our library is now comprised of over forty titles, a number of which have been translated into different languages around the world.

3dtotal Publishing is an offspring of 3dtotal.com, a leading website for CG artists founded by Tom Greenway in 1999.